Vito Acconci//Svetlana
Jacques Attali//Harry E
Cascone//Germano Cel
Coe//Steven Connor//C
Philip Dadson//Suzann̶e̶ ̶.̶.̶.̶.̶.̶.̶.̶,̶/̶/̶ ̶P̶a̶u̶l̶ ̶D̶e̶M̶a̶r̶i̶n̶i̶s̶//
Helmut Draxler//Marcel Duchamp//Bill Fontana//
William Furlong//Liam Gillick//Kim Gordon//Dan
Graham//Paul Hegarty//Martin Herbert//Chrissie Iles//
Tom Johnson//Branden W. Joseph//Douglas Kahn//
Allan Kaprow//Mike Kelley//Seth Kim-Cohen//Yves
Klein//Christina Kubisch//Brandon LaBelle//Dan
Lander//Bernhard Leitner//Alvin Lucier//Len Lye//
Christian Marclay//W.J.T. Mitchell//Robert Morris//
Alexandra Munroe//Bruce Nauman//Max Neuhaus//
Hermann Nitsch//Michael Nyman//Jacques Rancière//
Steve Roden//Angela Rosenberg//Luigi Russolo//
R. Murray Schafer//Michel Serres//Steven Shaviro//
Mieko Shiomi//Michael Snow//Antonio Somaini//
Emily Thompson//Yasunao Tone//David Toop//
Bill Viola//Paul Virilio

Sound

Whitechapel Gallery
London
The MIT Press
Cambridge, Massachusetts

Edited by Caleb Kelly

SOUND

Documents of Contemporary Art

Co-published by Whitechapel Gallery
and The MIT Press

First published 2011
© 2011 Whitechapel Gallery Ventures Limited
All texts © the authors or the estates of the authors,
unless otherwise stated

Whitechapel Gallery is the imprint of Whitechapel
Gallery Ventures Limited

ISBN 978-0-85488-187-1 (Whitechapel Gallery)
ISBN 978-0-262-51568-9 (The MIT Press)

A catalogue record for this book is available from
the British Library

Library of Congress Cataloging-in-Publication Data

Sound / edited by Caleb Kelly.
 p. cm. — (Documents of contemporary art)
Includes bibliographical references and index.
ISBN 978-0-85488-187-1 (Whitechapel Gallery) —
ISBN 978-0-262-51568-9 (MIT Press : pbk. : alk.
paper)
1. Sound in art. 2. Arts, Modern—20th century.
3. Arts, Modern—21st century. I. Kelly, Caleb, 1972–
NX650.S68S685 2011
709.04'07—dc22
 2010030892

10 9 8 7 6 5 4 3 2

Series Editor: Iwona Blazwick
Commissioning Editor: Ian Farr
Project Editor: Sarah Auld
Design by SMITH
Justine Schuster
Printed and bound in China

Cover, *front*, Christian Marclay, *Untitled (Sonic
Youth, Soul Asylum and One Mix Tape)* (2008),
cyanotype on paper. © Christian Marclay. Published
by Graphicstudio, University of South Florida,
Tampa, Florida. Courtesy Graphicstudio and Paula
Cooper Gallery, New York. Photo: Will Lytch.
inside flap, Christian Marclay, detail of installation
view, 'Sonic Youth etc...: Sensational Fix', curated by
Roland Groenenboom, Museion - Museo d'arte
moderna e contemporanea, Bolzano, Italy (2008-9).

Whitechapel Gallery Ventures Limited
77–82 Whitechapel High Street
London E1 7QX
whitechapelgallery.org
To order (UK and Europe) call +44 (0)207 522 7888
or email MailOrder@whitechapelgallery.org
Distributed to the book trade (UK and Europe only)
by Central Books
www.centralbooks.com

The MIT Press
55 Hayward Street
Cambridge, MA 02142
MIT Press books may be purchased at special
quantity discounts for business or sales promotional
use. For information, please email special_sales@
mitpress.mit.edu or write to Special Sales
Department, The MIT Press, 55 Hayward Street,
Cambridge, MA 02142

Documents of Contemporary Art

In recent decades artists have progressively expanded the boundaries of art as they have sought to engage with an increasingly pluralistic environment. Teaching, curating and understanding of art and visual culture are likewise no longer grounded in traditional aesthetics but centred on significant ideas, topics and themes ranging from the everyday to the uncanny, the psychoanalytical to the political.

The Documents of Contemporary Art series emerges from this context. Each volume focuses on a specific subject or body of writing that has been of key influence in contemporary art internationally. Edited and introduced by a scholar, artist, critic or curator, each of these source books provides access to a plurality of voices and perspectives defining a significant theme or tendency.

For over a century the Whitechapel Gallery has offered a public platform for art and ideas. In the same spirit, each guest editor represents a distinct yet diverse approach – rather than one institutional position or school of thought – and has conceived each volume to address not only a professional audience but all interested readers.

Series Editor: Iwona Blazwick; Commissioning Editor: Ian Farr; Project Editor: Sarah Auld; Editorial Advisory Board: Achim Borchardt-Hume, Roger Conover, Neil Cummings, Mark Francis, David Jenkins, Kirsty Ogg, Gilane Tawadros

...
to create sound as raw
concept
...
finding particles of
information through listening
...
whether it's the sound of the
wind as it whistles through
a crack in an automobile
window or the white noise
of subway chatter
...
Just close your eyes in a bus
station and listen, just listen.
Just listen

Doug Aitken, from conversation with Amanda Sharp, *Doug Aitken*, 2001

The performer or performers shuffle into the
performance area and away from it, above,
behind, around, or through the audience.
They perform as a group or solo: but quietly

Alison Knowles, *Event Score # 1 Shuffle*, 1961

Caleb Kelly
Introduction//Sound in Art

At the centre of a large, dark gallery space sits a shed from which sound and light emanate. Inside this structure is a theatre-like tableau, populated with messily stacked records, record players, tables and chairs. A large opening at the front is treated by the audience like a cinema screen: they stand peering into it while listening to an unfolding love story. In addition to this narrative there are records playing (although this is a simulation), and loudspeakers at times blast sound, while within the wider space the audio environment shifts phases and zones via the surround speaker system. *Opera for a Small Room* (2005) by Janet Cardiff and George Bures Miller, explores a diversity of registers of sound – initially radiophonic and operatic before turning into a rock concert, complete with stage lighting and (invisible) performer.[1] In a different art space, *33 rpm* (2006) by Phil Dadson is constructed from numerous CD sized discs shaped into a large, three metre-high circle. On each disc are rubbings taken from the surfaces of volcanic rocks. The sonic component of this work is the imagined explosion of the massive volcanoes that spewed out these rocks as molten lava many years ago. Amidst the silence of the work we find imagined noise.[2]

These two examples of contemporary artworks, one theatrically enacting sound, the other mutely evoking absent noise, mark an increased interest in sound as a central element in installations. In their divergent methods they convey some of the breadth of approaches to the use of sound in art of the twenty-first century.

On entering almost any contemporary gallery space we hear sound emanating from TV monitors, computers and projection spaces, or from headphones handed out to gallery visitors, not to mention the echoes of voices and footsteps. The gallery is not the hushed space it was once purported to be but rather is filled with sounds that can range from noisy to quiet, from gentle to aggressive, from overlapping to discrepant or disruptive. This is not unproblematic, as the hard, square surfaces of the traditional gallery do not necessarily manage sound well; it echoes around the space, bumping into sound that has crept out of adjoining galleries, and in the process it interferes and merges with it. However, many galleries are currently working out strategies to deal with the increased volume within their confines. Tate Modern in London, converted from a former power station, has embraced a crowded and often noisy audience in its vast central Turbine Hall, who experience this public area as a playful and interactive place. The way it is used by all age

groups including children has raised the 'noise floor' of the building's environment substantially and begins to change the terms of engagement with contemporary art.

Addressing these sonic shifts in the ambience of art, this anthology seeks to draw attention to sound both in and around current art practice. Sound is now an integral aspect of art, from installation to screen-based, performance-based and participatory practices, yet its presence is too often ignored. Aiding this neglect is the view that sound is difficult to represent: one cannot look at sound in a book; the sound of a particular installation cannot be photographed and retained as a document.³ Critics from a visual art background often have trouble describing sound; their lexicon does not include an ongoing dialogue with audio concepts. Thus mainstream writing on art of recent decades has tended for the most part to avoid critical discussion of sound. Yet in the last few years what once seemed like a subterranean murmur among a small number of artists and theorists concerned with sound has risen to the surface, coalescing into a body of discourse with an unanticipated centrality for art of the present.

The belief that sound is a valid and critical factor in understanding contemporary art marks a shift from what is still called visual art – a term that suggests art engages exclusively with sight and visuality. Can this shift be examined so as to better interpret art created to engage senses other than sight? Is this a change in what it is for something to be art or simply an opening out of what was already there?

Art has explicitly dealt with perceptual regimes outside the visual since the 1960s, as witnessed in various manifestations of Minimalism and conceptualism, with their experiential understanding of the relationship of audience to artwork. Take, for example, Michael Asher's installation at the La Jolla Museum of Art in 1969. Asher altered the exhibition space with carpet and noise reduction rendering on the ceiling. This combination of surfaces had the effect of deadening the acoustics of the space, reducing the typical reverberation or echo of the room, in which he introduced one sound: a simple, electronically generated tone. This work focuses on the experience of the installation by its audience, who cannot help but notice the changed acoustics of the room and the electronic sound within the space.⁴ Its photographic documentation, of course, pictures an empty gallery. We cannot comprehend the experiential nature of the work by viewing the images. In a similar way the huge rolls and stacks of felt in Joseph Beuys' *Fond* series of 1979 engage the senses by deadening the acoustics of any room in which they are installed, completely lining the walls. One cannot enter the space without being aware of the hushed acoustic environment.

A key concept underpinning this anthology is that sound is immanent to contemporary art. It is already there, because all audiences, except for those who

cannot hear, attend to artworks with not only their eyes but their ears as receptors; often they may not be open or attentive, but every audience member is continually processing information gathered through the sense of hearing. It has often been remarked that we cannot close our ears.

In the years since the start of this century there has been an increased theoretical interest in sound in culture – what Jim Drobnick has termed the 'sonic turn'.[5] As Michael Bull and Les Back have noted, 'the experience of everyday life is increasingly mediated by a multitude of mechanically reproduced sounds … In parallel to this, cities are noisier than they ever were in the past.'[6] Given this increased awareness, how are we to re-listen to the sound world around us, and how do we situate our bodies and our everyday through these discourses?[7] Many of these issues are addressed by artists who direct us to rethink how we come to know the world through listening. A productive approach to sound making derives from the physical nature of sound, best described as 'sound as phenomenon'. The remarkable nature, or phenomenon, of sound is framed within a range of varying practices including Alvin Lucier's *I am Sitting in a Room* (1969), Laurie Anderson's *Handphone Table* (1978) and Ryoji Ikeda's *+/-* (1996). Another approach is straightforwardly to draw our attention to listening itself. This has often occurred in what have come to be known as 'sound walks'. Based in the expanded sense of listening espoused by John Cage, and initially pioneered by Max Neuhaus, this practice involves directing the audience around a geographical environment or artificial sound spaces, drawing their attention to the multifarious sounds they come across. This is a very productive area and numerous artists have employed this strategy in diverse forms, including Janet Cardiff, Akio Suzuki and Yasunao Tone.

Another way in which audio has gained a foothold in our recent understanding of art practice is via numerous large-scale art exhibitions focused on sound, such as 'Volume: Bed of Sound' (The Museum of Modern Art, New York, 2000), 'Sonic Boom' (Hayward Gallery, London, 2000), 'Bitstreams' (Whitney Museum of American Art, New York, 2001), 'Art>Music' (Museum of Contemporary Art, Sydney, 2001), 'Sonic Process' (Centre Georges Pompidou, Paris, 2002), 'Sounding Spaces' (I.C.C., Tokyo, 2003), 'Her Noise' (South London Gallery, London, 2005), and 'See This Sound' (Lentos Art Museum, Linz, 2009). In addition a number of recent publications have attempted to address 'sound art' as a concept.[8] Within these texts sound art has been understood as a movement or a genre, distinct from other forms. The term itself is confusing, as it is used to describe gallery-based works as well as experimental music practices. However, rather than a movement or genre, 'sound art' simply describes a medium, much like 'oil painting'. Terms such as oil painting do not provide any information of the content of the artwork, as they simply describe what it was created from. This misunderstanding is highly problematic and the reason why many artists, art

historians and critics think there is no such thing as sound art as a genre or movement. Max Neuhaus, a prominent exponent of sound installation, argues that 'in art, the medium is not often the message ... Much of what has been called "sound art" has not much to do with either sound or art.'[9] William Furlong, artist and founder of Audio Arts, begins his discussion of sound in art by stating that 'sound has never become a discrete area of art practice.'[10] This anthology argues for sound's importance within contemporary art itself. In doing so it will not focus primarily on 'sound art' – although it includes all the relevant discussions of this term. Rather, the focus is on 'listening' to the visual arts. Once we begin to listen we find that contemporary art is a rather rowdy area of practice.

The first section, *Concepts of the Sonic*, assembles texts that situate and theorize sound in relation to art practice. It begins with manifestos by two of the most referenced figures in the field of an expanded musical practice, Luigi Russolo and John Cage. Due to the close ties sound has with music, it is not possible to discuss sound in art without looking to music, and both Russolo and Cage exerted a major influence on both music and art. Russolo, a member of the Italian Futurists, argued in 1913 for an 'art of noises' as a celebration of the modern city, drawing our attention to the simple fact that in his era industrial noise was born. He called for the opening of music to all sound through the inclusion of the non-musical noises of the city. The use of noise is common in contemporary art practices that engage sound and the very possibility of being able to hear noise as sonically interesting has had a major impact on artistic practice after Russolo.

The second text is by the composer Cage, whose practices and concepts included chance operations, indeterminacy, the impossibility of silence, the incorporation of all sound into music, and the idea of listening to sound in itself. His presence pervades numerous texts in this anthology and his importance cannot be overstated, yet it has only been in the past few years that his influence has been explored in depth, especially in the art world.[11]

Cage's legacy is in part due to the wide range of practitioners with whom he had close associations, including his partner the choreographer Merce Cunningham, composers such as Morton Feldman and David Tudor, artists such as Robert Rauschenberg, Jasper Johns and the 'intermedia' artists who created Fluxus actions and Happenings.

Another significant figure is the French composer and musicologist Pierre Schaeffer (1910–95), whose writings have only recently been translated into English and for copyright reasons are unavailable for inclusion here. Schaeffer focused on music produced from recordings, which were edited in such a way as to remove the sounds from their referents (the objects that created the sound). He also worked on compositions that involve the use of everyday sounds, such as

those made by trains, for example. His music, known as *musique concrète*, has had a great influence on many contemporary sound forms (including sampling based genres such as Hip-Hop).

The second section explores the dimensions of *Noise and Silence*. Noise has been the focus of a number of theoretical texts that find joy in its complexities. Irregular vibrations of the air constitute noise, whilst regular vibrations produce tones. The complex, irregular nature of noise overloads the listener's capability to understand sound, presenting a chaotic and unstable set of relationships that engulfs the order and simplicity of pitched sound. For Michel Serres, perhaps more than any other theorist, noise forms the backdrop to all communication, the air we breathe and the sea from which all life emerges: 'We breathe background noise, the taut and tenuous agitation at the bottom of the world, through all our pores and papillae; we collect within us the noise of organization, a hot flame and a dance of integers …'[12] In noise there is a plenitude of form, from which all possible forms can arise, hence for Serres it is a source of celebration rather than the wish for its abatement.

Volume, as distinct from noise, draws our attention to our bodies, alerting us to the phenomena of sound entering the body, slipping into our mouths, our nostrils and our ears. It gets inside us, and when played loudly, it massages and rumbles our internal organs. Steven Shaviro explains the effect this has during a performance by the infamously loud rock band My Bloody Valentine: 'This isn't just a case of being overwhelmed by the sublime. You can't stand it and you can't see beyond it; but for that very reason you get used to it after a while, and you never want it to end.'[13] The aural 'spectacle' of volume is never so great as when played to a stadium filled with thousands of fans. Scores of people attend live gigs performed above the volume that causes hearing damage, a reminder that incredible volume is not a fringe practice but is at the centre of mainstream culture.

Kim Cascone looks for the detritus of recording production, finding in offcuts a wealth of material ripe for exploitation. He attends to background noise, the underbelly of recording, focusing on the almost silent 'noise floor'. These are some of the hitherto ignored territories that have been exposed and used by artists working with sound or experimenting with new musical tools.

While most writers in this field espouse the virtues of sound, a few are not so ready to embrace the sonic in art. Paul Virilio, for example, argues that silence has been put on trial and that noise in art is 'in the process of lastingly polluting our representations'.[14] Here the desire for quiet and peaceful contemplation goes hand in hand with the belief that art should be separate from daily life: the 'noise' of the everyday somehow lessens the experience of art, 'polluting' it.

After these discussions of noise our attention is directed to the spatiality of sound. How we hear sound in different spatial conditions is an important factor

in much recent practice. *The Listener and Acoustic Space* opens with R. Murray Schafer's definition of the 'soundscape' as 'any acoustic field of study'.[15] These fields include musical compositions, radio programmes and acoustic environments. He argues that the soundscape is continually filled with 'an indiscriminate and imperialistic spread of more and larger sounds in every corner of man's life'.[16] Schafer's ecology of sound has influenced numerous sound makers (Francisco López, Aki Onda, Chris Watson, Hildegard Westerkamp), who have sought out environmental sounds, both 'natural' and 'urban', in a radically changing soundscape. Using Schafer's insights as a starting point, Emily Thompson discusses modernist acoustics and mastery of the audition of sound. The character of sound and its acoustic properties is also addressed by the composer Alvin Lucier, who has been widely influential on artists working with sound phenomena. Lucier argues for an attention to the flow of sound through space, rather than to factors such as tone, harmony and melody that are traditionally privileged in Western art music.

A continuing concern to curators of sound in contemporary art is the space of the gallery itself. Brian O'Doherty, in his influential essay 'Inside the White Cube', wrote that the history of modernism was framed by the exhibition space: 'An image comes to mind of a white, ideal space that, more than any single picture, may be the archetypal image of twentieth-century art.'[17] The stark white cube is cleared and cleaned of anything that might detract from the contemplation of visual art, yet this space is not at all conducive to the contemplation of sound within art. The hard, flat surfaces cause sound to reverberate throughout the space, detracting from the experience of the work itself. Steven Connor alerts us to the issue of the gallery's bent toward visual perception and the logic of the direct line of sight. Sound does not adhere to the line of sight: it moves around walls and bounces through openings and between spaces, invading adjoining rooms. It does not follow safe and contained visuality, causing trouble in the museum, where quiet contemplation of art is expected. We cannot help, for example, but be aware of loud music emanating from the Douglas Gordon's installation *Feature Film* (1998) while trying to listen to the dialogue within Pierre Huyghe's *The Third Memory* (1999).[18]

If the white cube is the archetype of twentieth-century art display, then what would be the archetype of twenty-first century exhibition space? It would need to be able to handle new media – large projections, lighting environments and, of course, sound – and still be available for the display of more traditional artefacts. Internationally the black cube is becoming more common – a space that is darkened for projection and acoustically damped for sound. Perhaps we will see the expansion of purpose-built gallery environments dedicated to the needs and specificities of contemporary art, instead of the 'one-size fits-all' white gallery.

Of course there is not a straightforward answer to the exhibition of sound in the gallery. Helmut Draxler asserts that the conventions of the other arts cannot simply be transferred to the gallery: we do not recreate a cinema environment to display video art and thus we should not need to recreate a concert hall in the gallery to display sound works.[19] This argument is a little overstated as it connects video too closely to cinema and sound too closely to music. That said, the gallery can learn from other arts practices, especially cinema, as the contemporary cinematic space has been created to house often loud and dramatic sound. The cinema is dampened with carpet and soft chairs and rendered so as to hold sound within its confines. Set against this practice, contemporary exhibition spaces hold onto their open, white and well lit space, not ready for such dramatic changes to their conception of the perfect space for exhibition.

The fourth section, *Bandwaves*, contains a discussion of the relationship of music to art. Sound does not belong to any one arts discipline, it turns up in music, theatre, literature, dance, film, architecture and art. However, historically music has made the strongest claim to sound's ownership, not least in John Cage's notion that all sound can be, or is, music. Therefore any discussion of sound within contemporary art cannot exclude music, and many of the texts within this anthology directly address music practices. Here artists' relationships to music are surveyed, making clear the obvious: that many artists have a close connection with music; they listen to it in their studios, they make it, they engage with it through popular culture, they connect with the rock ethos, and they are fans. Music and contemporary art are directly and intimately linked in this way. Some artists are directly connected to music through their participation in 'art school bands' (for example, Kim Gordon, Dan Graham, Mike Kelley, Tony Oursler, Martin Creed), while for Vito Acconci, it is a 'passive spectator sport'.[20] Christian Marclay is a special case. His works in music and art are inextricably connected, with each side feeding the other. Here two of his recorded conversations, one with the artist and filmmaker Michael Snow, and the other with Sonic Youth musician and vocalist Kim Gordon, shed light on his connection to both worlds.

The final section, *Artists and Sound*, surveys the diversity of specific artistic practices that have emerged over the last century in response to the developments explored in the previous sections, and demonstrates why sound in art can never be reduced to a movement or genre. An objective of this volume is to heighten the art community's awareness of sound in art, with the hope that both art institutions and audiences – as we become increasingly attuned to the new aesthetics of listening – can fully engage with and participate in the sonic turn that is transforming the practice of numerous artists around the world.

1 Janet Cardiff and George Bures Miller, *Opera for a Small Room* (2005), included in the exhibition 'The Dwelling', Australian Centre for Contemporary Art, Melbourne (2009).

2 Phil Dadson, *33 rpm* (rock records) (2006), included in the exhibition 'Mistral', at Artspace, Sydney (2006).

3 Sound can be recorded, but the recording of audio elements of art does not function in the same way as photographs have come to be employed, as stand-ins for the art objects themselves.

4 For a further discussion of this work see Kirsi Peltomäki, *Situation Aesthetics: The Work of Michael Asher* (Cambridge, Massachusetts: The MIT Press, 2010) 22–6.

5 Jim Drobnick, 'Listening Awry', in *Aural Cultures: Sound Art* (Banff: YYZ Books, 2004) 10, note 7. The term 'sonic turn' is the audio version of W.J.T Mitchell's 'pictorial turn'. See W.J.T Mitchell, 'The Pictorial Turn', *Artforum* (March 1992) 89–94.

6 Michael Bull and Les Back, 'Introduction: Into Sound', in *The Auditory Culture Reader* (Oxford: Berg, 2003) 1.

7 Other texts that have sought to fill the gap in academic discussion of sound include: Veit Erlmann, *Hearing Cultures: Essays on Sound, Listening and Modernity* (Oxford: Berg, 2004); Christoph Cox and Daniel Warner, 'Introduction: Music and the New Audio Culture', in *Audio Culture: Readings in Modern Music* (New York and London: Continuum, 2004).

8 cf. Brandon LaBelle's *Background Noise* and Alan Licht's *Sound Art* (see bibliography).

9 Max Neuhaus, 'Sound Art?' (2000), reprinted in this volume, 72–3.

10 William Furlong, 'Sound in Recent Art', reprinted in this volume, 67–70.

11 Ina Bloom, 'Signal to Noise', *Artforum* (February 2010) 171–5.

12 Michel Serres, *Genesis* (Michigan: University of Michigan Press, 1995) 7.

13 Steven Shaviro, 'Bilinda Butcher' (1997), extract reprinted in this volume, 120–23.

14 Paul Virilio, 'Silence on Trial' (2003); extract reprinted in this volume, 103–4.

15 R. Murray Schafer, *The Soundscape: Our Sonic Environment and the Tuning of the World* (1977) 7; extract reprinted in this volume, 110–12.

16 Ibid., 3.

17 Brian O'Doherty, 'Inside the White Cube' (1976), in *Inside the White Cube: The Ideology of the Gallery Space* (Berkeley: University of California Press, 1999) 14.

18 This juxtaposition of works occurred at the exhibition 'Centre Pompidou: Video Art 1965–2005', Museum of Contemporary Art, Sydney (2006-7).

19 Helmut Draxler, 'How can we Perceive Sound as Art?', in *See This Sound* (Linz: Kunsthalle/Cologne: Verlag der Buchhandlung Walther König, 2009) 26; extract reprinted in this volume, 139–43.

20 Vito Acconci, 'Words before Music' (manuscript, 2000); included in this volume, 155–6.

WE USUALLY THINK OF THE CAMERA AS AN EYE AND THE MICROPHONE AS AN EAR, BUT ALL THE SENSES EXIST SIMULTANEOUSLY IN OUR BODIES

Bill Viola, Statement, 1985

CONCEPTS OF THE SONIC

Luigi Russolo
The Art of Noises//1913

[...] In antiquity, life was nothing but silence. Noise was really not born before the nineteenth century, with the advent of machinery. Today noise reigns supreme over human sensibility. For several centuries, life went on silently or mutedly. The loudest noises were neither intense nor prolonged nor varied. In fact, nature is normally silent, except for storms, hurricanes, avalanches, cascades and some exceptional telluric movements. This is why man was thoroughly amazed by the first *sounds* he obtained out of a hole in reeds or a stretched string. [...]

First of all, musical art looked for the soft and limpid purity of sound. Then it amalgamated different sounds, intent upon caressing the ear with suave harmonies. Nowadays musical art aims at the shrillest, strangest and most dissonant amalgams of sound. Thus we are approaching *noise-sound*.

THIS REVOLUTION OF MUSIC IS PARALLELED BY THE INCREASING PROLIFERATION OF MACHINERY sharing in human labour. In the pounding atmosphere of great cities as well as in the formerly silent countryside, machines create today such a large number of varied noises that pure sound, with its littleness and its monotony, now fails to arouse any emotion.

To excite our sensibility, music has developed into a search for a more complex polyphony and a greater variety of instrumental tones and colouring. It has tried to obtain the most complex succession of dissonant chords, thus preparing the ground for MUSICAL NOISE. [...]

Luigi Russolo, extracts from *L'Arte dei rumori* (1913); trans. Robert Filliou, *The Art of Noise*. A Great Bear Pamphlet (New York: Something Else Press, 1967) 4; 5–6. [Later translations have established the literal plural *Noises* in the title.]

John Cage
The Future of Music: Credo//1937

I BELIEVE THAT THE USE OF NOISE

Wherever we are, what we hear is mostly noise. When we ignore it, it disturbs us. When we listen to it, we find it fascinating. The sound of a truck at fifty miles per hour. Static between the stations. Rain. We want to capture and control these sounds, to use them not as sound effects but as musical instruments. Every film studio has a library of 'sound effects' recorded on film. With a film phonograph it is now possible to control the amplitude and frequency of any one of these sounds and to give to it rhythms within or beyond the reach of the imagination. Given four film phonographs, we can compose and perform a quartet for explosive motor, wind, heartbeat and landslide.

TO MAKE MUSIC

If this word 'music' is sacred and reserved for eighteenth and nineteenth-century instruments, we can substitute a more meaningful term: organization of sound.

WILL CONTINUE AND INCREASE UNTIL WE REACH A MUSIC PRODUCED THROUGH THE AID OF ELECTRICAL INSTRUMENTS

Most inventors of electrical musical instruments have attempted to imitate eighteenth and nineteenth-century instruments, just as early automobile designers copied the carriage. The Novachord and the Solovox are examples of this desire to imitate the past rather than construct the future. When Léon Theremin provided an instrument with genuinely new possibilities, Thereministes did their utmost to make the instrument sound like some old instrument giving it a sickeningly sweet vibrato, and performing upon it, with difficulty, masterpieces from the past. Although the instrument is capable of a wide variety of sound qualities, obtained by the turning of a dial, Thereministes act as censors, giving the public those sounds they think the public will like. We are shielded from new sound experiences.

The special function of electrical instruments will be to provide complete control of the overtone structure of tones (as opposed to noises) and to make these tones available in any frequency, amplitude and duration.

WHICH WILL MAKE AVALABLE FOR MUSICAL PURPOSES ANY AND ALL SOUNDS THAT CAN BE HEARD, PHOTOELECTRIC, FILM AND MECHANICAL MEDIUMS FOR THE SYNTHETIC PRODUCTION OF MUSIC

It is now possible for composers to make music directly, without the assistance of intermediary performers. Any design repeated often enough on a sound track is audible. Two hundred and eighty circles per second on a soundtrack will produce one sound, whereas a portrait of Beethoven repeated fifty times per second on a track will have not only a different pitch but a different sound quality.

WILL BE EXPLORED. WHEREAS, IN THE PAST, THE POINT OF DISAGREEMENT HAS BEEN BETWEEN DISSONANCE AND CONSONANCE, IT WILL BE, IN THE IMMEDIATE FUTURE, BETWEEN NOISE AND SO-CALLED MUSICAL SOUNDS.

THE PRESENT METHODS OF WRITING MUSIC, PRINCIPALLY THOSE WHICH EMPLOY HARMONY AND ITS REFERENCE TO PARTICULAR STEPS IN THE FIELD OF SOUND, WILL BE INADEQUATE FOR THE COMPOSER, WHO WILL BE FACED WITH THE ENTIRE FIELD OF SOUND.

The composer (organizer of sound) will be faced not only the with the entire field of sound but also with the entire field of time. The 'frame' or fraction of a second, following established film technique, will probably be the basic unit in the measurement of time. No rhythm will be beyond the composer's reach.

NEW METHODS WILL BE DISCOVERED, BEARING A DEFINITE RELATION TO SCHOENBERG'S TWELVE-TONE SYSTEM

Schoenberg's method assigns to each material, in a group of equal materials, its function with respect to the group. (Harmony assigned to each material, in a group of unequal materials, its function with respect to the fundamental or most important material in the group.) Schoenberg's method is analogous to a society in which the emphasis is on the group and the integration of the individual in the group.

AND PRESENT METHODS OF WRITING
PERCUSSION MUSIC

Percussion music is a contemporary transition from keyboard-influenced music to the all-sound music of the future. Any sound is acceptable to the composer of percussion music; he explores the academically forbidden 'non-musical' field of sound in so far as is manually possible.

Methods of writing percussion music have as their goal the rhythmic structure of a composition. As soon as these methods are crystallized into one or several widely accepted methods, the means will exist for group improvisations of unwritten but culturally important music. This has already taken place in Oriental cultures and in hot jazz.

AND ANY OTHER METHODS WHICH ARE FREE FROM THE CONCEPT OF A FUNDAMENTAL TONE.

THE PRINCIPLE OF FORM WILL BE OUR ONLY CONSTANT CONNECTION WITH THE PAST. ALTHOUGH THE GREAT FORM OF THE FUTURE WILL NOT BE AS IT WAS IN THE PAST, AT ONE TIME THE FUGUE AND AT ANOTHER THE SONATA, IT WILL BE RELATED TO THESE AS THEY ARE TO EACH OTHER:

Before this happens, centres of experimental music must be established. In these centres, the new materials, oscillators, turntables, generators, means for amplifying small sounds, film phonographs, etc., available for use. Composers at work using twentieth-century means for making music. Performances of results. Organization of sound for extra-musical purposes (theatre, dance, radio, film).

THROUGH THE PRINCIPLE OF ORGANIZATION OR MAN'S COMMON ABILITY TO THINK.

John Cage, 'The Future of Music: Credo' (talk delivered in 1937, first printed in 1958); reprinted in *Silence: Lectures and Writings* (Hanover, New Hampshire: Wesleyan University Press, 1961) 3–6.

Allan Kaprow
Right Living//1987

It has always interested me to see how far an earlier artist's innovations can be extended. In a crucial sense, the extensibility of a new move, its capacity to keep on ramifying, is the measure of its value. This distinguishes the truly generative idea from the mere fad.

For example, Mondrian saw in Cubism the precursor to a nonfigurative, transcendent formal language. This lofty sense of abstraction continued to resonate through Newman and Reinhardt and well into Minimalism.

In contrast, Duchamp picked up from that same Cubism's collages and constructions the ironic possibility that the artist's selective appropriation of commonplace materials and mass-produced images might replace the artist's traditional skill and individual creativity. The result was the Readymade, framed (in every sense of the word) as art by the gallery context. The idea of readymade art continued through Surrealism to assemblage, Happenings and events, Pop art, body art, Land art, right up to the present. Like pure abstraction, it has been a fundamental 'generator' in modern art.

But radical moves leave some things behind. Mondrian had no taste for the multiviewed illusions and puns of the everyday world in Cubism. Duchamp, for his part, had little interest in its rich formal play. Innovative jumps are often neither fair nor balanced.

Given the wide effect John Cage has had on a number of arts besides music, how has he been generative? The answers each of us gives may not be fair or balanced or particularly pleasing to Cage. But they can begin to map out the broad outlines of resonance.

From my vantage point, Cage made two principle experimental moves in music making: the sustained practice of chance operations to arrange and select the sounds and durations of a piece, and the welcoming of noise into a composition as equivalent to conventional musical sound.

Although it is clear enough that intense interest in both chance and non-art appeared across the whole range of the arts earlier in the century, Cage's focus upon them was more thoughtful and systematic in the 1940s and 1950s. And perhaps the moment in history was more receptive. Artists of all kinds were attracted by his example, and numbers of them became students in his classes (I was one).

It was apparent to everyone immediately that these two moves in music could be systematically carried over to any of the other arts. But the more

interesting prospect, as I saw it, was to follow the lead of these ideas well beyond the boundaries of the art genres themselves.

Consider: if chance operations and the appropriation of noise could summon to one piece of music fragments of Beethoven and scratchy noises equally, then such chance operations could also bring into combination or isolation any of the art genres, or none of them at all! But this could be problematic. A chance plan that might call for doing a piece in a concert hall, a gallery and a kitchen simultaneously simply couldn't be realized. Some external decision would have to be made in the interest of practicality. In other words, the chance method was wonderfully productive of fresh auditory experience, but Cage applied it at his own discretion and almost always within the social, physical and temporal limits of the concert situation.

Since I had to make practical decisions regarding what domains would be used for an event, the chanciness and uncontrollability of the everyday environment appeared more attractive than the relative predictability of the galleries, stages and formats of the traditional modern arts. Once in the streets or on the telephone, chance operations could of course be easily used, but after some time the sheer magnitude of unforeseeable details and outcomes for any projected event in the real world was so much greater than what a chance score might provide that devising a method to suspend taste or choice became superfluous. A simple plan was enough: 'Taking a walk for three hours. Turning left every hundred steps' … Suppose you turned left into a wall or oncoming traffic? A decision would be necessary on the spot.

Thus 'chance' was a given of the environment once you left the art context, and 'noise' as a metaphor of everything excluded from art was extensible to all events and places on earth and in the head. In short, as Cage brought the chancy and noisy world into the concert hall (following Duchamp, who did the same in the art gallery), a next step was simply to move right out into that uncertain world and forget the framing devices of concert hall, gallery, stage, and so forth. This was the theoretical foundation of the Happening, and for some years bodyworks, earthworks, information pieces and conceptualism variously extended that idea.

But in the years since the 1950s it has seemed to me that Cage's example was far more significant, more bountiful, than its impact on the arts might suggest. Emerging in his works, writings and teaching at that time was a worldview very different from the one we were used to. For Western artists the prevalent myth of the tragic sufferer held sway over everyone's imagination. (Miró's work was less than top-drawer simply because it was full of humour!) The real world was terrible, so the artist's calling was to create in fantasy a better world or, if not a better, at least a more critical one. To accomplish this

task often meant going through hell, and the lives of the best artists one knew then were hardly models for the young.

In Cage's cosmology (informed by Asiatic philosophy) the real world was perfect, if we could only hear it, see it, understand it. If we couldn't, that was because our senses were closed and our minds were filled with preconceptions. Thus we made the world into our misery.

But if the world was perfect just as it is, neither terrible nor good, then it wasn't necessary to demand that it should improve (one begins to know what to do with difficulties without making such demands). And if our art was no longer required to provide a substitute world, it was okay to give up trying to perfect and control it (hence the chance operations and noises). What happened for some of us was that our newly released art began to perform itself as if following its own natural bent. It may have occurred to us that we might live our lives in the same way.

Most Westerners would find this hard to accept, while for those who accept its wisdom it is much easier said than done. But here, I believe, is the most valuable part of John Cage's innovations in music: experimental music, or any other experimental art of our time, can be an introduction to right living; and after that introduction art can be bypassed for the main course.

Allan Kaprow, 'Right Living' (1987), in Kaprow, *Essays on the Blurring of Art and Life*, ed. Jeff Kelley (Berkeley and Los Angeles: University of California Press, 1993) 223–5.

Douglas Kahn
The Latest: Fluxus and Music//1993

The future therefore belongs to philophonics.
– Erik Satie[1]

Fluxus was the most musical of the avant-garde (or experimental or neo-avant-garde) art movements of this century. Surrealism had gone as far as working up an antipathy toward Western art music; other avant-gardes incorporated music but rarely created it; and, with the exception of Italian Futurism, achievements in music certainly could not stand next to those of the visual arts, literature, performance and cultural thinking in general. Fluxus became the beneficiary of this 'tardiness of music with respect to the arts' John Cage once noted,[2] tardiness

stemming from the relatively minor role music played in the important avant-gardes that preceded it.

Fluxus was the first of the avant-garde movements to have counted among its members so many involved in musical composition and performance, and key participants such as La Monte Young, Nam June Paik, and Benjamin Patterson were, in fact, highly trained. Many of the acknowledged influences on the formation of Fluxus were events conducted under the auspices of music, ranging from Cage's legendary classes at the New School for Social Research in the late 1950s to the numerous musical performances associated with the string of events at the loft of Yoko Ono (married at the time to the composer Toshi Ichiyanagi), at George Maciunas' AG Gallery, and elsewhere. The inaugural Wiesbaden festival was presented under the guise of 'new music', and many of the Fluxus events that followed were billed as 'concerts'. Even the eventual major split in the Fluxus ranks was understood as having been occasioned by a music-world controversy – the protest over the 1964 New York performance of Karlheinz Stockhausen's music-theatre event *Originale*.

That it was more musical than its predecessors, however, is not to say that Fluxus itself should be considered predominantly musical. Much of the Fluxus corpus defied categorization along the lines of established artistic disciplines – music, performance and the written word often coalescing into hybrid forms, exchanging places, or fitting themselves into the cracks between existing media. But because its ostensibly 'abstract' nature provided good ground for a malleability of meaning, because the highly codified nature of its practice served as the perfect foil for an anti-practice, and because it was historically unexploited, music played a central role in the overall conception and evolution of Fluxus; and ideas about music, especially those that concerned the relationship of art to nature, society, mass media and the everyday, played a significant part in the formulation of theoretical positions in important Fluxus documents.

The Limits of Avant-Garde Music
The strategy that had propelled music into an avant-garde practice in the first place was the progressive incorporation of extramusical sounds into the circumscribed materials of music. Based on a response to existing conceptions of what was and what was not a musical sound, it asked the questions: Which extramusical sounds should be imported into the domain of music? and How should such an importation be accomplished? Within this inquiry, there was a presumption that the central component of music was its sonicity – that composition was to start with a notion of sound. This may seem a fairly mundane proposition, but in the context of Western art music at the time and to a surprisingly great extent today, it was very radical, set as it was against the entrenched

conservatism of musical thought and practice. Western art music had treated musical sound in an unproblematic way: the range of instruments and the types of sounds the instruments were supposed to make did not vary fundamentally from one composer to the next or from one generation to the next; the primary task at hand was how to organize this finite set of sounds. Why these sounds should be privileged to the exclusion of all other possible sounds was of little or no concern.

The Italian Futurist Luigi Russolo inaugurated avant-gardism in music when he questioned the nature of musical materiality. In his famous 1913 manifesto 'Art of Noises' (and 1916 book of the same title) he proposed that, because musical sound was self-referential and thereby had no link with the world and its sounds, music had stood still and become self-occupied, while everything that happened in life all around it had energetically advanced into the modern world. His stated goal was to open up music to all sounds, the 'subtle and delicate noises' of nature and rural settings, the brutal noises of the modern factory and city. But he also stated, both in his writings and in the way he designed his class of *intonarumori*, the noise-intoning instruments he built to play his music, that he wished to avoid imitation of these worldly sounds. It is hard to have it both ways, to invoke the sounds of the world – say, by phonographically reproducing them, by bringing the actual sound-making device or event into the concert hall, or by simulating them through other means – without to some degree being imitative. Thus Russolo's embrace of 'all sounds' became conditional upon the tenacious requisites of musical signification. If he had chosen to create a compositional and performance practice based upon the tension between sound and musical sound, he might have created a (relatively) autonomous art of noises. Instead, his 'great renovation of music'[3] became one that would not confound the representational bounds of what stood as musical sound. For the next half-century it represented the strategy propelling or repelling composers with avant-garde motives. They, too, were allured by extramusical sounds but refused to become too associative, too referential. Edgar Varèse's 'liberation of sound' actually domesticated the implications of Russolo's radicalism enough to be ushered into mainstream orchestral practice, while Pierre Schaeffer's *musique concrète*, with its notion of *acousmatiques*, served only to repeat the general presuppositions of Russolo's project.

It was Cage who took Russolo's impulse to its logical conclusion when he proposed that any sound can be used in music; there need not be even any intention to make music for there to be music, only the willingness to attune to aural phenomena. In other words, sounds no longer required any authorial or intentional organization, nor anyone to organize them – just someone to listen. This new definition of music served to extend the range of sounds that could qualify as musical raw material as far as possible into the audible, or potentially audible, world. Categories like dissonance and noise became meaningless, and

the line between sound and musical sound disappeared; every sound had become musical sound.

In practice, however, Cage (like Russolo) could go only so far if he was to remain within the bounds of music. Despite the expansiveness of his theoretical programme, he too had to keep sounds from referring to phenomena too far afield from the restricted realm of musical sound.[4] When he used recorded or radiophonic sound, for instance, he manipulated it either in order to decrease or destroy its recognizability (as in *Williams Mix*, 1952) or to decrease or destroy any context that might make a sound, or set of sounds, sensible in other than a received musical way (as in *Variations IV*, 1964). His famous *4'33"* (1952) silenced the expected music altogether and thus tacitly musicalized the surrounding environmental sounds – including the sounds of an increasingly restless audience.

To musicalize sound is just fine from a musical perspective, but from the standpoint of an artistic practice of sound, in which all the material attributes of a sound, including the materiality of its signification, are taken into account, musicalization is a reductive operation, a limited response to the potential of the material. For Cage himself, the reductions and impositions that came with the musicalization of worldly sound were at odds with the core precepts of his own aesthetic philosophy, especially as expressed in his famous axiom 'Let sounds be themselves.' To ask, as Cage did, for sounds bereft of their associations was to dismiss the vernacular, deny experience, and repress memory – for there are no sounds at the material level heard by humans that are heard outside culture and society. There are no sounds heard through a pure perception – only an apperception 'contaminated' by sociality. Cage's ideas, in fact, can be understood as protecting Western art music against an aurality that, during this century, had become increasingly social.

Sounds have always carried a multiplicity of extant and potential, real and imaginary associations and codifications, changing all the time with different contexts and through different modes of transformation. But with the advent of the acoustic and electronic mass media, the number of sounds and their associations actually accumulated, proliferated and became accelerated; what once may have been assuredly 'natural' sound, for instance, might have become both common and oblique, immediately familiar but ultimately understandable only at the end of a fairly fragile, long string of associations.[5] This was certainly the state of aurality by the 1950s, for there had been more than two decades of sound film and radio broadcast, and television was on the rise. This was also the time during which Cage's ideas on sound were first registered in any pronounced way and the time that served as an incubator for the Fluxus artists.

It was Cage, in fact, who exerted the greatest initial influence on that loose, continually reconfiguring group of individuals associated with Fluxus. Indebtedness

to Cage was widely and freely proclaimed – Nam June Paik confessing, for instance, that 'my past 14 years is nothing but an extension of one memorable evening at Darmstadt '58'.[6] La Monte Young also had become well aware of Cage while he was studying with Stockhausen in Darmstadt (his important 'Lecture 1960' derives from Cage's own 'Indeterminacy' lecture, published in 1959 in Stockhausen's journal *Die Riehe*) and the stark conceptual reductions of his early events resonate with the theatrics of Cage's *4'33'*. In the historical genealogies that George Maciunas (and others) drew up for Fluxus Cage is positioned as the bridge between the avant-garde of the earlier part of the century and artists of the postwar period. Maciunas. in fact, devised one genealogical chart for Fluxus structured specifically by the influences on Cage himself:

> We have the idea of indeterminacy and simultaneity and concretism and noise coming from Futurism, theatre, like Futurist music of Russolo. Then we have the idea of the Ready-made and concept art coming from Marcel Duchamp. Okay, we have the idea of collage and concretism coming from Dadaists … They all end up with John Cage with his prepared piano, which is really a collage of sounds.[7]

After funneling all these historical moments into the person of Cage. Maciunas attributes successive developments to his singular influence: 'Wherever John Cage went he left a little John Cage group, which some admit, some not admit his influence. But the fact is there, that those groups formed after his visits.'[8] While in New York, Cage faithfully attended many performances of lesser-known artists, who often looked upon him – with his pedigrees from North Carolina's Black Mountain College and elsewhere – as a father figure. His classes at the New School for Social Research attracted the likes of George Brecht, Al Hansen, Dick Higgins, Allan Kaprow and Jackson Mac Low, all of whom went on to participate centrally within Fluxus and/or associated activities.[9] In one of the classes led by the electronic composer Richard Maxfield, who had taken over for Cage, George Maciunas met La Monte Young and was thus introduced to the new music, performance and intermedia scene he later helped to transport to Wiesbaden and beyond. 'That the introduction of Fluxus at Wiesbaden was presented as a 'Festival of New Music',' the writer Bruce Altshuler has noted. 'points to a critical influence from this [Cagean] direction. And the equipment list for the subsequent 1962 concerts in Copenhagen and Paris – with its radios, candles, broken glass and junk metal, wooden blocks and vacuum cleaner – displays as much as anything else what came out of the [Cage classes at the New School].'[10]

To have freshly confronted the Cagean aesthetic in the late 1950s would have been both exhilarating and frustrating: so much was allowed that nothing, it might seem, was left to be set free. 'Every young artist tried to define himself/

herself as going past Cage but this was very difficult because the Cagean revolution was very thorough', recalls the composer James Tenney, citing an influence so total as to have 'created a situation where we don't have to kill the father anymore'.[11] Yet it was no accident that Nam June Paik, in an act of symbolic emasculation, chose to cut off Cage's tie as part of his performance *Étude for Pianoforte* (1959–60), for throughout Fluxus literature and activities there are repeated attempts to supersede or escape the Cagean aesthetic, to get to the point somehow of being 'post-Cage'.

Teased by Cagean avant-gardism, and simultaneously provoked by the difficulty of advancing a musical practice based upon its expansive rhetoric of all sound, Fluxus artists chose to exercise a number of strategic options. These break down into two general, often related categories, the first concerned explicitly with the sonic materials of music, and the second with the relatively unexplored territory of musical practice and performance. Both were grounded in an exploration of the boundaries of music – the inside-outside dilemma – that had challenged the musical avant-garde from Russolo through Cage.

Fluxus and the Properties of Sound
The first strategy that informed the Fluxus aesthetic was a response to the difficulty of conjuring up and recuperating into music the figure of a plenitude of sound that exists on the outside of music. Rather than focusing on the expanse of all sounds, one group of artists who were influential in the early formation of Fluxus concerned themselves with the more circumscribed investigation of sound in its singular, existential and elemental state, concentrating on questions of border cases of sound production and audition, of the integrity of the various integrities of a sound per se. Thus, the historically earlier question of What sounds? receded in Fluxus and was replaced with questions such as Whether sounds? or Where are sounds in time and space, in relation to the objects and actions that produce them? or What constitutes the singularity of 'a sound'?

Cage had already thrown the last dirt on dissonance and noise; in the Fluxus venture the question of noise was forgotten once and for all, and musical sound and sound moved very close to each other. However, Fluxus questions about sound were framed almost entirely in terms of its acoustic, physiological and kinaesthetic properties. Focusing on these states and activities did little more to challenge the status of musical materials as entities divorced from their worldly associations than had the practice of Cage and his predecessors.[12] So although the exploration of the 'borderline', as it was called in the Fluxus vernacular, did not introduce fundamentally new artistic aural practices, it did extend existing processes and configurations and produced a number of compelling pieces, with La Monte Young's foray into sustained sounds, in

particular, pointing to a rich and unexplored artistic area of sonic spatiality in relation to physical acoustics.

One way Fluxus explored the margins of musical sound was to separate these sounds from their normal connections. In the performance of music, the making of a sound is always connected with a task. For example, sounds will always occur if the task is to play a violin or smash it. But the converse – that every task produces a musical sound – is not always true. There are many tasks executed in the midst of an orchestral performance from which no sounds are supposed to emanate. Fluxus took the next logical move: whereas these small or silent sounds in an orchestra are repressed in favour of the production of the musical work, in Fluxus sound-producing tasks do not need to produce musical sound each and every time, or even produce audible sound, in order to produce works. Some sounds, for instance, are produced only 'incidentally', as in George Brecht's *Incidental Music* (1961):

INCIDENTAL MUSIC
Five Piano Pieces,
any number playable successively or simultaneously, in any order and combination, with one another and with other pieces.
1.
The piano seat is tilted on its base and brought to rest against a part of the piano.
2.
Wooden blocks.
A single block is placed inside the piano. A block is placed upon this block, then a third upon the second, and so forth, singly, until at least one block falls from the column.
3.
Photographing the piano situation.
4.
Three dried peas or beans are dropped, one after another, onto the keyboard. Each such seed remaining on the keyboard is attached to the key or keys nearest it with a single piece of pressure-sensitive tape.
5.
The piano seat is suitable [sic] arranged, and the performer seats himself.[13]

Brecht himself described the incidentalness:

What you're trying to do is to attach the beans to the keys with nothing else in mind – or that's the way I perform it. So that any sound is incidental. It's neither intentional nor unintentional. It has absolutely nothing to do with the thing whether you play

an A or C, or a C and a C sharp while you're attaching the beans. The important thing is that you are attaching the beans to the keys with the tape'.[14]

Mieko (Chieko) Shiomi referred to incidentalness a few years later in her *Boundary Music* (1963):

> Make the faintest possible sound to a boundary condition whether the sound is given birth to as a sound or not. At the performance, instruments, human bodies, electronic apparatus or anything else may be used.[15]

La Monte Young's *Piano Piece for David Tudor #2* (1960) made use of an incidental sound connected with the normal act of playing a piano and sequestered it, through the skill of the performer, so that the small sound produced by this act would become perceptible only to the performer, and not the audience. The point of the piece, in fact, was to eliminate even this remaining degree of incidentalness.

> Open the keyboard cover without making, from the operation, any sound that is audible to you. Try as many times as you like. The piece is over either when you succeed or when you decide to stop trying. It is not necessary to explain to the audience. Simply do what you do and, when the piece is over, indicate it in a customary way.[16]

Young's *Composition 1960 #5* (1960), known as 'the butterfly piece', split the tasks of sound production and sound perception between species, further isolating the question of audibility by eliminating the human performer altogether. In this case, the human listener must consider that sounds may exist even though humans may not be able to hear them unaided:

> Turn a butterfly (or any number of butterflies) loose in the performance area. When the composition is over, be sure to allow the butterfly to fly away outside. The composition may be any length but if an unlimited amount of time is available, the doors and windows may be opened before the butterfly is turned loose and the composition may be considered finished when the butterfly flies away.[17]

Audibility, for those who dare wonder, is usually the absolute minimum requirement for the existence of music. The music semiotician Jean-Jacques Nattiez has written, for example, that 'we can ... allow (without too much soul-searching) that sound is a minimal condition of the musical fact.'[18] In this respect Young's *Composition 1960 #2*, written concurrently with the butterfly piece, was

easier to think of as music since the work, 'which consists of simply building a [small] fire in front of the audience'[19] at least produced sounds that would go in and out of audibility. (As Satie wrote, 'Here, we are in pyrophonics.')[20] Yet, according to Young,

> I felt certain the butterfly made sounds, not only with the motion of its wings but also with the functioning of its body and ... unless one was going to dictate how loud or soft the sounds had to be before they could be allowed into the realms of music ... the butterfly piece was music as much as the fire piece.[21]

Young's line of reasoning marked a departure from Cage's ideas about what music requires in order to exist. For Cage – firm in the belief that there is no such thing as silence and following a strategy of all sounds – to bring certain small sounds into audibility through amplification was to bring them into music. He was even willing to entertain the idea that sounds produced by molecular vibrations might one day be amplified and musicalized, echoing the conjecture of a 1933 Italian Futurist radio manifesto:

> The reception amplification and transfiguration of vibrations emitted by matter. Just as today we listen to the song of the forest and the sea so tomorrow shall we be seduced by the vibrations of a diamond or a flower.[22]

Cage's interest in amplified small sounds went back to 1937, when in his essay 'The Future of Music: Credo' he called for 'means for amplifying small sounds', and can be found later scattered in various of his scores and writings.[23] It is no coincidence that he cited amplified small sounds in referring to his *0'00'* (1963), for this work can be considered Cage's response to the Fluxus developments of that time, especially to its emphasis on performance and everyday life.[24]

> 0'00' ... is nothing but the continuation of one's daily work, whatever it is, providing it's not selfish, but is the fulfilment of an obligation to other people, done with contact microphones, without any notion of concert or theatre or the public, but simply continuing one's daily work, now coming out through loudspeakers.[25]

Cage claimed that 'the piece tries to say ... that everything we do is music, or can become music through the use of microphones ... By means of electronics, it has been made apparent that everything is musical.'[26]

But while Cage was saying that the amplification of a small sound to make it audible creates music. Young was beginning to say, with respect to *Composition*

1960 #5, that any sound could be music as long as the existence of sound was conceivable; in other words, the arbitrary limitations of the human ear or technology (imagine the difficulty of placing a microphone on the butterfly) should not define the bounds of music. Young was nevertheless still quite Cagean in the way he argued for musical sound existing apart from human audition. Like Cage, he said he did not want to impose sense upon sounds because that would be anthropomorphizing them – 'the usual attitude of human beings that everything in the world should exist for them'.[27] But he was willing to think of the butterfly sounds as music, as though music were somehow not exclusively a human activity but practised by other species as well.

Small sounds were on the mind of Milan Knizak when he composed a Flux-radio piece in 1963 that, barring wind, would be very quiet: 'Snowstorm is broadcast.'[28] The previous year Alison Knowles, in her *Nivea Cream Piece for Oscar* [Emmett] *Williams* (1962), had already used the microphone to amplify the small sound of a daily task:

> First performer comes on stage with a bottle of Nivea Cream or (if none is available) with a bottle of hand cream labelled 'Nivea Cream'. He pours the cream onto his hands and massages them in front of the microphone. Other performers enter, one by one, and do the same thing. Then they join together in front of the microphone to make a mass of massaging hands. They leave in the reverse of the order in which they entered, on a signal from the first performer.[29]

The fascination with small sounds and sounds going in and out of audibility has a definite fetishistic quality about it. Any attempt to possess a sound, to become engrossed in it, however, will be frustrated by the very transience and ephemerality of sound itself. The problem in such an enterprise, then, becomes how to hold onto a sound, keep a sound around long enough to hear it truly: to make the minute, fleeting and banal into something captivating or even profound. Both Young and Takehisa Kosugi attempted to address this problem of 'holding on' to a sound by experimenting with techniques of repetition and sustainment. Breaking through traditional notions of the integrity of a single sound, their work in this area demonstrated that any single sound contained exceedingly complex processes of production, of internal configuration: that a single sound's interaction with corporeal and environmental space transformed it from one moment to the next; and, therefore, that a simple musical structure of repetition or sustainment was not simple at all.

Perhaps the most outstanding repetition piece was Young's *X for Henry Flynt* (1960), in which a loud sound is repeated steadily every one to two seconds, a great number of times, with instrumentation and the number of repetitions left

unspecified. While repetitive works such as Satie's *Vexations* (1893) and *Vieux séquins et vieilles cuirasses* (1913) have often been cited as precursors of *X for Henry Flynt*, there were, in fact, significant differences in the enterprises. Satie's works repeated units of organized musical sounds (not individual sounds, as did Young's), and thus any attempt to perceive the interiority of a sound first had to contend with how that sound might relate to others. (This condition also pertains to the subsequent 'minimalist' work of such composers as Philip Glass, Steve Reich and Terry Riley.) Young's piece, moreover, made evident the fact that, despite attempts at repeating a sound, true repetition is actually impossible: factors of performing the task, of the physics of the instrument, the acoustics of the setting, the vicissitudes of listening, and the resonant complexity of the chosen sound itself forbid it. And, although repetition may have been understood by some individuals with a certain religiosity to enable access to a sonic 'essence', a piece like Young's confirmed that no such thing as essence or identity could exist: even the mechanical act of skipping a record will fail to yield such an inviolable musical entity. Thus, the repetition of a single sound, as it invokes the influences of all those external factors usually overlooked or excluded from consideration, is neither repetitious nor singular, nor conducive to possession.

Through its simplicity, one of the factors that *X for Henry Flynt* highlighted was the disciplined, task orientation of the performance. Kosugi's Fluxus events, such as *Theatre Music* (circa 1964) 'Keep walking intently' – integrated this type of performance with aural aspects, in this case the sound of the repetition of footsteps. But Kosugi also created an intermediary form – set between the techniques of repetitive sounds and sustained sounds – that employed the idea of gradual processes. Perhaps the best-known gradual process pieces were his *South No. 1 to Anthony Cox*, in which the word south is pronounced for a 'predetermined or indetermined duration', and *South No. 2 to Nam June Paik* which more specifically instructs the performer to prolong the task of pronunciation for a minimum of fifteen minutes. Shiomi's *Disappearing Music for Face* (1964), a performance, film and flip-book that all involve a smile very gradually dropping (over the course of about five minutes in performance to twelve minutes in film) to no smile, employs a similarly slow transformation, no matter how mute. Shiomi's 'music' was entirely visual, and thus it could be filmed at high speed to extend its duration. But in the Kosugi process pieces, slowing down the utterance 'south', using the technology of that time, would have altered the pitch beyond recognition. The yogic discipline of Kosugi's pronunciation of 'south' over a very long duration derived from an unusual vocal technique that turns in on its own minute operations, a rough technology that allowed a possible phonetic interior of the word to be divulged and further revealed that this interior was comprised not of syllabic segments but of an interpenetration between and among sounds. The

entirety of the sound 'south' – its integrity – was shown to be at once indivisible and exceedingly complex, and thus the specific integrities of other sounds or other things, like the words that roll so easily off the tongue, were revealed to be potential worlds in themselves.

Kosugi's gradual process takes place in a temporal dimension, its duration unfurling like the distance travelled (south). Sustaining an individual sound for a long period, on the other hand, promotes an experience of time decidedly different from the measured time of traditional music, including that of Cage, who preferred rhythm to harmony and championed Satie the 'phonometro-logist'.[30] It was not until several years after Young's Composition 1960 #7 (1960), in which a B and an F sharp are 'held for a long time', that Cage himself began to depart from measured time. As he described it:

> [0'00', Variations III and Variations IV] have in common no measurement of time, no use of the stopwatch, which my music for the previous ten years had – the structure of time, or the process of time; but in these pieces I'm trying to find a way to make music that does not depend on time.[31]

Young's Composition 1960 #7, however, was so much within time, so drastically simplified, that the very idea of time (measured or nonmeasured) in the conventional sense was dislodged and removed altogether. Time could no longer be measured as units of sound passed by, nor could any sequential organization of sound exist. The idea of a 'single sound' that would normally have some type of morphological standing ceased to exist and was replaced by an emphatically phenomenal and experiential situation, as attention shifted fully onto the interior, vertical dynamics of the sound and upon the act of listening.

Practically any sound contains elements within it that may need a duration longer than the life of the sound itself to come into being and to interact with other elements of a sound: sustaining a sound allows these activities to exist. The sustained sound, in all its dynamics, is not only to be heard but also to be transformed by the act of listening itself, with changing positions of the head, with the more noticeable thresholds and durations of attention. The unfolding of the dynamics of the sound within a particular space, relative to the heightened experience of a constantly modulating mode of listening, provided the markers for this new sense of time. The diminishment of time also accentuates the spatiality of sound. Sustained sound can occupy and be heard differently in different rooms and from different places within a room, and it also may 'drift' from one spot to another. A space 'filled' with an almost palpable sound develops around one's body, thereby heightening a sense of corporeality, especially when the body is vibrated by amplified sound.

Thus the turning inward on sound that constituted the strategic impulse of Fluxus to this point inverts with Young's sustained sounds from the fetishistic preoccupation with the constitution of the isolated, ever-smaller unit to the general structure of the entire work based upon time that has no meaning, to the expanses of spaces and mobility of bodies, to an autonomy of internal dynamics. In other words, a sound turns inside out. In relation to avant-garde practice from Russolo through Cage, this is an extremely important moment: a self-exhausting, inward-directed trajectory that suddenly creates, in its paradigmatic state, an entirely new form, signalling an end with elegance, a beautiful flourish as the last device. But as it marks such an end, Young's *Composition 1960 #7* at the same time makes possible music and acoustic works based upon new elaborations of space and the body (factors also repressed within the traditions of Western art music). Although Young and a few other composers and artists have continued to pursue this area, it remains largely unexplored. [...]

1 Erik Satie, 'Memories of an Amnesic (Fragments)' (1912–13), in Robert Motherwell, ed., *The Dada Painters and Poets: An Anthology* (New York: Wittenborn, Schultz, 1951) 18. The reader can assume that much of the content of this important book was familiar to many who were vital to the formation of Fluxus.

2 John Cage, 'Happy New Ears', *A Year from Monday* (Middletown, Connecticut: Wesleyan University Press. 1963) 31. However, in the same essay, Cage says in a deterministic spirit that 'changes in music precede equivalent ones in theatre, and changes in theatre precede general changes in the lives of people.' Historically, the term avant-garde music is almost entirely oxymoronic for the first half of this century. The mythic audiences that rioted at performances of compositions by Schönberg or Stravinsky were too bourgeois to represent an honest reaction. Other activities within the avant-garde (such as painting, performance, and writing) did not require the big technology of a symphony orchestra in order to be realized: all they needed was the modest technology of paint and a brush, a pen, an audience. Most composers, with only a few exceptions such as Antheil, Matiushin, Satie and Varèse, had little regular contact with the avant-garde.

3 Luigi Russolo, 'The Art of Noises. Futurist Manifesto', *The Art of Noises*, trans. Barclay Brown (New York: Pendragon Press, 1986) 23–30. The main source on Russolo is G.F. Maffina, *Luigi Russolo e L'Arte dei Rumori* (Torino: Martano Editore. 1978). Russolo's tactic was to provide extramusicality, noise and the realm of worldly sound by providing an expanded timbral range. For many timbral effects, even those residing unused within conventional orchestration, had themselves been restricted within Western art music. This strategy allowed him to make a discursive appeal outside the confines of musical materiality, while not fundamentally disrupting those confines.

4 See Douglas Kahn, 'Track Organology', *October*, no. 55 (Winter 1991) 67–78; and Frances Dyson, 'The Ear That Would Hear Sounds in Themselves: John Cage. 1935–1965', in Douglas Kahn and Gregory Whitehead, eds, *Wireless Imagination: Sound, Radio and the Avant-Garde* (Cambridge, Massachusetts: The MIT Press, 1992).

5 Because of the climate of repetition established by the mass media, metonymic snatches of
 sound could stand for an instance, class or context of sounds (and not just those in the mass
 media proper) and replace these at a greatly increased pace. Sounds, in other words, could be
 perceived at shorter and shorter durations and, thereby, in a compositional respect. Citation
 could occur at an elemental level and not, as was the case in musical practice, only at an
 organizational level, as in a melodic fragment. Cage's ideas at this time – his desire for a
 comprehension of a greater range of sounds (not just musical sounds) and for an apprehension
 of their singular integrity – are thus part of an understanding of this fundamental social
 transformation in aurality as delimited by the theoretical vein of Western art music.

6 Nam June Paik, 'Letter to John Cage' (1972), in Judson Rosebush, ed., *Video 'n' Videology: Nam June
 Paik (1959–1973)*, exh. cat. (Syracuse, New York.: Everson Museum of Art. 1974) unpaginated.
 Paik first met Cage in 1958 in Darmstadt, the centre for musical experimentation that included
 the circle of the composer Karlheinz Stockhausen. For a discussion of the 'major sensation' Cage
 created at Darmstadt with his new ideas on music, see Andreas Huyssen, 'Back to the Future:
 Fluxus in Context', in *In the Spirit of Fluxus*, ed. Elizabeth Armstrong and Joan Rothfuss
 (Minneapolis: Walker Art Center, 1993) 140–51.

7 'Transcript of the Videotaped Interview with George Maciunas by Larry Miller, March 24, 1978',
 in Jon Hendricks, ed., *Fluxus etc/Addenda l: The Gilbert and Lila Silverman Collection*, exh. cat. (New
 York: Ink &, 1983) 12.

8 Ibid.

9 See Bruce Altshuler, 'The Cage Class', in Cornelia Lauf and Susan Hapgood, eds, *FluxAttitudes*, exh.
 cat (Ghent: Imschoot uitgevers, 1991) 17–23.

10 Ibid, 17.

11 James Tenney, interview with the author, 21 March 1991.

12 Russolo's strategy had been possible only because Western art music excluded whole classes of
 sounds – and Cage's only because Russolo had settled for timbre and not for a general sonicity.
 Fluxus, in turn, was possible only because Russolo and Cage were not directed inwardly upon the
 unexploited ground of traditional Western art music.

13 George Brecht, *Water Yam* (1963); re-editioned (Brussels and Hamburg: Edition Lebeer
 Hossmann, 1986).

14 Michael Nyman, 'George Brecht: Interview', *Studio International*, vol. 192, no. 984 (November/
 December 1976) 257.

15 Reproduced in Ken Friedman, ed., *The Fluxus Performance Workbook*, special ed. of *El Djarida*
 magazine (Trondheim, Norway: Guttorm Norde, 1990) 47.

16 La Monte Young, ed., *An Anthology* (New York: La Monte Young and Jackson Mac Low, 1963)
 unpaginated.

17 Idem, 'Lecture 1960', *Tulane Drama Review*, vol. 10, no. 2 (Winter 1965) 73; 83.

18 Jean-Jacques Nattiez, *Music and Discourse: Toward a Semiology of Music*; trans. Carolyn Abbate
 (Princeton: Princeton University Press. 1990) 43.

19 Supra, 75, note 17.

20 Supra, 18, note 1.

21 Supra. 75, note 17.

22 F.T. Marinetti and Pino Masnata, 'La Radia', in F.T. Marinetti, *Teoria e Invenzione Futurista* (Verona: Arnoldo Mondadori editore, 1966); trans. Stephen Satarelli, in Kahn and Whitehead, eds, *Wireless Imagination*, op. cit., 176–80. […]

23 Cage's magnetic audiotape piece *Williams Mix* (1952). for example. calls for 'small sounds requiring amplification to be heard with the others' as one of the six categories of sonic raw material, and Cartridge Music (1960) requires 'amplified small sounds'. In a rumination on the sound of mushroom propagation he proposed the following: 'That we have no ears to hear the music the spores shot off from basidia make obliges us to busy ourselves microphonically' (supra, 34, note 2). 'The Future of Music: Credo' (1937) is included in *Silence* (Middletown, Connecticut: Wesleyan University Press, 1961).

24 What was often termed 'everyday' in the Fluxus vernacular, however, oddly denied the increasing incursion of media technologies and mass media into daily life. The Fluxus events taken to be emblematic of the everyday were in fact reduced to a generally asocial state in the same way that the Cagean aesthetic promoted a reduction of worldly sound to musical sound.

25 John Cage, quoted in Richard Kostelanetz, ed., *Conversing with Cage* (New York: Limelight Editions, 1988) 69–70.

26 Ibid., 70.

27 Supra, 75, note 17. We should probably look to save for the final word: 'We cannot doubt that animals both love and practise music. That is evident. But it seems their musical system differs from ours. It is another school … We are not familiar with their didactic works. Perhaps they don't have any.' (Satie quoted in John Cage. 'Erik Satie' [1958], in supra., 77 note 23.)

28 Hendricks, ed., supra, 194, note 7.

29 Supra, 33, note 15.

30 Russolo addressed complex sounds in the way he designed his *intanorumori* (noise-intoning instruments), basing them on a rotary action that could sustain sounds, hurdygurdy style. Other sustained sounds were decidedly mechanical. For example, Russolo tuned the exhaust manifolds of the airplane of the aviopoet Fedele Azari while, elsewhere in Italian Futurism, motorcycles were used in a theatrical setting for their sustained raucousness. Varese's klaxons or Cage's test-tone records, instead of rotating to hear a sound, were used to build a better glissando. Today, sustained sounds are regularly heard in motors, fans, transformers, and the like.

31 Cage quoted in supra., 69–70, note 25.

Douglas Kahn, extract from 'The Latest: Fluxus and Music', in Elizabeth Armstrong and Joan Rothfuss, eds, *In the Spirit of Fluxus* (Minneapolis: Walker Art Center, 1993) 102–8.

Branden W. Joseph
The Tower and the Line: Toward a Genealogy of Minimalism//2007

No article has so characterized the reception of Minimalism as Michael Fried's 'Art and Objecthood'. As Fried himself has noted, though their valences may be reversed, the terms of his argument have remained virtually untouched for nearly four decades.[1] The most important of these terms is undoubtedly *theatricality*, by which Fried characterized Minimalism's move beyond the individual arts or media into an undetermined area where, in the words of Clement Greenberg, which he quotes, 'everything material that was not art also was'.[2] Theatre, as a term, served to connect Robert Morris's phenomenological engagement with the body with 'some kind of final, implosive, highly desirable synthesis' of the arts, from which would arise our understanding of postmodernism.[3] In 'Art and Objecthood' Fried provided this intermedia realm with a veritable topography by referencing Tony Smith's infamous ride on the unfinished New Jersey Turnpike. Theatricality was a mundane spatial expanse, with no discernable bounds, which continued for an 'endless or indefinite *duration*'.[4]

Historically, 'Art and Objecthood' succeeded in linking Morris's theatricality to Donald Judd's derivation from modernist painting – a move that effectively severed Morris's work from its actual genealogy in John Cage's challenge to modernism.[5] It is not entirely true, however, as James Meyer has maintained, that Cage and his influence were absent from Fried's discourse.[6] Indeed, it was in large part to Cage that 'Art and Objecthood' attributed the implosion and theatrical 'degeneration' of the arts.[7] Fried, as we will shall see, proved somewhat more accurate in 'Three American Painters' of the previous year, where he less polemically characterized Cage's legacy as 'calling into question … the already somewhat dubious concept of a "work of art"'.[8] In that article, Fried posited Cage's neo-dadaism as 'antithetical' to modernist painting, placing it in much the same antagonistic role in which he would soon cast minimalist theatricality. It is my supposition that the parallel troubles posed to Fried by Cage and Minimalism are not unrelated. For as is entirely *un*noted in the literature on Minimalism, Cage had a well-defined notion of theatre, one both influential and readily available by 1961. This is far from an historical footnote. Though Fried's use of the term 'theatre' likely derived from his reading of Stanley Cavell (who also engaged with Cage), it was from Cagean theatre that Morris's actual 'theatrical' practice emerged.[9]

Running from the chance techniques of *Music of Changes* (1951) to the indeterminacy of *Variations II* (1961), Cage's challenge to the modernist project had already fully developed by the advent of Minimalism.[10] Nevertheless, and

despite its importance within the realms of art, music, dance and film, Cage's impact is more often diminished than explored. Frequently, the idea of chance, apart from any understanding of Cage's use of it, is hypostatized as his sole concern and equated with relativism. Caricaturing him as a holy fool, dismissing him as an imitator of dada, or disparaging him as a religious reactionary, critics overlook the logical, self-critical, and utterly consistent development of the first two decades of Cage's career. Quotations and compositions are routinely cited out of context, while the specifics of his scores and performances are usually ignored. Such off-hand treatment by critics and historians, however, differs markedly from that of those artists who interacted with Cage on a daily basis in New York or at Black Mountain College, encountered his work at Darmstadt, took his courses at the New School for Social Research, or studied his scores with Robert Dunn or the Judson Dance Theater. Although tracing the full development of Cage's project is impossible here, it is important to list five of its most significant implications.[11]

First is the production of an aesthetic of immanence. For over two decades, Cage sought to disarticulate any and all abstract or transcendent connections between sounds or between sound components like frequency, amplitude, timbre or duration. Beginning with investigations of chance, Cage worked to detach sound from pre-established meaning and composition from continuity or structure, whether harmonic, atonal, or the supposedly neutral time structures Cage himself lauded in the forties.

Going beyond a priori connections between sounds, Cage sought to disarticulate determinate a posteriori connections as well. Quickly realizing that, once fixed, a chance score like *Music of Changes* (which was indeterminate with regard to *composition*) was still determinate upon *performance*,[12] Cage made indeterminate the relation between composer and performer, as well as that between performer and listener for instance, by arranging musicians around the audience so that no two listeners would hear the same 'mix' of sounds. The goal was to eliminate from the acoustical experience – as much as possible – creation of any form that could be received as existing on a level above what Deleuze and Guattari, discussing Cage among others, would term 'a plane of immanence'.[13]

The second component of the Cagean aesthetic concerns the relation between the listener and the indeterminate musical production. Instead of confronting the composition as a unit or whole, listeners were to encounter sonic events as a 'field' or 'constellation' (Cage's terms) that not only potentially surrounded them, but opened onto and interpenetrated with random acoustical occurrences 'outside' and therefore beyond any single intentionality. (Hence Cage's quip that 'a cough or a baby crying will not ruin a good piece of modern music'.)[14] Like a glass house (one of Cage's favourite metaphors) or an auditorium with open windows, Cage's compositions acoustically emulated a 'transparency' to external events that sought

to undermine their autonomy. With neither formal nor 'spatial' delineations, compositions were to be grasped not as discrete acoustical 'time-objects' but as temporally changing yet a-teleological processes.[15] Instead of following a pregiven structure or attempting to comprehend a message, the listener was to assume an attitude of attentiveness within a differentiated but nonhierarchical field of sonic occurrences: 'to approach them as objects,' wrote Cage, 'is utterly to miss the point.'[16] For Cage, this reconfiguration of the subject-object/listener-work relation into that of a listener within a multidimensional, transformational field was an explicit challenge not only to abstraction but to dialectics: relationships such as those between frequency and amplitude, Cage noted,

> make an object; and this object, in contrast to a process which is purposeless, must be viewed dualistically. Indeterminacy when present in the making of an object, and when therefore viewed dualistically, is a sign not of identification with no matter what eventuality but simply of carelessness with regard to the outcome.[17]

According to Cage, seeing composition as an a-teleological process or a focusless but differentiated field produced a transformation in listening, which is the *third relevant point of his aesthetic: interpretation gives way to 'experimentation'*. In place of the attempt to comprehend a composition or any of its sounds as signs with determinable (i.e., bi-univocal) meanings – whether pregiven or a posteriori and even if multiple or ambiguous – the listener was to experience process as without ulterior signification, structure or goal. Cage sometimes groped for terms to describe this: 'awareness', 'curiosity', 'use', even 'an entertainment in which to celebrate unfixity'.[18] Nevertheless, 'experimentation', as defined by Cage, was a process of interpretation of reading and receiving signs, in the absence of pregiven signifieds.[19] Such was not conceived by Cage as negation (no received meaning whatsoever), nor as irrationality or mystical oneness, but at its most radical as a death of the composer that was a birth of the listener.[20] In this reconfigured situation, neither the unavoidably *perceived* connections between sounds nor the listener's thoughts or feelings about them were denied. 'Hearing sounds which are just sounds', Cage stated, 'immediately sets the theorizing mind to theorizing.'[21] However, the locus of the acoustical experience's meaning is transferred to the listeners, who are thereby allowed to 'become their own centres' rather than submit to the will of either composer or performer. 'Of course, there are objects', Cage declared about the related aesthetic of Robert Rauschenberg. 'Who said there weren't? The thing is, we get the point more quickly when we realize it is we looking, rather than we may not be seeing it.'[22]

Four: the disarticulation of transcendent structure was understood as a subversion of power. For Cage, the determinate passages from composer to score, score to

performer, and performer to listener were understood as power relations. Thus, to disarticulate them as necessary, bi-univocal relations meant that neither performer nor audience member had to be subservient to the will of another; they could instead work from their own centres, not by doing whatever they want, but nonetheless without being 'pushed', as Cage put it, in any one direction.[23] As he explained about one such relation, 'Giving up control so that sounds can be sounds (they are not men: they are sounds) means for instance: the conductor of an orchestra is no longer a policeman.'[24] This (ultimately utopian) attempt to dissolve or eradicate all forms or effects of power was essentially an anarchist position, and Cage explicitly labelled it as such in *ARTnews* in 1960: 'Emptiness of purpose', he wrote, 'does not imply contempt for society, rather it assumes that each person, whether he knows it or not, is noble, is able to experience gifts with generosity; that society is best anarchic.'[25]

The final relevant component of Cage's legacy concerns its *challenge to the disciplinary status of the separate arts*. Beginning with a quest to undermine the separation between music and noise, Cage moved to undo the distinction between sound and silence. Following his 1951 experience in an anechoic chamber, Cage famously proclaimed that there was no such thing as silence, only two kinds of sounds: 'those intended and those others (so-called silence) not intended'.[26] By 1954, Cage would extend the disarticulation of 'abstract' categories such as sound and silence to the distinction between the auditory and the visual. The inevitable combination of the two in all performed actions which begged the question of the separation between the visual arts and music-Cage described as 'theatre'.[27]

> Music is an oversimplification of the situation we actually are in. An ear alone is not a being; music is one part of theatre. 'Focus' is what aspect one's noticing. Theatre is all the various things going on at the same time. I have noticed that music is liveliest for me when listening for instance doesn't distract me from seeing.[28]

Whether explicitly referencing Cage or not, Fried was right to note the manner in which such 'theatre' questions the distinction between media or artistic disciplines.[29] Quite different from the boundless dissolution implied by Fried's analysis, however, Cagean theatre (especially as taken up around Fluxus) opened onto a situation in which *certainty* about the disciplinary status of the aesthetic object (even that it was necessarily 'aesthetic') was effectively dissolved. This did not imply that there was, magically, no longer any such thing as a painting or a sculpture, or that the institutions of concert hall, gallery and museum were no longer relevant or recognizable. What it did imply (as Fried, in fact, also observed) was that the disciplinary and medium based distinctions traditionally handed down could no longer be received as ontological facts, or even mutually accepted

conventions, but had to be reiterated in each instance.[30] For a generation situated in Cage's wake, however, as opposed to those artists championed by Fried, the issue was not how to restore the validity of medium or disciplinary distinctions through what Fried called 'conviction'. Rather, for a certain group of artists, not only could such distinctions not be taken for granted but the very idea of producing an 'advanced' work implied that the question of a work's status – the disciplinary, institutional place of the work as art or music – almost necessarily had to come into play. That is, for a certain group of artists (which would include Tony Conrad, La Monte Young, Morris, Walter De Maria, Simone Forti and Yvonne Rainer, but not Frank Stella or Donald Judd), the very notion of being 'advanced' meant not only that the status of the work (which might be an object or a process or both) was already in question but that the work had to take up that question and keep it in question. Not eradicating but continually problematizing medium or disciplinary specificity was, in other words, a primary condition of being 'advanced' after Cage. This is different from Judd's positioning of a 'specific object' in the formal space between (but no longer part of) painting and sculpture. For a more radical group of Minimalists, whether coming from music or visual art, a work could not be advanced, could not be 'new,' unless it took up the question posed by Cagean 'theatre.'

More important, the breakdown or problematizing of formal and disciplinary distinctions was – particularly after Cage linked his aesthetic to anarchism – an unavoidably *political question*. Indeed, it was a directly political question. According to Cage, the relations between composition, score, performance and audition involved the imposition of something like semantic force. Hence the conductor enforcing (his or her idea of) the composer's dictates was understood to function as a 'policeman'. For Cage, form and politics seemed connected by the simple fact and to the degree that form was politics. An abstract or transcendent connection or relation was, for Cage, an imposition of power. More specifically, we could say that, by 1960 at the latest, Cage conceived form as a particular *technique* of power, a moment within a micropolitics. To disarticulate, unstitch or undermine form, to produce an aesthetic of immanence, was therefore to disarticulate that technique. Rather than obscuring or avoiding a political project (a charge, for instance, routinely advanced about Cage's relation to dada), what Cage put on the table was the connection or articulation of politics and form. The situation from which the arts were approachable after Cage was no longer evidently and unquestionably that of 'objects' (even if musical performances) within a discipline or institution but of specific techniques within a field or realm of power effects.[31]

From 1957 to 1964 when he severed ties with Fluxus, Robert Morris was saturated with Cagean aesthetics, both directly and through his interactions with

Young, Forti, Ann Halprin, Henry Flynt and others. Much has been made of the 'theatrical' debut of Morris's *Column* (1961), which fell at a benefit performance for Young's *An Anthology*. 'Its literal fall from illusionism', writes Maurice Berger, rejected 'formalist sculpture's defiance of gravity'.[32] *Column* was not, however, Morris's only performing object. In a little-known concert of avant-garde music organized by Flynt at Harvard in 1961, Morris, although not listed on the flier, appeared alongside Young and Richard Maxfield. Originally slated to present *Water Sculpture* (possibly an early version of *Fountain* [1963] or a relative of the unrealized *Wind Ensemble* [c. 1959–60]), Morris ultimately debuted *Box with the Sound of Its Own Making* (1961).[33] That Morris's *Box* would appear as a 'performance' was not without precedent, for that had been how Cage received the work at around the same time. Invited to come and see that piece and others at Morris's New York apartment, Cage reacted to the *Box* as a private concert. As Morris told Jack Burnham, 'When he came I turned it on. I said this is something I made. I turned it on, and he wouldn't listen to me. He sat and listened for three hours. And that was really impressive to me. He just sat there.'[34]

Burnham would brush off Cage's response as 'sort of a perverse graciousness', and it has always seemed the idiosyncrasy of a composer avowedly devoted to non-musical sounds. Yet Cage's interest likely also stemmed from the work's theatricality, which it distilled into a discrete thing, one that problematized process and object, temporality and form, art and music, and, not least, performance and score. For although the *result* of a process, Morris's walnut box, in its simple and evident construction, also acts as instruction as to how to produce a subsequent 'performance' (an inversion Cage later adopted in his own work).[35] Morris's *Performer Switch* and *Game Switch* of the same year are similarly problematic objects – interactive, three-dimensional realizations of the type of word scores Morris submitted to and then withdrew from *An Anthology*, scores such as *Make an object to be lost* (1961); *Tomorrow 8 a.m. to 12 p.m.* (1961), and *To be looked at in a state of shock: nearly anything in a state of shock* (1961).[36] Indeed, all the works Morris described in a letter to Cage that February were decidedly hybrid without relinquishing genre or medium interrelations for a realm in which 'anything goes'. Works such as *Litanies* (1961) were described as 'Drawings, writings' and also 'a two and one half hour graphic recitation'.[37] Morris's lesser-known *Frugal Poem* (also known as *Words* [1961]) consisted of the repetition of the word 'words' filling an entire page. 'When read aloud', Morris explained to Cage, 'one substitutes the word 'talk' for 'words'. A tape was made of the scratching of the pencil as it was written – it is intended to be several superimposed images, i.e., drawing and/or poem and/or musical score and performance.'[38] Young performed *Words* in 1962 at the ONCE Festival in Ann Arbor, Michigan, on a programme with compositions by himself,

Maxfield, Flynt, De Maria, Terry Riley, Terry Jennings, Toshi Ichiyanagi and Christian Wolff.[39]

At the time, Young and Morris were particularly close, a connection inscribed in Young's most infamous and influential word score, *Composition 1960 #10 to Bob Morris* (October 1960), which reads in its entirety, 'Draw a straight line and follow it.'[40] Young's word scores were touchstones for the development of Fluxus, and *Composition 1960 #10* was 'answered' with particular frequency. Milan Knizak's *Line* (1965) made it into a competition: 'A line is drawn on the sidewalk with chalk. The longest line wins.'[41] Knizak had already been trumped, in a sense, by George Maciunas's *Homage to La Monte Young* (1962), which instructed, 'Erase, scrape or wash away as well as possible the previously drawn line or lines of La Monte Young or any other lines encountered, like street dividing lines, ruled paper or score lines, lines on sports fields, lines on gaming tables, lines drawn by children on sidewalks etc.'[42] Yoko Ono included three variant *Line Pieces* in her book *Grapefruit*, including an injunction to draw a line with yourself 'until you disappear'.[43] In 1961 Nam June Paik performed Young's piece by dipping his head in a bowl of paint and marking a broad line down a long sheet of paper in what became known as *Zen for Head*.

Young himself returned to *Composition 1960 #10* in the series *Compositions 1961*. Calculating that he completed twenty-nine works a year, Young decided to finish off a year's worth at once, carefully assigning each a 'date' between January 1 and December 31, 1961. Having further decided that originality was no criterion for a legitimately 'new' work, Young simply repeated 'draw a straight line and follow it' for each one. Thereafter, Young often performed *Composition 1960 #10* on the same bill with all twenty-nine of his *Compositions 1961*. At the Harvard concert in March (technically before many of the works were 'composed') Young premiered the entire suite with assistance from Morris (who, appropriately, drew the first line himself). For the remainder, Young and Morris used plumb lines and yardsticks to draw a chalk line across the stage – being careful to stay behind it, thereby following it at the same time – repeating the action once for each of the compositions, all the time trying to repeat the drawing as precisely as possible.[44] At the time, Young declared that he 'does not call such proceedings music, but rather "art" in general'.[45] 'Music', Flynt later commented, 'had become an arena for a transformation which did not need to be about music'.[46]

Cage was in the audience when Young reprised the Harvard performance, this time assisted by Robert Dunn, at Yoko Ono's loft concert series that May. 'We had a beautiful programme by La Monte Young,' Cage wrote to David Tudor:

> He and Bob Dunn drew 30 straight lines using a string with a weight in the manner
> somewhat of surveying. By the time La Monte finished, not only had all the

audience left, but Bob Dunn too had left exhausted. The next evening the project was shortened by shortening the line. Even then it took three hours.[47]

In his own letter to Tudor, Young emphasized the performance's intentionally workmanlike character, a relationship to labour echoed later in Morris's *Site* of 1964.[48] The primary interest of the performance, however, lay in the inadvertent, and thus indeterminate, differences in the paths traced by the chalk lines. Young noted how hard they had worked at making the lines straight, despite the fact that each one always included slight but noticeable deviations.[49] What was being performed was a dialectic, executed in time, between the ideal of a straight line and the inevitable alterations that arise in real world production. [...]

If Cage criticized Young's 'fixated' acoustical environment (as he would also the physical environments of Allan Kaprow), he did so not only for its separation from the plane of immanence but for its reintroduction of a power dynamic Cage wanted to avoid.[50] Whereas Cage sought to place the listener into a non-hierarchical field with which he or she could interact as a disinterested equal, Young reinscribed a dialectic between subject (listener) and object (the environmental, nearly overwhelming, sound). Indeed, via amplification, Young exacerbated the interaction to such an extent as to make the power relationship palpable. From *2 Sounds* onward, Young's listener and sound were engaged in a type of struggle, the phenomenological particularities of hearing in 'one's own terms' struggling for autonomy against the nearly overwhelming pressure of the sound. [...]

1 Michael Fried, 'An Introduction to My Art Criticism', in *Art and Objecthood: Essays and Reviews* (Chicago: University of Chicago Press, 1998) 43.

2 Clement Greenberg, 'Recentness of Sculpture' (1967), in *The Collected Essays and Criticism*, vol. 4, ed. John O'Brian (Chicago: University of Chicago Press, 1993) 252, quoted in Michael Fried, 'Art and Objecthood' (1967), Art and Objecthood, 152.

3 Michael Fried, 'Art and Objecthood', 164. The relationship of theatricality and postmodernism is made by, among others, Douglas Crimp, 'Pictures', *October*, no. 8 (Spring 1979) 75–88; Hal Foster, *The Return of the Real* (Cambridge, Massachusetts: The MIT Press, 1996) 35–69; and James Meyer, *Minimalism: Art and Polemics in the Sixties* (New Haven: Yale University Press, 2001) 242.

4 Fried, 'Art and Objecthood', 166.

5 See, for example, Robert Morris, 'Letters to John Cage', *October*, no. 81 (Summer 1997) 70–79. For a larger study of Cage's impact within the 1960s and the ways in which a generation of artists grappled with it, see my *Beyond the Dream Syndicate: Tony Conrad and the Arts after Cage* (New York: Zone Books, 2008).

6 James Meyer, 'The Writing of "Art and Objecthood"', in *Refracting Vision: Essays on the Writings of Michael Fried*, ed. J. Beaulieu, M. Roberts and T. Ross (Sydney: Power Publications, 2000) 71.

7 Fried, 'Art and Objecthood', op. cit., 164. Fried noted, 'Art degenerates as it approaches the condition of theatre.'

8 Fried, 'Three American Painters: Kenneth Noland, Jules Olitski, Frank Stella' in *Art and Objecthood*, op. cit., 259.

9 James Meyer has expertly traced Fried's debt to Cavell, in *Minimalism*, op. cit., 234–9.

10 This was actually the second major phase of Cage's development. The first revolved around percussion. Cage's work would transform again in the 1960s, beginning with *0'00'' (4'33' No.2)* (1962). Henry Flynt suggests that the latter transformation was, in part, brought forth by the developments in the circle around Young. Henry Flynt, 'La Monte Young in New York, 1960–62' in *Sound and Light: La Monte Young, Marian Zazeela*, ed. William Duckworth and Richard Fleming (Lewisburg, Pennsylvania: Bucknell University Press, 1996) 77.

11 The best critical study of Cage's work remains James Pritchett, *The Music of John Cage* (Cambridge: Cambridge University Press, 1993). I have attempted to chronicle certain aspects of Cage's development in detail elsewhere. See Branden W. Joseph, 'John Cage and the Architecture of Silence,' *October*, no. 81 (Summer 1997) 80–104; Branden W. Joseph, '"A Therapeutic Value for City Dwellers": The Development of John Cage's Early Avant-Garde Aesthetic Position', in *John Cage: Music, Philosophy and Intention, 1933–1950*, ed. David W. Patterson (London and New York: Routledge, 2002) 135–75; and Branden W. Joseph, 'White on White' in *Random Order: Robert Rauschenberg and the Neo-Avant-Garde* (Cambridge, Massachusetts: The MIT Press, 2003) 25–71.

12 John Cage, 'Composition as Process II: Indeterminacy' (1958), in *Silence: Lectures and Writings* (Middletown, Connecticut: Wesleyan University Press, 1961) 36. In all quotes, I have chosen not to reproduce Cage's chance-derived typography.

13 Gilles Deleuze and Félix Guattari, *A Thousand Plateaus: Capitalism and Schizophrenia*, trans. Brian Massumi (Minneapolis: University of Minnesota Press, 1987) 266–7.

14 John Cage, '45' for a Speaker' (1954) *Silence*, 161.

15 Cage, 'Composition as Process II' 38.

16 John Cage, 'Composition as Process I: Changes' (1958), in *Silence*, 31.

17 Cage, 'Composition as Process II', 38. Cage comments further on dualism and dialectics in 'Program Notes' (1959), in *John Cage: Writer*, ed. Richard Kostelanetz (New York: Limelight Editions, 1993) 81–2.

18 John Cage, 'Where Are We Going? And What Are We Doing?' (1961) in *Silence*, 237; and John Cage, 'On Robert Rauschenberg, Artist, and His Work' (1961) in *Silence*, 98.

19 Daniel Charles, *Gloses sur John Cage* (Paris: Union Générale d'Éditions, 1978), 91–109; and Gilles Deleuze and Félix Guattari, *Anti-Oedipus: Capitalism and Schizophrenia*, trans. Mark Seem, Robert Hurley and Helen R. Lane (Minneapolis: University of Minnesota Press, 1983) 370–71.

20 As Liz Kotz has observed, the more celebrated notion of the 'death of the author' put forward by Roland Barthes in 1968 was likely a reimportation of the idea into literature and art from the context of contemporary music. Liz Kotz, 'Post-Cagean Aesthetics and the "Event" Score', *October*, no. 95 (Winter 2001) 59, note 10.

21 John Cage, 'Experimental Music' (1957) in *Silence*, 10.

22 Cage, 'On Robert Rauschenberg' 108.

23 Cage, 'Where Are We Going?' 224–6.

24 John Cage, 'History of Experimental Music in the United States' (1959) in *Silence*, 72.

25 John Cage, 'Form is a Language' (1960) in *John Cage: An Anthology*, ed. Richard Kostelanetz (New York: Da Capo, 1970) 135. The essay originally appeared in the April 1960 issue of *ARTnews*. The history of Cage's relation to anarchism remains to be written. For a hint at the environment in which it operated, see Judith Malina, 'Remembering Jackson Mac Low', *Performing Arts Journal*, no. 80 (2005) 76–8.

26 John Cage, 'Experimental Music: Doctrine' (1955) in *Silence*, 14.

27 Cage, 'Experimental Music', 12.

28 Cage, '45' for a Speaker', 149.

29 Fried does specifically mention music, particularly Cage, in 'Art and Objecthood', 164.

30 See Fried, 'Art and Objecthood', 168–9, note 6.

31 Cage's decomposition of form, his production of an aesthetics of immanence, thus also opens onto a historiographic project. See Michel Foucault's critique of 'instititionalocentrisme,' in *Sécurité, Territoire, Population: Cours au College de France, 1977–78* (Paris: Gallimard/Seuil, 2004): 'A method such as this one consists in passing behind the institution to attempt to find, behind it and more globally than it, what one could call a technology of power. By that even, this analysis permits one to substitute for the genetic analysis by filiation a genealogical analysis ... that reconstitutes an entire network of alliances, communications and pressure points [points d'appui]. Thus, the first methodological principle: to go beyond the institution to substitute for it the overall point of view of a technology of power' (121).

32 Maurice Berger, *Labyrinths: Robert Morris, Minimalism and the 1960s* (New York: Harper and Row, 1989) 47.

33 Flynt, 60–61. Flynt further recalled that the *Box with the Sound of Its Own Making* was played during the intermission and perhaps before the concert and that Morris was upset that it was mistakenly left off the flyer (Henry Flynt, e-mail to author, 21 November 2006). Morris corresponded with Cage about the happening-like *Wind Ensemble* in letters dated 8 August 1960 and 27 February 1961; see Morris, 'Letters to John Cage', 70–73.

34 Robert Morris, interview by Jack Burnham, 21 November 1975, Robert Morris Archive. The interview is partly quoted in Berger, 31.

35 Such a reversal, in which the score comes afterward and as a result of the performance would be taken up by Cage in such works as *Variations V* (1965).

36 On Robert Morris's contributions to *An Anthology*, see Barbara Haskell, *Blam! The Explosion of Pop, Minimalism and Performance, 1958–1964* (New York: Whitney Museum of American Art, 1984) 91–103.

37 Morris, 'Letters to John Cage', 75.

38 Morris, 'Letters to John Cage', 74.

39 Programme reproduced in Flynt, 74.

40 La Monte Young, ed., *An Anthology* (New York, 1963) n.p.

41 Ken Friedman, ed., *The Fluxus Performance Workbook*, special issue of *El Djarida* (Trondheim, Norway, 1990) 29.

42 Jon Hendricks, *Fluxus Codex* (New York: The Gilbert and Lila Silverman Fluxus Collection/Harry N. Abrams, 1988) 358.

43 Yoko Ono, *Grapefruit: A Book of Instructions and Drawings* (1964; reprint, New York: Simon and Schuster, 2000), n.p.

44 See discussion and reproduction of the evening's programme in Flynt, 59–63.

45 Reported by William Weber in the Harvard Crimson, 11 April 1961, as cited in Flynt, 63. For a different discussion of the passage to 'art in general' that focuses on mainstream minimal and conceptual art, see Thierry de Duve, *Kant after Duchamp* (Cambridge,, Massachusetts: The MIT Press. 1996), esp. ch. 4.

46 Flynt, 63.

47 John Cage to David Tudor, n.d. (c. May 1961), Folder 2. Box 13, David Tudor Papers (940073), Getty Research Institute.

48 La Monte Young to David Tudor, c. May 1961, Folder 11, Box 13, David Tudor Papers (940073), Getty Research Institute. On Robert Morris's *Site*, see Berger. 81–2.

49 Young to Tudor. *c.* May 1961.

50 [footnote 56 in source] On Kaprow, see Michael Kirby and Richard Schechner, 'An Interview with John Cage', *Tulane Drama Review*, vol. 10, no. 2 (Winter 1965). The interview is reprinted in Mariellen R. Sandford, *Happenings and Other Acts* (London and New York: Routledge, 1995); quote appears on page 69.

Branden W. Joseph, extracts from 'The Tower and the Line: Toward a Genealogy of Minimalism', *Grey Room*, no. 27 (2007) 59–67; 69.

Ralph T. Coe
Breaking through the Sound Barrier//1971

Howard Jones of Kansas City uses sound to create experimental works of art that deal with time and place and the shapes of their environments.

The 1960s ushered in the era of open experimentation with technologically mixed media, and art criticism responded with new terms: timesthesia, electronic mystique, infinity expansion, time lag, image dislocation, communication of time shifts, aesthetic phenomenology, extra-dimensionality, among others. All of these terms denote attempts to cope with an art that places actual time measurement at the core of experience while assuring that experience is derived psychically, i.e., by mentally reactive characteristics within us. Form was not the language, only a by-product (residual) or an appearance (a presence rather than structure, conceptual in design).

Some asked, 'Is painting dead?' Others laughed at such an inconceivable notion or took offence. Meanwhile artists worked at sweetened abstractions: a 1950s colour field influence, or conversely (almost perversely), pictures tending toward graphic exposition rather than painterly quality. Painting attains the life of a camera still. 'Art' is evaded. And that evasion process encompasses some of the most interesting work done today, irrespective of media. There is rampant art in the world, despite increased levels of interest, a lack of commitment, a missing inner passion, both on the part of artists and collectors. It just isn't the same thing; we are pausing, and that pause doesn't refresh, let alone indicate direction.

Now I asked: 'Are Howard Jones' sound pieces even art?' The question wouldn't have been posed three or four years ago, during the vogue for time-electronic explorations. Nor at that time would Jones' exhibition, 'Three Sounds' (at the Howard Wise Gallery, New York, last January) have inspired passionless politeness on the part of John Canaday, who once secured Jones a teaching position at Tulane: 'There is a real question as to whether comments on this show belong in an art column,' he wrote in the *New York Times* art section, 'since the works involved are designed to supply auditory rather than visual experiences'.

Electronic art is finicky, very hard to construct, harder to ship. It isn't the easy commodity that dealers like art to be. On the other hand, institutional practitioners and promoters of technological art have insisted on the elephantine, spending their time on projects difficult to sell, and hard to get at since one has to go to them rather than have them come to you. Gigantic exhibition projects such as

'The Magic Theatre' at Kansas City's Nelson gallery, in which Jones participated, and the Los Angeles inter-continental extravaganza, just opened at the LA County Museum, have removed the artist from potential buyers by implying, perhaps without intending to, that timesthetic projects are public domain, never private arena. Into this state of affairs, sound intrudes as an extra complication.

'I'll never sell those three sound pieces', Jones told me before they went to New York. 'Who would want them? They're outsized.' In fact, all three were acquired by a private collector. And why shouldn't sound be attuned to the home? How about the domestic sized *Linear Relay*? Its tocking sounds (actually an early idea for *Linear Relay* involved tiny transistorized speakers) channelled along the walls of bedroom and porch in miniature alignment can travel in the relay of the mind's eye, even though no such piece has been built.

However, a domestic-sized *Linear Relay* would be a reflex action after the major effort. Jones has put over two years into the development of these outsized pieces. 'Ideas and parts were manipulated in many different ways. There were countless experiments into the qualities of sound, selection and of timing devices, right-sized speakers, the correct logic circuits, even proper casings – *Air 44* and *Air Relay* were first encased in black, but then I realized that black was too weighty and object-oriented.' White on white walls was the purist solution to the setting forth of sound as space.

There is something heroic in what Jones has attempted. One has to pay attention, for technically oriented art is realized in a province not meant for the lazy. (Its process is unfamiliar, hard to 'read'.) By comparison paint seems 'easy' and sound is more difficult to approach than light which is seen. Our aesthetic ear is lazy compared to our eyes. The ear has less memory. Under normal conditions our lives are governed more by what we see than what we hear. Sight makes us tend to rely on the physical world much more than does hearing. Conversely, the ear is more tuned to ideas, therefore less tied to the physical. It is potentially an ideal instrument of psychically oriented receptivity. 'Therefore, if properly schooled, the ear could be a path into the beyond, since our eyes are restricted to the physicality of the universe.'

Not that Jones' sound should be confused with music. We speak here of another discipline. It's wrong to expect a Jones sound piece to 'play', and the art world is hung up on this misconception. The problems are different. Today we automatically tend to 'compose' sound or make it into noise. There is no composing here in the usual sense. There is only one sound to each of the three pieces. 'I think of what I've done in the same way that I think about anything I've done. Even when I was painting, I wasn't interested in paint but in change and interval, like the light pieces: thinness or density in time. There is the same concern with space as a time dimension but not in format.'

Why look for consistency in the format today anyway? Aren't we beyond that now – even if it means attacking the fundamental precepts by which art magazines usually report art? Why recognize a person's work only in what it looks like (rather than by what it does) or what it is made of? Didn't the 1960s open new experiential areas?

What about the way Jones feels about or thinks in terms of timesthesia? How does he isolate and signify that essence? Think of Christo wrapping up things in black polythene bags: is that what it's really about?

Does sound have an aesthetic quality? That depends very much on who is hearing it. A capsule review of Jones' *Three Sounds* goes: 'The main problem with these works is that while the investigation of sound offers some new material for art, at the same time it suffers from the same old technological limitations – too simple, ultimately boring.'

Is this comment a reflection upon the artist or upon his critic? 'Simple?' Isn't it more a matter of the extreme, inexorable, impersonal essence that depersonalizes art today and which has a negative reaction in the Lyric-Abstraction syndrome and a positive result in artists like Jones or Christo? That impersonality is given, and it calls for real understanding on the road to acceptance. Why is sound 'boring'? Is it only exciting when it is made into 'noise'? Outward undynamics can stir the inner capacity to be more stimulated according to inverse ratios of involvement. We are talking about the reverse of syncopation here. As depersonalized in approach as artists like Jones are, the best of them also stress 'involvement' – they want to involve *you*. 'I've been put in light shows, sculpture and kinetic shows as such, but I don't believe in any of them. My pieces only fit into shows that are organized on a broad mental concept that comes first, before material concerns. My interest has never been sound or light for its own sake. I've always been involved in something beyond the medium.'

After all, sound has less definition than pigment, therefore is perhaps more magical and mysterious in its intangibility. In these three sound pieces, involvement is more subtle than the pantomime reactions elicited by Jones in 'The Magic Theater's' Sonic Game Room three years ago. The ear tuning is more personal. 'Sound is a personal thing with me, but more people ought to become attuned. Maybe someday sound will become like paint was, then we won't be so involved in whether it is paint, light or sound, but with concept – with idea. It's about an idea in time. Don't try to classify it materialistically. That's too parochial.' The listener should overlook the medium (while being conscious of what is going on technically and conceptually) as he confronts the work. He will go over the top of sound to get closer to Jones' truth. Let us become familiar with the experience of this medium in order to get close to its essence: sound shaped through time.

In the Wise gallery exhibition there were three pieces. Each cut through a fundamental segment of sonic perceptivity: these sounds were right because of their elemental level: each had one pitch, timbre and quality of duration, and a certain quality of attack and decay – not sounds that were involved or complex but which were uncomplicated in the extreme, not having more than one pitch or single duration. This way it is easier to sense change in space. 'If you keep the elements simple, then you place more emphasis on something other than note structure; you place it on the relationship to the space you move in … You've got a much better chance to realize the shaping of space if the sounds are elementary. If means and ends are confused, the situation becomes overly complex – like an explosion rather than a progression.' In the exhibition the pieces were set on timers so that each operated one at a time with intervals of silence between each three minute 'performance' – to avoid such confusion. Unfortunately competing exhibits by mixed medium artists (television lights) in the adjoining foyer of the gallery interfered with the intended purity of the situation, impairing the quality of receptivity. The three pieces worked better in the quiet isolation of Jones' studio. *Linear Relay* is the simplest piece. Here it is easiest to acknowledge what has been experienced; a metronome sound moves from speaker to speaker until a progression of 20 equidistant speakers has been activated. The five 8-feet-long conjoined wall-casings can turn a corner and the sound returns to the first speaker with no extra time lapse – absolute continuum. *Linear Relay* is capable of different alignments on floor or ceiling and potentially is capable of infinite extension. No matter where the sound goes, it always returns, never missing a beat. Therefore, definition is final if its extensions are infinite. '*Linear Relay* is the proper instrument by which to obtain experience in orienting to the less elemental or obvious aspects of the other two pieces.'

The definition of *Linear Relay* is obviousness. There is no physical movement. You don't 'see' its sound move; it changes physically. 'I don't like highly kinetic things.' Light is a physical thing, but at the border of experiential essence. Sound is similar: it can go up walls or bend around a corner like a prism beam. You can hear the shape of a particular room or space or environment. The result is sound in a vacuum nonetheless denied by its presence. It relates presence to the ears of the hearer. In this way it is total, absolute, yet changing. For sound is as intangible as it is stable. We are so accustomed to sound pollution that this sonic performance is dislocating in its aural purity – rather like a call bell in a hospital corridor.

It was impractical to build *Linear Relay* with plastic castings; too heavy a wooden structure would have been required. The 8-foot sections could be formed from one piece of metal bent to form the casing in one operation.

For the second piece, *Area Relay*, a non-linear format made possible distribution of sound over an area formed like a flat wall partition, an 8-foot square of vinyl,

facing a concealed shallow wooden interior structure, and a grid of nine exposed speakers place off centre, one to each square in the grid. Sound bows out from the speakers, but it changes because it is no longer *there*. It has switched to another section of the square. In stereo sound two speakers carry sound components at equal amplitude that meet at mid-point. Now if in a nine-speaker arrangement each speaker has a different amplitude and six out of the nine speakers are always on, sound is pulled multi-directionally. Its mid-points continually change across the board in all directions as the arrows in Jones' explanatory drawing indicate. It is as if magnetic poles could switch their loci continually. The change in amplitude (six degrees) pulls the sound according to the logic circuit. This is no longer contrast (as in high versus low frequency) but a 'delicate electronic upsweep that crosses the piece in a mysterious, undiscernible pattern and sometimes appears – if the conditions are right – to emanate from other areas of the room'. Sonic indefiniteness is increased by passing the sound through a reverberation circuit; sound tends to bloom four-dimensionally. With your eyes closed, the sources of the sound become disoriented. From a distance you can't position the sound; at fifteen feet or closer you can feel the sound pulling about you, eddying, swarming, then disappearing and again returning. A sine-wave controlled by a sawtooth gives a sound 'halfway between a wood thrush and a distant siren', echoing in its character the swirling pattern of change elicited by the circuit changes.

An earlier project (unexecuted) for *Area Relay* has 64 three-inch speakers in a diagonal grid pattern, but was a little too much like *Linear Relay* to satisfy the artist. It was too directional. 'I wanted a pull based on speaker-strength rather than on directional sound like the tock in *Linear Relay*.' In a sense *Area Relay* is a development of an earlier Jones 'light painting', *Area II* (1966), in which 49 light bulbs inset in a square panel are involved with space out in front of the work rather than with lights arranged in a painterly way or as bas-relief. In succinctness of presentation *Area Relay* is a finer work than the light piece: it better meets the criteria of Baudelaire and Chopin that art be above thought (though not above idea).

In *Air 44* there are no logic circuits, which in the other two pieces were designed by Dan Landiss, Jones' engineer ('the only engineer I've encountered neat enough to build sound generators the way an artist would want'). Here the tables are turned. *Air 44* has no relay; instead the spectator provides the 'relay' as he 'reads' the 17 exposed speakers set into the 24-foot long white vinyl wall piece. It is an exposition of white sound (the conjoining of all sounds) distributed through subtle variation in frequency pitch in order 'to carve space in an interesting manner'. Jones made a drawing for this article to project how these variations provide a stroll through the frequency scale. White sound is carved rather than relayed. The relay system is more tangential, less obvious, far less linear than with *Linear Relay*. White sound on white vinyl makes for white

perception. All of the sound is passed by a zener diode which regulates its flow in one direction, longitudinally but not linearly. There are cross-over networks to eliminate some portions of the white sound and emphasize others. However, the sameness of the sound does not vary with the passing time; it is not pulled, as in *Area Relay*. It varies only as the listener sculpts space in time. Of the three pieces, *Air 44* is the most difficult to appreciate. To this writer it finally became the deepest statement of the three, the most irreducible and the most pure, rather like a late (1904) as contrasted with an earlier (1885) Cézanne.

Four years ago Jones experimented with one sound on tape. In November 1968 he presented *Air 43*, a white sound tape at the City Art Museum, St Louis. Even then white sound had a mystique: 'There are different connotations. To a garage mechanic it might suggest compressed air, to an East Coast resident, the sea.'

To Jones *Area Relay* suggests nocturnality: 'things that go bump in the night'. There is in it a haunting unease of distant sounds – and night is the time to hear them. John Gruen, writing in *New York Magazine*, caught this delicate aura of suspense: 'Mercifully, Howard Jones' intriguing sound pieces do not for a moment assault us sadistically, but they have a way of making us aware of sound as a dangerous element, a kind of spooky, aural shadow that contrives to disturb our sense of location and our spatial experience in general … Jones never overwhelms the spectator, but sensitively exposes him to the working of meticulously controlled sound with its inherent power to define both objects and space. Moreover, Jones places each listener in contact with his own perceptual responses, defining his own vulnerability to the multi-levelled dynamics of sound, surely one of the most potent and frightening of elements. Just as light, uncontrolled, could blind, so sound, similarly unleashed could deafen. There is more contained in these three pieces than meets the ear: as Jones puts it, they 'spook the scene when they're around …'

When exhibited they were largely ignored or criticized along the lines of the least perceptive review which noted that 'the "Three Sounds" do not make music' and that their experimentalism and incompleteness made them candidates for the IBM Gallery, 'where a lot of it [mixed media, electronic art?] gets its public exposure among those who are most interested in these developments' (Hubert Crehan, *St Louis Post Dispatch*). Away to the electronic hobby-lobby! This review ended on a teeth-jarring mixture of inappropriate metaphor, leaving one to wonder what artists must go through. 'Before he is finished I hope he may transpose the music of the spheres into a new key, the key of see.'

A mere experiment, or three years of distillation? Are we suffering from collective loss of nerve after the achievements of the 1960s? Has the galloping hare of art overrun the tortoise of media? Are we blind to be deaf? Don't we need to remember our aural memory? Are *Three Sounds* any less above thought than older

art? Are they any less bold in idea than other elemental efforts? Neither 'lyric' nor 'expressionist', these three sounds are suspended in taut clarity – a difficult state to attain when it is done with passion. Can it be that these sensitive works, among the first consecrated to a pure sound exhibition, will attain a breadth of importance they are presently denied? Are they art? 'I don't care whether it's art or not. That's for someone else to decide. I've always been an artist.'

Ralph T. Coe, 'Breaking through the Sound Barrier', *ARTnews*, vol. 70, no. 4 (1971) 44–5; 65–7.

Suzanne Delehanty
Soundings//1981

[...] The transmission of Schwitters' *Ursonate* or Archetypal Sounds on German radio in 1932 carried his art to a wider audience and showed, as Marinetti and Bertolt Brecht had demonstrated in the same decade, that radio could be a medium for artists. László Moholy-Nagy used sound in quite another way. In 1922 he ordered works of art by telephone and thereby used the spoken language and modern technology to distance himself from the art object to point out that the artist's conceptual process is more essential than the materials used to create art. Since Schwitters and Moholy-Nagy made their bold experiments, the development of the telephone, radio and recording industries has allowed sound to be extended or stored to hold the past moment in the present, like traditional painting and sculpture, or more aptly the camera's image. These discoveries – along with talking films, which became a commercial success in the late 1920s, and television, which was mass-produced after the Second World War – expanded artists' interest in the aesthetic as well as the political and social influence of the systems of mass distribution and global communications. Since the 1960s many painters and sculptors – often working in collaboration with engineers under the auspices of the organization Experiments in Art and Technology (EAT) – have made records, films, videotapes and multimedia works, such as the Pepsi Pavilion for Expo '70, and frequently have used these technologies side by side with the more traditional materials of the plastic arts. In the sixties many artists also turned to the transitory medium of events and performances, which have a long genealogy in our century. The Dada performances of Hugo Ball at the Cabaret Voltaire in Zurich in 1916 and Gilbert and George, the British artists who transformed themselves into singing sculptures in the late sixties, are just two

examples of the transformation of the artist's own body and voice into the material, the object of art. The expansion of the materials of art to include sound, noise, music, silence and the spoken word – all invisible to the eye – satisfied the desire of artists to present the passage of time in the once timeless world of the visual arts. At the beginning of the fifth century BCE Heraclitus saw the world in flux. In the transmission of the philosophy of the Greeks to the Renaissance, Heraclitus' view was subsumed by a concept of time as a sequence of measurable points that could be arrested by the laws of Renaissance perspective and symbolized by an hourglass held captive in the illusory stillness of representation. This mechanistic notion of time was overturned at the end of the nineteenth century by the philosopher Henri Bergson, who echoed Heraclitus in his influential book of 1889 *Time and Free Will*. Bergson saw time as the ever changing process of duration and movement in which the past flowing into the present could not be truly discerned by either the human consciousness or memory.

In the twentieth century the use of sound allowed visual artists to express duration in Bergson's sense. Sound, both implied and actual, became inseparable from the realization that the viewer's perception of a work of art transpires in time which, as John Cage has observed, 'is what we and sound happen in'. The artist's gestures and moments of thought also unfold in time. In Man Ray's *Indestructible Object* of 1923 (re-editioned in 1958), for instance, the sound of the metronome recalls the artist's process: the eye is the viewer *in absentia*, who watches the artist working in the solitude of his studio. Sound is used for a similar purpose in Robert Morris's *Box with the Sound of Its Own Making* of 1961 and in the series of paintings with accompanying recordings that Roman Opalka began in 1965. Howard Jones, whose sonic wall relief from the sixties responds to human activity, considers that 'light and sound, like life and thought, are actively involved with time, change and interval'. Time and change were also the substance of the ephemeral mixed-media events that George Brecht, Dick Higgins, Alison Knowles and other Fluxus artists staged on both sides of the Atlantic in the early sixties. Like the concurrent and often overlapping Happenings of the Pop artists, these audio-visual actions exist today only by recollection or in such announcements as George Maciunas' 1964 poster for the Perpetual Fluxus Festival. The Fluxus artists' choice of the word 'perpetual' may seem contradictory but in fact it signified that time and change, rather than static permanence, are the material of life and, therefore, of art. Perpetual change is also at the heart of Jean Tinguely's *Tokyo Gal* of 1963. In this flirtatious assemblage of found objects and old radio parts, sound inseparable from movement expresses Tinguely's belief that 'everything changes, everything is modified without cessation; all attempts to catch life in its flight and to want to imprison it in a work of art, sculpture or painting, appear to me a travesty of the intensity of life!' [...]

In the last two decades, artists have used actual sound to investigate our experience of space itself. Bernhard Leitner, trained as an architect and urban planner, considers sound and its movement, rhythm and intensity as events in time. In his room-like environments from the seventies, Leitner has created new perceptions of space with intersecting invisible lines of transmitted sound. Max Neuhaus, who abandoned a career as a virtuoso percussionist in 1967, has made more than a dozen sound installations in such unexpected locations as Times Square, where he amplified a ventilation chamber of the subway to create a volume of activated space at street level. While invisible and not generally identified as a work of art Neuhaus' environmental piece may be perceived aurally by attentive passers-by. Bruce Nauman, by contrast, warps our habitual way of hearing and its capacity to inform our sense of proper physical location in space by removing or reflecting the ambient sound along his thirty-foot wall constructed from acoustic insulation. When we walk past Nauman's wall, the presence of ambient sound in one of our ears and its absence from the other alters our customary sense of balance. For Liz Phillips 'air is a material'. With an archway of delicate copper tubing and a bronze screen that receive and project electronically controlled sounds, somewhat like a Theremin or proto-synthesizer, Phillips creates what she calls capacitance fields that make the space sensitive to our actions, our weight and density, and allow us to mould and shape sound as if it were plaster or clay that a magician had removed from our sight but not from our touch. The singing bridge of Doug Hollis gathers the wind to make 'spaces to be discovered by the ears'. […]

The entrance of sound, both heard and unheard, into the plastic arts heralded nothing less than a new beginning. In this beginning was the word, the spoken word, ambient sound, noise, music and silence; all allowed artists to transform the visual arts into a new and third realm. In this realm, compounded in the artist's mind of physical and metaphysical reality, the once discrete, static relations among artist, art object and viewer began to quiver and resound. The artist, once merely a craftsman, became a creator. The onlooker, once solely a passive observer, became the artist's collaborator. The work of art, once silent, permanent and timeless, became a hybrid object that began to resonate in a third realm beyond the worlds of illusion and reality. Sound announced that human experience, ever changing in time and space – the substance of life itself – had become both the subject and object of art.

Suzanne Delehanty, extract from *Soundings: An International Survey of Sound in the Plastic Arts* (Purchase, New York: Neuberger Museum/State University of New York, 1981).

Dan Lander
Sound by Artists//1990

The desire to compile [the anthology *Sound by Artists*] was driven by the noticeable lack of information and critical analysis regarding an art of sound. Although there has been an abundance of activity centred on explorations into sonic expression, there is no sound art movement as such. In relation to artists' works, sound occupies a multitude of functions and its employment is often coupled with other media, both static and time-based. As a result, it is not possible to articulate a distinct grouping of sound artists in the way one is able to identify other art practices. As the reader will discover, the ideas and projects put forth between the covers of this book are diverse and at times at odds with one another. The contributors included span many disciplines: critic, curator, writer, composer, video artist, installation artist, visual artist, performance artist and some more aptly described as sound, audio or radio artist. *Sound by Artists* is a collection of information pertaining to a disparate artform, presented in the hopes of stimulating dialogue.

The terms experimental music and sound art are considered by some to be synonymous and interchangeable. In fact, it is difficult to identify an art of sound precisely because of its historical attachment to music. Although music is sound, the tendency has been to designate the entire range of sonic phenomena to the realm of music. With the introduction of *noise* – the sounds of life – into a compositional framework tending towards the ephemeral and avoiding the referential, artists and composers have created works based on the assumption that all sounds uttered are music. The Futurist Luigi Russolo, envisioning an all-inclusive music, stated in *The Art of Noises* (1913) that:

> We want to give pitches to these diverse noises, regulating them harmonically and rhythmically. Giving pitch to noises does not mean depriving them of all irregular movements and vibrations of time and intensity, but rather assigning a degree or pitch to the· strongest and most prominent of these vibrations. Noise differs from sound, in fact, only to the extent that the vibrations that produce it are confused and irregular. Every noise has a pitch, some even a chord, which predominates among the whole of its irregular vibrations.[1]

Noise is considered by Russolo for its expressive musical qualities only and not for any other significant meaning(s) that it may hold. Here, we have a definition of music that considers all (organized) sound *as* music, limiting the possibilities

for an art of sound autonomous from the structures and presuppositions traditionally attached to musical composition and reception. The imposition of a 'musical template' onto the sounds that otherwise, in a day to day context, have meanings other than musical ones, leads us to a dead end conclusion: all sound is music. In defence of a music autonomous from noise, Chris Cutler, drummer and critic has written:

> But if, suddenly, *all sound* is 'music', then by definition, there can be no such thing as sound that is not music. The word music becomes meaningless, or rather it means 'sound'. But 'sound' already means that. And when the word 'music' has been long minted and nurtured to refer to a particular activity in respect of sound – namely its conscious and deliberate organization within a definite aesthetic and tradition – I can see no convincing argument at this late stage for throwing these useful limitations into the dustbin …[2]

The 'useful limitations' that constitute and enrich a musical art practice, restrain and limit an art of sound. The stripping away of meaning from the noise of our world constitutes a refusal- fetishizing the ear, while ignoring the brain – to engage ourselves in dialogue with the multiplicity of meanings conveyed by the sounds we produce, reproduce and hear. If a critical theory of sound (*noise*) is to develop, the urge to 'elevate all sound to the state of music', will have to be suppressed. *Noise* – your lover's voice, a factory floor, the television news – is ripe with meaning and content distinguishable from the meaning and content of musical expression. It is this content that constitutes any possibility for an art of sound.

Recorded sound, like the photographic picture, is a form of representation and whether the method employed is optical film, magnetic tape or digital sampling, recording is fundamental to the development of the audio arts. Although photography, for which theories of representation are well established, preceded that of sound recording, a theory of phonography (recorded sound) has yet to emerge. In fact, the process involved in both media is similar. A mechanical instrument is used to collect data which is edited, then manipulated and finally presented as a finished work of art, conveying a particular point of view and revealing the political and social attitudes of its author. And yet, compared to the visual arts, for which theories of representation are well developed and refined, phonography, as a form of cultural and social representation, exists in a vacuum, devoid of any substantial critical discourse.

With the introduction of relatively inexpensive tape recorders, microphones and signal processing instruments, recording has become accessible. However, general usage of tape recorders remains limited to two passive acts: recording and playing back previously recorded music. By contrast, most people use their

camera as a tool for documenting their family, friends, travel and other activities, not as a duplication machine to copy other photographs. Furthermore, what one sees when looking at their photographs is self-generated and self-referential: you were there. Listening to a recording (even one that you have made yourself) of pre-recorded music amounts to nothing more than the selection of a cultural product that exists with or without your 'participation'. The potential of the microphone/tape recorder is boundless - compact, battery operated, inexpensive and readily available - as an instrument for artistic and social expression. Any social or private activity that emits sound can be recorded. Can you imagine placing an LP on the turn-table that contains the sound of your first words, your grandfather's diary or the sounds of the social function that you attended last weekend? As William S. Burroughs points out, you could

record your boss and co-workers analyse their associational patterns learn to imitate their voices oh you'll be a popular man around the office but not easy to compete with the usual procedure record their body sounds from concealed mikes the rhythm of breathing the movements of after-lunch intestines the beating of hearts now impose your own body sounds and become the breathing word and the beating heart of the organization the invisible brothers are invading present time the more people we can get working with tape recorders the more useful experiments and extensions will turn up ...[3]

Artists whose works are specifically constructed for recording tape are aware of the possibilities brought about by the inherent properties of the medium. Contrary to other artforms such as painting and sculpture, sound recordings are not bound to a fixed space; and through duplication, multiples can be distributed, allowing the work to be heard at various sites and at various times. Furthermore, what the listener hears is not a representation of the work, but the *work itself.* In fact, like bookworks, many listeners can be in possession of the actual artwork and, over time, gain an intimacy with the work that is impossible with traditional artforms. Given the fact that playback systems are so abundant, and cassette tapes and postage so affordable, artists working with recorded sound have, at least theoretically, the potential to reach a wide and diverse audience autonomous from the institutions and bureaucracy associated with the contemporary art museum system.

Of course, another form of distribution is radio, which would seem to offer an unlimited space in which an art (of radio?) could proliferate. However, radio, as we have come to know it – 'don't touch that dial' – is already full of itself. Baudrillard states that

in terms of the medium the result is space – that of the FM frequency – which is saturated with overlapping stations, so that what was once free by virtue of there having been space is no longer so. The word is free, but I am not; the space is so saturated, the pressure of all which wants to be heard so strong that I am no longer capable of knowing what I want. I plunge into the negative ecstasy of radio.[4]

Contemporary radio is a state-controlled medium, ever moving, always full, offering brief interludes of nostalgic re-runs from its mythical 'golden era' and attempting, endlessly, through its smooth and icy voices, to inform us of the mundane. Radio has been co-opted as a tool for the dissemination of state and corporate ideology. As a medium, radio is underdeveloped because it refuses to recognize the perpetration of its self-defined limitations. Like television, radio is a stagnant technology. Unless access to radio is gained, we may never come to realize its implementation as a vehicle for cultural expression and dissension. If radio were to become a space where imagination, experimentation and chance-taking could occur, the numerous possibilities that the medium may hold might begin to bear fruit. Although there are practitioners of radio art, the conditions governing the medium make tenuous the realization of an art of radio: the self-conscious casting out of disembodied objects, ephemeral and tangible in the same breath. If a sound liberation is to occur it will mean confronting the meaning(s) of the noise we produce, challenging the context of its reproduction and transmission, and engaging in an active, rather than passive, investigation of sound recording technologies.

1 Luigi Russolo, *The Art of Noises* (1913) (New York: Pendragon Press, 1986).

2 Chris Cutler, 'Editorial Afterword', *Records Quarterly*, vol. 2, no. 3 (London, 1988).

3 William S. Burroughs, *The Ticket That Exploded* (New York: Grove Press, 1987).

4 Jean Baudrillard, *The Ecstasy of Communication* (New York: Semiotext(e), 1988).

Dan Lander, Introduction, *Sound by Artists*, ed. Dan Lander and Micah Lexier (Toronto: Art Metropole, 1990) 10–14.

William Furlong
Sound in Recent Art//1994

Sound has never become a distinct or discrete area of art practice such as other manifestations and activities were to become in the 1960s and 1970s. Although it has been used consistently by artists throughout this century, there has never been an identifiable group working exclusively in sound, so one is not confronted with an area of art practice labelled 'sound art' in the same way as one might be with categories such as Pop art, Minimal art, Land art, body art, video art, and so on. Another factor is the diversity of functions and roles that sound has occupied within various artists' work.

This failure of sound to construct a distinct category for itself has in fact proved an advantage, given that categories in the end become restrictive and the work circumscribed and marginalized. Therefore, in spite of the frequency with which sound has been utilized within artists' work, it remains remarkably clear of prior associations, historical precedent or weight of tradition. Sound has in fact provided an additional ingredient and strategy for the artist with the potential of addressing and informing senses other than the visual.

As a result, an increasing volume of work has emerged, particularly since the mid 1970s when, for the first time, artists could completely engage in the medium of sound through access to recording technology. This meant that the artist was in complete control.

Much of the work that evolved owed very little to conventional music with melodic structures. It was more concerned with collage, montage, overdubbing, reconstitution, juxtaposition with digital, chance or repetitive structures. The recording process offered a new context for artists, enabling them to generate artworks within a technological acoustic space, reproduced each time the recording is replayed. The work itself is therefore realized on such an occasion, rather than a reproduction or documentation of it. Furthermore, the consequent lack of dependence on a particular space or object released the artist from the associated constraints and restrictions. The mechanisms for externalizing and disseminating the work were appropriately expanded through the record, audio cassette and broadcasting. The attraction for the artist of working with recorded sound no doubt resided in its characteristic of maintaining an integrity with regard to the relationship between the moment of recording and the subsequent hearing. The psychophysical and acoustic nature of the recording itself is structurally re-entered in real time by a listener on subsequent occasions. The distancing process and 'filters' associated with other media are

absent, and the artist can therefore utilize this sense of the original experience when the work is presented.

As well as its own unique characteristics, recorded sound shares many of the characteristics of more traditional media such as painting and sculpture. Collage, juxtaposition, reduction and addition, contrast, abstraction, realism and so on are all techniques at the artist's disposal. It also has the potential to generate visual imagery in the mind of the listener. As well as defining its own space, recorded sound is also capable of defining and interacting with physical space in a sculptural sense.

Prior to the 1970s, artists' works in sound appearing in recorded form were primarily recordings of live events. This distanced the artist from the creative possibilities of the recording process itself, and the medium therefore became purely a means of retaining an acoustic event, or used as a strategy for its non-object-based nature. Artists such as Le Parc, Tinguely and Takis regarded sound as an integral consideration in their work. The sculptural object produced sound but the work could not satisfactorily be separated. The sounds produced were also dependent upon and arose out of the material nature and kinetic functioning of the work.

Given the diversity and elusive nature of what has taken place since the mid 1970s, it is not surprising that very little literature exists that draws together work carried out in this area. I also start at this point as a result of a personal involvement through the establishment of *Audio Arts* magazine on cassette in 1973. I will therefore use this period as the primary focus here.

The editorial of the November/December 1976 issue of the British art magazine *Studio International* on the theme of 'Art and Experimental Music' stated that 'although several contributions in this issue deal with aspects of music from the viewpoint of art, the main emphasis rests on experimental music in its own right'. Important though that issue of *Studio International* proved to be, it is interesting to speculate that there did not appear to be a sufficient body of new work in sound stemming from artists themselves which might have altered the focus of the issue. It did in fact reflect the attention even by the art world to musicians such as (in the USA) John Cage, Steve Reich, Philip Glass, (and in Britain) Cornelius Cardew, Gavin Bryars and Michael Nyman – an interest often not reciprocated by the music establishment.

I should, however, say that the overlap that has occurred across the boundaries of electronic music, concrete poetry and soundworks by artists is seen as healthy and mutually valuable, although at the same time it can defeat a straightforward linear analysis and easy categorization. Furthermore, such an interdependency has prevented artists' work in sound being seen as a separate area of art practice.

Parallel to that issue of *Studio International*, Bob George in New York was producing his *Two Record Anthology of Artists' Aural Work and Music: Airwaves*. This project arose directly from George's involvement with many of the artists on the compilation. These included: Vito Acconci, Laurie Anderson, Jacki Apple, Connie Beckley, Terry Fox, Jana Haimsohn, Julia Heyward, Richard Nonas and Dennis Oppenheim. This double album represented a recognition that a small yet significant number of artists were utilizing the medium of sound and regarding it with the same seriousness and creative attention as any other medium.

In his piece for one of the records, *Labyrinth Scored for the Purrs of 11 Different Cats*, Terry Fox created several layers of natural sound orchestrated into a dense, almost mechanical set of rhythmic vibrations. Laurie Anderson manipulated phrases played backwards and forwards at various speeds in her piece *Two Songs for Tape Bow Violin*, through the contact made between a strip of recorded tape attached to her violin bow; and a playback head positioned where the bridge would normally be on a violin. Amongst the 14 individuals on the two records there is no stylistic unity but rather a wide range of content and formal innovation alongside explorations into the translation of sound through recording and technology.

I do not, however, wish to suggest that the engagement was merely on a formal level – far from it. Artists were in fact making use of a medium that could convey and relate to the experience of living within and responding to the urban environment, invaded as it is by information conveyed through electronically-based media. Here was a generation of artists who for the first time had gained access to a new medium and therefore would naturally wish to explore its vocabulary.

New Music for Electronic and Recorded Media, an LP record produced in 1977, was the first anthology of women's electronic music and work in sound. It included works by Johanna M. Beyer, Annea Lockwood, Pauline Oliveros, Laurie Spiegel, Megan Roberts, Ruth Anderson and Laurie Anderson. Like *Airwaves* it brought together a new generation of composers and artists who were exploring content and audial concepts through experimentation and the manipulation of the recording process. Charles Amirkhanian, editor of the compilation, stated in the sleevenotes: 'Today we have composers willing to mix media and sonic materials in thoroughly inventive ways to achieve ends which are new sounding and often more engaging than that of the "academic" avant-garde.'

A year earlier, in 1976, Audio Arts published the cassette *Recent English Experimental Music* as a supplement to the 'Art and Experimental Music' issue of *Studio International*. This included works by Howard Skempton, Christopher Hobbs, Gavin Bryars, John White, Michael Parsons, James Lampard and Michael Nyman. Unlike the Amirkhanian record, works on the cassette were based more

on live performance (often in art galleries) using acoustic instruments. The pieces on the tape reveal both a re-evaluation of existing musical conventions with regard to structure and composition as well as a tendency to experiment with an extraordinary range of acoustic possibilities, instruments and sounds. Although not stemming directly from the visual arts, I include a reference to this record and cassette as a new generation of composers and artists alike were re-assessing established conventions with regard to sound and producing new work that extended beyond conventional boundaries.

Both in America and Europe, conceptual art had created the space for work to develop outside of the material boundaries of object making, thus allowing artists to incorporate temporal and time-based elements into their work. Furthermore, issues concerning context were also being examined by artists, leading to a wide range of non-gallery strategies, employed to externalize their practices.

In Britain, Gerald Newman was an artist alone in his engagement with recorded sound. As early as 1970 he presented a soundwork at the Lisson Gallery in London. In his works a concern for 'recorded space' translated into a concern for the physical space where the work will be realized. This is normally a darkened room or area of the gallery arranged in such a way as to minimize interruption from those not listening to the work. The elements of his works have consistently come from radio broadcasts woven together across the four tracks of his tape recorder to produce a dense layering of sound. The starting point has often been a news bulletin of major social or political consequence; yet the resultant work tends to transcend the immediate or local and address a more fundamental and substantial level of expression.

During the mid 1970s European artists did not enjoy the same access to recording technology as their American counterparts. Yet this situation was rapidly changing through the introduction of mixed-media areas into art schools. Tape recorders and synthesizers were being purchased alongside video and film equipment for students anxious to work in media more to do with the present than the past. As a result, sound quickly became an integral part of performance, mixed media and installation works. […]

William Furlong, extract from 'Sound in Recent Art', in *Audio Arts: Discourse and Practice in Contemporary Art*, ed. William Furlong (London: Academy Editions, 1994) 128–30.

Liam Gillick
Some People Never Forget (The Use of Sound in Art of the Early Nineties)//1994

... Sam Taylor-Wood dancing to the sound of machine gun fire, a film loop in a darkened basement. At first the sound is unidentifiable but the rhythm is clear. Kirsten Oppenheim luring you into an enclosed space: the treatment of seduction to an all over treacle that makes it hard to define. Lothar Hempel collaborating with the youth of Denmark, or organizing concerts in Venice. Henry Bond's videos of Techno, sound checks and drummers, using a video camera and quick-cutting the results to a soundtrack of contemporary activity. Christine Borland's tapes of the breath-gaps of a saxophonist. Played in Portugal, the result fills the largest space with the shortest moments all cut together to film a record of what happens in between. Angela Bulloch's sound chairs and mats that trigger helium laughter or the Trans-Europe Express; walking into the gallery or sitting on its chairs is enough to make the work function. Peter Fend's depositions to the United Nations, using recorded documentation in an ongoing project reassessing the geopolitical structure of our environment. Douglas Gordon's telephone calls to unwitting strangers, leading to unease and disquiet. Christian Marclay's focus upon the vinyl disc. Remixing, zipping together record sleeves. An attempt to focus on the possibility of an elderly technology. The Kelley Family using the imagery of the recent past and sending out a flyer that considers the potential of rock legend: a Californian cross-over that incorporates the work of Raymond Pettibon for Sonic Youth and others. Bethan Huws' invitation to the Bistritsa Babi. Brought to Britain and taken up to the Northumbrian coast, they sang to the waves and anyone who came. Martin Kippenberger's album of lounge music, not produced alone and not sung by him. Philippe Parreno's gallery guide and conferences in the voice of Jean-Luc Godard – the ultimate impersonation. Noritoshi Hirakawa with sounds of sex from behind closed doors. Georgina Starr whistling and crying. A video plays the face of the artist as you hear the sobs. Mat Collishaw and the ambient sound of death and dog barks. The installation is photographic and the sound backs everything up. Giorgio Sadotti leaving everything a rock group could ever need in a gallery space. As the visitors gain in confidence the sound is secretly recorded. Anya Gallaccio placing twenty-one whistling kettles linked to a compressor in an old pumping station. A painful sound that betrays a disturbing set of emotions. Richard Prince making a gold disc for Parkett. An edition in a frame for everyone to have at home. Fischli and Weiss making a rubber record that won't stand playing. It's more real than most records. Carsten Höller lecturing on sexuality and the possibilities of smell. The

scientist joins the artists and shares knowledge in such ways that it is impossible to ignore the transfer of information ...

Liam Gillick, 'Some People Never Forget (the Use of Sound in Art of the Early Nineties)', in *Audio Arts*, ed. William Furlong (London: Academy Editions, 1994) 133.

Max Neuhaus
Sound Art?//2000

From the early 1980s on there have been an increasing number of exhibitions at visual arts institutions that have focused on sound. By 1995 they had become almost an art fad. These exhibitions often include a subset (sometimes even all) of the following: music, kinetic sculpture, instruments activated by the wind or played by the public, conceptual art, sound effects, recorded readings of prose or poetry, visual artworks which also make sound, paintings of musical instruments, musical automatons, film, video, technological demonstrations, acoustic re-enactments, interactive computer programs which produce sound, etc. In short, 'Sound Art' seems to be a category which can include anything which has or makes sound and even, in some cases, things which don't.

Sometimes these 'Sound Art' exhibitions do not make the mistake of including absolutely everything under the sun, but then most often what is selected is simply music or a diverse collection of musics with a new name. This is cowardly.

When faced with musical conservatism at the beginning of the last century, the composer Edgard Varèse responded by proposing to broaden the definition of music to include all organized sound. John Cage went further and included silence. Now even in the aftermath of the timid 'forever Mozart decades' in music, our response surely cannot be to put our heads in the sand and call what is essentially new music something else – 'Sound Art'.

I think we need to question whether or not 'Sound Art' constitutes a new art form. The first question, perhaps, is why we think we need a new name for these things which we already have very good names for. Is it because their collection reveals a previously unremarked commonality?

Let's examine the term. It is made up of two words. The first is sound. If we look at the examples above, although most make or have sound of some sort, it is often not the most important part of what they are – almost every activity in the world has an aural component. The second word is art. The implication here

is that they are not arts in the sense of crafts, but fine art. Clearly regardless of the individual worth of these various things, a number of them simply have little to do with art.

It's as if perfectly capable curators in the visual arts suddenly lose their equilibrium at the mention of the word sound. These same people who would all ridicule a new art form called, say, 'Steel Art' which was composed of steel sculpture combined with steel guitar music along with anything else with steel in it, somehow have no trouble at all swallowing 'Sound Art'.

In art, the medium is not often the message.

If there is a valid reason for classifying and naming things in culture, certainly it is for the refinement of distinctions. Aesthetic experience lies in the area of fine distinctions, not the destruction of distinctions for promotion of activities with their least common denominator, in this case sound. Much of what has been called 'Sound Art' has not much to do with either sound or art.

With our now unbounded means to shape sound, there are, of course, an infinite number of possibilities to cultivate the vast potential of this medium in ways which do go beyond the limits of music and, in fact, to develop new art forms. When this becomes a reality, though, we will have to invent new words for them. 'Sound Art' has been consumed.

Max Neuhaus, 'Sound Art?', in *Volume: Bed of Sound* (New York: P.S. 1, 2000) n.p.

Paul DeMarinis
On Sonic Spaces//1997

Much of my recent work examines the archaeology of sound recording in an effort to explore the hidden dimensions of technology and culture as they intertwine within and among our perceptions of sound, memory and communication.

In his 'Ninth Bridgewater Treatise Fragment' of 1838, Charles Babbage, commonly cited as an ancestor of digital media, portrays a world filled with non-dissipative sound waves. Each sound, as it is created, propagates amongst the hard Newtonian billiard balls of matter, adding to an eternal din from which the cosmic maker, at the end of his creation, can discern every act, word and deed. By this eternity-windowed FFT,[1] it is assured that no good will go unrewarded at the end of time, and no evil unpunished. The atmosphere is in effect a cosmic recording medium, and the hush we hear in still air holds, encoded, the words of all time.

The invention of the phonograph a few decades later presented a different set of observations: that of multiplying sounds. And not merely as direct copies. The earliest phonographers discovered that when they recorded a sound, upon playback three sounds were heard. The first sound they heard was of course the sound they intended to record, perhaps with some distortions but always faithful and accurate enough to satisfy, for a while. In fact the similitude of the first faint scratchings on foil and wax was so startlingly faithful at the time that Edison was accused of perpetrating a hoax when the 'sound-writer' was displayed in Paris in 1878.

The second set of sounds heard coming from the horn of the phonograph were the inadvertent sounds of the environment, which rode along unnoticed during the recording process. These sounds had been little noticed before and simultaneously presented a set of problems to be solved and the discovery of a new world to be explored – the vast variety of forms of sound art, soundscape, sound sculpture and sound design which have been discovered in this century and are still being charted. As far as the solution of the problem of interfering environmental sound is concerned, the relative isolation of the recording studio and the absolute numerical isolation of direct synthesis often cause their sounds to go begging when it comes to combining or contexting them with other sounds.

But a third sound was heard as well – the sound of the recording apparatus itself – and this presented both a subtler set of problems and a new and paradoxical kind of territory of its own. The rumblings of the mechanism, too, register upon the wax, and the texture and grain of the wax has its own raspy voice, a voice that sang along with every diva and accompanied every chance sound passing by the microphone. Surface noise, channel noise, the song of long ago and far away, presented a gift in disguise to the recordist and artist alike. This noise is an audible indication that information is being sent. In effect this 'noise-floor' is the sound of silence of any given channel.

Theodor Adorno noticed the new role that surface noise was taking in the sound cinema as a backdrop for continued attention and suspended disbelief and coined a term for it: *Horspielstreifen*, or 'hear-strip' – 'the delicate buzz during a film of recorded silence whose purpose it is subliminally to confirm the presence of a reproduction underway, thereby establishing the minimum existence of some type of presence' (Douglas Kahn).

In earlier times silence had to be created before music could fill it. In various musical cultures, a variety of sounds and figurations assumed the role of creating the presence of silence – the omnipresent drone of the tamboura in Indian music is an example. In Western classical music, the Alberti bass[2] served European music well in this role for over a century, and its variations were still at work in the century that created mechanical recording. [...]

With little variation, the bourdon basses,[3] the quiet repetitive figures, and pianissimo trillings created and sustained an artificial background of figurative silence while keeping the listeners rapt in attention.

With the advent of surface noise and channel noise as an omnipresent musical experience, these representations of silence gradually disappeared. That is, they became foreground features of the music and took on a life of their own. Many examples can be heard in the so-called minimal style of works by Philip Glass and others.

Popular music continued compressing, normalizing and filling every moment and crevice of the groove with sound, perhaps in order to suppress a feared existential confrontation with the surface noise. At the same time, almost in opposition, classic and academic circles elevated a new, idealized acoustic silence to the very highest position in the pantheon of sounds. The work and writings of John Cage come immediately to mind. The various (and ambiguous) meanings he ascribed to the word silence in his writings, as well as his very ambivalent position on recording itself attest to the continuing discomfort composers and sound artists were having with the sounds of surface noise. It was, so to speak, 'a scratch that no needle could itch'. [...]

1 [FFT (fast Fourier transform) is an algorithm used in computing for its speed.]

2 [Alberti bass, named after Domenico Alberti (1710–40) is a form of accompaniment in which chords follow the repeating sequence: lowest, highest, middle, highest.]

3 [A 'bourdon bass' denotes the lowest types of bass note, such as the drone of a bagpipe.]

Paul DeMarinis, transcript from paper presented at the International Conference on Auditory Displays, Palo Alto, California (3 November 1997).

W.J.T. Mitchell
There Are No Visual Media//2005

'Visual media' is a colloquial expression used to designate things such as television, film, photography and painting, etc. But it is highly inexact and misleading. On closer inspection, all the so-called visual media turn out to involve the other senses (especially touch and hearing). All media are, from the standpoint of sensory modality, 'mixed media'. The obviousness of this raises two questions: (1) Why do we persist in talking about some media as if they were exclusively visual? Is this just a shorthand for talking about visual *predominance*? And if so, what does 'predominance' mean? Is it a quantitative issue (*more* visual information than aural or tactile?) or a question of qualitative perception, the sense of things reported by a beholder, audience, viewer-listener? (2) Why does it matter what we call 'visual media'? Why should we care about straightening out this confusion? What is at stake? [...]

From the standpoint of art history in the wake of postmodernism, it seems clear that the last half-century has undermined decisively any notion of purely visual art. Installations, mixed media, performance art, conceptual art, site-specific art, Minimalism and the often-remarked return to pictorial representation have rendered the notion of pure opticality a mirage that is retreating in the rear-view mirror. For art historians today, the safest conclusion would be that the notion of a purely visual work of art was a temporary anomaly, a deviation from the much more durable tradition of mixed and hybrid media. [...]

With regard to the senses and media, Marshall McLuhan glimpsed this point some time ago when he posited different 'sensory ratios' for different media. (*Understanding Media: The Extensions of Man*, 1964.) As a shorthand, McLuhan was happy to use terms such as 'visual' and 'tactile media', but his surprising claim (which has been mostly forgotten or ignored) was that television, usually taken to be the paradigmatically visual medium, is actually a *tactile* medium: 'The TV image ... is an extension of touch' (*Understanding Media*, 354), in contrast to the printed word which, in McLuhan's view, was the closest that any medium has come to isolating the visual sense. However, McLuhan's larger point was definitely not to rest content with identifying specific media with isolated, reified sensory channels, but to assess the specific mixtures of specific media. He may call the media 'extensions' of the sensorium, but it is important to remember that he also thought of these extensions as 'amputations' and he continually stressed the dynamic, interactive character of mediated sensuousness (*Understanding Media*, 42). His famous claim that electricity was making possible

an extension (and amputation) of the 'sensory nervous system' was really an argument for an extended version of the Aristotelian concept of a *sensus communis*, a coordinated (or deranged) 'community' of sensation in the individual, extrapolated as the condition for a globally extended social community, the 'global village'.

The specificity of media, then, is a much more complex issue than reified sensory labels such as 'visual', 'aural' and 'tactile'. It is, rather, a question of specific sensory ratios that are embedded in practice, experience, tradition and technical inventions. We also need to be mindful that media are not *only* extensions of the senses, calibrations of sensory ratios, they are also symbolic or semiotic operators, complexes of sign-functions. If we come at media from the standpoint of sign theory, using Peirce's elementary triad of icon, index and symbol (signs by resemblance, by cause and effect or 'existential connection', and conventional signs dictated by a rule), then we also find that there is no sign that exists in a 'pure state', no pure icon, index or symbol. Every icon or image takes on a symbolic dimension the moment we attach a name to it, an indexical component the moment we ask how it was made. Every symbolic expression, down to the individual letter of the phonetic alphabet, must also resemble every other inscription of the same letter sufficiently to allow iterability, a repeatable code. The symbolic depends upon the iconic in this instance. McLuhan's notion of media as 'sensory ratios' needs to be supplemented with a concept of 'semiotic ratios', specific mixtures of sign-functions that make a medium what it is. Cinema, then, is not just a ratio of sight and sound, but of images and words and of other differentiable parameters such as speech, music and noise.

The claim that there are no visual media is really just the opening gambit that would lead toward a new concept of media taxonomy, one that would leave behind the reified stereotypes of 'visual' or 'verbal' media and produce a much more nuanced, highly differentiated survey of types of media. [...]

If there is any shred of doubt lingering that there are no visual media, that this phrase needs to be retired from our vocabulary or completely redefined, let me clinch the case with a brief remark on unmediated vision itself, the 'purely visual' realm of eyesight and seeing the world around us. What if it turned out that vision itself was not a visual medium? What if, as Gombrich noted long ago, the 'innocent eye', the pure, untutored optical organ, was in fact blind? (*Art and Illusion*, 1961) Of course, this is not an idle thought but actually a firmly established doctrine in the analysis of the visual process as such. Ancient optical theory treated vision as a thoroughly tactile and material process, a stream of 'visual fire' and phantom 'eidola' flowing back and forth between the eye and the object (see David C. Lindberg, *Theories of Vision from al-Kindi to Kepler*, 1976). Descartes famously compared seeing to touching in his analogy of the blind man with two

walking sticks. Vision, he argued, must be understood as simply a more refined, subtle and extended form of touch, as if a blind man had very sensitive walking sticks that could reach for miles. Bishop Berkeley's *New Theory of Vision* argued that vision is not a purely optical process, but involves a 'visual language' requiring the coordination of optical and tactile impressions in order to construct a coherent, stable visual field. Berkeley's theory was based in the empirical results of cataract operations that revealed the inability of blind persons whose sight had been restored after an extended period to recognize objects until they had done extensive coordination of their visual impressions with touch. These results have been confirmed by contemporary neuroscience, most famously by Oliver Sacks' revisiting of the whole question in 'To See and Not See', a study of restored sight that exposes just how difficult it is to learn to see after an extended period of blindness ('To See and Not See: A Neurologist's Notebook', *New Yorker*, 10 May 1993). Natural vision itself is a braiding and nesting of the optical and tactile.

The sensory ratio of vision as such becomes even more complicated when it enters into the region of emotion, affect and intersubjective encounters in the visual field – the region of the 'gaze' and the scopic drive. Here we learn (from Sartre in *Being and Nothingness*, for example) that typically, the gaze (as the feeling of being seen) is activated not by the eye of the other, or by any visual object, but by the invisible space (the empty, darkened window) or even more emphatically by sound – the creaking board that startles the voyeur, the 'hey you' that calls to the Althusserean subject. Lacan further complicates this issue by rejecting even the Cartesian model of tactility in 'The Line and the Light', replacing it with a model of fluids and overflow, one in which pictures, for example, are to be drunk rather than seen, painting is likened to the shedding of feathers and the smearing of shit and the principal function of the eye is to overflow with tears, or to dry up the breasts of a nursing mother (*Four Fundamental Concepts of Psychoanalysis*, 1964). There are no purely visual media because there is no such thing as pure visual perception in the first place.

Why does all this matter? Why quibble about an expression, 'visual media', that seems to pick out a general class of things in the world, however imprecisely? Is this not like someone objecting to lumping bread, cake and cookies under the rubric of 'baked goods'? Actually, no. It is more like someone objecting to putting bread, cake, chicken, a quiche and a cassoulet into the category of 'baked goods' because they all happen to go into the oven. The problem with the phrase, 'visual media', is that it gives the illusion of picking out a class of things about as coherent as 'things you can put in an oven'. Writing, printing, painting, hand gestures, winks, nods and comic strips are all 'visual media' and this tells us next to nothing about them. So my proposal is to put this phrase into quotation marks for a while, to preface it by 'so-called', in order to open it up to fresh investigation. And in fact

that is exactly what I think the emergent field of visual culture has been all about in its best moments. Visual culture is the field of study that refuses to take vision for granted, that insists on problematizing, theorizing, critiquing and historicizing the visual process as such. It is not merely the hitching of an unexamined concept of 'the visual' onto an only slightly more reflective notion of culture – i.e. visual culture as the 'spectacle' wing of cultural studies. A more important feature of visual culture has been the sense in which this topic requires an examination of resistance to purely culturalist explanations, to inquiries into the nature of visual *nature* – the sciences of optics, the intricacies of visual technology, the hardware and software of seeing. [...]

The break-up of the concept of 'visual media' is surely one way of being tougher on ourselves. And it offers a couple of positive benefits. I have suggested already that it opens the way to a more nuanced taxonomy of media based in sensory and semiotic ratios. But most fundamentally, it puts 'the visual' at the centre of the analytic spotlight rather than treating it as a foundational concept that can be taken for granted. Among other things it encourages us to ask why and how 'the visual' became so potent as a reified concept. How did it acquire its status as the 'sovereign' sense, and its equally important role as the universal scapegoat, from the 'downcast eyes' that Martin Jay has traced, to Debord's 'society of the spectacle', Foucauldian 'scopic regimes', Virilian 'surveillance' and Baudrillardian 'simulacra'? Like all fetish objects, the eye and the gaze have been both over- and underestimated, idolized and demonized. Visual culture at its most promising offers a way to get beyond these 'scopic wars' into a more productive critical space, one in which we would study the intricate braiding and nesting of the visual with the other senses, reopen art history to the expanded field of images and visual practices which was the prospect envisioned by Warburgean art history, and find something more interesting to do with the offending eye than plucking it out. It is because there are no visual media that we need a concept of visual culture.

1 Marshall McLuhan, *Understanding Media: The Extensions of Man* (New York: McGraw Hill, 1964); reprinted edition (Cambridge, Massachusetts: The MIT Press, 1994).

W.J.T. Mitchell, extracts from 'There Are No Visual Media', *Journal of Visual Culture*, vol. 4, no. 2 (2005) 257–8; 260; 261; 263–6.

Christoph Cox
From Music to Sound: Being as Time in the
Sonic Arts//2006

In the summer of 1979, The Kitchen, New York's centre for the experimental arts, mounted a festival titled 'New Music, New York'.[1] The week-long programme presented performances by Philip Glass, Meredith Monk, Tony Conrad, George Lewis, Michael Nyman and others, and marked the coming-of-age of minimalist and experimental music.[2] In the Spring of 2004, The Kitchen and a host of other New York arts institutions celebrated the 25th anniversary of that event with a festival titled 'New Sound, New York', billed as 'a citywide festival of performances, installations and public dialogues featuring new works by sound artists who are exploring fresh connections among music, architecture and the visual arts'.[3] The shift in title – from *music* to *sound* – is emblematic. For, over the past quarter century, 'sound' has gradually displaced 'music' as an object of cultural fascination. Not only has 'sound art' become a prominent field of practice and exhibition, embraced by museums and galleries across the globe, the academy has also witnessed an explosion of interest in auditory history and anthropology led by social scientists who have turned their attention to sound as a marker of temporal and cultural difference.[4] Within the field of music itself, composers, producers, and improvisers have become increasingly attracted to the broader sonic domains against which music has always defined itself: noise, silence, and non-musical sound.

It is common to think of music as a subcategory of sound. According to this view, sound encompasses the entire domain of auditory phenomena, while music is a narrower domain delimited by some selection and organization of sounds. However compelling this ordinary view may be, I want to propose that we conceive of this relationship differently, that, instead of a mere difference of degree we think of music and sound as differences of kind marked by their different relationships to being and time. Taking my terms from Friedrich Nietzsche and Henri Bergson, I want to argue that the shift from 'music' to 'sound' marks an ontological shift from *being* to *becoming* and a temporal shift from *time* (*le temps*) to *duration* (*la durée*).

My argument here will be both conceptual and historical. Drawing on two key moments in the history of sonic experimentation over the past half-century, I want to show how music has given way to sound, and to offer some philosophical speculations on sound, time and being. [...]

John Cage: Toward Becoming, Duration and the Virtual

With this philosophical framework in place, I now want to return to my initial suggestion about the shift from music to sound in contemporary culture. I do not have the space here to tell this story in full. So I will simply draw attention to two key turning points. The first of these occurs in the 1950s with John Cage and his circle. Cage, I think, inaugurates a shift in music akin to the philosophical shift prompted by Nietzsche, Bergson and Deleuze. For Cage inaugurates a 'deconstruction of music'; and he does so precisely with reference to becoming, duration and the virtual.

In a lecture delivered at Darmstadt in 1958, Cage lays out what he takes to be the essential formal aspect of European art music, the production of 'time-objects': 'the presentation of a whole as an object in time having a beginning, a middle and an ending, progressive rather than static in character, which is to say possessed of a climax or climaxes and in contrast a point or points of rest'.[5] Such musical 'time-objects' are cut by the composer from the flux of becoming and duration. In contrast with this open flux, these musical works are bounded and fixed in the form of a score that ensures the identity of the work over time and that determinately regulates the behaviour of performers whose role is to carry out the instructions of the composer and score.

One can imagine a number of criticisms of this notion of music, for example that it places the performer in the role of a mere copyist or that, for audiences, such works could soon become predictable and dull. Yet Cage's objections are of another sort. They are, precisely, ontological. Cage objects to the notion of music as a *being* and insists that it become a *becoming* – 'a process essentially purposeless', 'a process the beginning and ending of which are irrelevant to its nature'.[6] That is, Cage argues that music should come into accord with the post-theological world in which we live, a world that is fundamentally *open*, without origin, end or purpose. This is the meaning of Cage's famous imperative: 'art must imitate nature in her manner of operation.'[7] That is, art – music – must be a becoming not a being, duration not time.

This, of course, is the genius of Cage's *4'33"* (1952), which he consistently deemed his most important and successful piece.[8] At issue in *4'33"* is a confrontation between *le temps* and *la durée*. The title of the piece explicitly refers to the spatialized time of the clock – a fact Cage underscores by noting that the title could also be read 'four feet, thirty-three inches'.[9] And, of course, the performance of the piece is regulated by a stopwatch. Yet the arbitrariness of this temporal scope (determined through chance procedures) and the sonic experience it discloses indicates that *4'33"* is after another experience of time: the time of duration and the virtual, into which it opens an aural window. Beyond music, it opens up the infinite and continuously unfolding domain of worldly sound.

The sequel to this work, *0'00"* (1962) further radicalizes this argument about temporality. The piece calls for 'nothing but the continuation of one's daily work, whatever it is, ... done with contact microphones, without any notion of concert or theatre or the public'. 'What the piece tries to say', continues Cage, 'is that everything we do is music, or can become music through the use of microphones; so that everything I'm doing, apart from what I'm saying, produces sound.' Again, Cage includes the temporal marker. But, at the same time, he reduces it to zero, puts it under erasure. 'I'm trying to find a way to make music that does not depend on time', he said of the piece. '[I]t is precisely this capacity for measurement that I want to be free of.'[10]

The aim of *4'33"* and *0'00"*, then, is to open time to the experience of duration and to open musical experience to the domain of sound. It is also to open human experience to something beyond it: the non-human, impersonal flow that precedes and exceeds it. 'I think music should be free of the feelings and ideas of the composer', Cage remarks. 'I have felt and hoped to have led other people to feel that the sounds of their environment constitute a music which is more interesting than the music which they would hear if they went into a concert hall'.[11] Cage urges the composer 'to give up the desire to control sound, clear his mind of music, and set about discovering means to let sounds be themselves rather than vehicles for man-made theories or expressions of human sentiments.'[12] 'Music is permanent', he writes, 'only listening is intermittent.'[13]

'Chance' and 'silence' are Cage's transports into this transcendental or virtual domain.[14] These two strategies allow the composer to bypass his subjective preferences and habits in order to make way for sonic conjunctions and assemblages that are not his own – that, to quote Deleuze, are 'pre-individual' and 'impersonal'. And 'silence', for Cage, names not the absence of sound (an impossibility, he points out), but the absence of intentional sound, an attention to the sonic life of the world or nature. *4'33"* remains Cage's most elegant attempt along these lines. But so much of Cage's work – his work with radios in the 1950s, for example – reveals that he conceived of sound (natural and cultural alike) as a ceaseless flow, and composition as the act of drawing attention to or accessing it.

Sound Art and the Experience of Duration

Beginning from Cage, one could go on to show how the post-Cagean legacy furthered this reconception of being, time, music and sound. Episodes in this historical story might include Morton Feldman's efforts to reclaim 'time in its unstructured existence'; musical minimalism's interest in the 'pure sound-event' (Glass) and in what Deleuze calls 'non-pulsed time'; experimental music's rejection of a closed, physical model of music in favour of an open, biological model; the eradication of the time-object and the embrace of ephemerality in

free jazz and improvised music; and DJ culture's dissolution of the record-object into a continuous and anonymous sonic flux.[15] Such a story would show how, within the domain of 'music' itself, the past half-century has witnessed a general shift from *music* to *sound*, from the activity of composition and the fixing of sound in space and time to a notion of *sound as time*, as flow, duration, becoming.

Yet, however rich and important were the reconceptions of sonic being and time undertaken by Feldman, minimalism, experimental music, improvised music and DJ Culture, they remained somehow bound to the discourse and practice of music. The emergence of sound art in the early 1970s – and its proliferation over the past decade or so – signals a more profound break with this discourse and practice.[16] Withdrawing from the space of the concert hall and renouncing the rituals of musical performance and musical listening, sound art affirms the idea of sound as an impersonal flow. As such, it constitutes the most thoroughgoing acceptance of the challenge presented by Cage's *4'33"* and *0'00"*.

The discourse and practice of sound art has tended to focus on issues of space, site and architecture. From Alvin Lucier's *I am Sitting in a Room* (1971) and Max Neuhaus' 'Place Works' to Achim Wollscheid's projects for public buildings and Toshiya Tsunoda's exploration of environmental vibrations, sound art practice has concerned itself with the resonances of sound in space. And, as attested by recent volumes such as *Site of Sound: Of Architecture and the Ear* and *Surface Tension: Problematics of Site*, sound art discourse has followed suit.[17] As such, it has ignored the profound reconception of time fostered by sound art.

For decades now, one of sound art's founding fathers, Max Neuhaus, has contrasted his early career as a musician with his later sound art practice by drawing a distinction between time and space. In a programme note from 1974, Neuhaus writes:

Traditionally composers have located the elements of a composition in time. One idea that I am interested in is locating them, instead, in space, and letting the listener place them in his own time. I am not interested in making music exclusively for musicians or musically initiated audiences. I am interested in making music for people.[18]

This idea is echoed in Neuhaus' introduction to his collection of 'Place Works':

Communion with sound has always been bound by time. Meaning in speech and music appears only as their sound events unfold word by word, phrase by phrase, from moment to moment. The works collected in this volume share a different fundamental idea – that of removing sound from time, and setting it, instead, in place.[19]

Finally, reflecting on his permanent sound installations, Neuhaus recently told an interviewer: 'The important idea about this kind of work is that it's not music. It doesn't exist in time. I've taken sound out of time and made it into an entity'.[20]

Neuhaus casts the music/sound art dichotomy in terms of time/space – a distinction reiterated by younger sound artists such as Stephen Vitiello.[21] Yet the time/space distinction is a red herring. The real distinction is between two kinds of time: *pulsed time* (the time of music and meaning) and *unpulsed time* or *duration* (the time of sound matter itself). The 1974 passage suggests just this distinction, contrasting the time of musical composition with the listener's 'own time', and distinguishing the time of 'musicians or musically initiated audiences' from the time of ordinary 'people'. Here Neuhaus' discourse converges with that of Morton Feldman, who dedicated himself to liberating duration from clock time. Alluding to Bergson, Feldman remarked: 'I am not a clockmaker. I am interested in getting to Time in its unstructured existence'. I feel that the idea is more to let Time be, than to treat it as a compositional element. No – even to construct with Time won't do. Time simply has to be left alone.' Recalling Cage, he concluded: 'not how to make an object, not how this object exists by way of Time, *in* Time, or *about* Time, but how this object exists *as* Time. Time regained, as Proust referred to his work.'[22]

Dispensing with the protocols of performance and composition, sound art is better equipped than music to foster this relationship to time. Take for example, Neuhaus' most famous permanent installation, *Times Square* (1977–92 and 2002 to the present), a stream of rich metallic drones broadcast from deep inside a ground vent in New York City's busiest district. Audible but unobtrusive, the piece blends with and subtly alters the sonic environment; and in so far as that environment is ever-shifting (dawn, the morning commute, rush hour, midnight), the installation is new each moment. Though continuous, *Times Square* is experienced in temporal slices that serve as openings onto a flow of duration of which we are a part but that also surpasses us. In this way, *Times Square* (which we might read as 'time's square') presents an indefinite extension of 4'33" and, even more fully than that piece, affirms Cage's dictum: 'music [or sound] is permanent; only listening is intermittent.'

This relationship between sound and duration is equally disclosed in recent projects such as Christina Kubisch's *Electrical Walks* (2003 to the present), which invite listeners to wander a territory wearing headphones designed to receive electromagnetic signals. Where Janet Cardiff's audio walks unfold all the pulsed time of narrative and composition, directing the movements of listeners via a pre-recorded soundtrack, Kubisch's walks operate very differently and bear a very different relationship to time and space. Open-ended and uncomposed, the *Electrical Walks* simply provide listeners the means by which to tap into the

invisible currents of electromagnetic sound that flow through the spaces of modern life. Such an experience not only provides a *figure* for duration, the continuous, open-ended and qualitatively heterogeneous flow of time. It places us within duration itself.

Toward a Sonic Materialism

I have tried to show that over the course of the last half-century – and particularly in the past decade – we have witnessed an important shift from the traditional conception of *music* to a notion of *sound-itself*. I suggested that we think this shift not only as the movement from a narrower domain of music to a broader domain of sound, but as marking a shift in our relationships to being and time. Music, I argued, constitutes a domain of beings, time-objects that spatialize sound and that mark a pulsed time, the tempo of narrative and the subject, forms with beginnings, middles and ends. I argued that sound reveals to us something different: not being *in* time but being *as* time, what Nietzsche calls 'becoming' and Bergson 'duration'. And I tried to show that 'sound' constitutes a kind of virtual or transcendental dimension, a vast field of sonic forces and fluxes in relation to which any particular sonic environment or piece of music is a mobile section. Music, it seems to me, tends to foreclose this domain and this experience, offering the illusion of being, autonomy, boundedness, fixity and human invention. Sound art, on the other hand, opens up this domain, giving us a glimpse of the virtual whole.

Extending the analyses of Gilles Deleuze and Manuel De Landa, I want to urge that we think of sound as an anonymous, non-human and impersonal flux, a flow or becoming akin to geological flows, flows of genetic material, flows of language – natural fluxes with different rhythms and speeds.[23] To be sure, music forms a part of this flow. But it is only a part of a more general sonic becoming. On this model, the analysis of sound and music would not concern itself with the examination of *forms* (the organization of pre-given, pre-individuated entities: pitches, scales, meters, works, etc.) but with the investigation of fluid matter distinguished by different speeds, forces and intensities. Cage's *4'33"*, Neuhaus' *Times Square*, Kubisch's *Electrical Walks* and so much of contemporary sound art invite us to think of sound in these materialist terms – sound as a continuous and heterogeneous fluid material that makes audible the immanence of being and time.

1 A few sentences in this essay are drawn from previous publications: the introduction to *Audio Culture: Readings in Modern Music*, ed. Christoph Cox and Daniel Warner (New York and London: Continuum, 2004) xiii-xvii; the original English version of 'Wie wird Musik zu einem organlosen Körper? Gilles Deleuze und experimentelle Elektronika', *Soundcultures: Über digitale und*

elektronische Musik, ed. Marcus S. Kleiner and Achim Szepanski (Frankfurt am Main: Suhrkamp verlag) 162–93; and 'Nietzsche, Dionysus and the Ontology of Music', *A Companion to Nietzsche*, ed. Keith Ansell Pearson (Oxford: Blackwell, 2006).

2 Highlights from the festival have recently been released on CD: *From the Kitchen Archives: New Music New York 1979* (Orange Mountain Music, 2004).

3 http://www.thekitchen.org/04S_april.html

4 A sampling of such work can be found in *Hearing History: A Reader*, ed. Mark M. Smith (Athens, Georgia: University of Georgia Press, 2004) and *The Auditory Culture Reader*, ed. Michael Bull and Les Back (Oxford: Berg, 2003).

5 Sanford Kwinter, *Architectures of Time* (Cambridge, Massachusetts: The MIT Press, 2001) 4.

6 [footnote 13 in source] Cage, 'Composition as Process II: Indeterminacy', *Silence* (Hanover, New Brunswick: Wesleyan University Press, 1961) 38 (*Audio Culture*, 182–3).

7 [14] See, for example, Cage's 'Introduction to Themes & Variations', *Audio Culture*, 221.

8 [15] See, for example, *Conversing with Cage*, 2nd edition, ed. Richard Kostelanetz (London and New York: Routledge, 2003) 70–71; 86.

9 [16] Ibid., 70.

10 [17] Ibid., 74.

11 [18] Ibid., 70.

12 [19] Cage, 'Experimental Music', *Silence*, 10.

13 [20] Cage, 'Introduction to Themes & Variations', *Audio Culture*, 224. Compare Gilles Deleuze and Felix Guattari: 'music is not the privilege of human beings: the universe, the cosmos, is made of refrains.' *A Thousand Plateaux*, trans. Brian Massumi (Minneapolis: University of Minnesota Press, 1987) 309.

14 [21] Note that, following Kant, Deleuze distinguishes between the 'transcendental' and 'the transcendent'. The former names the conditions for the possibility of actual sensual experience, while the latter names what transcends sensual experience altogether. The description of a 'transcendental' or 'virtual' field that precedes the subject occupied Deleuze throughout his career, from *The Logic of Sense*, trans. Mark Lester (New York: Columbia University Press, 1990) 100–117 to 'Immanence: A Life', in *Pure Immanence*, trans. Anne Boyman (New York: Zone Books, 2001) 25–33. In the latter text, Deleuze elaborates on the distinction between 'the transcendental' and 'the transcendent'.

15 [22 and 23] Feldman, 'Between Categories', *Give My Regards to Eighth Street*, (Boston, Massachusetts: Exact Change, 2000) 87. See Philip Glass quoted in Wim Mertens, *American Minimal Music*, trans. J. Hautekiet (London: Kahn and Averill, 1983) 90. Deleuze himself associates 'non-pulsed time' with Cage and Minimalism. See *A Thousand Plateaux*, 267 and my 'Wie wird Musik zu einem organlosen Körper?' 173–7.

16 [24] 'Sound art' is a notoriously slippery and contested term. By this term, I mean, first and foremost, works of art that focus attention on the materiality and transmission of sound, and that are presented in galleries, museums and public spaces. This definition is not intended to be exhaustive or rigorously precise but merely heuristic.

17 [25] *Site of Sound: Of Architecture and the Ear*, ed. Steve Roden and Brandon LaBelle (Los Angeles: Errant Bodies Press, 1999); *Surface Tension: Problematics of Site*, ed. Ken Ehrlich and Brandon LaBelle (Los Angeles: Errant Bodies Press, 2003).

18 [26] Max Neuhaus, 'Program Notes', *Sound Works, Volume I: Inscription* (Ostfildern Ruit: Edition Cantz, 1994) 34.

19 [27] http://www.max-neuhaus.info/soundworks/vectors/place

20 [28] Max Neuhaus quoted in Alicia Zuckerman, 'Max Neuhaus' Times Square', *Arts Electric* (2002): http://www.arts-electric.org/articles0203/020530.neuhaus.html. Now found at http://www.arts-electric.org/stories/2002/020530_neuhaus.html

21 [29] See the conversation between Vitiello and Marina Rosenfeld in *NewMusicBox* (1 March 2004): http://www.newmusicbox.org/article.nmbx?id=2414 and 'Audio Files: Sound Art Now: An Online Symposium' www.artforum.com (April/May 2004).

22 [30] Feldman, 'Between Categories', *Give My Regards to Eighth Street*, 85–8.

23 [31] See Manuel De Landa, *A Thousand Years of Nonlinear History* (New York: Zone Books, 1997).

Christoph Cox, extracts from essay first published in German as 'Von Musik zum Klang: Sein als Zeit in der Klangkunst', in *Sonambiente Berlin: Klang Kunst/Sound Art*, ed. Helga de la Motte-Haber, et al. (Heidelberg: Kehrer verlag, 2006) 214–15; 218–23.

Ulay

I sit with wide open mouth in front of
the guests.

There is the sound of saliva being
sucked out.

The sound stops, I close my mouth.

I sew my mouth shut and sit.

I leave.

Marina Abramovic and Ulay, from *Talking about similarity*, 1976

Jacques Attali
Noise//1976

For twenty-five centuries Western knowledge tried to look upon the world; it failed to understand that the world is not for beholding. It is for hearing; it is not legible but audible. Our science has always wanted to monitor, measure, abstract and castrate meaning, forgetting that death alone is silent and that life is full of noise – work noise, human noise, animal noise. Noise bought, sold or prohibited. Nothing essential happens in the absence of noise.

Today, our sight is dimmed and no longer sees our future, having constructed a present out of abstraction, non-sense and silence. Now we must learn to judge society more by its sounds, its art, its festival, than by its statistics. By listening to noise, we can better understand where the folly of humanity and its calculations is leading us, and what hopes it is still possible to have. [...]

Among sounds, music as autonomous production is a recent invention. Even as late as the eighteenth century it was effectively submerged within a larger totality. Ambiguous and fragile, ostensibly secondary and of minor importance, it has invaded our world and daily life. Today it is unavoidable, as if, in a world now devoid of meaning, background noise were increasingly necessary to give people a sense of security. And today wherever there is music there is money: looking only at the sums, in some countries more is spent on music than on reading, drinking or keeping clean. Music, an immaterial pleasure turned commodity, now heralds a society of the sign, the immaterial for sale, the social relation unified in money.

It heralds, for it is *prophetic*. It has always been in its essence a herald of times to come. Thus, as we shall see, if it is true that *the political organization of the twentieth century is rooted in the political thought of the nineteenth, the latter is almost entirely present in embryonic form in the music of the eighteenth century.*

In the last twenty years, music underwent yet another transformation, forecasting a change in social relations. Already, material production is supplanted by the exchange of signs. Showbusiness, the star system and the hit parade signal a profound institutional and cultural colonization. Music makes mutations audible. It obliges us to invent categories and new dynamics to regenerate social theory, which today has become crystallized, entrapped, moribund.

Music, as a mirror of society, calls this truism to our attention: society is much more than economistic categories, Marxist or otherwise, would have us believe.

Music is more than an object of study: it is a way of perceiving the world; a tool of understanding. Today no theorizing accomplished through language or mathematics any longer suffices; it is incapable of accounting for what is essential

in time – the qualitative and the fluid, threats and violence. In the face of the growing ambiguity of the signs being used and exchanged, the most well established concepts are crumbling and every theory is wavering. The available representations of the economy, trapped within frameworks erected in the seventeenth century or, at latest, towards 1850, can neither predict, describe nor even express what awaits us.

It is thus necessary to imagine radically new theoretical forms in order to speak to new realities. Music, the organization of noise, is one such form. It reflects the manufacture of society; it constitutes the audible waveband of the vibrations and signs that make up society. *An instrument of understanding, it prompts us to decipher a sound form of knowledge.*

My intention here is thus not only to theorize *about* music, but to theorize *through* music. The result will be unusual and unacceptable conclusions about music and society, the past and the future. That is perhaps why music is so rarely listened to and why – as with every facet of social life for which the rules are breaking down (sexuality, the family, politics) – it is censored; people refuse to draw conclusions from it.

In [*Noise: The Political Economy of Music*], music will be presented as originating in ritual murder, of which it is a simulacrum, a minor form of sacrifice heralding change. We will see that in this capacity it was an attribute of religious and political power, that it signified order, but also that it prefigured subversion. Then, after entering into commodity exchange, it participated in the growth and creation of capital and the spectacle. Fetishized as a commodity, music is illustrative of the evolution of our entire society: de-ritualize a social form, repress an activity of the body, specialize its practice, sell it as a spectacle, generalize its consumption, then see to it that it is stockpiled until it loses its meaning. Today, music heralds – regardless of what the property mode of capital will be – the establishment of a society of repetition in which nothing will happen any more. But at the same time, it heralds the emergence of a formidable subversion, one leading to a radically new organization never yet theorized, of which self-management is but a distant echo.

In this respect, music is not innocent: unquantifiable and unproductive, a pure sign that is now *for sale*, it provides a rough sketch of the society under construction, a society in which the informal is mass-produced and consumed, in which difference is artificially recreated in the multiplication of semi-identical objects.

No organized society can exist without structuring differences at its core. No market economy can develop without erasing those differences in mass production. The self-destruction of capitalism lies in this contradiction, in the fact that music leads a deafening life: an instrument of differentiation, it has become a locus of repetition. It itself becomes undifferentiated, goes anonymous in the commodity, and hides behind the mask of stardom: it makes audible what is essential in the

contradictions of the developed societies: *an anxiety-ridden quest for lost difference, following a logic from which difference is banished.*

Art bears the mark of its time. Does that mean that it is a clear image? A strategy for understanding? An instrument of struggle? In the codes that structure noise and its mutations we glimpse a new theoretical practice and reading: *establishing relations between the history of people and the dynamics of the economy on the one hand, and the history of the ordering of noise in codes on the other; predicting the evolution of one by the forms of the other; combining economics and aesthetics; demonstrating that music is prophetic and that social organization echoes it.*

This is not an attempt at a multidisciplinary study, but rather *a call to theoretical indiscipline,* with an ear to sound matter as the herald of society. The risk of wandering off into poetics may appear great, since music has an essential metaphorical dimension: 'For a genuine poet, metaphor is not a rhetorical figure but a vicarious image that he actually beholds in place of a concept.' (Nietzsche, *The Birth of Tragedy*)

Yet music is a credible metaphor of the real. It is neither an autonomous activity nor an automatic indicator of the economic infrastructure. It is a herald, for change is inscribed in noise faster than it transforms society. Undoubtedly, music is a play of mirrors in which every activity is reflected, defined, recorded and distorted. If we look at one mirror, we see only an image of another. But at times a complex mirror game yields a vision that is rich, because unexpected and prophetic. At times it yields nothing but the swirl of the void.

Mozart and Bach reflect the bourgeoisie's dream of harmony better than and prior to the whole of nineteenth-century political theory. There is in the operas of Cherubini a revolutionary zeal rarely attained in political debate. Janis Joplin, Bob Dylan, and Jimi Hendrix say more about the liberatory dream of the 1960s than any theory of crisis. The standardized products of today's shows, hit parades and showbusiness are pathetic and prophetic caricatures of future forms of the repressive channelling of desire.

The cardinal importance of music in announcing a vision of the world is nothing new. For Marx, music is the 'mirror of reality' 'expression of truth'; for Freud, a 'text to decipher'. It is all of that, for it is one of the sites where mutations first arise and where science is secreted: 'If you close your eyes, you lose the power of abstraction' (Michel Serres). It is all of that, even if it is only a detour on the way to addressing man about the works of man, to hearing and making audible his alienation, to sensing the unacceptable immensity of his future silence and the wide expanse of his fallowed creativity. Listening to music is listening to all noise, realizing that its appropriation and control is a reflection of power, that it is essentially political. [...]

Jacques Attali, extract from chapter 1 ('Listening'), *Bruits: Essai sur L'économie politique de la musique* (1976); trans. Brian Massumi, *Noise: The Political Economy of Music* (Theory and History of Literature, vol. 16) (Minneapolis: University of Minnesota Press, 1985) 3–6 [minor revisions to translation; footnotes not included].

Michel Serres
Genesis//1982

Noise

[...] Catherine Lescault, the river-christened courtesan, is here [in Jacques Rivette's 1991 film based on Balzac's story *The Unknown Masterpiece*] baptized *La Belle Noiseuse*. I think I know who the *belle noiseuse* is, the querulous beauty, the noisemaker. This word *noise* crosses the seas. Across the Channel or the Saint Laurence seaway, behold how the *noise* divides itself. In Old French it used to mean: noise, uproar and wrangling; English borrowed the sound from us; we keep only the fury. In French we use it so seldom that you could say, apparently, that our language had been cleansed of this 'noise'. Could French perhaps have become a prim and proper language of precise communication, a fair and measured pair of scales for jurists and diplomats, exact, draftsmanlike, unshaky, slightly frozen, a clear artery unobstructed by embolus, through having chased away a great many *belles noiseuses*? Through becoming largely free from stormy weather, sound and fury? It is true, we have forgotten *noise*. I am trying to remember it; mending for a moment the tear between the two tongues, the deep sea one and the one from the frost-covered lake. I mean to make a ruckus [*chercher noise*] in the midst of these dividing waters.

Sea Noise

There, precisely, is the origin. *Noise* and nausea, *noise* and the nautical, *noise* and navy belong to the same family. We mustn't be surprised. We never hear what we call background noise so well as we do at the seaside. That placid or vehement uproar seems established there for all eternity. In the strict horizontal of it all, stable, unstable cascades are endlessly trading. Space is assailed, as a whole, by the murmur; we are utterly taken over by this same murmuring. This restlessness is within hearing, just shy of definite signals, just shy of silence. The silence of the sea is mere appearance. Background noise may well be the ground of our being. It may be that our being is not at rest, it may be that it is not in motion, it may be

that our being is disturbed. The background noise never ceases; it is limitless, continuous, unending, unchanging. It has itself no background, no contradictory. How much noise must be made to silence noise? And what terrible fury puts fury in order? Noise cannot be a phenomenon; every phenomenon is separated from it, a silhouette on a backdrop, like a beacon against the fog, as every message, every cry, every call, every signal must be separated from the hubbub that occupies silence, in order to be, to be perceived, to be known, to be exchanged. As soon as a phenomenon appears, it leaves the noise; as soon as a form looms up or pokes through, it reveals itself by veiling noise. So noise is not a matter of phenomenology, it is a matter of being itself. It settles in subjects as well as in objects, in hearing as well as in space, in the observers as well as in the observed, it moves through the means and the tools of observation, whether material or logical, hardware or software, constructed channels or languages; it is part of the in-itself, part of the for-itself; it cuts across the oldest and surest philosophical divisions, yes, noise is metaphysical. It is the complement to physics, in the broadest sense. One hears its subliminal huffing and soughing[1] on the high seas.

Background noise is becoming one of the objects of metaphysics. It is at the boundaries of physics, and physics is bathed in it, it lies under the cuttings of all phenomena, a proteus taking on any shape, the matter and flesh of manifestations. The *noise* – intermittence and turbulence – quarrel and racket – this sea noise is the originating rumour and murmuring, the original hate. We hear it on the high seas.

Proteus

Proteus – the god of the sea, a minor and marginal god, nonetheless a god of the first water, a god whose name stands at the beginning – is the shepherd who tends the oceanic flocks in the prairies of Poseidon. He dwells in the waters round the isle of Pharos, near the mouth of the Nile, Pharos, bearer of the first Beacon, Pharos, the fire that sheds light, standing out against a misty background, yet whose name means canvas, sail, veil: revealing, re-veiling. For instance, it is the pharos that Penelope weaves and unweaves. In these places of truth, Proteus undergoes metamorphoses: he is animal, he can be element, water, or fire. He's inert, he's alive. He's under the beam of the beacon, he's under the veil. He knows. He's a prophet, he possesses the gift of prophecy, but refuses to answer questions. He contains all information, admits no information. He's the possible, he's chaos, he's cloud, he's background noise. He hides his answers under the endlessness of information. When, for instance, his daughter consults him: he becomes a lion, he becomes a snake, he becomes a panther, a boar, water, a tree, and I don't know what all. The chain that steadies the phenomenal must be found. Chained, motionless, Proteus speaks, answers his daughter. Crafty, but not a trickster. At

last he has found his master in physics. Physics is Proteus chained. Background noise is this Proteus badly bound. The sea breaking free. Behold a myth, barely a myth, which grants us an epistemology that is globally accurate, locally rich and detailed. It doesn't grant it in a language all rigour-worn, but through a channel full of noise, murmuring and images.

What the narrative of Proteus does not tell is the relationship between chaos and form. Who is Proteus when he is no longer water and not yet a panther or a boar? What the narrative says, on the contrary, is that each metamorphosis or phenomenon is an answer to questions, an answer and the absence of an answer to the questioning. Locally responsive and globally *sub rosa*.[2] Each appearance – each experience – is a lighthouse-pharos and a pharos-veil, a flash of illumination and a black-out of occultation. Proteus conceals information under the vast abundance of information, a straw in a haystack full of straw. He has an answer for everything; he says nothing. And it is this nothingness that matters. To physics, then, I now prefer metaphysics. The latter is free of Proteus' chains.

Proteus' intermediary states are sea sounds as they are bounding, abounding, unbounding. The *belle noiseuse* is restless. And all at once I know, at sea, who the *belle noiseuse* is. We have to recognize her in the midst of the coloured wall of the swell, amongst the smacking and frothing of forms and tones, the breaking forth of the element divided against itself. Porbus and Poussin never had the right to look at the canvas. And when the old man unveils it, they can't make anything of it. They examine the painting, from left and from right, from right in front, alternately from below and from above. Points of view, phenomena. Fools. And they turn their back on the beautiful, living young woman. Fools. Porbus and Poussin did not see the *belle noiseuse*, and they consider the old man who sees her a fool. Balzac too thinks he is crazy. I guess I'm old enough now to see her. So many mariners never saw anything in the noise of the sea; only felt nauseous, organisms teeming with the sound and the fury, like the heaving grey itself; so many only felt the sad nausea over the root of the tree, an avatar of Proteus, so many only experienced phenomenological nausea, so many never saw the *belle noiseuse*, a naked Aphrodite resplendent in her beauty, rising fresh from the troubled waters, as the model Gillette who comes forth naïve and aborning from the chaotic canvas of the dying old master. Who cut his brush dripping with colour to throw it on the seascape and give rise to Aphrodite? [...]

1 *Soughing*: soft murmuring or rustling sound, as of the wind or a gentle surf.
2 *Sub rosa*: literally, 'in the depths of the flower', meaning secret, hidden.

Michel Serres, extract from *Genèse* (Paris: Grasset, 1982); trans. Geneviève James and James Nielson, *Genesis* (Michigan: University of Michigan Press, 1995).

Hermann Nitsch
The Music of the O.M. Theatre//1985

The new, non-additive form of the *Gesamtkunstwerk*, whose plot, or course of events, consists of real-life situations, uses the natural sound of the event as the acoustic-musical means of conveyance. The ecstasy of abreaction, of instinctual discharge, of the whole-hearted satisfaction of drives by means of Dionysian excess, is dependent on sound, desires noise. The sadomasochistic tearing asunder of skinned animal carcasses, raw meat and moist intestines, is encouraged by ecstatic noise. Noise is an essential component of the far-reaching satisfaction of drives. A maximum amount of intensive noise is produced, almost crossing the pain threshold. The orchestra consists primarily of drums, woodwind and brass instruments, beat instruments and noise instruments of all kinds. The guttural human cry is a crucial element of this (naturalist) music of expression, which enhances the event, the orgy. The force of sounds never heard before will assault and frighten us, the vomited, spewn-out sounds of wind instruments (tubas, trombones), noise instruments and screams reveal themselves as the expressions of long-repressed feelings. Aggression, animal heat, the noise of war and of lust, battle cries, the screams of death and of anger, force themselves out of our mouths, like warm, soft, bloodied and slimy intestines that spew forth from a wound. The noise music of the O.M. Theatre is revealing in nature. It turns repressions inside out, tears out our innermost feelings, like the disembowelment of an animal. The ecstatic cry activates our entire psycho-physical organization; cleanses tired senses of frustration, sluices the human mind with sensual experiences. I began to explore the theory of screams for my first abreaction play in 1961.

By producing ecstasies of disinhibition, the abreaction play constructs abreaction events that are experienced directly by the participants. The rediscovery of psychological human states that have been buried in the unconscious reveals values that are central to the tragedy; the naked state of excitement, deeply rooted in existence, that lies behind the word in the scream. In terms of human history, the use of the scream came before the word, which developed out of the mating call.

The scream is a more immediate expression of the unconscious, of the sphere of drives, than the word; a screaming situation normally arises when the id asserts itself, overcoming intellectual control and giving way to the elementary drive for life-assertion. Shock-like torture and sudden extreme pleasure, all situations that entail the impairment of consciousness, allow the scream to break through. The purpose of the screams produced through direct ecstasies in the abreaction game is

to enable us to plumb the psychological conditions that are buried deep down in our unconscious. The point is to uncover unconscious domains in our psyche. We may call it the deliberate regression towards early states of humanity. The ego of early man was more closely bound to the animalistic-vegetative component of the subconscious (and thus also to the mythical-religious). The negation of the word, the retreat into the ecstasy of the scream, stands for communication with the unconscious, the deliberate analytic immersion into the unconscious. We give ourselves up to the frenzy of vegetative, often hectic-dynamic laws; we shake off the bondage of the intellect. [...]

My music is not in the least illustrative or 'visual' in character. It rather determines events in the same way that it is also determined by events. I have always referred to the noise that I design, especially for my actions, as music. I use graph paper for writing down the score. Every millimetre stands for one second of playing time. The lengths of the parts of the individual instruments are indicated by horizontal lines. There are three different noise levels (they are recorded above the horizontal lines). The task of the musicians is to produce noise with their instruments and to take into account the level of noise outlined in the score, which corresponds to the intensity of the events of the play. The musicians are not allowed to borrow elements from musical works from the past, and this is why professional musicians have little understanding of my music and are in fact ill equipped for playing it. They confuse their play with improvisation. That is why I prefer to use amateurs, or people who do not actually know how to play the instrument they are using. The ignorance of the instrument gives rise to completely new, previously unheard sounds that break all traditional moulds. I have little sympathy for what passes for new contemporary music. A music that is derived from the genius that was Webern has exhausted itself in the predetermined development into sound patterns whose narrowness and hopelessness I find unbearable. My music is unfamiliar with the compulsion neurosis of music post-Webern. Cage is one of the very few who opened up to me the possibility of my own music. There is no prescribed rhythm, no dominant concept of tonality or atonality. What is crucial is the tone in its purest form (the tone colour), the intensity of the sound produced with the instrument. This re-establishes an affinity to Mahler, Scriabin, Ives, Bruckner and Wagner. The frenzy of tones, the use of tone colour, are well suited for extending the sphere of amorphous noise music. Epic, symphonic structures with inconceivable cumulations are thus made possible. I am thinking for instance of symphonies with many gigantic orchestras and choirs, whose performances would take up several days. The feast of the O.M. Theatre should also be understood as a gigantic symphony that is played out over six days. But my music, which is based on

Dionysian ecstasy, also knows calmer notes, tones and sounds. Nature itself provides the adagio. Sounds and tones that are taken for granted and barely registered are now fully discerned and plumb the nirvana of silence. The silencing of the tone colours that enrich the orgy makes way for the calm, wide, infinite tonal space of the night. In an almost vegetative manner, tones and sounds step forward from the immense sphere of the organic, the creatural, the human. They permeate the silence, they veil it, they fill it with a finely tuned world of tones and sounds. Music has become perceived reality. THE SOUNDS OF THE NIGHT, the cry of a bird, the barking of a dog, faraway music from a tavern, the sound of a plane flying past high above, without lights, human voices and cries, the singing of drunks, the drone of the faraway city, the scent of watered flowers, wet earth. Rain, shrubs in bloom, the taste of the flesh of fruits, the stars shining brightly, the dynamics of the stellar orbits, it all becomes music. The creation produces noise and sounds, it is sound, the thundering, jubilating, light-bright mating call of the universe. The screams of the resurrected, his LIGHTbody is music.

Hermann Nitsch, extracts from 'The Music of the O.M. Theatre', *O.M. Theater Lesebuch* (Freibord, Austria, 1985); trans. Susanne Baumann and Maria Nievoli, in *Museum Hermann Nitsch* (Ostfildern-Ruit: Hatje Cantz verlag, 2007) 90–91.

Kim Cascone
Residualism//1999

[…] Ordinarily I am concerned with – focus my attention upon – things or 'objects', the words on the page. But I now note that these are always situated within what begins to appear to me as a widening field which ordinarily is a background from which the 'object' or thing stands out. I now find by a purposeful act of attention that I may turn to the field as field, and in the case of vision I soon also discern that the field has a kind of boundary or limit, a horizon. This horizon always tends to 'escape' me when I try to get at it; it 'withdraws' always on the extreme fringe of the visual field. It retains a certain essentially enigmatic character.
– Don Ihde, *Listening and Voice*

green bits working furiously
from within the microcosm of binary digits we can now build any type of sound object and with some advanced mathematical gymnastics we can craft a model

of any type of behaviour represented by numbers ... we can create an audio file made up of tiny sonic grains mimicking the behaviour of flocking starlings, moving through the listener's three-dimensional soundspace using the wobbly orbit of Neptune and then sending the audio data through a waveshaping transfer function resembling this month's stock exchange. Numbers are fuel in the engine of the central processing unit ...

peripheral/ephemeral

when we zoom out, the numbers become invisible and sensory awareness overcomes theoretical awareness ... this is how the alchemy of digital audio works: the maths is embedded in the algorithm and through many levels of abstraction it is hidden from users' experience, keeping them safely distanced from the 'workings under the hood' ...

signal-centric

but even so, this engineered distance from the microverse of numbers reveals no more than what the maths has created: sonic objects that exhibit some sort of behaviour, i.e. signals ... the object is defined by its smallest moving parts: its existence in time, its spectral architecture, the decay rates of its individual sinewaves, but never what is background to it or by the artefacts 'thrown off' by the sound-object ... sound is never described in what is absent, missing or overlooked: negative space ... most of the digital detritus gets noise reduced, multi-band compressed, brickwall filtered out ... but we now find ourselves immersed in the next wave of digital audio ... new tools have emerged that are capable of exploring both the signal and what's behind it ... we are able to descend into the 'abyssal zone' of the noise floor and use what we find there as material for exploration ...

tweakUI

any selection of algorithms can be interfaced to pass data back and forth in fluidic data-space ... mapping effortlessly from one mathematical dimension to another ... bits racing around, bumping, chafing, building friction, emitting bursts of energy that radiate out into meat-space ... as the mad dash of shuttling bits exceeds the gigaflop speed barrier and spills out onto the vast network of other thinking machines, we are no longer alone in our information-space ... we are connected in real time to multiple levels of information which can easily be navigated with little more than the minimal motions of mouse clicks ... this connection to information-space has spawned many idea viruses which have infected others in meat-space ... our User Interface is now a tendril-like living organism of information with our minds now becoming the 'terminal' on the network ...

the result is that our focus has become fragmented and is too busy multi-tasking (the term might be attention deficit disorder), following non-linear media down the primrose path ...

the numerical meaning of the audio bits is streamed upwards through multiple levels of abstraction, into the hardware converters, out of the speakers and into the user's perceptual apparatus ... the user can now participate in the production of meaning because in non-linear (mental) space she/he creates meaning with movement ... movement between structures, genres, layers ... nomadic movement ... think of meaning as a by-product of movement ...

focal core

just beyond our focus exists a fringe that is defined as background, lack, netherworld, a horizon of silence ... it is invisible to us even as we peer directly into it ... this lack permeates, envelopes and eludes us ... we've been comfortable in our signal-centric world while this background often remained beyond our sensory horizon ... it is here that 'post-digital' music resides ...

datasphere

the 'post-digital' approach to creating music has changed into a digital deconstruction of audio by manipulating the *prima materia* itself: bits ... this bit-space (sans sound-objects) contains background information as most spaces do ... we have only recently begun to consider the gauzy veil of hums, clicks, whirs and crackling as worthy of our attention ... data-mining the noise floor is today's alchemical pursuit of turning bits into atmospheres ...

Electricity is total information
– Marshal McLuhan

the residual and deconstruction

the current creation of post-digital material has become a process of subtracting information (read: signal) until there is nothing left except for a residual layer ... conjuring 'post-digital' music from this layer takes place with little more than a cheap PC and a carefully chosen complement of DSP tools ... tools now aid composers in the deconstruction of digital filetypes: exploring the sonic possibilities in a Photoshop file that displays an image of a flower, trawling word-processing documents in search of coherent bytes of sound, using noise reduction software to analyse and process audio in ways that the software designer never intended ...

welcome to the 'post-digital' era where artists have raided the academic ivory towers, appropriated their tools, and injected new aesthetic meaning into

technological data ... this is resulting in a new modulation of boundaries and the de-mythologizing of the barriers that distance artists from the digital microcosm.

Kim Cascone, statement (October 1999) on *Residualism* (CD issued by Ritornell in 2000).

Yasunao Tone
Parasite/Noise//2001

Parasite in French has two meanings which it shares with English. It means an organism living in or on another organism, i.e., the biological parasite, and by extension, the social parasite (sycophant). But the word also means static or noise, as in informational theory. Although the physical existence of my installations in relation to other pieces is taken to have the former meaning, I am more concerned with the latter.

I have previously written of John Cage's work:

Cage's graphic notations not only disrupt the univocal relation between notes and pitches but are also more open to sound itself, that is, noise. Cage's suggestion to the students who would like to write an indeterminate score was to observe the imperfection of a sheet of white paper. Not only were the signs he wrote taken into account, but also the stains or smudges on the paper, which are also noise.

Incidentally, although the contemporary word for noise in French is *bruit*, Old French used the word *noise*, the same as in English. In Old French, *noise* means a noise, outcry, disturbance, a quarrel, derived from the shared etymology of the English and French word, traced back to origins in the *noise*/noise of sickness and nautical roots. Nausea and *nausée* are derivatives of the Latin *nauseam*, and the root is originally derived from the Greek *naus. Naus*, ship, noise, and the French words *noise, nausée, nautique, navire*, belong to the same etymon. In short, they are related to the sea, so noise is a sea of sound, pure frequency, uncontaminated by symbolization – or sound waves. Noise is always derivative, as there is no origin in a wave; I am not a source of movement. According to Gilles Deleuze, it is the 'movement you find in the new sports: surfing, wind surfing, hang gliding [which] takes the form of entering into an existing wave'.

During the recording session for my piece *Solo for Wounded CD*, my sound engineer Alex Noyse (no pun intended) appropriately observed that 'it's like

surfing on sound'. So, it is well-founded that Deleuze states as follows: 'There is no longer an origin as starting point, but a sort of putting-into-orbit. The key thing is how to get taken up in the motion of a big wave, a column of rising air, to get into something instead of in the origin of an effort.' Therefore, seeking movement is not to rely on some body's energy, as parasites do, but more importantly to discover the conditions that mediate, in this case, a work of art and the audience.

Arthur Danto, in a review of a Whitney Biennial, pointed out the importance of the museum guidance headset and wall texts for the audience's understanding of the works. His remarks have to be considered as a pragmatics of art, for despite the fact that these reference tools exist outside of the works and are superfluous to them, they are influential, if not indispensable, for mediation between work and audience.

This reminds us of Gerard Genette's idea of paratextual practice. In his book, *Seuils*, he elaborates on the idea of paratext, defined as 'that by which a text becomes book and offers itself as such to its reader, and more generally, to the public'. Paratext is midway between the inside and the outside of the book, found in such places as the title, preface, note, blurb and dedication. These are the locations where the interaction between text and readership occurs. In other words, this is a study of literary institution. So paratext is nominally mediation between reader and text; however, it lacks necessity where chance dominates, as it is like noise. Here emerge the modernistic notions of exclusion, such as the erasure of noise in music and contempt toward ornamentation in art, design and architecture, and so on; features which are nevertheless reterritorialized via new painting, noise music and postmodern architecture.

My installation piece uses audio headset guides distributed at the entrance and installed throughout the entire exhibition space. At first sight, they are similar to the audio guides museums distribute for information about the exhibited work. However, my headsets play a text read aloud, which has nothing to do with the exhibited works themselves. Accordingly, the text in *Parasite/Noise* is not exactly paratext in the terms that Genette implies, because it does not immediately mediate between an audience and the work.

My headsets are, so to speak, *pseudo* audio guides. Audio guides have a performative function. And just as the perforations dividing a sheet of stamps invite the user to 'detach stamp here', my headsets invite the audience to expect a commentary on the works exhibited. From a pragmatic point of view, there is a shared institutional convention between stamps and their users and museum headsets and their users. They share the same functions as paratext. But the text in my headset installation neither informs about nor refers to the works in front of you. The audience will soon realize that the two names, the paratext, of the

artist/authors, mean no more than a juxtaposition of two works. *Parasite/Noise* does nothing more than show the impossibility of the decodification or deciphering of a work. Instead my headset makes the audience interpolate between listening from the headset and seeing the other works. Then the audience is no longer a passive observer and finds the headset to be a tool for use, like Marcel Proust's suggestion to consider his book as binoculars and Cage's remark that he is a maker of cameras with which the audience takes photography. This is a case in point for an artistic apparatus I call paramedia. [...]

Yasunao Tone, statement on *Parasite/Noise* in *Yokohama International Triennial*, exh. cat., ed. Nobuko Shimuta, et al. (Yokohama: Yokohama International Triennial, 2001) 337 [footnotes not included].

Paul Virilio
Silence on Trial//2003

[...] *To speak or to remain silent*: are they to sonority what *to show* or *to hide* are to visibility? What prosecution of meaning is thus hidden behind the prosecution of sound? Has remaining silent now become a discreet form of assent, of connivance, in the age of the sonorization of images and all audiovisual icons? Have vocal machines' powers of enunciation gone as far as the denunciation of silence, or a silence that has turned into MUTISM?

It might be appropriate at this juncture to remember Joseph Beuys, whose work *Silence* parallels, not to say echoes, Edvard Munch's 1883 painting *The Scream*. Think of the systematic use of felt in Beuys' London installations of 1985 with the gallery spaces wadded like so many SOUNDPROOF ROOMS, precisely at a time when the deafening explosion of the AUDIO-VISUAL was to occur – along with what is now conveniently labelled the crisis in modern art or, more exactly, *the contemporary art of the crisis of meaning*, that NONSENSE Sartre and Camus were on about. [...]

With architecture, alas, the jig is already up. Architectonics has become an *audio-visual art*, the only question now being whether it will shortly go on to become a VIRTUAL ART. For sculpture, ever since Jean Tinguely and his 'Bachelor Machines', this has been merely a risk to be run. As for painting and the graphic arts, from the moment VIDEO ART hit the scene with the notion of the installation, it has been impossible to mention CONCEPTUAL ART without picking up the background noise of the mass media behind the words and objects of the art

market. Like TINNITUS, where a ringing in the ears perceived in the absence of external noise soon becomes unbearable, contemporary art's prosecution of silence is in the process of lastingly polluting our representations. [...]

Paul Virilio, extracts from *La Procédure Silence* (Paris: Éditions Gallilée, 2000); trans. Julie Rose, retitled in English *Art and Fear* (New York and London: Continuum, 2003) 69–70; 77–8.

Paul Hegarty
Noise/Music//2007

According to Walter Benjamin, Western art moves away from having a sacred value towards having exhibition value. Art's value becomes secular, aesthetic and social. It moves from sacred buildings to private ones and gradually becomes more public: aristocrats and monarchs build collections of art and curious objects, which are displayed to their peers; the bourgeois class follows suit and the public museum is created. Eventually, the public, including members of the lower classes, are allowed in, to be educated into the great heritage of the culture that sits atop them: exhibition value constrains works to being portable, of recognizable form (e.g. a framed painting, a statue on a plinth), and exchangeable. From the late seventeenth century onwards, art as an institution develops, including galleries, museums, criticism and a public of connoisseurs. This setting of art excludes noise – audiences must behave correctly, demurely; buildings must clearly show works that are autonomous and simultaneously part of a narrative. Far from disrupting this, modern art leads to a booming of the art institution and fuels the idea of art history as a narrative, where we move from one picture to the next. But modern art does introduce noise, in the form of avant-gardism. Even if ultimately this adds to the teleogical story of art, at any given stage from the 1850s onwards, some part of art was regarded as noise – as not carrying meaning, lacking skill, not being appropriate, being disturbing of morals, and so on.

Music, too, is harnessed in the modern concept of a concert where the audience sits silent, except for regulated participation, and the musicians are separated, elevated in more than one sense. Even as late as the eighteenth century, audiences at musicals are raucous, but gradually they are disciplined, and however we might imagine a Wagnerian *Gesamtkunstwerk* as a sort of noisy crossing of artforms, it completes the subjugation of the audience. Sound is totally

banished from the gallery – where art is to remain visual. The framed painting on a wall allows rational contemplation, and so massages the verticality of appreciation and analysis over the potential messiness of horizontality. Futurist and Dada performances occurred elsewhere – with their collisions of theatre, early sound poetry, film, dance, shouting, music and fighting happening in theatres for the most part, but also on many occasions outside of any cultural institution. It is only really with Fluxus in the late 1950s that sound is tentatively staged in galleries. Where Dada's radicality was in not being in a gallery, Fluxus, as a second generation of the same impulse, was able to be radical precisely for performing in official art settings (as well as elsewhere). This is the early days of performance art (also in Japan), and Fluxus flows into the outpouring of movements or approaches of the 1960s: conceptual art, Happenings, installations, body art, performance. As well as the acceptance of art's radicalization and disrespect for categorical borders between artforms there is also the question of technology. Sound creeps into galleries in the wake of affordable technologies, notably in tape technology in the 1960s, and the development of video in the late 1960s. This is the first point at which, I would claim, we can begin to talk of sound art, and, just as the (temporally amorphous) advent of Japanese noise music authorizes a retrospective rethinking of 'precursors' in noise, so the sound installations that begin to appear in the late 1960s allow or suggest ways in which sound was used to construct art, or was made as art rather than as music.

The Centre Pompidou proposed an intimate connection between sound and modern art in its 'Sons et lumières' exhibition (2005), examining how artists were inspired by music (like Kandinsky), made sound-producing sculptures (Moholy-Nagy), or incorporated sound as content. Duchamp's *With Hidden Noise* plays with the possibility but unlikelihood of the trapped ball of string etc. producing audible sound. Duchamp's actual musical experiments do not produce sounds that are particularly challenging. Kurt Schwitters' sound poetry is there of course. The second part of the show looks at actual sound performances/installations/objects that were designed for the gallery setting, and usually had been located there in the first place. I am not complaining about the hindsightfulness of the show, rather using it to show a problem at the heart of definitions of sound art: namely, that it comes to apply to pretty much anything that has to do with both together. Sound art, like 'noise music', is a noisy genre, something porous and very hard to define, but […] it is too self-contained, and sets up the listener as self-contained, in order to challenge not sufficiency but only the way in which it has been constructed (i.e. it's going to 'make you think', and in so doing reveal to the listening subject some part of a hitherto hidden sound reality).

'Sons et lumières' goes on to gloss over the longstanding incompatibility of sound with the gallery/museum setting. Sound in the gallery is noise – not only

inappropriate until recent times but something that spreads beyond its location, or the demands of a sense of location that a painting, say, requires. Sound-based art in an exhibition can be overbearing, and if there are several pieces they risk clashing. Contemplation of any given piece is disrupted, and in turn the sound piece becomes an ambience rather than a discrete work. To get round this, space can be allocated away from other works – a sort of quarantine. Alternatively, the piece can be totally isolated and accessed through headphones. So sound art continually raises the question of noise, even if often to be closed off (sometimes by the artists themselves). Once it is safely positioned, it then becomes a highly appreciated commodity of the gallery, as a CD, sound files, or even messier older media are transportable, convenient and probably not unique (however aleatory the actual playing out of the piece might be). This convenience must be part of art's acceptance of sound art in its most restricted form. Sound art takes many forms: sound installations, performances, recordings, whether for direct public consumption, or as purchasable objects to listen to domestically, interactive pieces, pieces designed for headphone use, transmission of sound (often from other locations). Each one of these has many variants. The sound source could be the most important factor, or the process of listening it establishes. Sound art is not just sound working as art. Brandon LaBelle notes that

> In bridging the visual arts with the sonic arts, creating an interdisciplinary practice, sound art fosters the cultivation of sonic materiality in relation to the conceptualization of auditory potentiality. While at times incorporating, referring to, or drawing upon materials, ideas and concerns outside of sound per se, sound art nonetheless seems to position such things in relation to aurality, the processes and promises of audition, and sonic culture. (*Background Noise*, 151)

The communal element of performance might be what counts, or the connection between the enclosedness and peculiar isolation of headphones. It can also basically just be experimental or avant-garde music brought into an art location. This is part of this music's attempt to get away from music and its standard settings, but, again, it is also a way of getting music heard that maybe does not function in concert settings, and that has found a new outlet. Sound art often reflects on its own production, and this can be the effective content of the piece (1960s/1970s art using tape recorders is fond of this). It does this in combination with an exploration of sound – as in Paul Kos' *Sound of Ice Melting* (1970), which has blocks of ice in the gallery, surrounded by microphones. Here sound becomes spectacle of its own production. Sound art extends this into a questioning of listening, and the position of the listener. LaBelle insists that the importance accorded listening and sound production means sound art is process at least as

much as product (sound consumption requiring the time of its playing feeds into this): 'sound art as a practice harnesses, describes, analyses, performs and interrogates the condition of sound and the process by which it operates' (*Background Noise*, ix). That this often supplants the 'what' of what is being listened to might be a problem on occasion, but it is essential to the process. Sound art is also about space, he argues, writing that it is 'the activation of the existing relation between sound and space' (ix). Sound and space are inherently linked, as sound for us is what disturbs air, and that is not going to happen in the absence of space, but sound also structures space, and sound art aims to both illustrate that and do it. Space is not fixed, but permanently forming and reforming, with sound as one of its constituent parts, and this occurs through human intervention and perception (as far as we can hear: humans cannot functionally have any other perspective). Following on from that, 'the acoustical event is also a social one' (x) – it is not just the interaction of human subjects with an object world; it is also interactivity as society. Hence, from these three points, the centrality of Cage's *4' 33"*, which opens these perspectives. Once we have these ideas as ways of thinking and listening, then our whole body is involved, as it is not just a matter of deciphering an encrypted block of sound – i.e. a musical piece. [...]

Paul Hegarty, extract from *Noise/Music: A History* (New York and London: Continuum, 2007) 77–9 [footnotes not included].

on each person's hand and began walking with them down 14th Street towards the East River. After a while I began to do these works as 'Lecture Demonstrations'. The rubber stamp was the lecture and the walk was the demonstration. I would ask the audience at a concert or lecture to collect outside the hall and would stamp their hands and lead them through their everyday environment. Saying nothing, I would simply concentrate on listening and start walking

R. Murray Schafer
The Soundscape//1977

Now I will do nothing but listen …
I hear all sounds running together, combined,
fused or following,
Sounds of the city and sounds out of the city, sounds
of the day and night …
– Walt Whitman, 'Song of Myself' (1855)

The soundscape of the world is changing. Modern humanity is beginning to inhabit a world with an acoustic environment radically different from any hitherto known. These new sounds, which differ in quality and intensity from those of the past, have alerted many researchers to the dangers of an indiscriminate and imperialistic spread of more and larger sounds into every corner of human life. Noise pollution is now a world problem. It would seem that the world soundscape has reached an apex of vulgarity in our time, and many experts have predicted universal deafness as the ultimate consequence unless the problem can be brought quickly under control.

In various parts of the world important research is being undertaken in many independent areas of sonic studies: acoustics, psycho-acoustics, otology [biomedical study of the ear], international noise abatement practices and procedures, communications and sound recording engineering (electro-acoustics and electronic music), aural pattern perception and the structural analysis of language and music. These researches are related; each deals with aspects of the world soundscape. In one way or another researchers engaged on these various themes are asking the same question: what is the relationship between humanity and the sounds of its environment and what happens when those sounds change? Soundscape studies attempt to unify these various researches.

Noise pollution results when we do not listen carefully. Noises are the sounds we have learned to ignore. Noise pollution today is being resisted by noise abatement. This is a negative approach. We must seek a way to make environmental acoustics a positive study programme. Which sounds do we want to preserve, encourage, multiply? When we know this, the boring or destructive sounds will be conspicuous enough and we will know why we must eliminate them. Only a total appreciation of the acoustic environment can give us the resources for improving the orchestration of the world soundscape. […]

The home territory of soundscape studies will be the middle ground between science, society and the arts. From acoustics and psycho-acoustics we will learn about the physical properties of sound and the way sound is interpreted by the human brain. From society we will learn how humanity behaves with sounds and how sounds affect and change behaviour. From the arts, particularly music, we will learn how humanity creates ideal soundscapes for that other life, the life of the imagination and psychic reflection. From these studies we will begin to lay the foundations of a new interdiscipline – acoustic design. [...]

The Notation of Soundscapes (Sonography)

The soundscape is any acoustic field of study. We may speak of a musical composition as a soundscape, or a radio programme as a soundscape or an acoustic environment as a soundscape. We can isolate an acoustic environment as a field of study just as we can study the characteristics of a given landscape. However, it is less easy to formulate an exact impression of a soundscape than of a landscape. There is nothing in sonography corresponding to the instantaneous impression that photography can create. With a camera it is possible to catch the salient features of a visual panorama to create an impression that is immediately evident. The microphone does not operate this way. It samples details. It gives the close-up but nothing corresponding to aerial photography.

Similarly, while everyone has had some experience reading maps, and many can draw at least significant information from other schematics of the visual landscape, such as architects' drawings or geographers' contour maps, few can read the sophisticated charts used by phoneticians, acousticians or musicians. To give a totally convincing image of a soundscape would involve extraordinary skill and patience; thousands of recordings would have to be made; tens of thousands of measurements would have to be taken; and a new means of description would have to be devised.

A soundscape consists of events heard not objects seen. Beyond aural perception is the notation and photography of sound, which, being silent, presents certain problems [...]. Through the misfortune of having to present data on silent pages, we will be forced to use some types of visual projection as well as musical notation; these will only be useful if they assist in opening ears and stimulating clairaudience.

We are also disadvantaged in the pursuit of a historical perspective. While we may have numerous photographs taken at different times, and before them drawings and maps to show us how a scene changed over the ages, we must make inferences as to the changes of the soundscape. We may know exactly how many new buildings went up in a given area in a decade or how the population has risen, but we do not know by how many decibels the ambient noise level may have risen

for a comparable period of time. More than this, sounds may alter or disappear with scarcely a comment even from the most sensitive of historians. [...]

R. Murray Schafer, extract from *The Soundscape: Our Sonic Environment and the Tuning of the World* (New York: Alfred Knopf, Inc., 1977); revised edition (Rochester, Vermont: Destiny Books, 1993) 3–4; 7–8.

Alvin Lucier
Careful Listening is More Important than Making Sounds Happen//c. 1979

The Propagation of Sound in Space

For several hundred years Western music has been based on composition and performance. Most attention has been focused on the conception and generation of sound, very little on its propagation. Written notes are two-dimensional symbols of a three-dimensional phenomenon. No matter how complex a system of notation or how real the illusion of depth, written music is trapped on a flat plane. Even musics from oral traditions are rooted in performance rotes and instrumental topologies or rely on texts, stories or social hierarchies. We have been so concerned with language that we have forgotten how sound flows through space and occupies it.

Sounds have specific spatial characteristics. Those of short wave length (high frequencies) are directional; longer ones (lows) spread out. Sound waves flow away from their sources roughly in three dimensional concentric spheres, the nodes and antinodes of which, under certain circumstances, can be perceived in a room as clearly as those of a vibrating string on a violin. Each space, furthermore, has its own personality that tends to modify, position and move sounds by means of absorptions, reflections, attenuations and other structurally related phenomena. Conventional acoustic engineering practice has historically defied these phenomena in an attempt to deliver the same product to everybody in the same space. Accepted as natural occurrences to be enjoyed and used, however, they open up a whole new field of musical composition. For the past several years I have conceived a series of works that explore the natural properties of sound and the acoustic characteristics of architectural spaces as musical objectives.

I was not composing music in 1965 and had lost confidence in the musics of my education. Post-Webern serialism, particularly as I had witnessed it earlier in Darmstadt, seemed florid and complex enough to be obsolete, and the tape music

of that period seemed to be only an extension of that language. I felt the need for a new idea. When the physicist Edmond Dewan offered his brain wave equipment with which to explore the possibility of making music, I had a ready and open mind. As I started learning to generate alpha to make sound, I began experiencing a sensibility to sound and its production different from that of other musics based on ideas of tension, contrast, conflict and other notions of drama. To release alpha, one has to attain a quasi-meditative state while at the same time monitoring its flow. One has to give up control to get it. In making *Music for Solo Performer* (1965), I had to learn to give up performing to make the performance happen. By allowing alpha to flow naturally from mind to space without intermediate processing, it was possible to create a music without compositional manipulation or purposeful performance.

In the spring of 1968, with Pauline Oliveros, I began picking up images for a new work. The ocean suggested sea shells, and a nearby canyon offered itself as a large resonant environment in which they could be sounded. I designed a performance of a new work, *Chambers*, in which several shell players, starting from a small circle, spread out through the La Jolla landscape, describing the outdoor space in terms of their sounding shells. Later I expanded the idea to include any small or large resonant chambers that could be made to sound. I thought of them as rooms within rooms which impinge their acoustic characteristics upon each other.

I then made several works that articulated spaces in more specific ways. *Vespers* (1968), based on the principle of echolocation [the use of sound to locate objects or navigate], uses pulsed sounds, such as those used in acoustic testing to make acoustic signatures of enclosed spaces. As reverberation times are measured, the quality of the surrounding environment is described by comparing the timbre of the outgoing pulses with those that return as echoes. Time and space are directly related; durations are proportional to distances between sound sources and reflective surfaces. In *I am sitting in a room* (1970), several paragraphs of human speech are used to expose sets of resonant frequencies implied by the architectural dimensions of various sized rooms. By means of a pair of tape recorders, the sound materials are recycled through a room to amplify by repetition those frequencies common to both the original recording and those implied by the room. As the repetitive process continues and segments accumulate, the resonant frequencies are reinforced, the others gradually eliminated. The space acts as a filter. We discover that each room has its own set of resonant frequencies in the same way that musical sounds have overtones. And in *Quasimodo the Great Lover* (1970) sounds sent over very long distances, by means of relays of microphone-amplifier-loudspeaker systems if necessary, capture and carry the acoustic characteristics of the spaces through which they

travel. Total distance is determined by the amount of space necessary to modify the original material to a point of unrecognizability.

Recent works have been more concerned with the properties of sound itself than with how it acts in space. *Still and Moving Lines of Silence in Families of Hyperbolas* (1973–74) is an exploration of standing waves and related phenomena. If a pure wave emanated from two sources, or one source and a reflective wall, standing waves will form in symmetrical hyperbolic curves equidistant and either side of an imaginary axis between the sources. If two closely tuned waves emanate from two different sources, beating patterns will cause the crests and troughs of sound to spin in elliptical patterns toward the lower-frequency source. Changes in intonation will cause changes in speed of beating and, if unison nulls are crossed, direction of movement. In this work, dancers search for and move in troughs of audible beats which move out to listeners as ripples on a pond, and players of electronic and acoustic instruments spin crests of sound in polyrhythmic figures through space.

In *Outlines of Persons and Things* (1975), sound waves are used to create diffractive patterns around opaque objects, producing silhouettes which may be perceived directly with one's ears, or loudspeakers which shift, enlarge and amplify the images. If either the object or the listener moves, slight phase changes will cause perceptible variations in the resulting fields. If the illuminating sounds consist of two or more closely tuned frequencies, temporary speed-ups and slowdowns of the rhythmic patterns will occur.

Often it is necessary to provide visual clues as to the overall sound situation. You may be sitting in the trough of a standing wave or on the edge of a sound shadow, but since you cannot be everywhere at once, you hear only what is available to your location in space. Your focus is oblique. In *Directions of Sounds from the Bridge* (1978), for example, sound-sensitive lights are stationed around an oscillator-driven cello to sample the changing volume shapes caused by the directional characteristics of the instrument. Stringed instruments cast sound shadows around themselves in shapes determined by their resonant characteristics. In small spaces or in situations where amplification is possible, the shapes that flow from the tops, bottoms and sides of instruments are apparent to listeners. And in *Bird and Person Dyning* (1975), a work in which phantom images seem to appear in various places in space because of the apparent locative properties of acoustic heterodyning [the generation of new frequencies by mixing two oscillating waveforms], a performer wearing miniature microphones in his/her ears, dips, turns and tilts his/her head, altering pitches of strands of feedback created between the microphones and pairs of loudspeakers. In this work as in several others, performing is more a matter of careful listening than of making sounds happen.

PARABOLOIDS, SPHEROIDS AND OTHER SIMILARLY SHAPED
ROOMS WITH MOVABLE WALLS COULD BE CONSTRUCTED

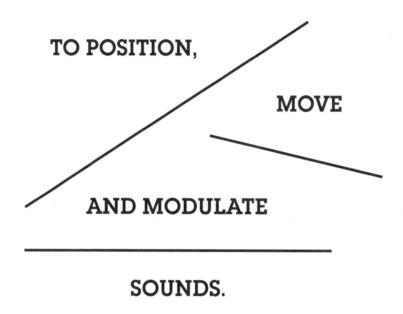

TO POSITION,

MOVE

AND MODULATE

SOUNDS.

WALLS, FLOORS AND CEILINGS COULD BE THOUGHT OF AS
ACOUSTIC LENSES.

Alvin Lucier, 'Careful Listening is More Important than Making Sounds Happen', c. 1979

I often dream of performance spaces specially designed for works based on the three-dimensional characteristics of sound. Paraboloids, spheroids and other similarly shaped rooms with movable walls could be constructed to position, move and modulate sounds. Walls, floors and ceilings could be thought of as acoustic lenses whose focal points are determined by reflective time. It is also possible to create imaginary spaces by means of computer simulation. In *RMSIM 1* (1972), a digital computer drives a configuration of analogue modules into which is fed a live microphone placed in an enclosed space. Changing values of resonant filters, amplifiers and reverberation units suggest changes in the size and structure of simulated rooms. And in *Clocker* (1978) a galvanic skin-response detector controls the speed of a ticking clock at several separate time delays, creating reflected sound from appropriately positioned loudspeakers so as to suggest changes in size and shape of memory-triggered rooms. Given enough delay lines and loudspeakers, any real or imagined rooms may be simulated.

I am now working on a series of solar sound systems for public places. Solar panels of various types, sizes, configurations and energy collecting capabilities are deployed at onsite locations, facing various compass directions relative to apparent daily sunrise and sunset. As sunlight falls on the panels at different intensities at different times of the day and year in various weather conditions, varying amounts of voltage are collected which drive packages of electronic music modules, amplifiers and loudspeakers, creating a continually changing music. Nearby trees and shrubbery, corners of adjacent buildings, passing people and cars may cast shadows or absorb enough sunlight to bring about further changes in the music.

Each installation will be unique. The number and size of the panels will be determined by the complexity of the sound system and size of the installation. In most cases, the basic sound source will be a pulse wave, chosen for its low power consumption – for example, it may be on duty for only ten per cent of a given cycle. Filters will be used for timbre control. All systems, however, will be completely solar powered. The generation, propagation and quality of the music will be determined by the intensity of the sun's rays at any given moment in time.

Alvin Lucier, 'Careful listening is more important than making sounds happen: The propagation of sound in space' (c. 1979), in Lucier, *Reflections: Interviews, Scores, Writings* (Cologne: MusikTexte, 1995) 430–38.

Bernhard Leitner
Acoustic Space//1985

[...] Modern building technology and building economics have indeed shown almost total disregard for the fact that human beings need rooms with good, 'live' acoustic qualities. I am not talking about technical means of soundproofing and the like. Take the following solutions which are typical for our civilization: people are buried in rooms built out of concrete, and at the same time we are developing highly sophisticated stereo and quadrophonic hi fi technologies to allow some sounds to come alive in these spaces. In all the theory of modern architecture we find very little or nothing about the relationship of sound, space and body. The main concern has been, as we all know, to use architecture and town planning as a means of resolving social conflicts and problems. But even this effort was essentially dominated by the powerful hostility with which the Enlightenment regarded the human body. [...]

Bernhard Leitner, statement from 'Acoustic Space: A Conversation between Bernhard Leitner and Ulrich Conrads', *Daidalos*, no. 17 (Berlin, September 1985).

Emily Thompson
Sound, Modernity and History//2002

[...] By identifying a soundscape as the primary subject of [*The Soundscape of Modernity*, 2002], I pursue a way of thinking about sound first developed by the musician R. Murray Schafer about twenty-five years ago. Schafer defined a soundscape as a sonic environment, a definition that reflected his engagement with the environmental movements of the 1970s and emphasized his ecologically based concern about the 'polluted' nature of the soundscape of that era).[1] While Schafer's work remains socially and intellectually relevant today, the issues that influenced it are not what has motivated my own historical study, and I use the idea of a soundscape somewhat differently. Here, following the work of Alain Corbin, I define the soundscape as an auditory or aural landscape. Like a landscape, a soundscape is simultaneously a physical environment and a way of perceiving that environment; it is both a world and a culture constructed to make sense of

that world.[2] The physical aspects of a soundscape consist not only of the sounds themselves, the waves of acoustical energy permeating the atmosphere in which people live, but also the material objects that create, and sometimes destroy, those sounds. A soundscape's cultural aspects incorporate scientific and aesthetic ways of listening, a listener's relationship to his or her environment, and the social circumstances that dictate who gets to hear what.[3] A soundscape, like a landscape, ultimately has more to do with civilization than with nature, and as such, it is constantly under construction and always undergoing change. The American soundscape underwent a particularly dramatic transformation in the years after 1900. By 1933, both the nature of sound and the culture of listening were unlike anything that had come before.

The sounds themselves were increasingly the result of technological mediation. Scientists and engineers discovered ways to manipulate traditional materials of architectural construction in order to control the behaviour of sound in space. New kinds of materials specifically designed to control sound were developed, and were soon followed by new electro-acoustic devices that effected even greater results by converting sounds into electrical signals. Some of the sounds that resulted from these mediations were objects of scientific scrutiny; others were the unintended consequences – the noises – of an ever more mechanized society; others, like musical concerts, radio broadcasts and motion picture soundtracks were commodities consumed by an acoustically ravenous public. The contours of change were the same for all.

Accompanying these changes in the nature of sound were equally new trends in the culture of listening. A fundamental compulsion to control the behaviour of sound drove technological developments in architectural acoustics, and this imperative stimulated auditors to listen more critically, to determine whether that control had been accomplished. This desire for control stemmed partly from new worries about noise, as traditionally bothersome sources of sound like animals, peddlers and musicians were increasingly drowned out by the technological crescendo of the modern city. It was also driven by a preoccupation with efficiency that demanded the elimination of all things unnecessary, including unnecessary sounds. Finally, control was a means by which to exercise choice in a market filled with aural commodities; it allowed producers and consumers alike to identify what constituted 'good sound', and to evaluate whether particular products achieved it.

Perhaps the most significant result of these physical and cultural changes was the reformulation of the relationship between sound and space. Indeed, as the new soundscape took shape, sound was gradually dissociated from space until the relationship ceased to exist. The dissociation began with the technological manipulations of sound-absorbing building materials, and the

severance was made complete when electro-acoustic devices claimed sound as their own. As scientists and engineers engaged increasingly with electronic representations of acoustic phenomena, sounds became indistinguishable from the circuits that produced them. When electro-acoustic instruments like microphones and loudspeakers moved out of the laboratory and into the world, this new way of thinking migrated with them, and the result was that sounds were re-conceived as signals.

When sounds became signals, a new criterion by which to evaluate them was established, one whose origins, like the sounds themselves, were located in the new electrical technologies. Electrical systems were evaluated by measuring the strength of their signals against the inevitable encroachments of electrical noise, and this measure now became the means by which to judge all sounds. The desire for clear, controlled, signal-like sound became pervasive, and anything that interfered with this goal was now engineered out of existence.

Reverberation, the lingering over time of residual sound in a space, had always been a direct result of the architecture that created it, a function of both the size of a room and the materials that constituted its surfaces. As such, it sounded the acoustic signature of each particular place, representing the unique character (for better or worse) of the space in which it was heard. With the rise of the modern soundscape this would no longer be the case. Reverberation now became just another kind of noise, unnecessary and best eliminated.

As the new, non-reverberant criterion gained hold, and as the architectural and electro-acoustic technologies designed to achieve it were more widely deployed, the sound that those technologies produced now prevailed. The result was that the many different places that made up the modern soundscape began to sound alike. From concert halls to corporate offices, from acoustic laboratories to the sound stages of motion picture studios, the new sound rang out for all to hear. Clear, direct, and non-reverberant, this modern sound was easy to understand, but it had little to say about the places in which it was produced and consumed.

This new sound was modern for a number of reasons. First, it was modern because it was efficient. It physically embodied the idea of efficiency by being stripped of all elements now deemed unnecessary, and it exemplified an aesthetic of efficiency in its resultant signal-like clarity. It additionally fostered efficient behaviour in those who heard it, as the connection between minimized noise and maximized productivity was convincingly demonstrated. Second, it was modern because it was a product. It constituted a commodity in a culture increasingly defined by the act of consumption, and was evaluated by listeners who tuned their ears to the sounds of the market. Finally, it was modern because it was perceived to demonstrate man's technical mastery over his physical environment, and it did so in a way that transformed traditional relationships

between sound, space and time. Technical mastery over nature and the annihilation of time and space have long been recognized as definitive aspects of modern culture. From cubist art and Einsteinian physics to Joycean stream-of-consciousness story-telling, modern artists and thinkers were united by their desire to challenge the traditional bounds of space and time. Modern acousticians shared this desire, as well as the ability to fulfil it. By doing so, they made the soundscape modern. [...]

1 R. Murray Schafer, *The Soundscape: Our Sonic Environment and the Tuning of the World* (Rochester, Vermont: Destiny Books, 1994), definition on 274–5. This edition is a largely unrevised version of material originally written in the 1960s and 1970s. See also Schafer, *The New Soundscape* (Scarborough, Ontario: Berandol Music/New York: Associated Music Publishers, 1969); and *The Book of Noise* (Wellington, New Zealand: Price Milburn, 1970). Equally stimulating in more theoretical ways is Jacques Attali, *Noise: The Political Economy of Music* (1977); trans. Brian Massumi (Minneapolis: University of Minnesota Press, 1985).

2 Alain Corbin, *Village Bells: Sound and Meaning in the Nineteenth-Century French Countryside*, trans. Martin Thom (1994; New York: Columbia University Press, 1998), ix.

3 See Barry Truax, *Acoustic Communication* (Norwood, New Jersey: Ablex, 1984), for a similarly contextualized study of the contemporary soundscape.

Emily Thompson, extract from *The Soundscape of Modernity: Architectural Acoustics and the Culture of Listening in America, 1900–1933* (Cambridge, Massachusetts: The MIT Press, 2002) 1–4.

Steven Shaviro
Bilinda Butcher//1997

It's loud, very loud. Swirling, churning guitars, aggressive distortion and feedback. Endlessly repeated, not-quite-tonal riffs. Blinding strobe lights. Noise approaching the threshold of pain, even of ruptured eardrums. This music doesn't just assault your ears; it invests your entire body. It grasps you in a physical embrace, sliding over your skin, penetrating your orifices, slipping inside you and squeezing your internal organs. You're brutalized by the assault – or maybe not quite. For beyond the aggression of its sheer noise, this music is somehow welcoming, inviting, even caressing. 'After about thirty seconds the adrenaline sets in; people are screaming and shaking their fists.' (Mark Kemp.) But then something clicks and quietly shifts, in your body and in your brain. 'After about four minutes, a calm

takes over. The noise continues. After five minutes, a feeling of utter peace takes over. Or violence.' It could be either, it could be both: you can no longer make sense of such a gross opposition. It's like a Zen illumination, perhaps; or an endorphin high, at the moment just before death. By taking noise 'way past the point of acceptedness', My Bloody Valentine guitarist Kevin Shields says, 'it takes on a meaning in itself', even if 'I don't know exactly what it means ' This isn't just a case of being overwhelmed by the sublime. You can't stand it, and you can't see beyond it; but for that very reason you get used to it after a while, and you never want it to end. As with psychedelic drugs – at least sometimes – sensory overload is only the beginning. There's a whole new world out there, beyond the experience of shock. You enter a realm of 'microperceptions', as Deleuze and Guattari put it: 'micro-intervals between matters, colours and sounds engulfing lines of flight, world lines, lines of transparency and intersection'. Things rush up on you, suddenly, in waves, and then slip ever-so-slightly out of focus. Densely articulated textures fade in and out. You pick up on subtleties you didn't notice before: wavering rhythms, minor chords, muddily shifting tonalities, synthesized special effects, Bilinda Butcher's floating vocal lines buried deep within the mix. You even hear fragments of pop melodies, tentatively emerging and then quickly dissolving; it's as if they were suspended in a chemical solution. These are the qualities sometimes described as 'dreamy' and 'ethereal' by listeners who haven't played the *Loveless* CD at sufficiently high volume. But such words fail to convey how deeply embodied – how physically attentive, you might say – this music actually is. The sound may be vague, murky, 'miasmatic' (Rachel Felder); but the murk is precisely rendered, a concrete, material presence. It surrounds you, envelops you, enfolds itself around you. This music is indeed 'spacey', in the literal sense that it seems to have a lot of room inside: room to wander about and to get lost in. Everything blurs, as in a musical equivalent of soft focus; everything shades into everything else. But no, that's not quite right; rather, you're stunned by the realization that there are so many types of ambiguity, so many distinct shades of grey. Your nerves and your viscera are tingling, as they register the tiniest differences, the most minute alterations. These are changes beyond, or beneath, the threshold of ordinary perception. Your sensory organs are being stretched or contracted far outside their usual range. In such altered states, as Deleuze and Guattari say, 'the imperceptible is perceived'.

Of course, you don't figure all this out until afterwards. You begin to make sense of it only as it slips away. The concert is over, and now it's the relative silence of the street that hits you with the force of a shock. You feel at once exhilarated and drained. The ringing in your ears takes quite a while to subside. Everything in the world has returned more or less to its proper place, but in an eerie state of abeyance. My Bloody Valentine's music leaves you with a strange

post-coital feeling: as if you knew you'd had an orgasm recently, but you couldn't remember when, or even exactly how it felt. Maybe this is what sex with space aliens would be like. In any case, the music never builds up to a phallic climax, in the timeworn manner of mainstream rock and roll and other such classical narrative forms. But it also evades – or defuses – the relentless erotic pulse of mutant dance forms like disco, techno and rave. And it eschews as well the frustrated-boy rage and angst of the 'industrial' sound. As guitarist/songwriter Kevin Shields puts it, this music expresses, not 'pure, unadulterated anger', but 'kind of all emotions rolled into one'. An intensity freed from specific content or focus; an erotic, bodily feel no longer tied to particular organs or zones. A sound as floating, enigmatic, and decentred – as 'ambient' and all-embracing – as anything by Brian Eno, but charged with a violent sense of physicality that Eno's music does not possess. [...]

So this diffusion and decentring, this in-betweenness, isn't merely a formal strategy; it's also an experience, the way the music is received and felt. There's no longer a clear distinction between inside and outside, or between subject and object. The music has become an extension of your flesh; or better, your flesh is now an extension of the music. Your ears, your eyes, your mouth, your crotch and your skin are absorbed into this irregularly pulsing, anexact, indefinitely extendible space, this postmodern mega-mall. The great ephemeral skin, Lyotard calls it: a labyrinth, or a hall of mirrors, continually breaking and reforming. It's really strange: the more 'alienating' the situation gets (to use that old-fashioned term), the more *intimate* it feels. Fredric Jameson calls it the 'hallucinatory intensity' of 'schizophrenic disjunction'. Or better, think of it as an overwhelming feeling of proximity, crushing and caressing you at once. You can't quite map out this space, you can't locate yourself precisely, and you can't even distinguish one object from another. Everything is just too close to your eyes to be brought. into sharp focus. The noise-laden air is suffocating; it presses down on your lungs, and scarcely gives you enough space to breathe. Yet you're trembling with excitement, or maybe with anticipation. Your flesh is all aflutter. The sound cradles and embraces you, inviting – even demanding – a sensuous, tactile response. Is it too much to say that this music feels sexy and sexual, even though it can't be identified with one particular gender? Not just because men and women share equal duties in the band. But because the sound of My Bloody Valentine has a lovely, playful evasiveness; it slips and slides easily around all sorts of distinctions conventionally associated with the binaries of gender. This music is both hard and soft, both noisy and lyrical; it penetrates and envelops you at once. You might think of it as androgynous, as simultaneously male and female. But maybe it's best described as neither. My Bloody Valentine seems to address

you from some sort of intergendered or othergendered space: the space, perhaps, of what have become known on the Internet as Spivak pronouns: 'e, em, eir'. Codified by Michael Spivak, these pronouns may be understood as the exact singular of 'they, them, their'. They compose a third person singular that retains the plural form's indifference, or indeterminacy, as to (biological, social, or grammatical) gender. [...]

Steven Shaviro, extracts from 'Bilinda Butcher', *Doom Patrols: A Theoretical Fiction about Postmodernism* (London: High Risk Books, 1997) 24-35.

Bill Fontana
Resoundings//c. 1999

[...] My 1976 recording of Kirribilli Wharf (on Sydney harbour) was the first time I attempted to apply sculptural thinking to the recordable listening process by making an eight-channel field recording.

Kirribilli Wharf was a floating concrete pier that was in a perpetual state of automatic self-performance. There were rows of small cylindrical holes going between the floor and underside to the sea below. They sounded with the percussive tones of compression waves as the holes were momentarily closed by the waves. This eight-channel recording consisted of placing microphones over the openings of eight such holes, making a real time sound map of the wave action in the sea below the pier. It was later installed as a gallery installation played from eight loudspeakers in a space.

This recording was germinal for my work because it was the first time that a conceptual analysis of a natural musical process resulted in a live recording that was as genuinely musical as music; and because of the spatial complexity of eight channels answering each other from eight points in space it also became genuinely sculptural.

It was also sculptural in another important way: the percussive wave action at Kirribilli Wharf had continuousness and permanence about it. This eight-channel tape was not a recording of a unique moment, as with the total eclipse, but was an excerpt from a sound process that is perpetual. Twelve years after this recording was made, I returned to Kirribilli Wharf and placed microphones there which transmitted live sound to the Art Gallery of New South Wales in Sydney, as part of a sound sculpture.

The most elemental characteristic of any sound is duration.

Sounds that repeat, that are continuous and that have long duration defy the natural acoustic mortality of becoming silent.

In the ongoing sculptural definition of my work I have used different strategies to overcome the ephemeral qualities of sound, that seem to be in marked contrast to the sense of physical certainty and permanence that normally belong to sculpture and architecture.

One of the most useful methods has been to create installations that connect two separate physical environments through the medium of permanent listening. Microphones installed in one location transmit their resulting sound continuums to another location, where they can be permanently heard as a transparent overlay to visual space.

As these acoustic overlays create the illusion of permanence, they start to interact with the temporal aspects of the visual space. This will suspend the known identity of the site by animating it with evocations of past identities playing on the acoustic memory of the site, or by deconstructing the visual identity of the site by infusing it with a totally new acoustic identity that is strong enough to compete with its visual identity. [...]

Bill Fontana, extract from 'Resoundings' (c. 1999), written during work in progress on the two permanent sound installations *Pigeon Soundings* and *Perpetual Motion* at the Kolumba Museum, Cologne.

Jacques Rancière
Metamorphosis of the Muses//2002

Rectangles and mazes filled with loudspeakers and screens. These are above all sculptural objects architecting and sculpting a space. They are also instruments for the production of images and sounds, surfaces for their dissemination, but also metaphorizations of the activity that produces them, of the meaning of this activity and its way of world-making. On these surfaces, in these volumes, bits and pieces of story are created and undone, engendered by sounds, programmed by computers, triggered by select participants or by the footsteps of passers-by as they move about through a squared-off area. Abstract lines or excerpts from films, images of opera choruses or bus routes, advertising jingles or shots on goal flash by on the screens. Sounds of water engender desert: images, symphonic flights of fancy transfigure scenes of everyday life. The screen sometimes goes

black to attest to music's power to create images all on its own. Conversely, the tricks of sound dissolve into the projection of light – asserting itself as if it alone generated the visible. These metamorphoses of the sound-image – in as much as they tend to identify with the very processes of the production of all seen and heard stories – themselves lead back toward two great narratives, two large demonstrations of metamorphic power. On one of the installation's coupled-up screens, two stories face one another, as if revealing the truth of all the others: on one side is a cloud of immaterial matter, where light and sound dissolve into their primal unity: on the other, images of DJs at work or of spinning turntables. Two great metaphors of aesthetic *ultima-ratio*: on one hand, the immaterial luminous-sound material in movement, which, within its eternal desirelessness, engenders all form and all melody. On the other, the activity of sovereign artistic will, which grabs hold of all matter, form or technique, which makes art with the noises and silences of the world, with the voices on the radio or the TV and advertising jingles as well as with all recorded and remixed music, from Bach to Michael Jackson, Balian gamelans and Senegalese drums to electronically produced sounds, which for that purpose make use of the computer's silent calculations like the scratching of the needle on the record-player or the crackling sounds of the amplifier. This double game of spiritualized matter and of sovereign manipulation splits the exhibition space in two. It makes it at once into a closed room, where art can exhibit the contradiction of its principle, and a space shot through by the voices of elsewhere – reconfigured by their noise. Indeed, the sound device which constructs a closed-off space by reproducing all forms of music – including that made up of the conditions of its production and distribution – thereby opening up to voices and sounds on the outside: both the noise of the world that surrounds the museum and – or so we are assured – the voices of the dead, recorded in cemeteries.

Let us leave the ghosts aside for the time being. They have a well-known penchant for becoming talkative whenever the inventions of technique propose new means of exploration of an unknown world and a poetics of remythologization of the world as a substitute for revolutionary nostalgia, and as a supplement to the rationality governing the exchange of commodities, opinions and leisure. Let us concentrate, rather, on what is behind the encounter of electronic sound and images, just as in the early years of the phonograph and the cinema, of radiology and the telephone. The voices of ghosts metonymize the device by which the sound and the image are doubly united: through their common dissolution in a cloud of matter similar to that of the spirit, and, conversely, through the collection of voices and recorded sounds, constantly augmented and made available for an infinite number of transformations, in the same way that unusable commodities such as visual artworks, street posters and shop signs have, for a long time now,

been brought down to the common identity of fragments available for any new art arrangement. The fusion of sound and image in a single and, at once, open and closed space also has to do with the equality between art and non-art: artistic sovereignty competes with infinite reproduction: just as computer operations compete with the rhythm of ancestral gongs and the grating of the mechanical tool; just as the manipulation of microphones competes with the evocation of the dead; social critique with board games: and the recycling of fragments and waste with loss in the great primordial ocean.

In all of this, some will perceive a new age of art – critical and egalitarian – deposing not only the hierarchies of the visible and the audible, music and noise, but also those of production and consumption, artistic creation and mechanical reproduction. The circulation between the high and the low, the old and the new, the inside and the outside, composes for them the figure of a critical art, reconsidering – with the laws of property – all the signs and messages in which art, business and domination merge and disband. Unless it draws up a new geography, a figure of the 'fourth world', erasing the economic and geopolitical divisions of wealth and domination. Others, however, will deplore the triumph of an art which has become similar to its opposite, rejecting all materials and techniques through which each art asserted its difference from the commodities and signs of business, and has ended up blending into a common undifferentiated sensorium. The fusion of the inside and outside, sound and image, music and noise, the visual artwork and the reprocessed message is for them but the latest in an interminable list of transformations of the primordial disappearance, through which the work of the tailor is hidden in the commodified clothing. It is nothing but spectacle, that is, the ultimate accomplishment of commodity fetishism. Things are beginning to come to light: nothing is closer to the exhibition of market domination than the critical misappropriation of its emblems; nothing is closer to the total artwork than the construction of advertising environments. However, rather than deciding upon what is indiscernible about these proximities, it may be useful to reactivate the elements and to release the stratifications which problematize the aesthetic and political meaning of this audiospatial sensorium. [...]

When luminous projection gives a space of visibility to 'mute' speech and music is also of course when reproductive devices are in the throes of development. The fact that these devices served for a time to capture the images or voices of the dead and that they are again being proposed for the same purpose at the beginning of the third millennium is not the key issue. The essential thing is in the new radicalization that the devices of technical reproduction confer upon the constitutive principles of aesthetic art. They do so in two principal forms: through revitalizing the relations between active creation and passive reproduction and by the generalized availability of images and sounds.

Mechanical reproduction is known to have successively led to two analyses: firstly, the prophecy of the death of art, stricken by the copy industry; subsequently, and quite to the contrary, a verdict of emancipation. where industry was to restore to the creative imagination and artistic autonomy all of their prerogatives, thereby definitively relieving them of the tasks of mimetic reproduction. The two diagnostics both turned out to be equally erroneous because both relied upon the overly simple opposition between original creation and the servile reproduction that the Romantic revolution had already revoked, by asserting its will to rewrite ancient poems, by dealing with them both as material for new constructions of art and as forms for new contents. The concept of the 'unique work' that Benjamin vainly sought to link to art's 'cult-based' past emerged at the same time as the Romantic identification of the creator with the traveller, collector or archaeologist, who recollects, reinterprets and recreates art's past. And, in fact, it developed along with the new forms of multiplication: with the promotion of the interpreter – that is, the instrumentalist, director, conductor, critic – and the technical forms of reproduction. From Romantic fragmentation and the Schlegelian idea of the 'poem of the poem' to the contemporary practices of deejaying, sampling and remixing, which multiply the 'unique copies' created by the artisans of reproduction, via the development of the industry that deals with conserving heritage and obliges its constant broadening and 'rejuvenation', it is possible to trace an empirically erratic but theoretically coherent line.

The upheaval in the relations between consciousness and unconsciousness, the old and the new, creation and reproduction, is also the scrambling of the opposition between art and non-art itself. Still contrary to the image of a Romantic modernity – alleged to have separated the autonomy of art from forms of life – the art of the aesthetic age has incessantly identified itself with its opposite. But this identification itself takes two forms. There is, on the one hand. the Dionysian roar of music which claims for itself the Apollonian shimmering of images. This roar is also the shift from an art of notes to an art of sounds, from the art of sound to the art of noises and from the latter to the boundless and anonymous murmur of life and/or machines; the passage from the kingdom of songbirds to that of insects, experts in stridulating, scratching and scraping, as Deleuze and Guattari would say.[1] Let us add that the insect is an eclectic animal. It can be serial or spectral, concrete or virtual. It can be in harmony with a tortured violin as much as with a misused electrical device, a synthesizer-produced sound, an electronic beep, the crackling of the loudspeaker or a recorded birdsong. It is the true interchangeability of these modes of production of 'sound particles'. Its artistic promotion is thus in agreement with the other forms of identification of art and non-art: the infinite multiplication of images,

the great metamorphism which incessantly reprocesses usable things, commodities and the disaffected icons of business, to make 'images', that is, something henceforth entirely different from copies: metamorphic elements, at once bearers of the signs of history and of the affect of the disaffected, susceptible to entering into all the combinations where expression can be given either to the meaning of a common destiny or the mute splendour of what is useless, reasonless. It is well known how the surrealist poetics of collage (taking these terms in their broadest sense, which goes beyond a mere school or technical procedure) played on this metamorphicity, which would transform any commonplace thing into a dream image and art material, but also any image of art into a profane and profanable commodity. The speed with which useful things become obsolescent and the speed with which art things are reproduced joined forces to spread infinitely the domain of this metamorphism. A certain artistic, anthropological or historical fundamentalism was only too happy to make music into the standard of resistance against this generalized metamorphicity of images, which means, with the erasure of the borders between the arts, the increasing indiscernability between art and non-art. The spiritism which dominates today in the new marriage of music and space, of art and technique, expresses in its own way this late 'becoming image', this 'becoming surrealist' of music. It is where the vast poem of yesterday's music and sounds runs up against that of the needle that scratches and the amplifier that crackles, the synthesizer that creates and the computer that invents, that the fusion of the two contradictory powers comes about: that of the grand Schopenhauerian background – indistinct as it is mute – of the 'ocean of sound',[2] whence all images emerge like spectres, only to disappear once again; and that of the Schegelian 'poem of the poem' – of metamorphicity, collage and infinite recreation produced on the basis of the great storehouse of images, ultimately identical to the life of the storehouse itself.

The art of the projection of sounds and images, which equalizes media from different eras and identifies the improvisation of performance with the making available of archives, offers itself then as eminently appropriate for configuring this space of installations which materializes the union of artistic decision with the raw factuality under the sign of living memory. To situate these small theatres of memory, which contemporary art exhibitions are inclined to become, one can indefinitely construct contradictory scenographies – mystical oceans of sound, blessed in the name of Bachelard, Stockhausen or Sun Ra, or the storefront windows of shopping malls, stricken by the maledictions of Adorno or Guy Debord. But for a long time now these topographies have become confused, the romantic sirens have learned to take all figures and to accommodate themselves in all places: ships' sirens (Varèse), old-fashioned umbrellas in the Opéra passageway (Aragon) or stock-exchange prices (Broodthaers). Unanimity of

modern noise and life, plunged into the perennially renewed ocean of dream images, critical atlas of signs and of misappropriated icons: these three great figures of the identification of art and non-art have not finished offering themselves to, and at the same time eluding, judgements that deplore the spectacle-king or exalt the ultimate figure of its radical critique. There is always the danger, as Deleuze and Guattari pointed out, of confusing cosmic machines and machines of reproduction. It may well be that they all have the same genealogy and that what clashes in the background of the great proclamation is above all the different ways of archiving, narrativizing and theatricalizing the archive; of slowing down or speeding up the metamorphoses of use objects and art documents into the material of memory and into forms of its theatricalization. The politics of art which redistributes the forms and time, the images and the signs of common experience will always remain ultimately undecidable.

1 [footnote 7 in source] Gilles Deleuze and Félix Guattari, *A Thousand Plateaux*, trans. Brian Massumi (Minneapolis: University of Minnesota Press, 1993).
2 [8] See David Toop, *Ocean of Sound* (London: Serpents Tail, 1995).

Jacques Rancière, extracts from 'La Métamorphose des muses/Metamorphosis of the Muses', in *Sonic Process: Une nouvelle géographie des sons* (Paris, Editions du Centre Pompidou, 2002) 17–19; 26–9.

Steven Connor
Ears Have Walls: On Hearing Art//2005

Sound art responds to two contrary tractions in the practices of making and displaying art. One is the desire to burst boundaries, to tear down the walls, to break out of the confined space of the gallery. Sound is ideal for this because of its well-known expansiveness and leakiness. Galleries are designed according to the angular, not to say perpendicular logic dispensed and required by the eye. The interior spaces of galleries are disposed in Euclidean straight lines and perpendicular planes, presumably because that is how light travels and how vision works. Rather than moving from source to destination like a letter or a missile, sound diffuses in all directions, like a gas. Unlike light, sound goes round corners. Sound work makes us aware of the continuing emphasis upon division and partition that continues to exist even in the most radically revisable or polymorphous gallery space, because sound spreads and leaks, like odour.

It is not what you put in a gallery that matters (as the gallery can surround any object with a sort of invisible force-field or glaze of 'aestheticality') but rather, whether or not that object stays in its place. I think it is in part this power of sealing or marooning things in their visibility, this allergy to things that spread, that makes galleries so horribly fatiguing and inhuman: at least to me. Sounds, by contrast, have a power to relieve and invigorate just as smells do. I can see works of art much better on a wet day, when the moist fug steaming from boots, macs and hair can ventilate my otherwise asphyxiated gawp.

Much of the work that is characteristic of sound art has either gone outside or has the capacity to bring the outside inside. Sound is doubly extramural: in a disciplinary sense, it adds to art a dimension that has traditionally been left to other, more temporal arts; secondly, in a more immediate or phenomenological sense, it introduces timely events into the permanent, partitioned world of art. Sound art comes not only through the wall but round the corner and through the floor. Perhaps the greatest allure of sound for artists, more than ever convinced of their libertarian vocation somehow to go over the institutional wall, is that sound, like an odour or a giggle, escapes.

According to R. Murray Schafer, Western music has done everything it can to retreat from this exposed or open-air condition. Observing how many languages have no separate word to distinguish music from sound in general – this is true, for example of Japanese, of Inuit, of most North American languages, as well as of African languages like Yoruba and Igbo – Schafer suggests that the special status of music in European and other Northern cultures has a strongly architectural determinant:

Music has become an activity which requires silence for its proper presentation – containers of silence called music rooms … In fact it would be possible to write the entire history of European music in terms of walls, showing not only how the varying resonances of its performance spaces have affected its harmonies, tempi and timbres, but also to show how its social character evolved once it was set apart from everyday life.[1]

In the special kind of sound we call music, in other words, time and duration thicken and aggregate into space and place.

Sound art, by contrast, has typically sought to expand beyond the gallery, to ventilate the gallery with the sounds of what lies outside it, or to temporalize place. The 'Sonic Boom' exhibition of sound art at the Hayward Gallery, London, in 2000 included a piece by the group Greyworld (the artists Andrew Shoben, Sabine Tress and Floyd Gilmore) in which the steps down to the Hayward Gallery from Waterloo Bridge were mined with sound sensors, allowing a kind of

feedback of the sounds of visitors as they ascended and descended. The sound and performance artist Janet Cardiff has taken the audio-guides that have become so popular in galleries and adapted them for audio-walks in different environments. Other sound works have taken to the streets in other ways. Between 1 November and 14 December 2002, the dancer Michael Clark set up a sound sculpture titled *Drawing Breath*, consisting of a loop of panting sounds outside the Janus sex shop in Soho. Since the shop specialized in the arcana of spanking, the reference was perhaps to the folkloric link between the midwife's slap and the breath of life. In 1998 the sound artist Scanner completed a piece entitled *Surface Noise*, built around movement through London. Here is his explanation of the methods by which the piece was devised:

> This work took a red double-decker bus as its focus. Making a route determined by overlaying the sheet music from 'London Bridge is Falling Down' onto a map of London, I recorded the sounds and images at points where the notes fell on the cityscape. These co-ordinates provided the score for the piece, and by using software that translated images into sound and original source recordings, I was able to mix the work live on each journey through a speaker system we installed throughout the bus, as it followed the original walk shuttling between Big Ben and St Paul's Cathedral.

When sound comes into the gallery to play, its exhilarating and delinquent leakiness can make for ironies. When David Toop was putting together the 'Sonic Boom' exhibition, he was faced with a positively suburban problem of sound pollution. Though many of the artists represented in the show might well have paid lip service to the idea of the importance and pleasure of the diffusiveness of sound, the potential for undesirable interference was high. The scarcely audible scratchings and sussurations of Max Eastley's ethereal metal figures were at risk of being swamped by the glorious but omnipresent headachy bruise of a sound that throbbed from Pan Sonic's low-frequency installation. During the planning, the artists involved became a new species of suburbanite, protesting against their noisy neighbours in the gallery space. The solution to which David Toop and some of his artists was led was the traditional one: they put up extra walls, and built rooms of sound, to insulate and contain the different sound events. At least one of the pieces in the exhibition played with that, Scanner's *The Collector*, in which a series of images of butterflies was projected onto the walls of a little enclosed booth or cabinet to the accompaniment of a soundtrack. The 'flutter' that is a feature of audio-talk became literalized in the piece's suggestion of tiny wings, beating and butterfly-kissing the auditory membrane.

Mixing

Sound is the permeable. A world of sound is a world grasped as irreducibly and undecomposably compound. The difficulty of conceiving this state becomes apparent as soon as one inspects the metaphors we habitually use to think of that which is conjoined. 'Complexity' has at its root the idea of one surface folded over upon another. Collage and juxtaposition similarly focuses attention on the edges or outward surfaces of things brought up against each other. Even the word 'compound', despite its helpful though etymologically irrelevant suggestion of things that have been kneaded or mashed together, derives from componere, meaning the putting of things together or alongside each other. Our language tends to separate the compound into the merely composite, into the setting together, surface against surface, or edge against edge, of entities which remain entire.

The vernacular language is a little wiser. Where we have traditionally spoken of the making of music as a composition, this act is more likely to be named in contemporary sound practice as a process of 'mixing'. Composition and music-making have started in many quarters to become once again what they always really have been, a mixing process more akin to cooking and chemistry than to calculation. Sound belongs to what the philosopher Michel Serres has called a 'philosophy of mixed bodies',[2] bodies which are compound all the way through. The unsighted, or undersighted, by which I mean both the blind and the intently listening, inhabit a world – a world which is the world – of mixed bodies, of permeable, impermanent, volatile space, of irreducible adulteration.

We might note in passing another feature of mixing, namely that it appears to be an effect of a new dispensation in sound production, in which listening and sound production enter into rapid exchanges or feedback loops with one another. The sound mixer has moved from the lowly accessory condition of the one who merely tunes or refines the sound to the condition of the one who produces or even originates it. The mixing of sounds is also a mixing together of the making and the hearing of sound, which had previously been much more strictly bifurcated.

The sighted world allows for neutral containers: frames, grounds or empty volumes, rooms in which things may occur, screens which may carry inscriptions, scenes which are, as we say, set for events. For the unsighted, there are no such set-ups or scenographies. In the unsighted world, latency is temporal and not spatial. And because it is temporal, it is also tense with possibility rather than neutrally open to it. Michel Chion has put this particularly well with regard to the difference between image and sound in film. Apart from in certain experiences of immersive cinema, the viewer of an image in the cinema can almost always see or intuit the edge of the frame, which remains the visible, or visualizable

horizon of everything that occurs as we say on the screen or in the frame. But sound in the cinema, like sound in the world, has no frame, no 'auditory-container'.[3] The world of the unsighted is a world without firmament, without permanent fixtures and fittings, walls or rooms. It is a world rather of events, which are both continuously about-to-be, for one cannot listen away as one can look away, cannot ever stop hearing, and also, so to speak, continuously intermittent. There is no background, no firmament, only figures which start forth from their own ground. John Hull has evoked wonderfully well this absence of givens, or set-ups, the world of unannounced annunciations, which the unsighted inhabit. Not visibility, but rather visitation.[4]

I have been evoking the different worlds of the oversighted and the undersighted, as though they were entirely different and incommunicable conditions. But it is doubtful that even these two conditions can be sealed or walled off from each other. Not only does sightedness include unsightedness as a possibility; blindness, at least in anyone who can use our vision-shaped language, includes the horizon of sight. Even the blind from birth, who might seem never to have had any visual experience, will learn to understand much of the meaning and import of the eye, must accede to the configuration of the world in terms of the eye. When we sighted say that we see what we mean, the unsighted indeed see what we mean by that, and mean the same as we in saying it.

Habitats

Sound is arousing and dangerous because it can so easily penetrate and permeate, so effortlessly become the soft catastrophe of space. The blast of Joshua's seven ram's horns, along with the vigorous shouting of the faithful was enough to bring down the walls of Jericho. But the artists of the 'Sonic Boom' exhibition who sought to fence off or wall up their own particular sound environments were responding to another, oddly opposite, feature of sound, namely its capacity to envelop, to fill, form and fix space. It is a power attested to in the story of Amphion, son of Zeus: when he played the lyre he was taught by its inventor Hermes, the stones of the walls of Thebes moved into place of their own accord. Sound can not only impregnate, irradiate, it can also, it seems, provide a haven or habitat: 'safe' as the saying is 'and sound'. We use sound to locate things, and to orient ourselves in space: to take the measure of things, we take 'soundings' or 'sound things out'. Something which responds favourably to this process may even be said to be 'sound', meaning presumably that it is in fact reassuringly resistant to sound's probative passage. Sound is exploratory rather than merely metric or analytic, because sound does not give us just the outline or contour of things – their size, shape and position – but also gives us the sense of their quality, or their relation to us: their texture, density, resistance, porosity, wetness, absorptiveness.

It is striking that many sound artists are concerned to use sound as a form of detention or agglutination of place, rather than its dispersal into sound or movement. One example would be William Furlong, who contributed to the Arts Council Touring Exhibition 'Voice Over' in 1998. Furlong, who presents his work under the name Audio Arts (like many DJs who prefer to name themselves as collectivities rather than as individuals) has employed a method in a number of his sound pieces that involves interviewing people about their habits, likes and dislikes, and then cutting and remixing the results. According to the 'Voice Over' curator Michael Archer, a piece such as Spoken For/Spoken About (1997), 'allows the place to speak and to be listened to by those who move through it ... A voice sounds in the space that it makes as it sounds.'[5]

Immersion

When you are in a bath, or even in a sauna, you feel yourself at once inside your skin and taken beyond it. One seems to expand outwards from one's core to one's skin. But this movement does not confine one in one's skin, but releases one to continue to expand into the element in which one is immersed. Didier Anzieu finds an analogue for this immersion in what he calls the 'sonorous envelope', or bath of sounds, to which all of us are subject, first of all as foetus, in which sound and tactile sensation are powerfully intermingled, and then the experiences of the young child, in which the sensation of being held and embraced continues to cooperate with the lulling and lalling, all the gentle hubbub, with which the child is surrounded. We can say therefore that the experience of immersion in sound is a strange hybrid that does not yield easily to the language of space. In the experience of sonorous immersion, one is on the outside of what surrounds one; one is sheltered within a space which one nevertheless oneself suffuses. For all the sad, wild foolishness of psychoanalytic surmise about the origins of autism in childhood trauma, the accounts offered by Edith Lecourt of the necessity felt by some autistic children for physical support and enclosure along with their auditory equivalents, in humming or other sound-routines, have a compelling poignancy. Sound is here erected as a barrier against the disordering, extinguishing incursions of sound itself.

I take it that this was the pun involved in the title of the installation in the Museum of Modern Art in New York which ran during the second half of 2000. In *Volume: Bed of Sound* visitors were invited to find a corner to snuggle into of an enormous futon bed, from which extruded a number of sets of headphones, each playing a piece of sound or music created by a composer or artist.

The capacity of sound to build as well as to take down walls is a more difficult matter to think about steadily than sound's diffusiveness. How can

sound be experienced as at once the diffuser and the builder of bounded place? What is it about sound that makes us imagine it to be habitable?

Partly it is because sound is voluminous. If vision always puts creatures physically constituted as we are in front of the world, then sound, as Walter Ong has put it, puts us in the midst of things. Sound puts us in the world from which vision requires us, however minimally, to withdraw. Even this is a simplification, for, in order for a sound to be audible, it is always necessary for it to be in us just as much as we are in it. We inhabit sound, because it happens to us. We do not inhabit the world of vision because our acts of looking are constantly doing things to that world. Looking, as Merleau-Ponty has remarked, is a kind of having. Listening can only approximate to this appropriative hand-eye coordination.

But the spatiality of sound comes about also for just the opposite reason, namely that we are in fact never wholly passive with regard to sound. We never merely hear sound, we are always also listening to it, which is to say selecting certain significant sounds and isolating them from the background noise which continuously rumbles and rattles, continually on the *qui vive* for patterns of resemblance or recurrence. As with sight, and following Wordsworth, the ear 'half-creates' what it thinks it hears. This language of sound is spatial. Why does the increase in frequency of a sound suggest that it is getting 'higher'? In other words, the spatiality of sound is a reflex, formed by the projective, imagining ear, the ear commandeering the eye to make out the space it finds itself in. It is in this sense that ears may be said to have walls.

Sound Objects

If some of sound art is concerned with what Pierre Schaeffer has called the 'acousmatic' dimensions of sound, namely sound produced without visible or even definable source, other kinds of sound art are interested in the ambiguous embodiments or fixations of sound. Ambiguous because, despite all our instincts to the contrary, there are no sound objects. We say, hearing a sound, that is a siren, or, that is the sea, but objects are only the occasions for sound, never their origins. And there is no sound that is the sound of one object alone. All sounds are the result of collisions, abrasions, impingements or minglings of objects.

Nevertheless, since the beginning of the century, composers and avant-garde artists have been following the lead of the Italian Futurist Luigo Russolo, in building or inventing objects to embody sound. Having called for an 'Art of Noises' in his manifesto of 1913, Russolo set himself to constructing a series of noise instruments: whirrers, rubbers, roarers, and the like. The expansion of the spectrum of music into more and more unfamiliar or unregistered areas of sound led composers such as Harry Partch to the construction of ever more outlandish instruments. One might have expected the development of the technologies of

sound synthesis and manipulation to have led artists away from the attempt to embody their new sounds, but the two tendencies have in fact advanced together in parallel. The visual and tactile correlatives of sound art have become more rather than less important in art galleries.

I spent four years thinking I was writing a book about the disembodied voice and concluded that there was never any such thing; that sounds, though always on the move, are hungry to come to rest, hungry to be lodged in a local habitation that they can be said to have come from. Sounds are always embodied, though not always in the kind of bodies made known to vision.

The phrase 'sound sculpture' refers interestingly to two kinds of thing. A sound-sculpture in the sense in which it is used by the American artist Bill Fontana is a piece of shaped sound, often with a close relationship to a specific location. Examples are his piece *Sound Sculptures through the Golden Gate* of 1981 or his *Acoustical Visions of Venice*. The latter mixed together sounds recorded at noon from thirteen different locations, all visible from the Punta della Dogana in Venice. But other artists use the term 'sound sculpture' to refer to instrument-like objects that are themselves designed or adapted to produce sound. In both cases there is a commerce between sound and shape, whether in the form of a shaping of time, or in the form of a kind of precipitation of sound in form.

This materialization may be the reflex of a loosening and dematerialization of sculpture that has taken place over the last century. Up until the twentieth century, sculpture referred to an art of shaped masses and materials. Increasingly through the century, sculptural forms have begun to exhibit interiority. From Hepworth and Moore through to Anish Kapoor, masses have become topologies, in which channels, apertures and cavities are more and more functional, just as they are in a musical instrument. As more and more air has circulated in and around sculpted forms, sculptures have become more and more like resonating bodies, more and more like instruments for making sound. Walter Ong has spoken of the link between sound and interiority: where vision only ever gives us information about the surface of things, sound can inform us about otherwise invisible interiorities – the sturdiness of a wall, the state of the lungs, the steadiness of the soul. One may see not just in sound sculpture but in sculpture in general a move away from the idea of mass formed from the outside in to the idea of a mass shaped from the inside out, as a shell or a shell-like ear is.

We are perhaps far from being sensitive enough to the cultural phenomenology of musical instruments. We can define an instrument as a sounding posture of the body. We learn to hear the postures imprinted in sounds: the fat, farting buttock-cheeks of the tuba, the undulant caressings of the cello, the hooked, crooked intensity of the violin (for all its feminine curlicues, the violin is an instrument of acute angles; chin, wrist, elbow, armpit). The more that the

artificial production and reproduction of sound, in amplification, for example, threatens to lead away from this sense of embodied source, the more we learn to replace or refuse this loss, as with the extravagant, martyred postures of the electric guitar, enacted both in the ecstatic writhings it evokes, and in the ever more baroque contortions of its own shapes. What a marvellous invention is the despised 'air-guitar'! When we hear an instrument that we have never heard before, we cannot fully or properly hear it until we have guessed or supposed in it the manner of its production, the mutual disposition of body and instrument that results in the sound, and of which the sound bears the impress. Sometimes, perhaps a little at a loss for an adequate sound-posture to project, we will treat the instruments of reproduction or transmission as instruments, as in the manipulations of tape and vinyl practiced since the *musique concrètistes* of the 1950s. We are not simply touched by this kind of sound. We take it into us, hear it in the mode of producing it, in an instrumental coenaesthesia [awareness of our existence through bodily registers]. This mode of touch gives us not so much touch as pressure, or as the impending of things upon us, as the touch of shape, or touch as the guarantee of shape. Philip Jeck's explorations of the linked sound and texture of old record players in his piece *Off The Record* seems to requisition something like this desire to apprehend the bodily shape of sound, here formed from the chattering gossip of twenty or thirty record players all tuned imperfectly together, rather as in N.F. Simpson's play *A Resounding Tinkle*, in which a hundred I-Speak-Your-Weight machines are being coached to sing the 'Hallelujah Chorus'.

So I have outlined a kind of paradox. Sound art is the gallery turned inside out, exposed to its outside, the walls made permeable, objects becoming events. Sound art is the most potent agency of that attempt to dissolve or surpass the object which has been so much in evidence among artists since Dadaism in the 1920s. And yet the gallery or museum seems to provide a kind of necessary framing or matrix, a habitat or milieu in which art can fulfil its strange contemporary vocation to be not quite there.

Pathos
The terms in which I have evoked an art of sound suggest a pleasurable ecology or interchange, a mixing of that which was previously kept coldly or aggressively distinct. But sound is not all pleasurable permeation or erotic meeting of membranes. Sound, as Aristotle puts it, is the result of a pathos. All sound is an attempt to occupy space, to make oneself heard at the cost of others. Sound has power. Michel Chion has pointed to an odd convention about invisible sources of sound in cinema, namely that they are usually thought of as having the power to see other characters who cannot see them.[6] This is perhaps because divinity is associated with invisible or sourceless sound, while mortality is associated with the condition of visible

audition. As John Hull has so crisply put it: 'When we say that the divine being is invisible, we mean that we do not have power over it. To say that the divine was inaudible, however, would be to claim that it had no power over us.'[7]

This note of pathos or *agon* is to be found occasionally erupting even in Romantic evocations of sound like Wordsworth's 'On The Power of Sound', which begins with an evocation of the perils of the ear:

> a Spirit aerial
> Informs the cell of Hearing, dark and blind;
> Intricate labyrinth, more dread for thought
> To enter than oracular cave;
> Strict passage, through which sighs are brought,
> And whispers for the heart, their slave;
> And shrieks, that revel in abuse
> Of shivering flesh; and warbled air,
> Whose piercing sweetness can unloose
> The chains of frenzy, or entice a smile
> Into the ambush of despair;

With its interest in that which goes through the wall, or that which can huff and puff and blow the house down, sound art might have been drawn more than it has been to the explosive gesture, to the raucous ugliness of Marinetti's sound events. One tireless exponent of the *agon* of sound has been Christian Marclay, who devised a piece entitled *Guitar Drag*. This piece conjoined a video showing a live electric guitar being dragged behind a pick-up track through Texas back roads with the sound recorded from the tortured instrument. But in fact if there is a characteristic gesture of sound art it is the incorporation in it of the light touch, of delicacy, of sounds that are at the fringes of audibility. One might instance for example the recent work of Kaffe Matthews, *on her eb and flo*, of performances in Vienna and London, using as her only sound source a small theremin, an electronic instrument played by moving the hands in the space between two electronic transmitters. The rice paper walls of the traditional Japanese house may, as R. Murray Schafer suggests, contrast with the glass windows of European houses in that 'glass resists nature; rice-paper invites its penetration'. Such houses are therefore auditory constructions, which not only have but also are ears. But they achieve this by reminding us of the violability of the ear. The ear is the most delicate of organs because it is more prone than any other organ to damage by an excess of the stimulus it is made to detect. Precisely because we are more continuously exposed to sound than to touch, taste, smell or sight, the ear is not exposed on the body's surface, but involuted, devious, sequestered, esoteric. To

hear our own hearing is to become aware of that fragile screen which must remain intact for hearing to occur at all. The burst tympanum is mute.

1 R. Murray Schafer, 'Music, Non-Music and the Soundscape', in *A Companion to Contemporary Musical Thought*, ed. John Paynter, Tim Howell, Richard Orton and Peter Seymour (London and New York: Routledge, 1992) 35.

2 Michel Serres, *Les cinq sens: Philosophie des corps mêlés* (Paris: Grasset, 1985) 12.

3 Michel Chion, *Audiovision: Sound on Screen*; trans. Claudia Gorbman (New York: Columbia University Press, 1994) 68.

4 John M. Hull, *Touching the Rock: An Experience of Blindness* (London: Arrow Books, 1991)

5 Michael Archer, in *Voice Over: Sound and Vision in Current Art* (London: Hayward Gallery, 1998) 8–15.

6 Michel Chion, op. cit., 129–30.

7 John M. Hull, op. cit., 127.

Steven Connor, 'Ears Have Walls: On Hearing Art', *FO(A)RM*, no. 4 (2005) 48–57.

Helmut Draxler
How Can We Perceive Sound as Art?//2009

[...] Just as the museum isn't neutral in its relationship to the objects exhibited in it, in the same way, sound reproduction techniques and the distribution media based on those techniques have had a significant influence on the category of music. Just like the visible world, the audible world too has changed under the conditions created by capitalist, industrial and democratic modernity: our everyday experience is marked by the din of machines and big cities, by the blaring and blatantly promotional and propagandistic media of radio and television, by the backdrop of functional music in the shopping malls, and by cell phone ringtones. The ubiquitousness of such noises is more a question of culture than of art, whether high or low. Just as visual culture can no longer be reduced to painting, in the same way, these aural scenarios can no longer be regarded as music. The English word *sound*, however, which as a collective term encompassing tones, *Klänge* [a German word for which the closest English equivalent is 'sounds' but which is actually more restricted in its meaning, as the author suggests (translator)] and noises has no direct equivalent in German, at least preserves the connection between these disparate phenomena.

It is directly related to sound recording, that is, to the transcription of tones, *Klänge*, and noises that was made possible by the invention of the phonograph, and which – as Douglas Kahn has shown – is what first turned them into a unified field of audible phenomena. Any attempt to establish a hierarchy among them that would privilege the human voice or pleasant instruments and thus ultimately music as a whole loses all validity in the presence of the recording device. Everything that rings, jingles, hisses, crashes or creaks can be recorded. Animal and natural sounds no less than street and machine noise, karaoke and symphony orchestras. Thus the phonographic reproduction medium has become the actual production medium of modernity. It has turned everyday sounds into a provocation for music and art, and conversely – in the case of John Cage – it has also brought music without sound into the realm of the conceivable. This has not only given rise to a reflexive and conceptual type of composing; it has also brought us closer than ever before to conceiving of music as we do objects in a museum – as the embodiment of a substantial conception of art.

The crucial question is: What is the significance of these now transformed auditory and visual cultures and the media that helped to transform them for our understanding of art? The answer to this question will determine how we experience sound in the museum, and *what* we actually experience when we do so.

According to one common answer, we are witnessing the end of traditional art and the establishment of a new media art. If that were the case, however, we would experience the more or less successful creative use of 'new media' as art. This view sees the transformation in question as taking place entirely within the realm of cultural and technological innovation, not within art, since art is not at issue. The imperative on which this argument is based – that 'art' must concern itself with the latest technological and media developments – underestimates the special historical conditions that are operative in this area: art is precisely no longer directly implicated or affected by these developments. It also ignores the specific aesthetic methods that have developed under these conditions. Provided these two differences are recognized – that art is not a direct participant in technological and medial modernity, and that its methods do not purely lie in the shaping or fashioning dimension of given tasks, apparatus or media – the above imperative doesn't seem to me to be entirely false. It goes without saying that for art's working methods, new technologies and media formats are important new realities with which to engage. However, special attention must be given to how, specifically, those new realities interact with the modern conditions of art before the special challenge that technologies and media constitute for art can be addressed.

A second answer sees popular culture as the specifically contemporary form of art (as Erwin Panofsky did with film when he compared it to the cathedrals of the Middle Ages) or additionally the sciences – as when present-day software

programs or aspects of the neurosciences and biotechnology are described as what 'really' constitutes art today. This response represents a generalized rejection of the distinction between culture and art, which is central to modernity, and thus indirectly of modern art itself, since it draws the criteria for the new from the old, that is, from a premodern conception of art that can actually be found in popular culture and the sciences. At the same time, it also excludes all of the categories that make it possible to speak about art in the modern sense – the categories of autonomy, the artwork, authorship and experience, Thus it is no wonder that such arguments are lacking in even the most basic attempt to formulate specific aesthetic criteria. Arguments like these are not only unhistorical in the extreme: they also overlook their own dependence on the very conception of art they purport to transgress or overcome. After all, it is a hallmark of precisely that conception of art that, in the contest to define its true, intrinsic nature, it frequently imagines itself as extsting beyond its own borders.

A third answer might be seen in the view of the avant-garde that has become increasingly widespread since the 1930s. According to this conception, the avant-garde saw itself as a 'project' directed both against the 'kitsch' of popular culture as well as against traditional art. In this conception, the specifically artistic is taken extremely seriously, so seriously that it is credited with the ability to provide immunity against the media and popular culture. However, this position is only to be had by pushing the theory of alienation to an extreme in which the whole of modern culture is denounced as scandalous, while 'art' is touted as the instrument of its redemption.

All three of these arguments, in my view, fail to capture the specific factors that actually make the phenomenon of sound as art interesting. In all of them, the elements of the medial, the cultural and the artistic are played off against each other – instead of being placed in relation. Sound, however, it seems to me, can only be grasped as an exemplary category of mediation. As a notion that encompasses all things audible, it mediates between music and noise and hence, in the traditional sense, between art and everyday life. This notion of the audible in turn has medial preconditions, so that sound has always moved within the tension between technological media and the modern culture based on them. This compound and internally complex phenomenon – the sonic culture of modernity – was already recognized early on as a fertile subject for a non-traditional or avant-gardist conception of art, from the direct incorporation of noise by the Futurists and Productivists all the way to the reflexive uses of sound in contemporary art. The shift that separates today's positions from the avant-gardist approach and its heroic embrace of din consists above all in the fact that in the interim, the immediate experience of hearing has increasingly been replaced by the code of the museum. Instead of true 'concrete hearing' we have

to do here too with a mediation, in this case between the various aspects of the sonic material and the fact that that material is exhibited in a museum, in other words, its exhibition value [*Ausstellungswert*].

Thus the question of what we can actually hear implies assumptions about the relationship between concrete hearing and contextual or reflexive perception. If we regard the codes of sound and museum as a kind of background system of metaphors that primarily concerns the semantic dimensions of the institutional or discursive setting, then they cannot be ideas or myths; they cannot be something detachable from experience itself that could thus be rejected, overcome or 'sublated' [*aufgehoben*] in the Hegelian sense. On the contrary, this system of metaphors reaches into experience and is implicated even in its 'immediacy'. From this perspective, the immediacy of hearing is actually the outcome of a complex process of mediation between music and noise, medium and culture, culture and the conception of art. For this same reason, it would also be completely mistaken to regard sound as noise in Jacques Attali's sense, that is, as pure rustling and as a fundamental interruption of the code of social exploitation. On the contrary, even noise can only be grasped as the code of a sound that in turn is dependent on a medium and a context in order to communicate itself. What is interesting, however, about the established view of noise is that it is associated with the notion of interruption and hence with a political dimension of sound, even if in my view that polltical dimension is mistakenly identified with a realm beyond mediation.

Thus the questions raised by sound in the museum are also of relevance to the social dimension of sound. Not merely in the sense of a museumification of pop cultural and media formats as new forms of the utilization of bourgeois representation, but also with respect to the criteria according to which sound can be aesthetically and politically evaluated at all. For what is at stake here is uitimately nothing less than how exactly the concrete experiences of hearing and perceiving interact with the cultural codes that structure and presuppose them but which those experiences can also call into question time and again. It is precisely the room between medium and code, sound and museum, that matters from a practical perspective and in terms of the process of reception.It must be possible to distinguish the codes and the media of sound both from each other as well as from the code of the museum and the medium of the exhibition. The social, aesthetic and technical aspects of mediality must be differentiated, and the cultural and institutional aspects of the code must be reflected. For unlike music, sound possesses no internal *Materialstand*, or historical state of the material – it does not develop. It can only be placed in concrete situations again and again, each time afresh, and addressed in such a way that visual and acoustic, aesthetic and institutional space can be distinguished and then, in this

distinctness, related again. Thus, the history of the relations between music and the visual arts since John Cage cannot be read as one of fusion in the sense of the total artwork, nor in terms of synaesthetic phantasmagoria, but rather as the history of a shift in the direction of the fields of sound and museality. The individual practices position themselves within these fields through links and borrowings: they are no longer music or painting but art in general, refracted through medium and code. It is equally possible for the medium of sound to be called into question by the code of exhibition value or for the code of sound to be placed in question by the medium of the exhibition.

In historical terms. Fluxus was surely the first movement to situate itself within these fields, even if its tendency to conceive of itself as a flowing intermediality does not entirely capture the main point. Even what flows needs poles between which to move. These poles no longer represent the old spatial and temporal artforms of painting/sculpture and music, but rather the media and institutions of modern culture. In retrospect, what calls out for explanation is no longer the gesture of border-crossing or transgression, that is, what made sound, as a processual phenomenon, of interest to the static arts, but rather what sound could possibly want from art. One answer may be that 'art' is so institutionalized that it is easier to address the mediated character of sound in its name than it is in other contexts. Thus, sound as art can speak at once from the vantage point of the medium as well as from that of the institution: as a result, it is able to thematize the tensions in their relationship with each other.

Helmut Draxler, extract from 'How Can We Perceive Sound as Art? The Medium and Code of the Audible in Museum Environments', in *See This Sound* (Linz: Kunstmuseum/Cologne: Verlag der Buchhandlung Walther König, 2009) 28–31 [footnotes not included].

I WENT TO ART SCHOOL, NOT TO MUSIC SCHOOL. I DON'T THINK

LIKE A MUSI-CIAN.

Christian Marclay, in conversation with Kim Gordon, *Christian Marclay*, 2005

Germano Celant
Artsound//1981

It is common knowledge among true libertines that the sensations channelled by the organs of hearing are the most exciting, their impressions the most vivid.
– D.A.F. de Sade, *Les cent-vingt journées de Sodome*

Compared to the silence and opacity of painting and sculpture, music seems sensational due not only to a certain fashionable lustre which fascinates but also to its connection with quotidian reality. Although each sound is an absolute entity arising from fixed notes it renders the world something unheard of: the extraordinary, formerly announced by the picture frame or the sculpture plinth, today emanates from loudspeakers and film projectors. For this reason one of the greatest measures of the contemporary artist is that of the self-expression needed to cross over between the roles of painter, photographer, filmmaker or musician, like, for example, Robert Longo, Mayo Thompson, Alan Vega, Laurie Anderson, Jack Goldstein or The Residents. These artists' requirements are effectively structured according to the imprint left on the photographic paper, film or record on which they are able to incise perfect signs. In addition, these original matrices shape the world itself, because from them derive thousands of copies – and thus millions of images and sounds – which circulate to countless viewers and listeners everywhere. Since artists have always been interested in shaping reality, or at least in influencing it, what better process is there than to reproduce their own ideas in limitless quantities? As may well be seen, after the opening up of the media that took place over the last two decades, all artists are now armed with cameras and recorders. To them, to click a shutter or record a tape is a normal process; it serves to tranquilize them, since they are able to take away with them any image or sound whatsoever, on the instant, without designing or composing it. The identification between trace and real world renders the world a box of sounds; therein lies its own existence, the rest does not count. And so it is perfectly logical that artists today react to their own restricted existence and start to roam like vagabonds in the space of electronic and filmic images. On this ground the location is not fixed, as in painting and sculpture, but spread out, since the panoply of figures and noises pours out through vast channels of diffusion. It is not surprising, then, that following the Velvet Underground's historic precedent, artists working at the beginning of this decade have broken away from the marginalization of art and moved on from the 'solo show' to the 'music show', in nightclubs or on screen.

The list of artists or art world people who have formed bands is by now very long; it goes from Red Crayola (collaborators with Art & Language) to the Disband of Martha Wilson, from Cabaret Voltaire to Alan Suicide, from Brian Eno to Glenn Branca, from Rhys Chatham to David Byrne. For these, imagination or the process of conceptualization have made everything useable, to the point where they support the creation of an indiscriminate catalogue of products. This attitude signals a change in the artistic as well as musical establishment, like a spectacular 'tune-up' of the avant-garde. It is not by chance that Talking Heads have put into [the album *Fear of*] *Music* poems by Hugo Ball and that Cabaret Voltaire has used the Sonorous poems of Marinetti, or that Philip Glass 'translated' himself in [the band] Polyrock.

Music is also now part of an industrial sector: it enables not only expansion towards an audience but the direct verification of audience reactions. In contrast to the sepulchral silence of exhibition spaces, the actions induced by music are explosive, almost like an exorcism of a dead painted or sculpted object. Each sound effectively eradicates the knowledge of this body, to the point of revitalizing the blind and exhausted eyes as well as the atrophied limbs of the show's spectator.

Might the mechanism formed in these years of musical wandering now be called 'inversion', which is to say, substitution of one establishment for another? One might say no; one might, rather, speak of equivalence, due to the fact that industry entered into art, and art, instead of being passively present at its own despoliation, has entered into industry. In addition, if musicians allow themselves the luxury of artistry, they do it because art 'acts' on the audience, and it can then be put on the stage. The musical rite is, therefore, complimentary to the artistic sacrifice, except that the artist hides behind the object, does not transcribe the self, and remains separate from the senses of the audience, while the singer and the musician do not. In some way, if artists form bands, from Peter Gordon to Arto Lindsay and Père Ubu, it means that art aspires to the destruction of the limits that condition its systems of traditional reception. It attempts to sacrifice itself, sweats and howls so as to be accepted and adored by thousands of spectators, to whom the 'diversity' of the rite gives pleasure. All forget, in fact, that the aspiration of every artist is to penetrate the citadel of society and be recognized. From 1968 to the mid 1970s, due to the feeling of shame brought on by political consciousness-raising, this opportunity was refused except by those who had recourse to the 'tragedy' of 'decorative' work. And yet, if it is as moralistic to declare oneself wealthy as declare oneself poor, today no one wants self-imposed exile from the world, artists least of all.

So, now that they no longer seem to have anything to do with politics, they have been infiltrating the shows, first in performances, now in concerts. Since the show is made to be seen, the jump from visual art does not prove unnatural;

in addition, the event occurs for everyone, in a way that replaces the loneliness of art with a mass participation that is further augmented by the circulation of records. Welcome, then, the exchanges and collaborations between artists and filmmakers, musicians and photographers, who piled in together at the Mudd Club or Rocky's in New York to set up gigs with Blondie and Lydia Lunch, Steve Pollack, the Bush Tetras and DNA. Naturally, setting out in the terra incognita of music is not easy. We understand, then, the trust in chance and improvisation that characterizes the musical products of the 'new wave'. The radicality of those who grew up with the avant-gardism of Futurism, Dadaism or Surrealism can no longer come from there but must be found, like a readymade, anew. Many such musicians neither know about music nor how to use traditional instruments; they often entrust themselves to found objects and gadgets which, along with gestures, lighting and film shots, become resonant instruments on a par with percussion and guitars. This levelling convergence of diverse sonic apparatus, even if informed by an idea of dematerialization, does not alter the status of the artist, who, following on from Minimalism and conceptualism, is used to taking to an extreme any 'material' that results in the sensitive or insensitive, expressive or inexpressive, so as to satisfy spectators and audiences who seem more and more enthralled with the sensibility of Sade's libertines. [...]

Germano Celant, extract from 'Artsound', trans. Carla Sanguineti Weinberg, in *Soundings: An International Survey of Sound in the Plastic Arts* (Purchase, New York: Neuberger Museum, State University of New York, 1981) 4–6 [translation revised].

Michael Snow and Christian Marclay
In Conversation//2000

Michael Snow As you know I've been involved with free improvisation for a long, long time. It's one of the major rediscoveries in art and music in the last hundred years, and really revolutionary in some ways. For me it came partly from jazz. I wondered how you started to improvise, using discs and so forth? There's a jump there, starting out with a respect for supposedly composed music, then finding out that you can make some gestures that open up a lot of things.

Christian Marclay It took me a while to really believe in improvisation. It didn't happen right away. I felt like I had to have a certain amount of control or have an

idea before I played. But working with improvisers was liberating. John Zorn, for instance, introduced me to a lot of musicians. For them – they'd pursued music their entire lives, practised eight hours a day – my approach was really refreshing. They gave me a lot of encouragement because they envied my ignorance and I, of course, envied their knowledge. It was weird. It took me a while to understand that I brought something to the mix that they didn't have.

Snow It's an interesting thing. I've only heard one performance of yours, in Lyon, which was very beautiful. But I recognized that the system, if you can call it that, was exactly what my band the CCMC does. We just play. There really isn't any thought, in a sense, because you can't think fast enough. It's all about gesture. As soon as you hear something you recognize, but not in a conscious way, it's happening. Improvisation really is an art of living.

A group called Artists Jazz Band started in Toronto in 1962. They were friends of mine, painters mostly, who just got instruments, didn't learn anything and started playing. I thought it was kind of a joke, because I'd been a professional musician before that. But I soon found out that it wasn't a joke at all. It was fantastic. When these guys got stoned enough, the music was really amazing. I have tapes of them attempting 'Mood Indigo' or 'Joy to the World' (which is a scale) and nobody could play it. But the result is incredible. Incompetence in relation to a 'legitimate' playing of the instruments was actually a means of making variations. [...]

Marclay Because of your knowledge of the piano, you can read notes, recognize keys, you have an understanding of music that is never going to be the same as mine. Yet there's a common understanding of Western music, because of listening habits that allow most people to recognize if something sounds good. It's not so much a question of exact pitch or anything learned, but perhaps because it is the music that we've been nurtured in, we understand when something is right or wrong. We recognize when musicians are in sync.

Snow That's an interesting point. The background of a culture makes things right or wrong. You work with found sounds. They're all sources that exist on records.

Marclay Working with found material is due to my inability to play instruments. I take found sounds and transform them to the point where I feel that they're mine.

We have something in common, in that we never take the medium we work with for granted. You always foreground the process of film. I allow the recording medium to be heard. We acknowledge the existence of our tools and machines. We are suspicious of illusion. Sometimes I wonder what in my development

made me want to make music with records. Duchamp – the idea of the readymade – was probably key. Finding something that's already out there was close to improvisation in a way. Improvisation is about dealing with the moment instead of preparing something ahead of time. [...] With the readymade, the decision to remove oneself from the selection process is close to improvisation. When you're improvising you try to be as innocent, as spontaneous as possible, although you can't help but to put in everything you know.

Snow You make what I think you have to call compositions out of found material.

Marclay It ends up being sort of a composition.

Snow A composition could be identified as a process susceptible to afterthoughts. You put this with this, that with that, you decide something doesn't fit and you change it. You can't do this in improvisation, at least in real time. You can't go back again. It seems to me that composition has to do with the possibility to go back.

Marclay Today the studio is a composing instrument. You can go back, edit and alter things. Most of my work is live. I do more live performances than recordings. It's hard to translate a live event on tape. The recording makes it final, like a composition. It removes the visual experience and the social interaction. [...]

Marclay There are parallels between our work. With *Record Without a Cover* you can't ignore the medium. You can't ignore that you are listening to a recording. There is confusion between what is intentionally recorded and what is damage to the surface of the disc. There's a push-and-pull between the reality and the illusion. You have to stay alert. *Wavelength* is much like that too. In a lot of your film work you constantly keep the viewer alert, aware of his or her thought process and the medium behind the experience. There's a tension between being fooled and being aware of the illusion. That's something I've been interested in too.

Snow That's what I meant about the sculptural aspect of what you do – the recognition that there is an object besides the illusion. Of course the illusion is convincing. We see a representation of a guitar and we all agree that 'it's a guitar'. But it isn't. So if it isn't a guitar, what is it? That's something I like to get people involved in: What is the transformation that takes place? It's so common that we read images, yet isn't it pretty mysterious that we can make that out and say, 'that's a guitar?'

Marclay This desire to be aware that everything has a meaning – if you use a camera or a paintbrush or a guitar, each of those tools has meaning beyond what you do with it. Duchamp said that when you use paint, you use a readymade because it comes out of a tube. This awareness and suspicion of the illusion and the fictional are important to me.

At some point in my development, *Wavelength* played an important role. I first saw the film when I was an art student in Boston in 1977 or 1978. However, when I read about it recently in your catalogue, I realized I could not remember the soundtrack.

Snow The sine wave or the sync sound?

Marclay I had no conscious memory of the sound.

Snow That's interesting, because the sound really is a pretty distinctive thing, the long glissando.

Marclay I know. It probably was part of my appreciation of the film that the sound became one with the image and connected with the zoom. There's a strong relationship between those two movements, the slow change in pitch and the slow close-up.

Snow I wanted to make them equivalent. The real equivalent of a zoom would be a crescendo or diminuendo, but since over that length of time it couldn't be controlled, I decided on going from as low as you can hear to as high as you can hear. I had the idea to use an instrument like a violin or a trombone, which has built-in glissando, and try to edit it all together on a tape. Then someone told me I could do it electronically. Well, I hadn't thought about that. Electronic music existed then but there weren't synthesizers. I met Ted Wolf, who worked at Bell Labs in New Jersey and said, 'I want to make this 40-minute glissando.' He said 'Oh yeah, you can use a sine-wave generator.' That's how it happened.

Marclay I thought it was really strange that I didn't remember the sound, but I tend to be a more visual person. I can't hum a tune.

Snow That's why you're a good improviser. [...]

Michael Snow and Christian Marclay, extracts from 'Michael Snow and Christian Marclay: A Conversation' (2000), in *Replay Marclay* (Zurich: JRP/Ringier, 2007) 126–8; 129–30.

Dan Graham
Sound is Material: Conversation with Eric de Bruyn//2004

Dan Graham [By the time of writing the article 'Subject Matter', an analysis of Minimal art referring to contemporary musical structures, in 1969,] I had become interested in Bruce Nauman and Steve Reich. I wanted to do a critique of Minimal art that would get rid of composition. Minimal art was non-anthropomorphic: the artist's inner and bodily experience was totally eliminated, similar to John Cage. But in the work that was done in San Francisco in Anna Halprin's dancers' workshop, the performer's and the spectator's physiological response to both the acoustic qualities of the room and their inside brain time became very important. In San Francisco this was the time of La Monte Young, Terry Riley (who influenced Steve Reich), and dancers like Simone Forti and Bruce Nauman, all of whom were doing work at Halprin's workshop. So there was a connection again of music to subject-oriented materiality; in other words, to the spectator's own responses in physiological terms, inside a physiologically activated space.

Eric de Bruyn Your critique of Minimalism was clearly being developed along musical lines.

Graham Yes, but I think that in American art the domains of music, dance, film and pop culture were always linked to art. They were never suppressed. Pop art was always linked to pop music; it actually began in England. […]

de Bruyn There is a definite communal aspect to pop music, but it's also a completely commodified form of experience. The performances of Reich and Nauman do not deal with this paradox.

Graham Bruce Nauman and Steve Reich were art-world elitists. The next phase was for people in the art world to form their own rock groups. Some of them were influenced by acoustic music groups from San Francisco that came to New York, like Television and The Feelies. Or you have the popularization of Philip Glass, who moved into all media and did a very pop, easily accessible kind of music. Or, even more accessible, Laurie Anderson.

de Bruyn In the essay 'The End of Liberalism' (1981) you take issue with the Frankfurt School's view that mass culture is inherently repressive.

Graham I don't agree with the Frankfurt School's idea that mass culture equals mass exploitation. There's an irony built into pop music as a result of the position that it was in, which is expressed, for example, in the song 'Johnny B. Goode'. Good music, like good art, comments ironically on its own position while remaining popular and being part of the commercial structure. I have two interests in music: as a consumer and lover of pop music and as a rock critic, which was partly a hobby situation. My first interest was literary criticism, which was superseded by rock critics like Lester Bangs, Greil Marcus, Sandy Perlman and Patti Smith. I was very interested in the tradition of rock criticism, and also I was influenced in my art by structures I found in rock music. So in a way it was my passion. The other music of Steve Reich and La Monte Young was interesting because it was communal music from New York which had to do with the communal reception of work within the art world. Art and music came together in the 1970s with people forming groups, like Glenn Branca's Theoretical Girls, who then moved from rock music into guitar-based classical new music. [...]

Dan Graham and Eric de Bruyn, extracts from 'Sound is Material: Dan Graham in Conversation with Eric de Bruyn', *Grey Room*, no. 17 (Fall 2004) 110; 112–13.

Mike Kelley
In Conversation with Carly Berwick//2009

Carly Berwick Does the history of noise begin with Dada and Futurism?

Mike Kelley Primarily, yes, because that's when, at least in serious music, there is a shifting away from the notion that music is limited to a specified group of notes and chord structures to an acceptance of the idea that music is the organization of sound – any sound. I was very influenced by Luigi Russolo's 'Art of Noises' of 1913 which I read as a teenager. That piece of writing really changed my life. I grew up in a milieu where the test of musical quality was the ability to play the fastest guitar solo. Never having had any access to musical training, I wondered how I could produce music. I was talentless. But thinking about it through Russolo and Futurism, or through Fluxus, which were art-related not music-related genres, I was free to make music based on ideas rather than the mastery of an instrument. I could work with sounds I was personally attracted to, like feedback and static, which had the intensity of

amplification of arena rock – the kind of sound that grabs you by your guts, that is so intense you cannot deny it. [...]

I'm not often that interested in controlling the sounds I make – it's more like play, done for the pure pleasure of experimentation. When I was in my late teens I would use old tape recorders and play loops of found and recorded sounds. I was at the University of Michigan then, studying art, and aware that such things were being done in the music and art context – Steve Reich's work for example. I became more aware of the ideas behind such works and the various modes of conceptual art. I was trying to find a niche for myself. But at that time I did not think I could find a place for my musical interests in my art practice. I saw it more akin to physical exercise, a free zone, where I could do what I wanted and it didn't matter whether it was any good or not. But oddly enough I did certain things so early that they were novel in the art context. Destroy All Monsters is such an early example of an art school noise band that there are not too many precedents for it. We were pre-punk, and in the early seventies there were no public venues where we could play. By default, we were an artwork. Because there was no place for us in the music world I always thought of the band as being a kind of sculpture – a sculpture of a rock band. The music was less important than the band structure. This was not so unusual really, because there were already popular fake bands like the Monkees that couldn't play at all and just acted their parts. The idea of doing something similar in the art context was interesting, but we also wanted it to be 'art', which means it had to be unpalatable. We wanted to sound heavy like a metal band. A certain kind of ugliness is a common aspect of the Detroit rock sound – like The Stooges, for example. [...]

Mike Kelley and Carly Berwick, extracts from 'Mike Kelley: An Interview by Carly Berwick', *Art in America* (November 2009) 172–3; 173–4.

Vito Acconci
Words before Music//2000

I'm sitting alone writing, here in my room ... Well no, not exactly. This isn't officially a room; not your image of a writer's hovel, a corner/garret/cellar that you escape to, that you're driven into, in order to take down notes from the underground, promptings from the depths of an aged and anguished and angry soul. Where I am is the antidote to privacy and deprivation: I'm in a large cavernous industrial loft turned into an architects' studio, and a disrumpled one at that – each day this place is filled with six or seven or eight people, talking and arguing about streets and plazas and parks and gardens, bustling around from drawings to study models to computers. The place is like a rehearsal hall for other places, far-flung places, a course of action from one table ('Here we are in Dayton, Ohio') to another ('Here we are in Tokyo'). But the people who work here have left for the day, they've gone off to lives of their own, so I *am* alone; I've been left alone here, after hours, in an echoing loft/office/studio – it's night, it's dark. I've turned off all the lights but the one on my desk, I can't see around the corner, around the bookshelves, where models could remind me of the world outside.

It's just me and my music now ... Well no, not exactly. I don't have any music that I've made myself; I'm not a musician, not a composer. I take my music from others. Like everyone else, I have my CDs; I'm old enough to have had records, of course, but I've thrown them all away by now; they were scratched up beyond recognition. I can't take care of music; I could never hold records by their edges, never put records back in their sleeves. I let them pile up naked on the floor; I couldn't treat records as precious jewels – they were instruments for use, and their deterioration proves that I used them, that I loved them. My records/tapes/ CDs are my pets, non-living ones that I can mistreat without a second thought. Mistreatment might be purposeful; mistreatment might prove that I've committed them to memory and I don't need them around any more. I won't keep scratchy records as artefacts of another time, as preservation and nostalgia; I'd rather remember that time, imperfectly, and impose *this* time onto it; I'd rather that *this* time interpret *that* time – I can only live once, let me live now.

I'm a consumer of music, not a producer ... Well no, not exactly. Like everyone else, I sing now and then: my own songs, made-up songs – the words – simplistic Cole Porter – the music – soured Kurt Weill, the tone a hybrid of Walter Huston and Mark E. Smith – but I sing them only to a person I'm sleeping with. The songs have the sound of intimacy – the *a cappella* voice, the whisper into the ear – but

they turn private space into public performance, like lovers singing to each other in an opera, in a musical.

Music doesn't *express* the self; it throws the self, like throwing your voice – it plays the self, like playing an instrument. My songs are born from the person I'm singing to, they're about that person, they embody that person; but my song turns her into my voice, it reduces her to language, it stills her movement into sing-song rhymes, it cancels her out in puns.

For me music is a passive spectator sport, not an active participatory one ... Well no, not exactly. It's true, I can't dance; that's probably why I build: those who can, *do*, while those who can't only write about it – people who can move their bodies dance, while people who are afraid to move build places for others to move in. But, though I don't dance, I rock to music when nobody's looking, I sway, I shake, I swoon, o yes I tremble – the music might be over, but I'm moving to the song I can't get out of my head, I'm moving at the commands of voices in my inner ear. A mystic sees things, while an insane person hears them; when you see something you know exactly where it is, but when you hear something you can't place where the sound is coming from – sound is all-over, there's a wall of sound, the wall is tumbling down and sound comes over you in waves.

The music's over now. The last person's gone for the day, the CD player's been turned off, and I won't turn it on again. Don't push me. As long as music is on, the music's inside me; but, in order to have an idea *about* music, I have to be outside music, I have to be *without* music. In order to think about music, I have to live in a condition of pre-music; if music fills the air, I have to empty the air. If I were a musician, I could reduce music into notes, into maths, into numbers. I'm not a musician, but I can count as well as the next person: 1 ... 2 ... 3 ... 4 ... Somebody stop me, or else I'll go up to billions; hearing myself count proves that I've shut everything else out – I can count the silence.

Vito Acconci, 'Words before Music', manuscript, Acconci archive (Brooklyn, New York, 2000).

Christian Marclay and Kim Gordon
In Conversation//2003

Kim Gordon When you were young, did you have a relationship with records?

Christian Marclay No, not much actually.

Gordon I only ask because when I was little I was obsessed with my dad's record collection. He had jazz records. I'd pick them out and lay them in a row and make a story out of the covers.

Marclay Did you listen to them?

Gordon Yes, I listened to them too.

Marclay My family wasn't very musical. My parents had this great-looking Braun turntable, and a bunch of Christmas records and a few show tunes that my mother brought back from the States. My father never really listened to music, so I didn't grow up listening to it much. Maybe that explains the freedom I have with records. I didn't collect and obsess over vinyl when I was a teenager. I was shocked when I first saw thrift stores filled with records. Thrift stores were a big deal for me when I first came to the States. I bought everything from thrift stores, and it was an incredible source for really cheap vinyl. Before that, the record was something I was taught to respect and preserve. But in the States everything was about consumption and I was reacting to that as well. I was also attracted to all the album covers – such an amazing variety. Now this is an obsolete art form, but there was so much creativity in the design of those 12-inch squares. [...]

Gordon Your work manifests itself through music and sound and it's all about that, but to me, you're such a consummate visual artist. You have so many more influences than those of a visual artist; influences that are more than just post-conceptual ideas. I'd never think of myself as a musician, because of my training as an artist. In some of your interviews you say the same thing. And because you can go and look at The Who or Sid Vicious and make an analogy to something in the art world, you're also a visual thinker.

Marclay It's my background. I went to art school, not to music school. I don't think like a musician.

Gordon Someone like Thurston [Moore, fellow member of the band Sonic Youth], who grew up listening to every lyric on every record, has studied rock and roll in the same way you studied visual art. I've realized that I'll never relate to music or write music or lyrics with the same intensity that makes me angry or passionate or excited about visual art. But I see it in Thurston and other people like Jim [O'Rourke, another band member], who grew up thinking about music in that way.

Marclay Thurston looks at pop music through a literary interest, through poetry and writing, from the point of view of the words. For me, lyrics have always been a totally abstract thing, because when I listened to pop music while growing up in Switzerland my English wasn't good enough. So I've never listened to pop music with a focus on the words.

Gordon Was it more the attitude and the intonation?

Marclay And the sound. There are many people in Europe who grew up listening to British or American pop songs and never understood the lyrics well. But it didn't matter: the music had meaning, even though I know the words are so important. Rap is even harder to understand because it contains a lot of slang that I'm not familiar with, or different accents. I tend to listen to the textures, the samples used, the more unusual the better. Very often, there's this language barrier. For example, I listen to a lot of Brazilian music and don't understand the words. Listening to lyrics in French is more natural for me. It's interesting that you have the same kind of relationship to lyrics as I do, that they're not always so crucial I'm surprised, especially because you sing. Which dominates in your mind when you create a song, the music or the lyrics?

Gordon The lyric ideas come from the music, or the mood of the music, but sometimes I'll just try and write conversationally. Or I have a bunch of lines, and then when I actually do a vocal take, I just try different stuff; sometimes meaning comes out when you juxtapose words or lines. It's more what goes with the voice. I've learned what works best for me because I'm not a natural singer or a trained singer.

Marclay With my first band, The Bachelors, Even, I wrote the lyrics first. I was a terrible singer. When my mother heard that I was singing in a band she said, 'That's not possible! He never even whistled in the shower.' So it wasn't something that came naturally. [...]

I was a student at the Massachusetts College of Art in Boston, and in 1977 I came to New York on an exchange programme to The Cooper Union. I was there for one semester, but I found this cheap apartment, so I stayed in New York for the whole year. Then I went back to finish my BA at Mass Art and I had this idea for the festival, to show what I'd discovered in New York. It was the first time that DNA played in Boston, and the first time that [the experimental noise musician] Boyd Rice played on the East Coast, as well as [the punk performance artist] Johanna Went. I wanted Vito Acconci to do something, because for me Vito is a key figure in this cross-over. He's not an obvious cross-over artist but I felt his work and attitude were very connected to rock and roll. I asked him if he wanted to come and do a lecture on the subject of his relation to rock music. He said 'yes', and then cancelled at the last minute; I was really disappointed. I still think he should do it one day. His word pieces were written like rock songs. He liked rock music, and I'd seen him in clubs.

Gordon I don't remember ever seeing Vito Acconci at clubs – Dan Graham was always there.

Marclay I remember seeing Vito at Tier.

Gordon Dan had one of the first stereo cassette players, and he recorded all these shows. It was an insanely large machine! But I remember I always heard of Vito as this rock and roller, in terms of his work.

Marclay The ranting on some of his early tapes, and his use of the body, made me link him to punk rock. There was a natural connection.

Gordon Well, he definitely had the fearless bravado, especially compared with someone like Dan, who's more cerebral, conceptual. But Vito – like Chris Burden and Bruce Nauman – had more obvious emotional manipulations going on.

Marclay But Dan is dealing with the relationship between the audience and the performer.

Gordon Yes, the time delay between the camera and the mirrors. It's very psychological but in a different way. Aesthetically, it looks like Minimal art, which is the difference. It's loaded with other things.

Marclay His performances were a cross between a lecture and a performance. It wasn't always clear what he was doing – sculpture, performance and lecture all

in one. New York was a really fertile environment; I got so much out of being there at the time. To be exposed first hand to it was exciting. You could go out and see so many kinds of activities that didn't take place in museums and galleries but in clubs. [...]

Christian Marclay and Kim Gordon, extracts from interview in *Christian Marclay* (London and New York: Phaidon Press, 2005); reprinted in *PressPlay: contemporary artists in conversation* (London and New York: Phaidon Press, 2005) 441–3; 445–6.

Martin Creed
Blow and Suck: Conversation with Jérôme Sans//2004

Jérôme Sans When did you start making music?

Martin Creed That's a difficult question. I think when I was about ten or eleven years old, and that was making up songs on the piano and guitar and swapping tapes with a friend. One person played something on the piano and sent the tape to the other, and then the other person played something on top, and so we made up little stupid songs. But I think I first tried writing music for a band when I was about twenty-one years old.

Sans But when did you decide to start a band?

Creed I didn't decide to start a band. It was just that I wrote, or tried to write, some music. I did that because I was unhappy with some of the sculptures I had made. And I think I was unhappy because some of the sculptures didn't have the process in them. For me the process is very important. In fact, the process is all that there is. For me it is just about trying to make things, to do things. The problem with some of the sculptures, or some of the visual works, was that all you saw was the end result. I was unhappy with that and in a piece of music I thought it could be possible to see the process more. A song is a process, from the moment before the music starts until the moment after it ends. So I wrote some pieces, or I tried to write some pieces, but I couldn't decide what instruments to use. I just wanted to write some songs. So I think I used what I knew. And what I knew was simple pop, what I grew up with, music played by guitar and drums. And I felt that the standard three-piece band covered well enough the whole

range of sounds, high, low and rhythmic. I wanted to try out some songs I wrote and I played them with some friends who were in another band. After some time these friends and I formed a band. [...]

Sans Your references came more from the culture of pop rock?

Creed Yes, exactly, but I wouldn't call them references. I would say it was more a matter of using what I was familiar with. It's hard to describe, but I wanted to use a kind of normal situation. There's nothing unusual about a three-piece band. Sometimes when I try to write songs, I find it very difficult to discover a starting point. And so sometimes I start from what I think is somehow normal, although I don't know if normal is exactly the right word. For example, I started to write a song for acoustic guitar and harmonica because I thought that they went together, in the tradition of folk music, and in the case of that song the instruments were the starting point. The blowing and sucking of the harmonica determined the lyrics and the music. The song is called 'Blow and Suck'. [...]

Sans How do you consider music inside your visual art work?

Creed To me they are almost the same. The music is an attempt to make something for the world – just like the visual work. It comes from the same desire to make things and show them, the desire to say hello, to try to communicate somehow. But there are differences between the visual and the audio works, partly because I play the music live in front of people. That makes a big difference.

Sans Is it because it is a performance?

Creed Yes. It is theatre. But I think it has to do with the freedom of the audience, or the lack of freedom. One of the things I like a lot about visual work is that the audience is often very free. Free to look at a painting for one second and then look away. When a band is playing, it is more difficult to look away. I mean you have to leave the room to get away from it. And so for me there is a lot of fear involved in playing music. When you play a piece you are asking someone to sit through it, to be patient. That makes it very different. And I think in that sense the music I make is very traditional music, very theatrical, in a normal way. [...]

Martin Creed and Jérôme Sans, extracts from 'Blow and Suck: Martin Creed interviewed by Jérôme Sans', in *Live* (Paris: Palais de Tokyo/Éditions Cercle d'Art, 2004) 76.

Martin Herbert
Infinity's Borders: Ryoji Ikeda//2009

Mathematicians at the highest level tend also to be aestheticians. 'If numbers aren't beautiful, I don't know what is', the Hungarian number theorist Paul Erdos once remarked; 'Mathematics, rightly viewed, possesses not only truth but supreme beauty – a beauty cold and austere', wrote Bertrand Russell. Yet beauty, one might say, only marks a staging point on an aesthetic continuum: not the end but a point where, while we might not be able to account wholly for that which moves us, we can still perceive the source of pleasure. Ryoji Ikeda's art and music does possess, not infrequently, 'a beauty cold and austere': consider, for example, *data.superhelix*, the tenth track on the Japanese multimedia artist's 2005 album *dataplex*. It's essentially a fleet rhythmic mesh, of increasing intricacy, composed of tiny blips of soft-edged white noise and thrumming sine wave approximating bass or percussive click. Like all of Ikeda's music, it feels like it was assembled under a microscope: yet it appeals to the body. There's a cool thrill in elements of such pristine clarity combining to create music with undeniable funk. And this, to me at least, borders on the beautiful.

But try this: test pattern *#0101*, from Ikeda's 2008 album *test pattern*. Both albums stem from the artist's larger ongoing project, *datamatics*, which enfolds both a stream of recordings and live shows involving mesmeric projections of quicksilver matrices of geometric lines and numeric sequences, at frame rates that test the processing power of computers. (Significantly, Ikeda notes that it's when the computers are on the verge of expiring that patterns begin to emerge.) In the aforementioned track, the fundamental elements are, again, sine and white noise: in his music, in search of something new, Ikeda long ago limited himself to the essential physics of sound, just as he works directly with the raw materiality of white light in his installations. But in *#0101* the music outpaces our ability to comprehend it. Its relentless sub-atomic flow of microsecond snippets is more than the ear can process, yet – crucially – it is pitched at the point where the listener can *begin* to access it, fragmentarily, and wants to. The track keeps infinitesimally resolving, in the ear, into convulsive but sinuous rhythm before flying apart again, its metre unsustainable. Now the majority of test pattern was produced in an unusual way, using conversion software that turns any data (sound, text, pictures) into barcodes and binaries: zeros and ones. Working hands-off – i.e. not manipulating his source material – Ikeda used this as a readymade score of sorts, instructing his music software to play a sine tone or burst of white noise whenever it encountered a 'one'. He used, among other

things, emails as his raw material: the surprising result, you might say, is the implicit vast song of data itself, the unpredictable but propulsive pulse that underlies our wired world. Often, it flies past beauty and into something else.

One might see Ikeda's output since the mid 1990s as presenting the material building blocks of our reality, visual and sonic, on an axis between the apprehensible and the overpowering, spectra, the series of light installations he began in 2001, which have manifested themselves in galleries, in Eero Saarinen's TWA terminal at JFK airport in New York, and most recently outdoors in Amsterdam and Paris, offers a parallel process to Ikeda's work with sound and visible data streams. (Not least because light is binary: it's either on or off.) There was much to see, for instance, in 2008's *spectra [Amsterdam]*: white light firing 600 feet into the sky from a grid of 25 projectors on Java island, in the Dutch city's docklands, or glowing out of 68 projectors strung around a rainwater-filled gas-holder in Westergasfabrjek. There was an atmospheric loveliness pervading this, a filmic quality in its engagement of the surrounding landscape. There was, also, a faint fearfulness. One did not want to stare directly into the light. Or, if one did, it was with the full awareness that one was dealing with the essential physics of the visible at the point where it might turn on us; that one was taking in – dangerously – more than human faculties can process. For all our ostensible intelligence, we are limited organisms and much in this world (and beyond it) overwhelms us. Our saving grace is that we can feel it, can be upraised and terrified at once by sensing our place, our smallness. That feeling, which we have previously called the Sublime, touches on something outside us; and within us too. 'Two things fill the mind with ever new and increasing wonder and awe', Immanuel Kant famously wrote: 'the starry heavens above me and the moral law within me'. For all that we can map a small portion of the skies, and communicate across the globe at a mouse's click, we are not beyond awe. And, as Ikeda's art suggests, we are not beyond the ability to *manufacture* awe: we don't necessarily need a night sky; we can make constellations on the ground. Additionally, a night sky is not reflexive. It can't comment on the ontological space we inhabit and what kind of beings – with what kind of limits – inhabit it, as Ikeda's art can. That art has nothing sadistic in it: sonic, visual or both, it never reaches the point where it stops giving. Ikeda, one might say, is a connoisseur of calibrated threshold experiences, adept at composing situations where pleasure coexists with a kind of ambient unease at reaching cognitive extremes, while his art sails past them. In a work like *data.tron*, Ikeda's giant immersive projection featuring more ones and zeros than one could ever hope to count, the paradox reasserts itself: if we can't quite perceive what's before our eyes, we can perceive that we're unable to perceive. Indeed, this may be the most art-like quality of Ikeda's output: that it delivers multiple experiences at once. (Art being a placeholder we

give to experiences that exceed our ability to categorize them, that necessitate a string of simultaneous and often contradictory descriptive adjectives rather than just one.) Such moves generously restore our sense of human frailty: unexpectedly so, given the seemingly mechanical means. At his art's highest arc, what Ikeda is broaching is the biggest issue in terms of humanity overpowering itself with its own concepts: infinity. It's logical in this sense that he has worked with a mathematician, the American number theorist Benedict Gross. For his 2008 exhibition at Le Laboratoire, Paris, which developed in part out of conversations between the two, Ikeda produced a pair of giant prints, a prime number and a natural number, which consisted of 7.2 million digits. Here the infinite is glimpsed, through an excessive fragment, as something that exists in two senses for us. We can accept that the term exists; but since what it truly portends stretches the brain, most of us don't bother to do it. The American author Bill Bryson, who writes for a mainstream audience, describes in his *A Short History of Nearly Everything* (2003) an amateur astronomer who has memorized the visible portions of the stars. To gauge this feat, Bryson writes, imagine 1,500 dining tables each scattered with a handful of salt; 'add one grain of salt to any table and let Bob Evans walk among them. At a glance he will spot it.' This, while it may boggle the mind, is barely a quark in infinity's breadth. And yet we all know, for practical purposes, what infinity is. What Ikeda's art does is to make us feel something of it, to locate it in our own nerve endings: in intensely variable streams of visual or sonic information, in what floods the retina. White light, one might say, is its own compact infinity since it contains all the colours (hence the title *spectra*): we can't see them, but we know intellectually that they are there. And the gap between the zero and the one is infinitely divisible in its own way: in every passing computer process a vast mystery is implicit. Part of the fascination, and the achievement, of Ikeda's career is how he has made binarism the model of his output. No other artist/musician has managed quite so effectively to straddle the two worlds, which traditionally remain distinct. (Rock stars want art's intellectual credibility, artists want music's visceral impact, rarely are the cross-overs happy.) If one reason for his success may be that he continually refreshes himself by alternating the tight, focused, small-crew work of the *datamatics* projects with the open, relatively improvisational spectra series, another is surely that there is, finally, little conceptual disjuncture between the elements of his work. A record of Ikeda's like the densely minimal +/- (1996) feels like art to me: it exceeds rationality and cognition in the way that the best art does; it just happens to come on CD. And, like Ikeda's light works, a good number of which have been enacted in public places, it speaks accordingly to a wider audience than that which strolls the rarefied precincts of the art world. And this seems right, because Ikeda's subjects – infinity, the consoling poetics inherent in

the digital world we've made, and the potential we have to exceed our rational selves in a world that sometimes feels as if it has no space for the unknowable – those subjects belong to all of us.

Martin Herbert, 'Infinity's Borders', in +/- [the infinite between 0 and 1]: Ryoji Ikeda, exh. cat. (Tokyo: Museum of Contemporary Art, 2009)

THERE WERE ALREADY POPULAR

FAKE

BANDS LIKE THE

MONKEES

THAT COULDN'T PLAY AT ALL AND JUST ACTED THEIR

PARTS.

THE IDEA OF DOING SOMETHING SIMILAR IN THE ART CONTEXT

WAS

INTERESTING, BUT WE ALSO WANTED IT TO BE

'ART',

WHICH MEANS IT HAD TO BE UNPALATABLE.

Mike Kelley, in conversation with Carly Berwick, *Art in America*, November 2009

ARTISTS AND SOUND

Marcel Duchamp
Musical Sculpture//c. 1912–21

Sounds lasting and leaving from different places and forming a sounding sculpture which lasts.

<div align="center">Identifying</div>

To lose the po*ssibility of reco*gnizing 2 *similar objects* – 2 colours, 2 laces, 2 hats, 2 forms whatsoever to reach the Impossibility of sufficient *visual* memory, to transfer from one like object to another the *memory* imprint.
 – Same possibility with sounds; with brain facts

Marcel Duchamp, *Musical Sculpture* (*c.* 1912–21), in *Salt Seller: The Writings of Marcel Duchamp*, ed. Michel Sanouillet and Elmer Peterson (New York: Oxford University Press, 1973) 31.

Yves Klein
On *Monotone Symphony (c. 1947–48)*//n.d.

Around 1947–48 I created a 'monotone' symphony whose theme is what I want my life to be. This symphony lasts for forty minutes and consists of one single, continuous, long drawn out 'sound'; it has neither beginning nor end, which creates a dizzy feeling, a sense of aspiration, of a sensibility outside and beyond time.

Yves Klein, undated statement on *Monotone Symphony* (c. 1947–48), in *Yves Klein 1928–1962: Selected Writings* (London: Tate Gallery, 1974) 17.

Alexandra Munroe
Spirit of Yes: Yoko Ono//2000

[…] Yoko Ono first met John Cage at one of D.T. Suzuki's lectures in the mid 1950s. Her friendship grew through her husband, Ichiyanagi Toshi, who was associated with Cage and would later emerge as one of Japan's pre-eminent electronic composers. Ichiyanagi had come to New York on a scholarship for the Juilliard School of Music. A precocious musician, he was trained in classical music but distinguished himself early as a composer of twelve tone music in the tradition of Schoenberg and Berg. Electronic composition fascinated Ichiyanagi, who knew Varèse and was an early follower of Stockhausen. An accomplished pianist and score-writer as well, Ichiyanagi was often asked to transcribe scores for an emerging group of avant-garde composers in New York and would occasionally perform in their concerts. By 1959, when he attended Johm Cage's historic class in Experimental Composition at the New School for Social Research, he and Ono were regulars in the Cage circle, which included Morton Feldman, Richard Maxfield, David Tudor, Stefan Wolpe and Merce Cunningham.

This early Fluxus period in New York saw artists developing a form of notation known as 'event scores'. Derived from Cage's codes of musical compositions, these terse instructions proposed mental and/or physical actions to be carried out by the reader/performer. These event scores were indebted as well to Marcel Duchamp, who in 1957 stated that the creative act could only be completed by the spectator. The early Fluxus scores were characterized by clarity and economy of language; to reinforce their status as art artists often signed and dated them. They could be performed in the mind as a thought (their visualization being performative), or as a physical performance before an invited audience. The events described basic actions, such as George Brecht's score, 'exit', or could pose the re-enactment of certain habits of daily life. Humour was an essential ingredient. Along with Brecht and the composer La Monte Young, Yoko Ono was among the first to experiment with the event score and its conceptual use of language as a form of art.

Ono's event scores evolved from a range of literary and metaphysical traditions that combined Duchampian poetics and irony with *haiku* and the Zen *koan*. Ono's instruction pieces, with their distilled conflation of image and and frequent reference to nature (skies, clouds, water), recall *haiku*'s 'quality of surreality' and 'complex of multiple implications'. They convey wit, elegance and profundity through irrational, often punning phrases intended to jolt the reader/viewer to a higher state of awareness. Contrary to the existentialist

notions of nonsense and nothingness that reflect a subjectified, alienated and pessimistic world of meaning, the Japanese literary and Duchampian views that Ono embraced share an affirmation of being and existence through a metaphysics of the everyday here and now.

The Zen *koan* offer another correspondence to Ono's event scores. These brief phrases – some a single character long and others such cryptic statements as 'To turn a somersault on a needle's point', are used as contemplative tools between master and disciple whose meaning, once grasped, leads to an experience of *satori* (enlightenment). In *Mystics and Zen Masters*, a classic American book on Zen well known to the Fluxus circle, Thomas Merton writes: 'The heart of the *koan* is reached, its kernel is attained and tasted, when one breaks through into the heart of life as the ground of one's own consciousness'. His quote of the fourteenth-century master Bassui resonates with Ono's strategy:

> When your questioning goes deeper and deeper you will get no answer until finally you will reach a cul-de-sac, your thinking totally checked. You won't find anything within that can be called 'I' or 'Mind'. But who is it that understands all this? Continue to probe more deeply yet and the mind that perceives there is nothing will vanish; you will no longer be aware of questioning but only of emptiness. When awareness or even emptiness disappears, you will realize that there is no Buddha outside Mind and no Mind outside Buddha. Now for the first time you will discover that when you do not hear with your ears you are truly hearing and when you do not see with your eyes you are really seeing Buddhas of the past, present and future. But don't cling to any of this, just experience it for yourself.

Some Fluxus scores feature banal and absurd elements of modern consumerism. Ono's work provokes contemplation on a different, even supernatural, level of human existence. One of her earliest scores was composed in 1955 and performed in New York in 1961 and Tokyo in 1962:

LIGHTING PIECE
Light a match and watch till it goes out.
1955 autumn

In this and several of Ono's instruction pieces, she isolates a sensory act of everyday life to bring us in direct encounter with the self – what in Zen terms is 'self-being'. She calls events an 'additional act', another dimension of art that provokes awareness of ourselves, our environment, our actions. In her 1966 work, *9 Concert Pieces for John Cage*, she scores *Breath Piece* with the simple instruction: 'Breathe' and *Sweep Piece* with the instruction, 'Sweep'. To Yoko art

is not a studio process but the process itself of living. It is experiential, sensual and intuitive. In a critical definition of how her approach differs from Kaprow's Happenings, she wrote: 'Art is not merely a duplication of life. To assimilate art in life is different from art duplicating life.'

Unlike Brecht, who sometimes scored music for motor vehicles, train stations and grocery deliveries, Ono's scores often suggest a realm of the wonderfully implausible and imaginary. At first glance, their conceptual aspect is less philosophical than wholeheartedly nonsensical in the tradition, say, of Lewis Carroll. Yet Yoko uses humorous nonsense for serious intent. By tossing logic and all it represents away, she prompts us to create and experience a 'mind-world'. [...]

Alexandra Munroe, extract from 'Spirit of Yes: The Art and Life of Yoko Ono', in *Yes Yoko Ono* (New York: Japan Society/Harry N. Abrams, 2000) 17–20 [footnotes not included].

Michael Nyman
Nam June Paik, Composer//1982

In his 1968 paper 'Expanded Education for the Paper-less Society', Paik made a categorical statement about the availability and transmission of a composer's work, a statement which takes on a very special relevance when one attempts even a cursory overview of his 'purely' musical output. He wrote that 'ninety-seven per cent of all music written is not printed, or printed early enough for contemporary evaluation, performance and study ... A vastly unfavourable gap exists for the composer, compared to the booming pop-op-Kinetic [and one might add today – video] art boom. Even experienced concert managers and performers have difficulties getting materials from composers, who are often unreachable, whereas composers on their part complain of the too rare performing chances.'[1]

Paik was a composer/performer before he became a video artist and though he has not produced many exclusively musical works in recent years, he remains a composer, even while he is a video artist. His musical work falls conveniently into three phases. The first takes in his conventionally notated works and began in 1947 with the Korean folk-flavoured music of his youth; it continued by way of the strictly serial solo violin variations of 1953 and the non-serial *String Quartet* of 1955–57. The second phase began in 1959 with *Hommage à John Cage*; the third in 1964, when he started his long collaboration with the cellist Charlotte

Moorman (with *Variations on a Theme by Saint-Saëns*). Paik's works with Charlotte Moorman have been more than adequately documented at source by various recording means: video (many of these pieces are video), photography, and the printed word (either as reviews or, in the case of the *Opéra Sextronique* arrest in 1967, as court reports). These works are part of American culture (Paik moved to New York in 1964), whereas the earlier works (well documented in their way, but less publicly so) were very much part of a European musical/art culture – his relationship with Cage (like LaMonte Young's) began in Europe after Cage was seen by the European avant-garde to be an important and respected (if ridiculed and misunderstood) cultural export, and many of the American artists he worked with under the Fluxus umbrella were expatriates too. Paik's pre-Moorman (pre-1964) scores are spread untidily through a labyrinth of scattered sources: occasional Fluxus publications, exhibition catalogues, obscure art magazines; they are casually mentioned in his own equally uncollected writings, or have never been committed to paper, or are perhaps lying among piles of TV junk in his loft on Mercer Street in New York. But many of the compositions that are available – exclusively verbally notated – can do little more than transmit basic information, and that for contemporary evaluation and study only: they are not scores to be performed by others, rarely even the memories of now long-distant (but not forgotten) past performances. They fail to notate (how could they?) the most crucial and the most characteristic dimension of Paik's early pieces – namely, Paik himself as performer.

Further on in the 'Expanded Education' document (a farsighted blueprint for an educational programme through video, every paragraph of which demonstrates Paik's knowledge of music history and his preoccupations as a musician), Paik admits the poverty of notation not only in regard to his own action music/antimusic (he used both terms) but to the events of other Fluxus composers, such as George Brecht, Young, and Henning Christiansen. 'Often there is no way to make the notation of music except by recording the whole performance... video tape will be a useful supplement for their sketchy instructions.'[2] Significantly, Paik exempted himself from this recording-as-notation process: Karlheinz Stockhausen and György Ligeti had suggested making a film of Paik in action which would be used as a score for other performers to use, but Paik rejected this proposal 'for a philosophical reason'.[3] Whatever that precise reason was it is obvious from eyewitness accounts (and unfortunately I didn't see or experience any of these extraordinary performances) that Paik's performing aura could not be mechanically reproduced and that performance-as-imitation was clearly unwelcome. Paik himself had a horror of repeating the same sequence of actions in the same way: by analogy he pointed out that the pianist Wilhelm Backhaus played a cadenza well only once; it deteriorated on repetition. So that

in 1961, when Paik had to perform his own work (*Simple*, *Zen for Head* and *Étude Platonique No. 3*) twelve times in the first run of Stockhausen's *Originale* (a large-scale theatre piece for, or rather by, a bunch of 'originals' of whom Paik was one); he found it acutely boring just to repeat the same set of actions: occasionally something or other put him into an 'absolute state of mind which I found marvellous'.[4] In his published account of Paik's contribution to his piece, Stockhausen noted admiringly that Paik changed his performance every day so that any description of what he did could only 'sketch the actions of one evening without trying to concretize in words the important and individual elements of these moments'.[5] According to Stockhausen, Paik would come 'onto the stage silently, usually shocking the public through a series of rapid actions',[6] throwing beans at the ceiling and into the audience, hiding his face behind a roll of paper which he unrolled endlessly slowly in a breathless silence – sniffing, pushing the paper into his eyes over and over again until it became wet with his tears; and so on. Paik's performance ideal was 'variability as a necessary consequence of intensity'[7] – an intensity that he shared with LaMonte Young, who, however, was totally unconcerned with variability since he seemed to spend the whole of 1961 trying to perfect the art of drawing straight lines. George Maciunas responded unenthusiastically to this activity in his *Homage to LaMonte Young*, part of the instructions for which run: 'Erase, scrape or wash away as well as possible the previously drawn line or lines of LaMonte Young or any other lines encountered.'[8] Maciunas' *12 Piano Compositions for Nam June Paik*, however, is a more positive and accurate response to Paik's activities, instructing Paik to (among other things) 'with a straight stick the length of a keyboard sound all keys together,' 'place a dog or cat (or both) inside the piano and play Chopin,' 'stretch 3 highest strings with tuning key till they burst.'[9] Paik's demand for variety, variability and constant change led him to inquire in the mid 1970s why new American music was so boring: 'Americans need not be entertained every second, because they are so rich. America has in a way this very rich attitude that makes boring, long music possible. But I'm not writing boring music that much. The reason is that I come from a very poor country and I am poor. I have to entertain people every second.'[10] But Paik's talent for extravagant, violent and unexpected actions in these 'entertainments' often drew the spectator's attention away from what Paik claimed were the more important features of a piece. This is hardly surprising when one is dealing with events of the order of the notorious 1960 performance of *Étude for Pianoforte*, when Paik jumped off the stage and proceeded to cut Cage's shirt tail and tie and then smother him and David Tudor with shampoo (scrupulously avoiding Stockhausen in the process!). But Paik, in all innocence, claimed to be disappointed when, amidst all the bean throwing, shaving cream and water dousing during his *Simple*, a 15-second tape collage passed unnoticed.

This collage was an essential part of the work since his 'quality of performance was dependent on the quality of tape playback'.[11] And in the 1959 *Hommage à John Cage*, beyond (or prior to) the overt actions involving screaming, toys, tin boxes full of stones, eggs, smashed glass, a live hen and a motorcycle, there were serious philosophical and musical purposes: the first movement was proof for Paik that the 'elevated and the ugly are inseparable – therefore every listener has to behave as though he had just heard the *St Matthew Passion* for the first time'.[12] The performance as a whole was backed with a tape collage of a type then being pioneered by Paik, built out of a mixed bag of classical and non-musical sound sources: Beethoven's *Fifth Symphony*, a German song, Rachmaninoff's *Second Piano Concerto*, a lottery announcement given over the phone, a news announcement of a foreign ministers' conference held in Geneva about the reunification of Germany, and a recording of concrete sounds – such as a Japanese toy car, a prepared piano, sine waves, noise and so on. Paik remarked sadly that although he spent 80 per cent of his working time on the tape and sound components of the performance, 'several "actions" became famous instead of my tape toil and tear. I was half happy and half sad. I thought my action is the accompaniment to my tape, but people took it opposite way.'[13]

Though Paik's overall intention at this time was to find a way out 'of the suffocation of the musical theatre as it is today',[14] it was a little naïve of him to expect that his meticulously crafted collages would have more impact than his obviously mesmeric actions (the eye is more easily and immediately impressed than the ear in certain environments). Paik, who would have liked to 'complement Dada with music',[15] particularly admired those Dada artists for whom 'humour was not an aim but a result'.[16] Many of his (presumably) serious but (possibly) mischievous events had humorous effects – like those of Cage, who acted at that time as a release mechanism for Paik, as he did for many other artists, however much he may have disapproved of the effects of this 'release'. Still, one might wonder how much fun it must have been for the audience in Mary Bauermeister's studio in Cologne in 1960, confronted with an onstage motorcycle with its engine left revving, and an absent Paik. After some minutes it became apparent that the perception of time passing and the expectation that something was to happen were rapidly being replaced by the perception of carbon monoxide filling the space and the expectation of asphyxiation. The engine was turned off and Paik returned some time later saying that he'd been in a bar and forgotten about the bike: not for nothing did Cage say of Paik's performances that 'you get the feeling very clearly that anything can happen, even physically dangerous things'.[17] [...]

Like many of the other Fluxus composers, but in a more deliberate, evolved way, Paik introduced another series of classical music artefacts into his performances, namely, the music itself, either extracted on tape or played live.

Beethoven's *Moonlight Sonata* was a particular favourite of Paik's: it formed the basis of *Sonata quasi una fantasia* (in which he alternately played and stripped) and was used again as the soundtrack for his *TV Electronic Opera No. 1* in 1969. Similarly Saint-Saëns' *The Swan* was an obvious choice for his cello-based pieces, the sexual obsessions of which were present in his works of the early sixties: one of the very first Paik-Moorman works, *Cello Sonata No. 1 for Adults Only* (1965), is none other than the *Sonata quasi una fantasia* with a more formal structure, Bach replacing Beethoven and Moorman replacing Paik; while *Serenade for Alison* (Knowles) was described by her husband, Dick Higgins, as a 'melodramatic striptease for amateurs only'[18] and the *Symphony No. 5* contains the following instructions: in the 10003rd year of the performance the (obviously male) player is to 'pick up your old impotent penis with your finger and play the first piece of Czerny – *étude* (30) with this penis, on keyboard (alone, or in a public concert … To a very beautiful girl,/please, hold the bow/of the violincello/in your beautiful vagina,/and play an attractive music/on the violincello/with this beautiful bow in a public concert/(preferably Saint-Saëns' *death of swan*).'

Paik's collaboration with Alison Knowles was more limited and less technologically evolved than that with Moorman. Yet *Serenade for Alison* is not only an early example of the striptease theme, but also one of a number of scores-as-lists (minimal/repetitive music) that Paik composed around 1962. Serenade has the performer taking off a number of different coloured pairs of panties and performing actions with them. (As a former music critic with no great fondness for the profession or its current practitioners, I could not but fail to be attracted the eighth operation: 'Take off a pair of bloodstained panties, and stuff them in the mouth of the worst music critic.')[19] Other 'list scores' have ten young men successively poking their penises through a hole in a large white sheet of paper (*Young Penis Symphony* with its 'expected world première about 1984'[20] – a work immortalized in George Brecht's own *Symphony No. 1* with its sole instruction: 'Through a hole').[21] In *Gala Music for John Cage's 50th Birthday*, Cage (one assumes) is instructed to sleep with different (female) film stars and members of international royalty on successive nights, while in the Wuppertal 'Exposition' Alison Knowles realized Paik's 'In January, stain the American flag with your own monthly blood. In February, stain the Burmese flag with your own monthly blood', etc., etc.[22]

But Paik warned against too much emphasis being placed on the *what* of music: he was tired of 'renewing the form of music, whether serial or aleatoric, graphic or five lines, instrumental or *bel canto*, screaming or action, tape or live'. (This is not quite accurate since he expressed his pride in a letter to Cage in never having composed any graphically notated scores.) Becoming preoccupied with the *where/for whom/how*, he started exploring the question of moving sounds

around, or allowing the audience to move around static or mobile sounds, or allowing them to produce sounds with specially designed installations. Paik characterized the 'Exposition' as a situation wherein 'the sounds sit, the audience plays or attacks them', and his own action music as 'the sounds, etc., move, the audience is attacked by me'. [...]

1 Nam June Paik, 'Expanded Education for the Paper-less Society', *Nam June Paik: Video 'n' Videology 1959–1973*, exhibition catalogue (Syracuse, New York: Everson Museum of Art, 1974) 31. (Since this book lacks numerical pagination, for the reader's convenience page numbers have been assigned, page 1 being the foreword.)

2 Ibid., 33.

3 Ibid.

4 Nam June Paik, interview by Gottfried Michael König, in 'Die Fluxus Leute', *Magnum*, 47 (April 1963); reprinted in *Nam June Paik: Werke 1946-1976, Musik-Fluxus-Video*, ed. Wulf Herzogenrath, exhibition catalogue (Cologne: Kölnischer Kunstverein, 1976) 51.

5 Karlheinz Stockhausen, *Texte*, vol. 2 (Cologne: DuMont Schauberg, 1964) 128.

6 Ibid.

7 Nam June Paik, interview by Gottfried Michael Koenig, in *Nam June Paik: Werke*, 51.

8 George Maciunas, 'Homage to LaMonte Young', *happening & fluxus*, ed. Hans Sohm, exhibition catalogue (Cologne: Kölnischer Kunstverein, 1970) n.p.

9 George Maciunas, '12 Piano Compositions for Nam June Paik', *happening & fluxus*.

10 Nam June Paik, letter to Hugh Davies, 6 May 1967, collection of Hugh Davies.

11 Calvin Tomkins, 'Profiles: Video Visionary,' *New Yorker* (5 May 1975) 48.

12 Nam June Paik, letter to Wolfgang Steinecke (2 May 1959), *Nam June Paik: Werke*, 39.

13 Nam June Paik, letter to High Davies, 6 May 1967.

14 Nam June Paik, letter to Wolfgang Steinecke, May 2, 1959, Nam June Paik: Werke, p. 40.

15 Ibid.

16 Ibid.

17 Tomkins, 'Profiles: Video Visionary', 48.

18 Nam June Paik, 'Erinnerung an München' (typescript), July 15, 1972, collection of Hugh Davies.

19 Nam June Paik, untitled typescript, November 14, 1967, collection of the artist.

20 Tomkins, 'Profiles: Video Visionary' 75.

21 Dick Higgins, 'Postface', in *Jefferson's Birthday/Postface* (New York: Something Else Press, 1964) 71.

22 Nam June Paik, 'Serenade for Alison', *dé-coll/age*, 3 (1962); reprinted in *Nam June Paik: Werke*, 50.

Michael Nyman, extracts from 'Nam June Paik, Composer', in *Nam June Paik* (New York: Whitney Museum of American Art, 1982) 79–90.

Robert Morris
Letter to John Cage//1961

[...] It was nice to meet you the other day at the loft concert.[1] You expressed an interest in the machines I have made and I wanted to tell you a little about what I have done in the past few months. First of all I changed somewhat the *Wind Ensemble*. In the first movement I have eliminated the smells and reduced the banging pile-driver sound to one beat per 2 seconds and the volume to a not especially loud one.[2] The second movement is left as is. However, the temperature of the theatre begins to rise and reaches its maximum of 85–90 degrees in this movement. The third movement is changed completely: it will consist of a duration of no sound or light and the windows should he opened and the heat off.[3] In your letter of July sent in response to my sending you the first draft of the *Ensemble* you said I left no room for nothing to happen. Now the changing of the 3rd movement is not conceived by me as 'nothing happening' but rather the change was motivated by my increasing concern to achieve an allegorical function in my work. Actually, I can not conceive of nothing happening – I'm not trying to make a logical statement.[4] In fact, a kind of 'nothing' image is very important to me and I have even said that I want to arrive at zero, although going toward it is like successive divisions of a line – for the arrival one must go outside the process. For the time being I am involved in a kind of reducing process of attempting to find images that are closer and closer to the limit. This is, of course, very Protestant – wanting to achieve an absolute or final statement, to put a stop to process, to beat time (unintended pun). I am able to assign both a negative and positive value to this approach. On the one hand it reflects the desire to get outside by making logical steps (doing next to nothing so that nothing will be a real 'next'). Then there is the dislike of the personality which needs to go on making art – perhaps by a kind of attenuation one will finally lose the habit. On the positive side there is my feeling about perception itself. You mentioned in your letter of July that 'most of what happens never was in anybody's mind'; I feel that all of what does happen is in everybody's mind – the statements are not exclusive of one another, I guess it is more a matter of focus. I feel that by reducing the stimulus to next to nothing (some of us really are trying to say nothing in an elegant manner) one turns the focus on the individual, as if to say, 'whatever you got in the past you brought along anyway, so now really work at it'. I cannot deny in this a 'percentage of malice' toward expression, the art situation; or that it underlines solipsism ... but I intended to describe what I have done and plan to do. But before I do I want to add about the *Wind Ensemble* – it strikes me as very

dreary to make a concert of it. I dislike it from beginning to end. The only way I might be pleased with having it performed would be to have the first movement in one theatre, then everyone would have to get up and travel across town to another theatre for the second movement, and to another theatre for the 3rd. Better still, travel to another city for the second, third city for the third.[5]

Objects made:
1. *The Performer Switch.*
An electrical switch fitted into a 3" x 5" wooden card file box (no wires, just the switch and box) with the following directions on the inside of the lid: 'To begin turn on – continue doing what you are doing – or don't – do something else. Later switch may be turned off – after a second, hour, day, year, posthumously'.

2. *The Game Switch.*
Same construction as above, but with no directions. The switch has two 'on' positions.

3. *Clock.*[6]
A wooden box about 2' square, 8" deep, mounted on wall. Over the front of the box is stretched a tight membrane of thin rubber. Hanging below is a rubber handle resembling a penis. Directions: 'Pull gently about an inch and hold for exactly one minute.' When handle is pulled it turns on motor in box which pushes out very slowly a bulge in the shape of a breast against the rubber membrane. The bulge extends about an inch and recedes and disappears. The cycle takes exactly one minute.

4. *The Plus and Minus Box.*
An oak box about 1' x 2' x 5" mounted on wall. It has two doors in front which lift, the left marked '+' and the right '-'. Opening the plus side exposes a plane of grey rubber, continuing to lift the door activates a rod which pushes against the rubber from behind like a finger. It pushes out about an inch when the door is completely raised. The left side or minus side is a reverse image of the right – a depression occurs in the rubber plane when the door is lifted.

5. *The Box With the Sound of its Making Inside.*
– Told you about this.[7]

Drawings, writings, etc.
1. *Frugal Poem.*
On a page of dark paper the words 'words words words' are written, filling the

entire page. When read aloud one substitutes the word 'talk' for 'words'. A tape was made of the scratching of the pencil as it was written – it is intended to be several superimposed images, i.e., drawing and/or poem and/or musical score and performance.

2. *Drawing or unilluminated manuscript.*[8]
On a dark grey sheet of paper 18" x 24" Duchamp's 'Litanies of the Chariot' ('Slow life. Vicious circle. Onanism … etc.') are written and repeated enough times to fill the page – it amounts to a two and one half hour graphic recitation. The time is recorded at the bottom.

3. *Methods for Painting*:
A. Dictate them to friends.
B. Squeeze out equal amounts of all of one's colours onto the palette, mix thoroughly, thin to a liquid and cover the entire canvas as evenly as possible.

4. *Sculptures*
A. Indeterminate
 1. 45" x 72" x 37"
 2. 85 lbs.
 3. 17 mph.
 4. 520º F.
 5. NNE 3º 10' 25"
 a. 1 foot
 b. one yard
 c. one mile
B. Directive
 1. (for La Monte Young) Make a box, even one that will contain something, and leave it in a field).[9]
 2. Put a piece of meat in a metal box and weld it shut.

5. *Piece #1*, 1961
To be looked at in a state of shock: nearly anything in a state of shock.

Plans for sculpture:
 I won't describe these in detail. One consists of a set of four cabinets: Standing, Leaning, Sitting, Lying. They are to be placed next to each other; there is just enough room inside for one to assume the stated positions – baffles fitted inside Leaning and Sitting so that one must conform to these positions when the door is closed. Another work is to be a pillar 2' x 8' which telescopes out two more

feet. It is to be motorized and geared in such a way that it has a 48hr. cycle – 24 up and 24 down.

If you are in town one of these days and have the time perhaps you might like to see some of the objects – if so please call before 6 p.m. or after 10:30 p.m. [...]

1 [footnote 8 in source] Morris is likely referring to one of the concerts organized by La Monte Young at Yoko Ono's loft. In February 1961, Henry Flynt had given a pair of performances there, the first of which was attended by John Cage. See the list of concerts in Henry Flynt, 'La Monte Young in New York, 1960–62', in *Sound and Light: La Monte Young/Marian Zazeela*, ed. William Duckworth and Richard Flemming, *Bucknell Review*, vol. 40 (Lewisburg, Pennsylvania: Bucknell University Press, 1996) 56; 58.

2 [9] Morris would use a similar idea in his dance Site of 1964, in which the soundtrack consisted of 'a tape of construction workers drilling with jackhammers' (Maurice Berger, *Labyrinths: Robert Morris, Minimalism and the 1960s* [New York: Harper and Row, 1989] 81.)

3 [10] In its new form, this movement recalls La Monte Young's *Composition 1960 # 4*, in which the lights are turned off for the duration of the piece and no intentional actions are performed. Reprinted in *An Anthology*, ed. La Monte Young (New York: Fluxus Editions, 1963).

4 [11] cf. the first line of Morris's 'Blank Form' essay of 1960–61 which was to have been published in *An Anthology*: 'From the subjective point of view there is no such thing as nothing' (reprinted in Barbara Haskell, *Blam!: The Explosion of Pop, Minimalism and Performance, 1958–1964* [New York: Whitney Museum of American Art, 1984] 101). Morris's statement echoes Cage's famous pronouncement that there is no such thing as an absolute silence.

5 [12] In this, Morris approaches certain ideas espoused by Allan Kaprow, who proposed, for example, that 'The Happening should be dispersed over several widely spaced, sometimes moving and changing, locales' ('The Happenings are Dead: Long Live the Happenings!' [J.966], in Allan Kaprow, *Essays on the Blurring of Art and Life* [Berkeley: University of California Press, 1993] 62). It is unlikely, however, that Cage would have approved of Morris's intended modification. For Cage would come to condemn the giving of directions to the audience of a Happening. See Richard Kostelanetz, *The Theatre of Mixed-Means* (New York: Dial Press, 1968) 56.

6 [13] The piece was later titled *Footnote to the Bride*.

7 [14] Cage did go to Morris's studio to see this piece, staying to listen to the entire three-and-a-half hour tape. 'When [Cage] came I turned it on ... and he wouldn't listen to me. He sat and listened to it for three hours and that was really impressive to me. He just sat there' (quoted in Berger, *Labyrinths*, 31).

8 [15] This piece was later titled *Litanies*.

9 [16] This piece is similar to a piece of 1961 that Morris submitted (and later withdrew) for publication in La Monte Young's *An Anthology*:

Make an object to be lost.

Put something inside that makes a noise and

Give it to a friend with these instructions:

'To be deposited in the street with a toss'

 1961

(Reprinted in Babara Haskell, *Blam!*, 101.)

Robert Morris, Letter to John Cage dated 27 February 1961, from Robert Morris, 'Letters to John Cage' (edited by Branden W. Joseph, from letters, 1960–61, in the John Cage Archive, Northwestern University Music Library, Evanston, Illinois), *October*, no. 81 (Summer 1997) 71–6.

Mieko Shiomi
On Works 1961–68//1973

My most serious concerns, which began when I was a student of musicology at the Tokyo University of Arts, were the questioning of the essence of music and the possible music of the future. Since I was dissatisfied with merely studying musicology, I set out to pursue these questions through experimentation and the creation of actual musical works. In 1961 Takehisa Kosugi, S. Mizuno, myself and a number of other students in our class at the University founded an experimental circle called Group Ongaku. We composed for conventional instruments, made concrete music on tape, and at weekly meetings we gave improvised performances.

This explosion of activity was characteristic of our insatiable desire for new sound materials and new definitions (redefinition) of music itself. Every week we discovered some new technique or method for playing a previously unthought-of *objet sonore*, and argued endlessly about how to extend its use, and what relationships of sound structures could be created between each performer. We experimented with the various components of every instrument we could think of, like using the inner action and frame of the piano, or using vocal and breathing sounds, creating sound from the (usually unplayable) wooden parts of instruments, and every conceivable device of bowing and pizzicato on stringed instruments. At times we even turned our hands to making music with ordinary objects like tables and chairs, ashtrays and bunches of keys.

It was during these two years of experimentation and experience of working with new forms that I defined the essence (or one of the essentials) of music as a concentrated duration of activity involving the occurrence of sounds and silence. It was also at this time that I composed *Boundary Music* and *Music for Two Players*.

Boundary Music
Make the faintest possible sounds of a boundary condition whether the sounds are given birth to as sounds or not. At the performance, instruments, human bodies, electronic apparatuses or anything else may be used. 1963

Music for Two Players
Stand face to face to one another and stare at the opposite player's eyes:
at first 3.0 m apart (4 minutes)
then 1.0 m apart (4 minutes)
then 0.3 m apart (4 minutes)
then 6.0 m apart (4 minutes)
then 0.5 m apart (4 minutes)
An assistant may show them the time and distance. 1963

In retrospect, I think these musical experiments were of an extreme kind. I felt myself to be much freer with this work than when 1 was engaged in the study of modern European music. This period also saw the creation of *Endless Box* – made by folding many square sheets of white paper, all of different sizes. People liked the piece just as an object, but for me it was charged with the sensual reality of removing one boxed covering to reveal another, then another, and so on. This work, in particular, I feel, characterized and was of the same essence as the music: there was the same concentrated duration and activity as the sound music I had composed.

At that time I was unaware that in New York this kind of work was called an 'Event'. One day I came across a Fluxus work by George Brecht at T. Ichiyanagi's place, and what a pleasant surprise it was. I soon got into contact with various other Fluxus people, which made me take a trip to New York in the summer of 1964. I met George Maciunas, Dick Higgins, Alison Knowles, Nam June Paik, Ay-O, Takako Saito, Joe Jones, Peter and Barbara Moore, among others, who were very kind to someone they knew only as a little girl from Japan. We did some performances together and, although I enjoyed my stay in New York, one problem overtook me. It was the problem of communication. Or maybe I should say the inconvenience of communication. After one had run around giving concerts and attending other peoples' concerts and performances, it was frustrating to be physically restrained to one place at a time. I felt that art should be alive everywhere all the time, and at any time anybody wanted it. And so I came up with the idea of the *Spatial Poem*.

The idea is to have simultaneous performances at different places all over the world. I sent invitations to over a hundred people whom I had heard of through Fluxus, plus several to people I knew personally. I invited them all to

perform, the same simple event, but to perform it in their own way and to make out reports about the event and send those reports back to me. The first Poem was 'word event':

> *Spatial Poem No. 1*
> *word event*
> Write a word or words on the enclosed card and place it somewhere.
> Please tell me the word and place, which will be edited on the world map. 1965

About 80 people participated. I made a map with flags on which were printed the words and the places. George Maciunas and Joe Jones helped me make it.

After returning to Japan, I decided to continue with this sort of event as a series:

Spatial Poem No. 2	*direction event*
Spatial Poem No. 3	*falling event*
Spatial Poem No. 4	*shadow event*
Spatial Poem No. 5	*open event*
Spatial Poem No. 6	*orbit event*

At present, I have completed the first six events. Altogether the series will comprise nine events. For the first four events we made separate maps in different styles which were then sent back to each participant. Some of the maps were very fragile so I am planning to publish a book including all the reports for the nine events on the completion of *Spatial Poem No. 9*. The reports returned by various people are very diverse and full of individuality – some poetic, some realistic or cynical, some artificial, some spontaneous, etc. When they are all collected together, they present a fantastic panorama of human attitudes.

I would like to think the collective anonymous poem can be preserved as a monument for the people of the thirtieth century – if we survive that long. (I would like to thank the participants who joined in to make this monument.)

Apart from the *Spatial Poem* series of works, I was also interested in intermedia art, and in 1968 I composed *Amplified Dream No. 1* and *No. 2*. *No. 1* was performed at the Intermedia Art Festival in Tokyo in January 1969 by Takehisa Kosugi, Y. Tone and myself. *No. 2* took place in the huge, circular Olympic Stadium in Tokyo as part of the Cross Talk Intermedia Festival presented by the American Cultural Center in February of the same year with the help of K. Akiyama, G. Yuasa and Roger Reynolds.

Basically, the outline of *Amplified Dream No. 2* was: a big white windmill, specially built for this work, standing in the middle of the floor on which were

fixed a number of electronic devices and several rows of light bulbs. Beside it stood a large fan controlled by an operator. Surrounding this central core were three grand pianos forming a triangle. Three pianists played upper glissando and cluster according to *Amplified Dream*'s morse code (·– – –·– –··········–·····–··–········– – –, dot for cluster on the middle keys, dash for upper *glissando*).

The performers wore thick gloves to prevent damage to their hands, and each of them varied the performance according to the intensity of light coming from strong blue and white spotlights behind. The piano sounds were picked up individually by contact microphones attached to the inside of the pianos and controlled by ring modulators operated in conjunction with graphs created according to the same morse code. These circuits were intermittently cut off by electronic relays and lights operating on the windmill. About halfway through the piece a five-channel taped piece of music, also controlled by morse code graphs, was introduced. Thus the piano, electronic and taped sounds were all controlled by the collective forces of wind, light and morse code, via electronic devices and live operators.

During this period I had the chance to see a number of performances of intermedia works, and realized some of the differences between intermedia and happenings or events. In intermedia, all the elements (musical instruments, lights, images, performers, electronic apparatus and various objects) should be treated as media or mechanisms to present the particular structure of the piece, and not as just a collection of objects put together. This transformation from object to media seemed to me an ideal, but I found that there were certainly many delicate intangibles not always depending on how tightly any particular element was related to the whole piece. For instance, when I was performing Kosugi's *Catch Wave '68* I had to hold an electronic device in my right hand, and was required by the instructions to move my outstretched right arm slowly in a clockwise direction. On the table in front of me was placed another piece of apparatus, which made various electronic sounds according to the distance between and direction of approach of the two devices. Since the placing of the object was very delicate, even the slightest and invisible movements of my body induced unexpected metamorphoses of sound. This really fascinated me so much that I felt I had become part of the electronic apparatus, not just a performer.

I have been lucky to have the opportunity of collaborating with many excellent artists, and never felt conscious of being a woman artist when I was single. This was partly due, I think, to the fact that I lived independently from my family and nothing except the limits of my own ability hindered my way of life. In short, my activities would hardly have been any different if I had been born a man. The character of my work might have differed, but this is mere speculation – a speculation that doesn't particularly bother me. After marriage, however, in 1970,

the problems of being a woman did confront me. Like most married women, the trifling jobs of being housewife and mother began to restrain my activities. My husband is sympathetic to my work, but frequent meetings, rehearsals, concerts and discussions throughout the night would cause great problems in running a home. And so, for now, my work is limited to the kind I can do at home, and I submit to the inconvenience of the situation because it is only a brief period in my life; in the near future the children will leave me more free time.

Eventually I will again begin serious work in the area that most interests me now: the kind of intermedia work that inclines toward musical performance, not necessarily requiring big and expensive apparatus, but needing more inventive ideas and plans about the relationships between sound, symbol, light, space movement and time.

Mieko Shiomi, untitled text on her work from 1961 to 1968, *Art & Artists* (October 1973).

Len Lye
Happy Moments//c. 1966

When you wake up in the morning, your wits are supposed to be fairly sharp, and the very first image your senses pick up such as hearing something or seeing the colour of something or feeling your bare feet on the linoleum floor-whatever it may be, then that is the day it is. For instance, if you've just heard someone clanking a nice bit of metal outside your window, then it's sound day. If you passed me a hundred dollar bill – New Zealand dollar, of course – I wouldn't care how much it was, I would care about what sound it made if I rustled it between my fingers. I would sharpen my wits of hearing that entire day. So you get a whole range of days, you get colour days, weight days, distance days, sound days, so on. This sharpens your various senses and finally, the thing you get most kick out of – for example, sound, or the sound of a voice or the sound of instrumental stuff, ordinary sound effects – whatever it is, if it's sound, for instance, then you have learned that your temperament leans most toward sound. Consequently, you should be more interested in sound, composing sound and so forth.

Len Lye, extract from 'Happy Moments' (*c.* 1966), in *Figures of Motion: Selected Writings* (Auckland: Auckland University Press/Oxford: Oxford University Press, 1984) 30–31.

Harry Bertoia
Why is Sound Left Outside?//1987

For a number of years I had realized that sculpture has existed in silence through time. Looking at sculpture, like walking in the forest, I thought: 'Why is sound left outside?'

The sounds [come] from I don't know where … They come from the depths of the earth … I don't know. But they have profoundly attracted my attention and I think I will remain with them and continue … towards where? Until I achieve the point where I feel simply sufficient … if that ever comes.

Harry Bertoia, 'Why is Sound Left Outside?', statement on the sound sculptures made by the artist and his son Val Bertoia in the early 1970s, quoted in *The World of Bertoia*, ed. Nancy N. Schiffer and Val O. Bertoia (Atglen, Pennsylvania: Schiffer Pubishing, 2003) 208.

Bruce Nauman
Untitled//1969

Drill a hole about a mile into the earth and drop a microphone to within a few feet of the bottom. Mount the amplifier and speaker in a very large empty room and adjust the volume to make audible any sounds that may come from the cavity.

Bruce Nauman, *Untitled* (1969), for the proposal-based exhibition 'Art in the Mind', Allen Memorial Art Museum, Oberlin College (1970).

Chrissie Iles
Cleaning the Mirror: Marina Abramovic//1995

[…] John Cage was to have an important influence on Marina Abramovic. He once described hearing as the most public of the senses, since it allowed contact with people from a distance. Abramovic's engagement with the public first began at a safe distance, in a series of sound environments. Her first sound piece, *Three Sound Boxes* (1971), consisted simply of three boxes placed in the gallery each emitting the sound of sheep, the sea and the wind. In hoping to lull the audience into a peaceful state of mind by evoking memories of the countryside, Abramovic was prefiguring the objects she was to make much later, which are designed to bring the visitor to a calm state of mind, but this time through experiencing nature by direct physical contact with its materials.

This process was also attempted photographically in *Project – Empty Space* (1971), when the first evidence of Abramovic's concern with empty space appeared. In a small room, a circle of slide projectors projected a panoramic sequence of large black and white images of Belgrade round the walls. As the sequence progressed, more of the city was removed, until the final image showed people in an open space. This 'liberating' of the horizon or sky evokes the work of Yves Klein, for whom the sky represented both the immaterial and the infinite. Through the void, 'the realm of freedom and creativity, a space where sensibility is evoked and endlessly recognized, a zone of nothingness and everything, where there are no names, rules, boundaries or definitions', Klein had sought to explore the fundamental nature of being.[1] He grounded his ideas of transformation in practical discipline of the body, practising meditation, fasting and Kudokan judo. Although Abramovic was not to become involved in the physical and mental rigours of eastern thought systems until much later, *Project – Empty Space* and her subsequent solo performances *Freeing the Memory, Freeing the Body* and *Freeing the Voice* mark the beginning of an emptying process by which the artist and the public have been repeatedly placed in a state of preparation to enter another physical and mental level of being.

Cage observed that technology had liberated sound from objects. For *Sound Ambient: Airport and Sonorous Space: Birds Chirping* (1971), Abramovic used this freedom to play a Duchampian trick. In the second of these works, she placed a loud tape recording of birdsong in the branches of a tree in front of the Student Cultural Centre in Belgrade, whilst inside, people sitting in the communal area heard the first work: a disembodied voice announcing gates, times and flight numbers for plane departures to Bangkok, Hong Kong, Tokyo and Honolulu. In an

earlier, more aggressive sound 'action', she played for three hours a tape of the sound of a house collapsing through speakers on the roof and walls of an unknown and inhabited house in a street in Belgrade, to the great alarm and surprise of passers-by.

In her most dramatic sound environment, *Sound Space – War* (1972), reconstructed for this exhibition, viewers entered the Museum of Contemporary Art in Belgrade and walked directly into a stark white corridor, where they were assaulted by a barrage of ear-splitting machine-gun fire. The blast lasted only a few steps before visitors found themselves in complete silence. In a nearby room in a second sound piece, *Forest*, a notice on the wall instructed the visitor to 'Walk. Run. Breathe. Do everything that you do in the forest. Write down your experiences in the forest.' For this purpose sheets of white paper were pinned to the surrounding walls. [...]

Abramovic dealt with space more literally in two subsequent sound pieces which were to lead directly to working with her own body for the first time. In the first, *Sound Environment White* (1972), an artificial emptiness was created by covering the walls of a room in the Student Cultural Centre in Belgrade with sheets of white paper and placing a reel-to-reel tape-recorder in the middle of the floor. A blank tape recorded and amplified the silence of the room. This amplification made the experience of the silence both phenomenal and symbolic. Cage had discovered in his own work that silence is not the absence of sound but an aspect of it.[2] For him, silence was a powerful metaphor for 'non-being', through which one eventually could arrive at 'being'. Abramovic's interest in sound was stimulated by the combination of its immateriality and its ability to have a direct impact on the body without involving the intellect. Amplifying the silence of the room produced a vibration which caused the space to become charged, as the artist herself was later to charge the space with her own presence in both her solo performances and those with Ulay. The eastern belief in the ability of sound to act on the body through vibrations and 'inner scales' inaudible to the human ear became a subject of interest in the early twentieth century, from Gurdjieff and Kandinsky onwards. Gurdjieff argued that the single note of the snake charmer's tune contained inner octaves, the inner vibrations of which the snake felt and obeyed. Thomas McEvilley, writing about Abramovic and Ulay's sound performance *Positive Zero*, points out that according to tantric and occult theory sound reality produces image reality according to the 'Great Chain of Being', and 'the performance ... was an art-historically based intuitive approximation of this occult process'.[3]

In *Spaces* (1973), Abramovic's concept became more sophisticated. She emptied seven rooms in the Museum of Contemporary Art in Zagreb and worked with the feeling she picked up from each space. Turning herself into a sensor, she

translated what she felt into metronomes placed on the floor of each room and set them at a tempo which she felt corresponded to the rhythm of the room. In the last room the metronome was silent. The metronomes contained a double meaning: their rhythms were not only metaphors for the perceived rhythms of each room, but aural imprints of Abramovic's emotional state at that particular moment. Unlike *Sound Environment White*, these rooms were dealing not with space but with time. […]

This definition of the relationship between time and non-time could be a description of the different rhythms of Abramovic's metronomes: *allegro*; *andante*; *prestissimo*; *largo*; *presto*; *lente*. Only in the last room could the idea of transformation be considered, in the quiet stillness of the silent metronome. It is at the point of stillness that the invisible inner life can be heard most strongly. This was the first piece to contain any evidence of the artist's own emotional state or presence. It led directly to her performance *Rhythm 10*, made six months later at the Edinburgh Festival, which took the rhythmic sounds of the metronomes into a new and violent territory.[4] It was through sound that the body entered Abramovic's work and became its central subject.[5]

It was also through sound that video first appeared in her work. Video had entered art through performance, sharing its concerns with real time and the body and developing as a 'live' medium from its initial role as a documentary tool. In Abramovic's first video piece, *Sound Ambient White – Video*, made just before she left Yugoslavia for Edinburgh in 1973, the screen was white. A blank video tape was playing, emitting white noise. This was a clear reference back to the blank audio tape in *Sound Environment White* and to the deafening shooting sounds of *Corridor*. Abramovic had introduced video into her work an immaterial way. It was as though she had arrived at video and performance at the same moment and had separated out their different aspects. The white blankness of the video and the bloody drama of *Rhythm 10* could be read as parallel pieces, operating on the viewer like the sound corridor and the forest environments had done.

Sound Ambient White – Video unconsciously echoed one of Nam June Paik's earliest pieces, *Zen for Film (1962), projector*. But as Paik's friend and mentor Cage, writing about the piece, has pointed out, 'there is never nothing to see'.[6] One's attention is drawn to tiny details such as scratches, imperfections on the wall and particles of dust on the screen. It was precisely this kind of amplification that Abramovic's early sound pieces had been dealing with. There are many connections between Paik's video work and that of Abramovic. Her concern with the properties of the medium itself continued in her works made with Ulay, grounding her video work in the object. Having arrived at video through the immateriality of sound, she rejected its psychological aspect. […]

1 [footnote 8 in source] Yves Klein, in *Yves Klein*, exh. cat. (London: Hayward Gallery, 1995).

2 [10] Frances Dyson, 'The Ear That Would Hear Sounds in Themselves', in *Wired Imagination: Sound, Radio and the Avant-Garde*, ed. Douglas Kahn and Gregory Whitehead (Cambridge, Massachusetts: The MIT Press, 1992). Dyson tries to untangle the relationship between silence and sound and between the literal and metaphorical in Cage's work, including the role of the technological intermediary. Cage came to realize that silence meant not a total absence of sound but, rather, the giving up of intention. Cage's ideas on silence and chance were to influence Abramovic's work – see for example *Mikado* (1982), at the Centre d'Art Contemporain, Geneva, where sticks were thrown at random to create an artwork.

3 [11] Thomas McEvilley, 'Ulay/Marina Abramovic', *Artforum*, vol. 22, no. 1 (September 1983).

4 [12] Richard Demarco had invited Abramovic and seven other artists, some from the group she had worked with in Belgrade, to Edinburgh to take part in 'Eight Yugoslav Artists'. It was here in Scotland that Abramovic met Beuys, Kantor, Günter Brus and others for the first time, all of whom made a strong impact on her thinking.

5 [13] Both sound and silence continued to be central aspects of Abramovic's work in her early solo performances (see *Freeing the Voice, Freeing the Memory* and the rhythm of the music and her body in *Freeing the Body*) as well as in her subsequent collaborative works with Ulay. See *AAA– AAA performance* (1978) *Positive Zero – sound performance* (1984).

6 [14] John Cage, in *Nam June Paik – Video Space*, ed. Toni Stooss and Thomas Kellein (New York: Harry Abrams Inc., 1993).

Chrissie Iles, extracts from 'Cleaning the Mirror', in *Marina Abramovic: Objects Performance Video Sound* (Oxford: Museum of Modern Art/Stuttgart and London: Edition Hansjorg Mayer, 1995) 22; 23; 24.

Max Neuhaus
Listen (1966–76)//1990

The impetus for the title was twofold. The simple clear meaning of the word, to pay attention aurally, and its clean visual shape – LISTEN – when capitalized. It was also – partly, I must admit, as a private joke between me and my then current lover, a large French-Bulgarian woman, who when angry used to shout it before she began to throw things – its imperative meaning. LISTEN was my first independent work as an artist. As a percussionist I had been directly involved in the gradual insertion of everyday sound into the concert hall, from Russolo through Varèse and finally to Cage where live street sounds were brought directly into the hall. I saw these activities as a way of giving

aesthetic credence to these sounds – something I was all for. I began to question the effectiveness of the methods, though. Most members of the audience seemed more impressed with the scandal than with the sounds, and few were able to carry the experience over into an appreciation of these sounds in their daily lives. I became interested in going a step further. Why limit listening to the concert hall? Instead of bringing these sounds into the hall, why not simply take the audience outside – a demonstration *in situ*. The first performance was for a small group of invited friends. I asked them to meet me on the corner of Avenue D and West 14th Street in Manhattan. I rubber stamped LISTEN on each person's hand and began walking with them down 14th Street towards the East River. At that point the street bisects a power plant and, as I had noticed previously, one can hear some spectacularly massive rumbling. We continued, crossing the highway and walking, alongside the sound of its tire wash, down river for a few blocks, re-crossing over a pedestrian bridge, passing through the Puerto Rican street life of the Lower East Side to my studio where I performed some percussion pieces for them. After a while I began to do these works as 'Lecture Demonstrations'. The rubber stamp was the lecture and the walk was the demonstration. I would ask the audience at a concert or lecture to collect outside the hall and would stamp their hands and lead them through their everyday environment. Saying nothing, I would simply concentrate on listening and start walking. At first, they would be a little embarrassed, of course, but the focus was generally contagious. The group would proceed silently, and by the time we returned to the hall, many had found a new way to listen for themselves. Of course, there were a few 'mishaps'. I remember one in particular at a university somewhere in Iowa. The faculty must have thought I was actually going to give a talk. They were nonplussed when I told the students to leave the hall but, fortunately, not quick-witted enough to figure out a way of contradicting the day's guest lecturer. The students were more than happy to escape and take a walk. Several hundred of us formed a silent parade through the streets of this small town – it must have been Ames. The faculty was so enraged that, to a man, they boycotted the elaborate lunch they had prepared for me after the lecture. I quite happily ate a lot of meat and potatoes. A number of years later, when Murray Schafer's Soundscape project became known, I am sure these academics didn't have any problem accepting similar ideas. The reality, though, was quite another matter – not being safely contained between the covers of a book. I suppose the real definition of this series of pieces is the use of the word LISTEN to refocus people's aural perspective. I began to think of other ways of using it. (The Iowa experience had blacklisted me as university lecturer.) The largest version of the work (one million people) was an opinion editorial that I wrote for the New York

Times in 1974, condemning the silly bureaucrats of the Department of Air Resources for making too much noise. Unable to do their real job of cleaning up the air that New Yorkers breathed, they naïvely applied their energies to 'cleaning up' the sound of the city. To keep their pot boiling, they published a pamphlet entitled, 'Noise Pollution Makes You Sick'. I countered with 'Noise Propaganda Makes Noise'. The basic point being that by arbitrarily condemning most man-made sounds as noise, they were making noise where it never existed before. The most tragic result of their meddling is the people one has seen blasting their ears out (quite literally) with 'Walkmen' while riding the subway, convinced that they are protecting their ears from the subway sounds which are, in fact, much less loud. There were other manifestations of the idea. I organized 'field-trips' to places that were generally inaccessible and had sounds that could never be captured on a recording. I also did some versions as publications. One of these was a poster with a view looking up from under the Brooklyn Bridge, with the word LISTEN stamped in large letters on the underside of the bridge. This idea came from a long fascination of mine with sounds of traffic moving across that bridge – the rich round texture formed from hundreds of tires rolling over the open grating of the road-bed – each with a different speed and tread. The last work in the series was a do-it-yourself version. I published a postcard, in the form of a decal with the word LISTEN outlined in open letters, to be placed in locations selected by its recipients.

Max Neuhaus 'Listen' [on the Listen series, 1966–76], in *Sound by Artists*, ed. Dan Lander and Micah Lexier (Toronto: Art Metropole, 1990) 63–7.

Bill Viola
Writings//1976–85

Street Music (1976)
On Sunday, September 26, 1976, at 8 a.m., I fired a rifle into the air several times on the corner of Cedar and Nassau streets in the Wall Street district of New York.

The shots were recorded on several stereo audiotape recorders with various miking configurations. The tapes are intended to be played back both at normal speed and at slower speeds to reveal sound echo patterns and reverberation in the deserted streets.

Statement (1985)

In 1973 I met the musician David Tudor and became part of his *Rainforest* project, which was performed in many concerts and installations throughout the seventies. One of the many things I learned from him was the understanding of sound as a material thing, an entity. My ideas about the visual have been affected by this, in terms of something I call 'field perception', as opposed to our more common mode of object perception. In many of my videotapes I have used the camera according to perceptual or cognitive models based on sound rather than light. I think of all the senses as being unified. I do not consider sound as separate from image. We usually think of the camera as an 'eye' and the microphone as an 'ear', but all the senses exist simultaneously in our bodies, interwoven into one system that includes sensory data, neural processing, memory, imagination and all the mental events of the moment. This all adds up to create the larger phenomenon we call experience. This is the real raw material, the medium with which I work. Western science has decided it is desirable to isolate the senses in order to study them, but much of my work has been aimed at putting it all back together. So field perception is the awareness or sensing of an entire space at once. It is based on a passive, receptive position, as in the way we perceive sound, rather than an aggressive, fragmented one, as in the way our eye works through the narrowing function of focused attention. This perception is linked more to awareness than to momentary attention.

I have learned so much from my work with video and sound, and it goes far beyond simply what I need to apply within my profession. The real investigation is that of life and of being itself; the medium is just a tool in this investigation. I am disturbed by the over-emphasis on technology, particularly in America – the infatuation with high-tech gadgets. This is also why I don't like the label 'video artist'. I consider myself to be an artist. I happen to use video because I live in the last part of the twentieth century, and the medium of video (or television) is clearly the most relevant visual artform in contemporary life. The thread running through all art has always been the same. Technologies change, but it is always imagination and desire that end up being the real limitations. One of my sources of inspiration has been the thirteenth-century Persian poet and mystic, Rumi. He once wrote; 'New organs of perception come into being as a result of necessity. Therefore, increase your necessity so that you may increase your perception.'

Bill Viola, 'Street Music' (1976) and 'Statement' (1985), in Viola, *Reasons for Knocking at an Empty House: Writings 1973–1994* (Cambridge, Massachusetts: The MIT Press, 1995) 151–2; 48–9.

Laurie Anderson
Writings//1977–79

Duet for Door Jamb and Violin

This duet is performed on the threshold. The length of the bow stroke is determined by the width of the door. Contact microphones are attached to the jambs at the impact points, amplifying the staccato, knocking sound as the bow bangs back and forth.

When the violin is electric, the violin speakers are located in one room and the door jamb speakers in the adjoining room. During the performance, tonal and percussive are alternately separated and mixed by kicking the door open and shut.

From *Words in Reverse*

I can draw you so that you have no ears. I can draw you so that you have no ears at all. So that where your ears would be, there is only blank paper.

Laurie Anderson, 'Duet for Door Jamb and Violin', in Anderson, *Notebook*, Artist Book Series #1 (New York: The Collation Center, 1977); extract from *Words in Reverse*, Top Stories #2 (New York, 1979).

Tom Johnson
Takehisa Kosugi and Akio Suzuki: Stunning by Coincidence//1979

It was a quiet Tuesday afternoon, and I was not ready for the experience that awaited me at the Cooper-Hewitt museum. After browsing around the photographs, wall hangings and sculpture, which are part of the current 'MA, Space/Time in Japan' exhibit, I wandered into the performance area. I was stunned to find ten priests facing the wall, absolutely still, meditating, completely undistracted by the gathering audience. A few minutes later I was stunned again to discover that those totally lifelike priests were statues. Then began the most stunning performance of new music I have attended in months.

Akio Suzuki appears on the small stage and takes his place behind an attractive piece of sculpture. Six coiled springs are stretched vertically between black cylinders mounted on a frame. He strokes one of the springs gently and it resounds with a

strong, deep sound. He strokes again, scratches, plucks, moves from spring to spring, tests the resonances, listens. He is clearly improvising. There is no sense that he is playing specific rhythms, or making a composition, or asserting his will on this remarkable instrument he has made. He drifts with the music, allowing the springs to make their own sounds in their own time. After a while he stretches one of the springs out across the stage and sings into the black cylinder on one end. His voice resonates for such a long time that he can catch breaths without disturbing the tone. The resulting sound sustains without interruption, and its resonance spreads eerily around the whole room at once. Takehisa Kosugi has still not appeared, but one can hear a sporadic clicking from behind the back wall of the stage.

Suzuki moves back to the six vertical springs and plays them some more. Then he bends over what appears to be a small glass table. He begins rubbing on the table in small circular motions and produces a sound that could have come from a wine goblet. He is not trying to dominate the glass. Maybe he is allowing the glass to dominate him. No. They are equal. They are both part of nature, and they are simply flowing together. It's a special kind of sensitivity that's hard for Westerners to understand, but which seems completely natural in this Japanese setting.

Kosugi can be seen now, and we realize that the clicking emanates from a fishing reel. Slowly, ceremonially, he walks to the front of the stage, gradually letting out a line that is stretched to some point behind the stage.

Suzuki returns to the six vertical springs, but now he plays them with a pair of mallets. As he moves from one spring to another, one can hear that the basic pitches of the springs have been carefully tuned.

Kosugi has gradually made his way from the front of the stage out through the audience. The clicks from the reel come in clusters whenever he takes another step. He walks with great concentration, listening to the reel and holding it carefully, but never trying to tell it what to do.

Suzuki moves back to the small glass table, this time producing little clicking sounds.

Kosugi has disappeared into an adjacent gallery, and the clicking of the reel is fainter. The line he has stretched out over the audience sways slightly in response to the movements at the performer's end.

Suzuki is now stroking a corrugated surface on the floor with a wooden stick. The sound is similar to the clicking of the reel, but the similarity seems more coincidental than intentional.

Kosugi remains out of sight, but the clicking continues. The line he has stretched out over the audience reflects the line of a long coiled spring that is also stretched over the audience, but this too seems like a coincidence. We are in a very subtle artistic world where there can be no direct relationships, no Western rationality, no look-what-I-made. Only coincidence.

Suzuki continues playing on the corrugated surface, but he is also listening to the clicking of the reel.

Kosugi reappears in the doorway, and we realize that now he is reeling the line in instead of letting it out. He is intent on what he is doing, but he is also listening to the sound of the stick moving across the corrugated surface.

The two performers now come together in one of the oddest and most beautiful duets I have ever heard. They never force a relationship. They never attempt to imitate each other. They don't take turns making their similar sounds, but they don't not take turns either. They are not controlling, organizing, composing. Yet they are listening, sensing. I have seldom seen two performers so completely tuned in on the same types of sounds, the same performance attitude, the same philosophy, the same sense of what music ought to be. They are at one with the reel, the stick, the situation and each other. And while I realize that I am romanticizing in an inappropriately Western way, I can not help feeling that they are tuned in on some sort of basic life flow.

Suzuki eventually gets up and moves over to the black cylinder at the end of the coiled spring that stretches clear across the room.

Kosugi eventually finishes reeling in his line and disappears backstage again.

Suzuki now focuses on his new black cylinder and, with one little tap, produces the most amazing sound of the afternoon. The tap races down the coiled spring, resonates in the black cylinder at the other end, races back, races down again, and makes five or six round trips before fading off into silence. It is an ingenious sound discovery, unlike anything I have ever heard before. The effect could easily hold my interest for twenty minutes, but the inventor-sculptor-performer lets us hear it only a few times. How odd. I can't think of any other musicians who would work for fifteen or twenty minutes with a familiar everyday sort of clicking and would then toss off a brilliant sound discovery like this in less than a minute. What elegant pacing.

Kosugi reappears with his violin. He improvises short phrases, some of which revolve around only two notes, and some of which are more active. The phrases have unique individual curves that remind me of the quick brush strokes of a calligrapher. And each one has a few little flaws too. Places where the ink or the sound doesn't quite fill in. Places where a brush hair or a bow hair wanders a little to one side. The violinist moves a lot as he plays. Many phrases begin standing tall and end in crouch. The music seems to emanate from his breathing, from his body. I don't think his brain has a whole lot to do with it. He seems quite at home on his instrument, and I have little doubt that he could play Bach respectably if he wanted to. But now he is not striving for any specific, thought-out results. The sounds have a more physical origin, and the scratchiness or mellowness of the tone seems more a matter of muscular accident than conscious

decision. Sometimes the phrases are quite strident, but since they are disconnected from the will, they never seem aggressive.

Suzuki is now balancing a small board on one end. Sometimes it falls to one side and clicks against a dowel he holds in his right hand. Sometimes it falls against the dowel in his left hand. There is something quite elegant about the choice of wood and the appearance of the grain. It is clear that this man has produced a lot of sculpture. His sensitivity to materials, colours and lines is apparent in all of his instruments, and one senses a sculptor's eye even in the little piece of wood he is playing now. Sometimes he moves over to a metal plate, rubbing on it with a stick, and producing rough sounds that relate more closely to the violin music.

Kosugi continues playing his violin, or perhaps allowing the violin to play him. As always, he and his partner remain tuned in on one another, listening, flowing and allowing the coincidences to happen until, as another kind of coincidence, they stop playing and end the performance.

It was a quiet Tuesday afternoon again, though I felt much different from before. [...] Experimental music, I learned, is still largely ignored in Japan, even when the aesthetic seems totally Japanese, and the two do not expect many performing opportunities there.

Tom Johnson, 'Takehisa Kosugi and Akio Suzuki: Stunning by Coincidence', *Village Voice* (New York, 23 April 1979).

Christina Kubisch
About My Installations//1986

My sound installations are based on electro-magnetic sound transmission. A series of electric cables are installed in an indoor/outdoor situation. The cables can be fixed to walls, ceilings and floors or suspended in the air. They can follow the natural forms and architecture of the place (for example, cables can be wrapped around trees in a wooded area or strung around columns in an old monastery) or they can form an independent geometric structure throughout the space.

Sound transmission originates with an audio source (generally tape) that is amplified by a specially built amplifier from which the cables are sent and returned, forming a loop. One 'pair' of cable structures forms a stereo output (left and right channels). The public (listener) wears a wireless headphone with an

adjustable dynamic range control. The listener can walk around freely, receiving the sounds via the built-in electro-magnets, which function like pickups. Through movement (or non-movement), the listener is able to choose between various sound sources and their combinations. The volume of the sound increases as the listener moves closer to the cables. Quick movements through the space cause the sounds to fade into one another, while slow movements cause sequences of sounds. The space between the cable fields produces silence.

The sounds can be electronic, natural or instrumental and are compiled, in advance, in my sound studio. The 'composition' for any given installation is related to the 'sound-architecture' of the cable structure.

Sounds

I generally work with 'opposing' sounds.

Natural sounds: recordings made in nature, animal sounds, water sounds, the sounds of different materials, the voice, primitive instruments like a sea-shell or an Australian didgeridoo.

I am particularly interested in these sounds because they are evocative and, when heard in a different space from the original, can take on a magical and mysterious quality. My intent is to create a landscape of sounds (soundscape) in which the public can move freely, exploring and individually changing the composition. It's like walking in a jungle or along the seaside at different times of the day and on different paths.

Electronic sounds: I like to create sounds that are close to the character of the above mentioned sounds, interesting in their timbre and structure, and yet, not immediately identifiable with traditional instruments. The sounds are more articulated in their innate micro-structure than in melodic or harmonic patterns. Of special interest to me are rhythmic. Structures and their combinations. For example, a listener 'caught' between two cable-fields is apt to hear a polyrhythmic pattern. Natural and electronic sounds can be integrated into a kind of music that I call Ethno Electronics: music where electronic nature and natural electronics are so integrated that they form a new unity.

Afterword

The predominant means of acoustic communication today are radio, records, cassette tape and video. The technical media have radically altered the relationship existing between listener and music. Technology has bred a musical standard that is intended to be appreciated through loudspeaker systems and has very little to do with performance techniques used in the past.

As early as 1958 Karlheinz Stockhausen, a pioneer in the field of electronic music, wrote:

And what have record and radio producers done up to now? They have reproduced a music that was conceived and written for performance in concert halls and opera houses. Radio has striven to perfect technical reproduction to a standard that made it progressively more difficult for the listener to distinguish between original and copy. The illusion must be complete. The conscious deception perfect. All this leads towards a society that gains its spiritual sustenance from cans.

Canned music is able, through computer-controlled recording and reproduction techniques, to produce the sensation of 'being in the centre of the musical performance'. However, it is precisely this 'perfection' that discourage listeners from indulging in musical activities themselves. Creative musical experience need not, however, be limited to academic practice or to recorder recitals during 'musical afternoons' at home. The fear of electronics ignores the fact that each note is an electrically converted vibration and that live sound material can be produced 'naturally' by current, in the same way as traditional instruments. Listening is, in itself, an activity that must be consciously learned and developed. In contrast to the conditions in concert halls, our ears, coupled with the other senses, perceive rotund, spherical and moving sound. Creative listening is the starting point for my sound installations and sound-zones in which the structure of the composition is combined with sequences of tone and movement. The audience is able to move freely between various acoustic fields distributed throughout the sound zone, enabling the listener to discover ever new and individual sound combinations. These sound zones are often created in the open air: in woodland glades for instance, or in buildings that were not constructed to act as concert halls, such as deserted factories, shipyards and cellars.

Christina Kubisch, 'About My Installations', in *A Different Climate: Women Artists Use New Media* (Düsseldorf: Stätliche Kunsthalle, 1986); reprinted in *Sound by Artists*, ed. Dan Lander and Micah Lexier (Toronto: Art Metropole, 1990) 69–72.

Michel Chion
Video/Mouth: Gary Hill//1994

[...] Don't the rapidity and lability of the video image ultimately bring video closer to the eminently rapid element that is text?

It is therefore natural that, alongside numerous video artists whose subject is dance, there is Gary Hill, who has taken on the particular field of experience that involves the confrontation of a spoken text with an image, at the same pace. One of his works, *Incidences of Catastrophe* (1988), 'interprets' Maurice Blanchot's text *Thomas the Obscure* in very fluid images that show the material substance of Blanchot's book itself – the pages being flipped in close-up and following the threads of the written discourse – in alternation with sights of shifting sands and ocean waves, agitated by many visual movements that have the rapidity of a text. Listening to a text being pronounced is an activity that puts the ear and the brain to work. In film, when language is read or spoken, the image is often left high and dry, static in relation to the verbal text. It is much easier in video to go fast visually, to the point of giving what we see on the screen the look of a talking mouth: it closes and opens, puckers, bares its teeth at great speed. And all this without needing to show the image of an actual mouth. This visual fluttering, found in music videos and in video games, thus attains the speed of the auditory and of text. It is visible stuff to listen to, to decode, like an utterance. The image loses its quality of a relatively stable surface, and what becomes significant is the changes in its tempo or appearance. Paradoxically, this might explain why video makers often don't know what to do with sound, aside from providing a neutral background of music or a voice. For it can be argued that everything involving sound in film – the smallest vibrations, fluidity, perpetual mobility – is already located in the video image.

Other videos by Gary Hill, such as *Primarily Speaking*, confront text and image in an even more intriguing manner. While we hear a poetic reading, we see close-ups of objects that resemble fragments of small animal skeletons. The camera is constantly changing focus on these objects so that the variations in focus, the modulations of sharp and blurry on various depth planes, occur at the same pace as the text being read, and they are almost synchronous with the phonemes being uttered, suggesting a deciphering, as if they partake in a code. Here the image stirs like a mouth. Can we even continue to call it an image in the usual sense?

This question of the nature of the video image brings us around to the question of the status – or rather the non-status – of the frame in video.

In film the frame is important, since it is nothing less than that beyond which there is darkness. In video the frame is a much more relative reference. This is because, for one thing, monitors always cut off an undetermined part of the image, and for another, when we look beyond the borders, there is more to see. Since we normally behold the video image in a lighted place, the image does not act as a window through which our attention is chanelled.

So in film, since we're dealing with a frame that's set in stone – even if it's 'transgressed' in actual viewing through masking in theatre projections or cropping for video – there is a possible tension, a potential contradiction between this frame and the objects it contains. The entire art of film has been based on this very contradiction between the container (the borders of the frame, but also the temporal limits of the shot) and the content. While in video we might say that the image is that which it contains, that it is modelled on its content. For example, it can become a mouth that one watches as if one were deaf.

There may well be a precise relation at the core of video art between the vagueness of the frame and the indeterminate status given to sound – since in film frame and sound are strongly interrelated, particularly through the factor of offscreen space. Generally speaking, video art does not devote much thought to the place of sound. In the cinema the place of sound is clear: sound is determined in relation to a notion of the fictional space, and this space extends beyond the frame, constantly being remodelled with changes in framing. In any case, the image is the point of departure.

In commercial television the situation is equally simple, even if better hidden. Television is fundamentally a kind of radio, 'illustrated' by images. Television sound already has its established place, which is fundamental and mandatory (silent television is inconceivable, unlike cinema). But as far as video art is concerned, we do not yet know much. This also means that there is still plenty of room to experiment. So, back to your monitors – but don't forget the speakers. [...]

Michel Chion, extract from *Audio-Vision: Sound on Screen* (New York: Columbia University Press, 1994) 163–5.

Svetlana Alpers
Rebecca Horn: *Chorus of the Locusts* I and II (1991)//1996

I came upon this pair of works by Rebecca Horn on a miserable, rainy day in late winter in Hamburg. It was 1993. My visit to the Kunsthalle was an escape from the weather and a way to fill time before catching a plane back to Berlin where I'd been living since the previous fall. I was doubly on the road, away from being away, free, but also somewhat at loose ends, unfocused. There was a striking painting of a Delft church interior by Gerrit Houckgeest (hardly a household name, but long of interest to me) hanging in the museum. I wanted to see it.

The Hamburger Kunsthalle is not very large. It doesn't feature the art of this particular nation or of that particular period. It doesn't centre on the kind of masterpieces that draw crowds. It is austerely and cheerfully like a working space: there is a diverse permanent collection; ambitious temporary exhibitions come and go; art students study and even exhibit there. I never did find the Houckgeest (one gets used to that in museums), but there were other singular things: a dark, vertical canvas filled to the top with a flower bed lit from the front – an alternative to a still life painted, surprisingly, by the young Renoir; a 'Cézanne' portrait of a man, which turned out to be by Picasso; Philipp Otto Runge's obsessional portrait of three sinister children posing in a garden before a white picket fence; and, best of all, a series of religious panels by Meister Francke, which duplicated the close observation and free compositional style of this painter's miniatures on an unexpected scale and to astounding effect. I found myself, then, in a happy and receptive mood: happy because I was enjoyably involved in looking.

Near the top of the building there was another staircase, as if to an attic. Worth the effort? I went up anyway and emerged in an odd room. I'd never seen anything quite like it. The ceiling was lined with rows of typewriters, neatly arranged. Monumental, out-of-date office machines hung upside down. Here and there and now and then one or two typed away for a time and then stopped. The beat was kept (was that the point?) by a blind man's stick, white and hanging loosely down. The ribbon spewed out from one machine (had something gone wrong? could it be fixed?) onto the bare gallery floor. There was no real reason to bother with something like this, but I was intrigued and stayed on, attending to the erratic noise and trying to connect it to the movements that were going on. It took time. I never succeeded in getting it quite right.

Turning, I saw another room, companion to the first. This time the ceiling was bare, but the floor was covered for no apparent reason with row upon row of empty wineglasses – four thousand of them, Horn has noted – carefully set in

place. The rims and bowls were glistening, reflecting the available light. Were they meant to contrast with the dull, black metal of the suspended typewriters next door? Perhaps seeing them this way, as still lifes grown to the size of a room, comes from looking at photographs of them after the fact. But there and then something moved ever so slightly. From the midst of many glasses certain ones struck their neighbours to make a distinctive, dull clink. The movement and the sound brought the objects to life. As in the first room, this put one in a mood for some attentive looking, the essential museum mood, one might say. The intermittent chatter of tapping keys and now, in addition, the occasional chatter of clinking glasses continued. Otherwise isolate objects or beings had been brought together and began to perform some odd ritual of their own. It was a clever construct, but also a melancholy one.

I was pleased, naturally, when I found that the sculptures in the Hamburg rooms had been made by a woman. I hadn't really thought about it, because Horn does not distinguish her making in such terms. The pair of rooms were, or so I imagined them to be, like studios: domestic spaces that, historically, have been worked in by men as well. The artist I posited was decisive in the making of things and a bit detached. A keen observer who was prepared to set things up, depart, and let them play out their funny, risky course.

I have described the experience of looking as if I had been alone. In fact I went about the museum with a friend, and we talked intermittently of what we saw, sometimes agreeing, sometimes not: agreement was not really the issue. It was, rather, a matter of being in play. The typewriters and glasses registered a (and, on that day in Hamburg, my) mood. They became enabling realizations of a state of mind, and so, of a way of being. They focused and dignified being at loose ends on a rainy day. At the right moment, every now and then, they still do.

Svetlana Alpers, 'Rebecca Horn: *Chorus of the Locusts* I and II', *Artforum* (Summer 1996).

Brandon LaBelle
Other: Maryanne Amacher//2006

[...] The work of Maryanne Amacher shifts attention from standing waves and the acoustics of airborne sound to that of structural vibration. Contemporaneous with [Michael] Brewster, Amacher has been working with sound installation for the last thirty years. Her projects mirror much of Neuhaus' strategies, from early works using telephone lines to relocate live sound from one location to another, to music performances staged across a dispersed environment, and to her interest in sound phenomena and the activation of heightened listening experiences. Amacher's work articulates the driving force behind much sound installation. Through working with technology and extended systems of sound amplification, her focus has led to a deeper concern for architecture and geographic location. Started in 1967 and ending in 1980, her *City Links* series consisted of installing microphones at given locations and feeding these sounds to another, distant location to create 'synchronicities of different places'. From the Buffalo airport to Boston Harbour, the *City Links* series exposed to Amacher the 'tone of place', as she describes it:

> In regular music you don't have any models to learn about spatial aspects because usually the performers are on stage or the music's on a record and you don't really hear things far away and you don't hear things close-up and you don't hear nothings and you don't hear things appearing and disappearing and all these kinds of shapes that emerge from this.

Broadcasting using FM transmission or through 15kc telephone link, Amacher could listen to the distant and the proximate, the sound environment as a complex spatial event in which nothing and then something comes through, acoustic shapes dancing, a sonic play of various characters. One such installation work lasted for three years and consisted of a microphone installed at Pier 6 in Boston Harbour and fed directly to her studio at MIT.

Over the course of its installation, Amacher lived with the sounds of Boston Harbour, hearing all its rhythms and voices, the tone of the place, which Amacher identified as hovering around a low F-sharp, or 92Hz. 'It could have been coming from anything and I wasn't making a scientific analysis to know exactly what was producing this tone, but that was the tone of this space, really; the colour of it.'

The tone of place led Amacher to develop and elaborate her installation works into expansive sound environments specifically drawing upon architectural space. Her series of works *Music for Sound-Joined Rooms*, started around 1980,

reveal such interests through narratives about growing life forms, or growing musicians, as in a Petri dish, which would develop over the course of the work to inhabit a space. For one such installation, speaker systems were positioned throughout an abandoned house in St Paul, Minnesota, so as to lead a visitor through the space. For Amacher, the work aimed to create intense levels of energy circulating throughout the house, which would force people out, up onto a nearby hill, to 'observe this whole Victorian house, this whole structure sounding …' thereby turning the house into a sound environment that was more energy than sound, more body than ear.

The installation revealed for Amacher the potential of working with architecture, not only as a spatial outline of air-space, but as structure. As Amacher describes: 'An entire building or series of rooms provides a stage for the sonic and visual sets of my installations. Architecture especially articulates sonic imaging in "structure-borne" sound, magnifying colour and spatial presence as the sound shapes interact with structural characteristics of the rooms before reaching the listener.' The work is positioned against architecture rather than within. Locating sound in adjoining rooms, along a hallway, sounds occur structure-borne, travelling through walls, floors, corridors and ceilings. Installation works such as *Synaptic Island* (1992) and *Maastunnel Sound Characters* (1995) position architecture as an instrumental body, for structure-borne sound creates sound by elongating the length of a sound wave. For instance, 'The wavelength we feel for an airborne sound-wave for middle C is only four feet [whereas] the structure-borne sound wave is over twenty feet.' Utilizing such sonic behaviours, space can be incorporated into the sculpting of particular sound work: rather than house a work, work can literally become a house.

Amacher's 'sound characters' operate to immerse the listener/viewer in a specific narrative of sound and space, as a 'sonic theatre' in which the material function of architecture shifts to that of vibration. Exhibited at the Tokushima 21st Century Cultural Information Center, *Synaptic Island* initiated a complex scenario by relying not only on the architectural space but the neurological life of an individual. Amplifying varying frequencies, the installation activated what the artist calls 'the third ear'. The third ear essentially hears sounds not so much amplified from outside but created inside the ear as it resonates with given frequencies. Neurophysiologically, the body produces its own internal sonics through the acoustical excitation of sound waves in space, operating to trigger additional sounds or microfrequencies heard entirely inside the head. Dependent on the exterior, yet derived from its own unique identifying and experiential features, psycho-acoustic listening occurs as individualized vibrations. Here, noise vibrates both the architecture of rooms as well as the ear canal, situating a listener within a spatiality that penetrates as well as absorbs the body.

Both Amacher and Brewster redesign architectural space by creating additional zones of experience: for Brewster, volumetric presence is not confined to walls and the layout of cubes, but rather through clouds of sound that hover within space, as separate and distinct volumes that carry weight, mass, texture and colour; for Amacher, architecture's boundaries, in turn, do not stop at the wall but proceed up the wall, into space and through the body, shifting the definition · of what it means to inhabit space. For in this sense, space comes actively to inhabit the body. [...]

Brandon LaBelle, extract from *Background Noise: Perspectives on Sound Art* (New York and London: Continuum, 2006) 170–74 [footnotes not included].

David Toop
Haunted Weather: Music, Silence and Memory//2004

Janet Cardiff

In 1999 I walk into a public library in Whitechapel, East London. At the desk I am issued with a Discman, a CD and headphones. In exchange I give a credit card as security. After pressing start on the CD player, I hear the voice of Janet Cardiff in the headphones, guiding me to a specific shelf in the crime fiction section of the library. I can hear some ambient sounds from the library – people moving across the hard floor, hushed voices – yet already I feel unsure whether these are part of the CD recording or happening as real-time events. Cardiff guides me through dim corridors, their dull municipal paint peeling in long strips like the dead skin of a burns victim. I am inside her head, she is inside mine and we are both inside the stories of many books. It reminds me of something the artist Susan Hiller's said about her own audio installation *Witness* (2000): 'The effect of so many voices all speaking at once is something like the sense I have of the vast sea of stories we live within, and the option to listen to individual stories is a choice left to viewers as they wander through it.'[1]

Janet Cardiff hurries me now. Somebody is signing out a book, leaving the library; we have to follow. I don't question why. I have placed myself in her hands, inside her voice, pulled along by the compulsion of her work. We walk along Brick Lane, past the sari shops, past the vague blur of vivid sweets, pungent scents and vivid music, into bleak side streets where a sense of threat enters the narrative – footsteps approaching from behind – and again there's that uncertainty

about their location from within the artist's story or my own story, right here on this street with which I have no familiarity.

I am leaving myself behind. My radar, the detection system that alerts me to safety and location, seems to be switched to low intensity readings because I am in three places at once: inside Cardiff's urgent narrative which unfolds like an old-fashioned crime novel; in step with her voice of guidance, which safely walks me over dangerous roads, along narrow pavements and secret alleys; then in my own sense of the here and now, thinking about her work and the ideas it stimulates, observing the strange juxtapositions of Dickensian London and the upsurge of services aimed at the financial sector, what Iain Sinclair calls the 'money lake'. To be directed and informed by this voice is a noirish feeling and parental at the same time. I respond as a parent, having guided my child across roads enough times; simultaneously as a child, my small hand in my mother's hand. Then as a child again, I think about the noir voice, a voice-over, maybe Veronica Lake or Barbara Stanwyck, drawing me into darkness. Confused. I follow like a lamb.

The sclerotic artery of Commercial Street is negotiated without injury as we step, hand in hand, head in voice, towards Liverpool Street Station. We cross Bishopsgate and she asks me to sit for a while on one of the benches that look across towards Spitalfields. Look at that person walking past, she says, and indeed there is a person walking past. Of course, this area is hardly short of people walking past at any time of day but the operations of chance at work here are still fascinating. We sit in church quiet, which allows me to regain a better grasp of who I am and where we have been together, then end inside the transparent cathedral of Liverpool Street Station, gazing down from the street level balcony at the purposeful scurrying below. Something operatic plays on the headphones, which may be a touch overstated, too much like a 1990s television advertisement for insurance, but then again, the end is definitely an end.

Born in Canada in 1957, Janet Cardiff now lives in Lethbridge, Alberta. Making these kinds of piece, it's not easy to be prolific. They demand the right context, a unique engagement with the setting and a one-to-one relationship with each collaborator, who in other circumstances we would call the audience. Along with *The Missing Voice (Case Study B)*, as experienced above, her other pieces include In *Real Time*, created for the Carnegie Library of Pittsburg, *A Large Slow River*, set in Oakville Galleries, Gairloch Gardens in Oakville, Ontario, and *Forty Part Motel*, based on *Spem in Alium*, composed by Thomas Tallis. For the latter piece, forty separately recorded voices were played back through the same number of loudspeakers, all of them placed strategically through the performance space. Writing about this piece, Cardiff said: 'When you are listening to a concert the only viewpoint normally is from the front, in traditional audience position. With this piece I want the audience to be able to experience a piece of music from the

viewpoint of the singers. Every performer hears a unique mix of the piece of music. For the audience to be able to move throughout the space in the ways they choose they are able to be intimately connected with the voices as well as hear the piece of music as a changing construct. I am interested in how sound may physically construct a space in a sculptural way and how a viewer may choose a path through this physical yet virtual space.' [...]

Stephen Vitiello

During the second half of 1999, American composer Stephen Vitiello was a resident artist in New York's World Trade Center. The Lower Manhattan Cultural Council had been offering a residency programme for several years, allowing painters, photographers and sculptors to set up temporary studio space on the 91st floor. Then in 1999, this programme expanded to include media artists. Vitiello describes the project:

I had read Alan Licht's article on Maryanne Amacher, where she spoke of her residency at the New England Fisheries. She had mounted microphones over the water and had a sound feed permanently running into her studio. I borrowed that idea, with the intent that I would open my studio windows, mount a set of microphones outside and have constant access to the sound outside the building – to listen to and process. I was awarded the six-month residency but didn't know until I moved in that the windows were sealed shut and were triple-thick glass, shutting out all unwanted sound from this picture-perfect real estate.

My studio had been the former home of a Japanese investment firm which had gone out of business in the Asian economic crash. I set about the task of working out how to get the sound from outside the studio to the inside without being able to open the windows. I tried all sorts of microphones and looked into lasers. Finally, a friend introduced me to some very inexpensive, commercially available contact microphones. With some extra amplification and tweaked equalization, I was able to get sound. The first that I ever heard come through was church bells. It was chilling and so liberating. In retrospect, I think the fact that the windows did not open made the project successful. I had the task of bringing in what we were denied. The second filled in the void – allowing an emotional, physical connection to the view that was otherwise impressive but also flat. The airplanes and helicopters, the storm clouds, the movement of the building, suddenly had presence. The terror and beauty of being that high up became much more real.

I captured sounds with the contact microphones, as well as with photocells. Bob Bielecki, an engineer friend, came up one night. We were talking about the way that the view changed at sunset. The buildings seemed to disappear, being replaced by the ghostly lights in windows, on the river, the red and green tracking

lights on the wings of the planes. He wired up some tiny photocells for me, that were usually used in electronic equipment such as light meters. When wired to an audio cable and pointed through a telescope, at the lights, we were able to hear the frequency of some of the lights as a sound frequency, thus listening to the lights. The lasting image I have of working in the studio is of sitting alone at night, with a pair of headphones running though my mixing board and out to two contact microphones taped to the window. The microphones became a stethoscope through which I could listen to the pulse of the building.

With my original proposal, I expected to take those sounds and manipulate them in real-time performances. During my residency, I recorded several different kinds of sound – windy days, planes and helicopters, traffic, the building swaying after a hurricane – but almost never found an effective way or reason to process the sounds. There was nothing that I could do or wanted to do to 'improve' them or make them more musical.

After the buildings were destroyed, I thought I should out the tapes away. The reality of what had happened made any use seem trivial or potentially disrespectful. Two weeks after September 11, I was asked to speak at The Kitchen, along with several other artists, on our experiences of working in the World Trade Center. I played the recordings with some hesitation. The response from the audience was very strong and direct. They felt that I had to share these recordings, as this was a way of listening to a building that could never happen again. I was then invited to present the piece as part of the Whitney Biennial. The Whitney specifically wanted a 5.1 surround presentation. I met with an engineer who introduced me to a high-end processor that successfully stretched the stereo signal and played it back from 5 discrete speakers, plus subwoofer. The feeling is that you are standing in the midst of the building as it sways and creaks with moments of wind and a plane passing.

While that residency and project had a very strong influence on my work, I haven't made a habit of recording the city, or a focus on 9/11 as subject matter. One attempt to address 9/11 was made in a concert at The Cartier Foundation in Paris just last week, January 2003. The concert was programmed as part of an exhibition curated by Paul Virilio, on the concept of Accident as a cultural, post-technological phenomenon. I was told that Paul wanted me to use my World Trade Center recordings in the concert.

Rather than focus on those sounds, I got a recording of 9/11/02, when a moment of silence was observed in NYC and Washington. That moment of silence is filled with the anxious clicks of journalists' cameras and wind whipping the microphones and audience. We (a duet with Scanner) started the performance with that recording, and gradually began to stretch it, slow it down and try to re-inhabit that moment, re-presented to an audience caught under the hanging sculpture of Nancy Rubins, made up of a collection of crushed and burnt airplane parts.

In general, my work has continued to relate to architectural spaces, to site-specific projects, looking to capture the feeling of spaces through sound and to create spaces to replant some of these sounds. Depending on the context, sounds may go through vast forms of digital or analogue manipulation. Others, remaining relatively pure, or as much as a digitally captured recording can hope to be pure, remain a form of truth. [...]

1 Susan Hiller in conversation with Mary Horlock, *Paletten* (17 July 2001).

David Toop, extracts from *Haunted Weather: Music, Silence and Memory* (London: Serpent's Tail, 2004) 122–4; 124–7.

Philip Dadson
Sound Stories//2000

Ngahau

A series of bays run south from Mimiha, isolated and removed from the crowds. Ngahau and Mimiwhangata were once strongholds of Northern tribes with fortified promontories jutting into the sea. It's quiet there aside from the regular rhythms of the sea, the peeps and squawks of nesting seabirds and the continuous high pitched twitter of skylarks hovering over the dunes at the back of the beach. There's a pa[1] on Ngahau with deep trenches that lead to a remote and idyllic bay, where the stones are veined with colour and crystalline quartz. These stones have felt the breach of raiding canoes on the beach and warble underfoot with the same floating harmonics as the skylarks of Mimiwhangata. Unsuspected sentinels of intruders on the silence.

U Hei

Working near Hokitika on a film about the notorious Stan Graham,[2] I explore dry old river courses in the breaks and discover flat rounds of schist, magically flecked with silver. I find I can make them sing – like a paradiddle on a drum – by holding one flat in the cup of my hand and oscillating another. The stones chatter with voices resonant of water-worn histories. In Tango-cho, a coastal village far out on the west coast of Honshu, I visit old friends, sound artist Akio Suzuki and his wife Junko Wada. Our mutual fondness for stones leads us to the beach. We trek to where a river meets the sea and I find a pair of stones: one in the river – perfectly

spherical; and the other on the beach – flat. The river is called 'U' meaning cosmos, and the beach is 'Rei' meaning flat. 'U Rei' – flat cosmos, a kind of koan, maybe illuminated by the song of the stones.

1 [Maori word for a barrier-like fortification or dwelling area made from natural materials.]
2 [A New Zealand farmer who committed a mass murder by rifle in 1941.]

Phillip Dadson, extracts from *Sound Stories* (Christchurch, New Zealand: Robert McDougall Contemporary Art Annex, 2000) n.p.

Antonio Somaini
Catching the Waves: Carsten Nicolai's
Klangfiguren//2006

We ask for an electric, scientific painting!!! The waves of sound, light and electricity distinguish themselves from one another only in relation to their length and amplitude; after the successful experiments on free-fluctuating colour phenomena by Thomas Wilfred in America, and the sound experiments led by the American and German TSF [*Télégraphie Sans Fil*: 'wireless' radio], it will be easy to capture sound waves and diffuse them, with the help of giant transformers, as coloured and musical spectacles in the air ... At night, giant colourful light-dramas will unfold in the sky, while during the day these will be converted into sound waves, which will make the atmosphere resonate!!![1]

The excited prose, the avant-gardist enthusiasm and the grandeur of the spectacles imagined in 1921 by Raoul Hausmann, leading figure of the Dadaist movement in Berlin, may seem to have very little to do with the restrained and cold, essential minimalism of Carsten Nicolai's installations. Still, a common interest connects through time, like a 'fil rouge', the work of such distant and different artists: the possibilities of a 'direct' and simultaneous translation of sound into image and vice versa. In the case of Hausmann, who had been seduced by the artistic potential of the 'Optophone' invented in 1912 by Fournier d'Albe,[2] the reversible transition from the sonic to the visual made possible by 'Optophonetik'[3] is celebrated as the most appropriate way of capturing the new consciousness of space and time which characterizes life in the modern city. According to him, only a form of art that fully exploits the new possibilities of conversion and translation introduced by the electric media can offer an adequate

response to the general psychophysiological transformation and heightened sensory awareness brought forth by modernity. Nicolai's position, some eighty years later, is inevitably different: situated in the middle of that general process of inter-translatability and remediation which characterizes all media in the digital era – the fact that any form of information can be translated into digital binary codes and then vehicled through any medium – the examples of translation of sound into image and vice versa exhibited in his works explore a variety of alternative and at times curiously anachronistic routes.

Nicolai's circumvention of the realm of sound has produced a wide variety of results: besides his well-known minimalist electronic music compositions and collective synaesthetic performances, we find a large body of plastic work which explores in different ways the material and spatial nature of sound and the possibility of its visualization. Many of the works by Carsten Nicolai exhibited at the Stedelijk Museum voor Actuele Kunst in Ghent reformulate the old project of translating sound into image. Some of them, like *Wellenwanne* (2000) or *Milch* (2000), go about this project with an almost archaeological attitude which seems to be in contrast with the general scientific precision and high-tech appearance of his installations. In both cases, the visualization of the invisible nature of sound avoids any form of digital mediation in order to revert to the 'archaic' indexicality of the imprint. In *Wellenwanne*, several flat aluminium trays are filled with water, each resting on four loudspeakers which transmit the sound compositions via vibrations from a CD player onto the water surface, generating wave patterns which are astonishingly regular and possess an almost decorative quality. Such ornamental dimension is even clearer in *Milch*, where the ripples generated on a milk surface by very low frequency sinus waves (10 to 150 hertz) are photographed and printed on aluminium panels. In both works, sound frequencies that are barely audible for the human ear and intrinsically invisible as any sound, are caught and visualized in the form of clear and regular patterns which, although utterly abstract and almost grid-like, are directly indexically linked, like the finger print to the finger, to the vibrations which have generated them.

All together, the water and the milk surfaces of *Wellenwanne* and *Milch* remind us of sound waves, of the many ways in which they can manifest themselves, and in so doing they hint to the possibility of a form of 'tactile' hearing. The almost archaeological dimension of such works lies in their direct reference to the experiments led in the late eighteenth century by the physicist Ernst Chladni on the sound imprints or 'Klangfiguren', regular patterns obtained by covering with very light powder the surface of a thin and elastic plate which would then be set in vibration. The results of such experiments, as illustrated by Chladni in his *Entdeckungen über die Theorie des Klanges* (1787),[4] were quite

astonishing: each sound would generate perfectly symmetrical star-like shapes on the round plates, revealing the hidden order and harmony that links the realms of the aural and the visual. Such anachronistic historical references are not uncommon in Nicolai's work: the two re-sounding polyhedrons which gave name to the two spaces in which was articulated his exhibition at the Schirn Kunsthalle in Frankfurt, *Reflex* and *Anti* (2005), bear a clear reference to the enigmatic solid which appears in the famous engraving by Dürer entitled *Melancholia I* (1514). In both cases, by referring to the past, Nicolai is saying something about the way his work is to be perceived and understood. The reference to Dürer's solid, which in the engraving stands as an emblem both of the achievements and of the insurmountable limits of Renaissance perspective, reveals the fascination and at the same time the anachronistic nature of any attempt to revive a lost unity of art and science. The re-enactment of Chladni's experiments on the 'Klangfiguren', on the other hand, is at the same time a nostalgic reference to a Romantic 'Naturphilosophie' which celebrated the convergence of art and nature, and a way of reaffirming how the materiality of sound is at the centre of his work, both of his musical compositions and of his installations. The vibrating milk and water surfaces may be read in metaphorical representation of our own bodies immersed in sound: bodies which are not the mere carriers of a pure and abstract 'ear', but a complex and interconnected sensorium, vibrating like a resounding object. As his electrifying musical performances of sound clearly show, our experience of sound can be a tactile and immersive experience.

In a work like *Telefunken* (2000), the translation of sound into image does not revert to the archaic paradigm of the imprint, but still avoids the mediation of the digital. No neutral and pre-programmed binary code is inserted between the sound and the audio and 'electric' reversibility of the aural and the visual envisioned by Hausmann's 'Optophonetik' is here presented in simple and elegant terms. The audio tracks of a CD – various test sounds generated by waves of variable frequence, amplitude and form, including some barely audible 'white noise', a combination of all the different sound frequencies – produce simultaneously on the TV screens a series of pulsating horizontal lines whose width changes according to the frequencies transmitted by the audio signals. Rerouting the audio signal of the CD player into the video input of the television, Nicolai is not introducing a new software to visualize sound, but rather working on the potential hidden in the frictions and in the unexpected, almost erroneous, connections between existing media. As in the case of *Wellenwanne* and *Milch*, what appears as an utterly abstract image, totally detached from physical reality, reveals itself as a direct and analogic manifestation of sound, one of the many ways in which sound can be perceived.

Works such as *Wellenwanne, Milch* and *Telefunken* locate precisely Carsten Nicolai's research within that long artistic tradition which has never ceased to question the relation between the visual and the sonic and the status of synaesthesia.[5] His works do not belong to the tradition which has seen in the abstractness and self-referentiality of music an exemplary paradigm through which to underline the immaterial and temporal dimension of the pictorial image: on the contrary, the abstract forms exhibited by these works possess the same referentiality and the indexicality of a photograph, that is, of an analogic image generated by some form of direct contact. Nor does such work refer to the tradition which has aimed at uniting sound and image in order to produce experiences which were often set within the framework of a *Gesamtkunstwerk* poetics and accompanied 'by the ideal of an empathic fusion of bodies and souls.[6] A tradition that begins at least with the *clavecin oculaire* (1725) with which Louis-Bertrand Castel aimed at overcoming the static nature of the pictorial image, continues with the light projections of the *clavier à lumières* introduced by Scriabin in his symphonic poem 'Prométhée: Poème du feu' (1916), and runs all the way to the 'expanded', abstract cinema of the 1960s. Although the exploration of collective experiences is certainly not absent from Nicolai's work – one may just recall the important role played by 'visuals' during his performances, between electronic sounds and light projections in the recent installation *Synchron* at the Neue Nationalgalerie in Berlin – what is evoked in works such as *Wellenwanne, Milch* and *Telefunken* is a different tradition: the one that has explored the possibility of a direct, analogic and eventually reversible transposition of sound waves into images.

To this tradition belong, next to the already mentioned Raoul Hausmann, figures such as László Moholy-Nagy, Oskar Fischinger and Rudolf Pfenninger, all active in the 1920s and 1930s. The first, in an essay entitled 'Produktion. Reproduktion' and written in 1922, suggested that the gramophone could be transformed from an instrument of 'reproduction' into an instrument for the very 'production' of sound: a careful and scientific study of the shapes of the grooves of vinyl discs – these being as well a form of sound imprint – aimed at clearly identifying the correspondences between graphic forms and sounds, could enable the creation of an 'acousic writing' which would allow composers to bypass both the traditional forms of notation and the role of musical instruments and musical performance.[7] Fischinger and Pfenninger, on the other hand, investigated the way in which, thanks to the new technologies introduced in cinema by Tri-Ergon and Tobis-Klangfilm,[8] sound could be graphically designed onto the optical soundtrack running parallel to the film carrying the images, and then made audible through a photo-electric selenium cell and a microphone. Although in many ways similar, their approaches reflected different aims:

Fischinger had artistic ambitions and was mainly interested in discovering which sounds corresponded to certain ornamental graphic patterns, while Pfenninger, an engineer, had a more scientific and systematic approach and was mainly interested in classifying the various signifying units in order to give place to a language – the 'tönende Handschrift', as he called it – capable of generating sounds in a purely synthetic way.[9]

By referring to Chladni's 'Klangfiguren' and to these early modern experiments on electric media translations of sound into image, Nicolai takes a clear stand in the current discourse on synaesthesia. In the context of the general inter-translatability which characterizes contemporary digital media, works such as *Wellenwanne*, *Milch* and *Telefunken* reaffirm the artistic potential of direct and analogic translations. All together, they underline the materiality of acoustic frequencies and the possibility of a bodily and tactile experience of sound. In the context of the proliferation of digital images which seem to have lost their indexical rooting in reality, they show how utterly abstract images may have the same archaic ontological status of the imprint. His whole work, as he himself has often recognized, revolves around a certain number of polarities, such as visible/invisible, audible/inaudible, spatial /temporal, permanence/instantaneity. Set at the centre of this complex polar field, sound is experienced not so much as 'music' but as an infinite potential: one of the many possible manifestations of that core element of reality which consists of waves, vibrations and frequencies. There is a work in Nicolai's oeuvre that for me synthesizes this attitude towards sound as the 'indefinitely translatable', and that is *Void* (2002): a series of chrome-plated and glass tubes which are said to contain a sealed sound, whose transient and ephemeral nature is now inaudible but perhaps preserved for a future translation by that organic medium which is our ear, or by some medium which we still don't know.

1 Raoul Hausmann, 'PREsentismus. Gegen den Puffkeïsmus der teutschen Seele', *De Stijl*, no. 9 (Leiden, September 1921) 4–5. […]

2 See E.E. Fournier d'Albe, 'The Type-Reading Optophone', *Nature*, no. 3 (September 1914), quoted in Marcella Lista, 'Empreintes sonores et metaphores tactiles: Optophonétique, film et vidéo', in *Sons & Lumières: Une histoire du son dans l'art du XXe siecle* (Paris: Éditions du Centre Pompidou, 2004) 64.

3 The term appears in Raoul Hausmann, 'Optophonetika', *MA* (May 1922). […]

4 See also Ernst Chladni, *Die Akustik* (Leipzig, 1802).

5 The relationship between sound and image and the question of synaesthesia have been recently at the centre of large exhibitions such as the already quoted 'Sons & Lumières', curated by Sophie Duplaix and Marcella Lista for the Centre Pompidou, Paris, in 2004, or 'Visual Music: Synaesthesia in Art and Music since 1990', curated in 2005 by Kerry Brougher, Jeremy Strick, Ari Wiseman and

Judith Zilczer for the Hirshhorn Museum and Sculpture Garden, Smithsonian Institution, Washington D.C. Both exhibitions acknowledge the important precedent of the already quoted 'Vom Klang der Bilder: Die Musik in der Kunst des 20. Jahrhunderts', curated by Karin von Maur for the Staatsgalerie Stuttgart in 1985. For an interesting evaluation of the present discourse on synaesthesia, see Christoph Cox, 'Lost in Translation: Sound in the Discourse on Synaesthesia', *Artforum*, XLIV, no.2 (October 2005) 236–41.

6 See P. Rousseau, 'Concordances. Synaesthésie et conscience cosmique dans la "Colour Music"', in *Sons & Lumieres*, op. cit., 29–38.

7 Lázló Moholy-Nagy, 'Produktion. Reproduktion', *De Stijl*, vol. 5, no.7 (Leiden, 1922) 97–101.

8 See Thomas Y. Levin, 'Des sons venus de nulle part: Rudolf Pfenninger et l'archéologie du son synthetique', in *Sons & Lumières*, op. cit., 51–60.

9 Rudolf Pfenninger, 'Die Tönende Handschrift: Das Wunder des gezeichneten Tons' (1931).

Antonio Somaini, 'Catching the Waves: Carsten Nicolai's Klangfiguren', in *Audio Visual Spaces: Carsten Nicolai* (Ghent: Stedelijk Museum voor Aktuele Kunst, 2005) 59–62.

Steve Roden
Active Listening//2005

[...] Active listening is being open to the possibilities of music and it is being open to these possibilities in spaces outside of concert halls and car radios – for certainly music is everywhere. John Cage's writings/thinkings/talkings about sound/music/listening have asked us to consider that anything can be music. I like to tweak this proposition with the thought that although anything can be music, not everything is music. Marcel Duchamp spoke of the viewer completing a work of art and that a work of art has no meaning without a viewer to bring meaning to it. And so I think, as active listeners, we can become 'composer listeners', as we decide what sounds in the world we are going to ignore and what we will choose to listen to as music. Anyone who has stood at the side of a small stream, lost in the sounds of the water flowing over the stones, has already done this. [...]

Steve Roden, extract from 'Active Listening', text for the *Bronx Soundwalk* catalogue (Paris and New York: Soundwalk, 2005) n.p. (www.soundwalk.com)

Douglas Kahn
Joyce Hinterding and Parasitic Possibility//2008

Joyce Hinterding wants to cook her meals on Channel 7, to direct the energy of the broadcast signal toward something useful. Of all the signals radiating metropolitan areas, those of broadcast television carry the most energy. Concentrating this power provides a spark that illuminates Tesla's dream of transmitted electricity, if not the reality. The prosaic reality is that the magnitude of power marshalled to flood these signals across large populations is nothing more than testament to an intrinsic political desperation at the centre of control. It is from this location and through these channels that electromagnetic wave propagation becomes the carrier wave for propaganda. Using it diminishes the signal, but the amount of energy that reaches an individual antenna is minuscule compared to that being transmitted, so it would take a huge swarm of antennae to sap the tiniest loss from signal strength; a suspension bridge in the path of transmission would be a better bet. For one exhibition in New Zealand in the early 1990s Hinterding wanted to start with a gallery space cluttered with antennae, following a story she had heard about a household in England intent on scavenging their energy from the air, but it proved to be too expensive. Yet even if Hinterding could gather enough antennae for domestic use in her New South Wales home, it would still be distasteful knowing that Prime Minister Howard melted cheese while sending troops to Iraq.

For Hinterding, antennae in themselves have important sculptural implications because they demonstrate via electromagnetic induction – 'the most extraordinary concept' – that 'everything is active; all materials are active'. She had earlier become interested in incorporating sound into her work because resonance and sympathetic vibrations in sound exemplified 'what exists between things rather than things'. Rather than being driven by drives and exercising mastery over inert objects, electromagnetic induction served Hinterding as an analogue that enabled, in effect, an affective wave function of attunement with the physical world.

Her interest in using antennae was first excited by an article by Tom Fox, 'Build the "Whistler" VLF Receiver', in the 1990 *Popular Electronics Hobbyist Handbook*. Whistlers are naturally-occurring electromagnetic waves generated primarily by full spectrum electromagnetic bursts from lightning interacting with the ionosphere and magnetosphere. These are signals reflected and refracted, lens-like, through the upper atmosphere, and at times travelling great distances, while spiralling around magneto-ionic flux lines of the magnetosphere,

across the equator and far out into space, from one hemisphere to the other, sometimes bouncing repeatedly between hemispheres. Being electromagnetic waves they are travelling at the speed of light. Because they are exceedingly long waves that, moreover, travel thousands and hundreds of thousands of kilometres, they end up falling into the human audible range of frequencies once they are translated, transduced into vibrations in the air.

This patch of the electromagnetic spectrum is properly called the 'audio frequency range', or VLF (Very Low Frequency) for short, since it is dominated though not exhausted by the VLF range. It represents one of only two places on the spectrum that intersect experientially with human vision and audition. The other place is well known: visible light. Humans can perceive light unaided whereas it takes simple technology to transduce electromagnetism into sound. Such technology may include hair, fur, pine needles and grasses when polar aurorae are heard, although there are varying opinions. Whistlers and other ionospheric VLF phenomena can be heard through simple transducers alone – a long wire with a simple telephone receiver as the transducer will work – whereas radio signals outside the audio frequency range must be transposed up or down, or rendered from data, in order to fall within the range of hearing.

The sounds of ionospheric VLF are fascinating and beautiful, ranging from short bursts of noise that have been described as metallic bacon frying, to bird-like chirping, to the ethereal glissandi of whistlers themselves, and the echo-trains of whistlers piled up from bouncing back and forth between what are called conjugate points in the northern and southern hemispheres of the earth. Tom Fox recounts how the first sounds he heard after he built his solid-state VLF receiver were not the mysterious sounds of whistlers, but the sound of Omega Navigation system operating between 10 to 14 kHz (Omega beacons ceased transmission once GPS became more widely available). The real fun, he said, 'starts when you pick up a whistler. That strange sound starts as a high-pitched whine, at about 20 kHz, and sweeps down in frequency to a pitch like that of a high-soprano singer; it lasts about a second.' [...]

In 1991, Hinterding was in-residence at the Greene Street Studio in New York through an Australia Council Fellowship. When she first turned on her VLF receiver and antenna inspired by Tom Fox, she hoped to hear the Omega Navigation signal that would in turn let her know that she was at least in the right neighborhood for whistlers, but all she heard was the 60 Hz hum of the US electrical grid and, strangely, a Christian fire-and-brimstone preacher instructing everyone through the hum to 'Stand in front of the mirror. Repent! Repent!' She didn't understand why there could be a broadcast that low, apart from reaching sinners wherever they might be. The saving grace was that it made her wonder whether 'Repent! Repent!' was pulsating just outside the

window, resonating sympathetically in the conductive mass of the fire escape, and it made her wonder where else was the call to repent in that big rat's nest of vibrating metal called a city.

She finally heard natural radio for the first time during the same year at Walter De Maria's *Lightning Field* in New Mexico, where she camped out and made recordings deep into the night. She was not there to watch lightning – it's not good to be too close to lightning while recording VLF, or in any instance, for that matter – instead she was there on an artistic pilgrimage and because of the isolation the site provided from electrical grid that interferes with VLF reception. Following instructions, she found the Omega tracking signal and knew her antenna and receiver was working. [...]

Douglas Kahn, extract from 'Joyce Hinterding and Parasitic Possibility', in *Re-Inventing Radio: Aspects of Radio as Art* (Frankfurt am Main: Revolver, 2008).

Seth Kim-Cohen
Doug Aitken's *Sonic Pavilion*//2009

[...] Doug Aitken's *Sonic Pavilion* (2009) is located on a thickly forested hilltop in the grounds of the Inhotim cultural institute in Brazil. After five years of planning and construction, *Sonic Pavilion* was up and running when I visited in the third week of August, a few weeks before its October launch. As Aitken explained to me, the unusually long construction time was necessitated by the work's central feature: a hole approximately one mile deep and one foot in diameter. Using specialized equipment, the hole was painstakingly drilled, emptied, drilled deeper, emptied again and so on before being lined with concrete. Aitken then lowered a battery of microphones and accelerometers into the hole at varying depths. At the top, the sounds that result – of the earth's rotation and the shifting of seismic plates – are transposed into the range of human hearing and amplified by eight loudspeakers arrayed around the circular interior of the structure. The printed project description speaks of 'translating' the earth's movement: 'This artwork strives to provide a new relationship to the earth we constantly walk upon and occupy, revealing its mysterious and living dialogue.'

Aitken is not the first artist to turn to the medium of sound in an effort to create, as he put it, an experience with 'no beginning and no end, deep-rooted, pure and direct'. There is a pervasive sense – not just among visual artists who

turn to sound as an alternative but also among artists who work primarily with sound – that the sonic is truer, more immediate, less susceptible to manipulation, than the visual, as if the adjective sound (meaning 'solid, durable, stable') should somehow constitute the noun. This tendency has a history. In 'Primal Sound', an essay written in 1919, Rainer Maria Rilke fantasizes about dropping a phonograph needle into a skull's coronal suture (the line created by the fusing of bone plates during infancy):

> What would happen? A sound would necessarily result, a series of sounds, music … What variety of lines then, occurring anywhere, could one not put under the needle and try out? Is there any contour that one could not, in a sense, complete in this way and then experience it, as it makes itself felt, thus transformed, in another field of sense?

Rilke's fantasy announces the dream of a unified field of the senses, bridging 'the abysses which divide the one order of sense experience from the other' and 'completing', to use Rilke's verb, our experience of the world. The implication is that there is a wholeness out there and that any feeling we may have of insufficient understanding is merely a product of our inadequate perceptual faculties in here.

Unaware of the book in my bag, Aitken at one point conjured the name Fitzcarraldo, relating the folly of his project to Herzog's. Yet while Herzog's film and Aitken's installation both offer challenges to the intransigence of the earth, Rilke's hypothetical experiment offers a way to describe the fundamental difference between them: for Herzog, dropping a phonographic needle into the suture's groove would be meaningless, except for the act of having done it. The resultant sound would not get us any closer to the 'truth' of the skull or its onetime inhabitant (brain, soul, self); it would document only the act *qua* act. 'Here, in the self-aware presentation of doing something – rather than in the faithful representation of something – resides the only experience to which we can convincingly ascribe the adjective true. Herzog warns against the seduction of thinking that the truth is something out there and that knowing is simply a matter of quantifying and transporting that something in here: 'Facts do not create truth.' Aitken's *Sonic Pavilion*, on the other hand, equates the facticity of sensory experience with truth; but then dodges the responsibilities of this equation, clinging to the justifying premise that, ultimately, there is a something, a telos, backstopping experience.

The pavilion is accessed by means of a spiralling, inclined walkway that starts outside, following the contour of the hill, before turning into a winding concrete corridor that appears to move inevitably toward this evasive something. The spiral path continues inside on a raised wooden ramp that doubles as the room's only seating. As the sloped corridor emerges into the glass pavilion, the earth

appears through the panoramic windows in its primaeval virginity, the Brazilian forest receding endlessly in every direction. When the visitor nears the glass, a lenticular film blurs the periphery of the field of vision as in cinematic depictions of a dream or a memory. Everything – the corridor leading inward like a cathedral labyrinth, the emptiness of the interior, the austere geometry, the foggy visual frame – is designed to induce the impression of unprecedented access to secret sensory experience.

The sound of the pavilion is unpredictable, or, as it is called in music, aleatory. During my visit, the speakers emitted a low, steady rumble. Occasionally, a brief, higher-pitched moment of friction intervened, like the sound of rubbing your hands together in the cold. I take Aitken at his word when he says the primal churning of the audio is the sound of the earth a mile below its surface. But what was I actually hearing? Stone moving against stone? Loose material shifting as solid material beneath it gave way? To pedantically supply this information would reduce the 'mysterious and living dialogue' to the didactic monologue of a science exhibit. I found myself relating the sound of the earth to more familiar, worldly sounds: wind across a microphone, jet engines from inside the jet, the massive transformer outside my bedroom window; and to musical and artistic sounds: the Theatre of Eternal Music's *Inside the Dream Syndicate, Volume I: Day of Niagara* (1965), Peter Ablinger's *Weissl Weisslich 6 for twelve cassette recorders* (1992), and, most uncannily, *Nurse with Wound's Salt Marie Celeste* (2003). The sound itself is nothing special: only the suggestion of its source solicits our attention and grants it meaning. Of course, this is always the case: meaning does not simply inhere within the in-itself, regardless of whether it is the thing-in-itself or sound-in-itself. Meaning is only ever produced by the frictions between things. Like every medium, sound derives its meaning from context, from intertextuality, from the play of difference in its conceptual and material strata. It is the worldly, rather than the earthly, that presents the possibility of meaning.

The situation and design of *Sonic Pavilion* insist that there is something sacrosanct beneath the superficial stratum we occupy. The sound emanating from the hole and amplified in the pavilion is the cipher that will unlock the coded mystery of the deep. The Rilkean implication is that a phenomenal entity, like the earth, possesses immanent, essential properties that are consistently expressed across different sensory manifestations. It might be comforting to think that phenomena can be 'solved' and that experience can be completed by filling in the blanks in our senses. But confronting the existential burden of knowing that experience inevitably evades completion is surely more honest. *Sonic Pavilion* denies the visitor the privilege of assuming this burden, offering blissful ignorance in its place. Too bad. It's not every day that an artist is given the opportunity, the site and the resources to dig a mile deep hole in the ground.

Sonic Pavilion comes so close to initiating a genuine act of consciousness, of conscientiousness, of conscience. But ultimately it refuses to gaze into the void at its core, abdicating the responsibility of facing up to what Wallace Stevens describes as nothing that is not there and the nothing that is.

Seth Kim-Cohen, extracts from 'The Hole Truth: Doug Aitken's *Sonic Pavilion*', *Artforum* (November 2009) 99–101.

Angela Rosenberg
Hearing and Seeing: Karin Sander//2010

[...] The exhibition 'Zeigen. An Audio tour through Berlin by Karin Sander' poses unusual challenges for the viewer. Upon entering it, the Temporare Kunsthalle appears to be completely empty: because nothing seems to refer to a work of art, visitors are confronted with their own expectations of an exhibition with this title and such an extensive cast of participating artists. However, on stepping up close to the walls, one sees a thin strip of lettering running round the hall in a continuous line, naming all the artists involved in alphabetical order. Big names lie alongside those of young or lesser known artists, each assigned a three-digit number.

By entering this number into an audio guide system – a playback device and headphones of the kind that are standard equipment in many museums today – the visitor can select and listen to any contribution. The titles appear in the display of the device, while the works themselves remain, at least for the time being, invisible.

Karin Sander's exhibition concept poses a challenge not only for the public but for the artists, too. Her invitation requested contributions containing 'acoustic information about a work or working process ... that would translate your work and make it "visible".' Sander, who sent this invitation to several hundred artists, soon outstripped her direct personal and professional circle, using other groups and networks to contact artists unknown to her. Recommendations and extensive follow-up work broadened the circle yet further, not so much systematically as through a snowball effect. Within the short two-month preparatory period, 566 artists replied, ready on short notice to enter into this – for many unfamiliar – terrain. Depending on what statistics one cares to credit, this number is approximately one tenth of the artists living and working in Berlin right now and, as such, may stand as a representative cross section of the Berlin art scene.

By specifying that visual, narrative, conceptual or processual material be transferred to the auditory level, Sander's invitation excluded tone artists and musicians. Yet the contributions include musical performances as well as ecstatic emotional outpourings such as laughter and tears. All in all, the works evince an immense variety mirroring their creators' different artistic standpoints. The approaches adopted vary from the transparent to the ostensibly cryptic. Works are sometimes illustrated verbally: what is seen in a picture is related, sung, or otherwise described. Artistic aims are proclaimed in manifestos. Or critics, friends, children are invited to explain works. Sometimes noises occurring while producing works are documented in a kind of workshop report. There are numerous conceptual pieces of varying poeticism as well as astute, absurd and enigmatic contributions that, taken together, generate a compelling acoustic panorama.

But the making visible that Sander intends is not primarily the transfer of an aspect of an artist's work or method of work to a different sensory level. Like sight, hearing enables one to orientate oneself in space. However, while seeing goes hand in hand with desiring – in the classic example the palpable realism of the fruits in a still life making one reach out to touch them – hearing stimulates the imagination, generating an inner picture that is private to the hearer and that can only be expressed indirectly through words or images. The individual acoustic contributions point the visitor to a different level of perception that takes one away from the customary, learned, visual approach to art toward an acoustic, emancipatory, imaginative experience. It is only as a product of the individual subject's power of imagination that the individual works come into being: they hang on no wall but materialize instead in visitors' heads.

Given the sheer number of works presented, it is obviously all but impossible to 'see' or hear/listen to the exhibition in its entirety. By subjecting the visitor to this calculated overload, Sander deliberately sounds out the potential of a synoptic exhibition, bringing the limits of the exhibition space and of human receptivity into direct relation. The listening, imagining visitor gains an insight into the complexity and effort of imagining involved in artistic work. Ultimately, the role division of artist, institution and beholder is also called into question, particularly when the exhibition promises something that the visitor alone can complete. What is at stake here, therefore, is not so much the dematerialization of the work of art as the nature of art – its essence and form, and its spatial, thematic and symbolic extensions.

Angela Rosenberg, extract from 'Hearing and Seeing', in *Zeigen: Eine Audiotour durch Berlin von Karin Sander* (Berlin: Temporäre Kunsthalle Berlin, 2010).

Biographical Notes

Vito Acconci is an American experimental architect (since 1988) based in New York. Formerly he was internationally known as a conceptual artist since the mid 1960s. Retrospectives include Museum of Contemporary Art, Chicago (1980) and Museu d'Art Contemporani de Barcelona (2004).

Svetlana Alpers is an American art historian, artist and critic whose books include *The Art of Describing: Dutch Art in the Seventeenth Century* (1983) and *The Vexations of Art: Velázquez and Others* (2005). She is Professor Emerita at the University of California at Berkeley.

Laurie Anderson is an American performance artist and musician who began as a conceptual artist in the late 1960s. Since the early 1970s she has made solo experimental performances internationally and collaborated with many other leading artists, musicians and composers.

Jacques Attali is a French political economist and scholar, and an adviser to governments and non-governmental organizations on economic, technological and humanitarian issues. His numerous books include *Noise: The Political Economy of Music* (1985) and *A Brief History of the Future* (2006).

Harry Bertoia (1915–78) was an Italian-born sculptor, furniture designer and musician, based in the United States from the early 1930s. He began making sculpture in the late 1950s and during the 1970s collaborated with his son Val Bertoia on sound sculptures and performances.

John Cage (1912–92) was an American experimental composer, artist and writer, a leading figure in the post-1945 American avant-garde and influence upon the international Fluxus movement. His books include *Silence: Lectures and Writings* (1961/1973), *A Year from Monday: New Lectures and Writings* (1967), *M: Writings 1967–1972* (1973), *Empty Words: Writings 1973–78* (1979), *X: Writings 1979–1982* (1983) and *Composition in Retrospect* (completed in 1992) (2008).

Kim Cascone is an American composer of electronic music, who has produced solo compositions since the mid 1980s both under his own name and the aegis of Heavenly Music Corporation. From 1986–96 he released most of his work through the record company he formed, Silent.

Germano Celant is an Italian curator and critic who has been internationally influential since the late 1960s. He was curator of the 1997 Venice Biennale and is Senior Curator at the Solomon R. Guggenheim Museum, New York.

Michel Chion is a French experimental composer and Associate Professor at the University of Paris III: Sorbonne Nouvelle. He was a member of the Groupe de Recherches Musicales (1971–76). He has written extensively on music in cinema, electronic music, and the work of Pierre Schaeffer.

Ralph T. Coe (1929–2010) was an American art historian, curator, and a collector and pioneer of the study of Native American art. He was Director of the Nelson-Atkins Museum of Art, Kansas City, from 1977–82.

Steven Connor is Professor of Modern Literature and Theory at Birkbeck College, London, and Academic Director of the London Consortium. His books include *Theory and Cultural Value* (1992) and *Dumbstruck: a Cultural History of Ventriloquism* (2004).

Christoph Cox is a critic, theorist and curator of art and music. Professor of Philosophy at Hampshire College, Massachusetts, he is editor-at-large of *Cabinet* and a regular contributor to *Artforum* and *The Wire*. He is the co-editor of *Audio Culture: Readings in Modern Music* (2004).

Martin Creed is a British-born artist based in London and Alicudi, Italy, who has exhibited since 1989. Solo shows include Gavin Brown's Enterprise, New York (2000), Kunsthalle Bern (2003), Stedelijk Van Abbemuseum, Eindhoven (2005), Ikon Gallery, Birmingham (2008).

Philip Dadson is a New Zealand sound and intermedia artist based in Auckland, and founder of the rhythm/performance group From Scratch, which originated from his involvement in the late 1960s with the London-based Scratch Orchestra. He has performed, collaborated with others and exhibited internationally since the 1970s.

Suzanne Delehanty is principal of Suzanne Delehanty LLC, which provides strategic planning and art advisory services for initiatives that bring art, artists and communities together. A museum director since 1971, from 1996 to 2005 she was founding director of the Miami Art Museum.

Paul DeMarinis is an American electronic media artist who since 1971 has created numerous international performance works, sound and computer installations. His major installation works include *The Edison Effect* (1989–93), *Gray Matter* (1995) and *The Messenger* (1998/2005).

Helmut Draxler is an art and cultural theorist and independent curator based in Berlin. He is Professor of Aesthetic Theory at the Merz Akademie college of design, Stuttgart. His books include *Gefährliche Substanzen: Zum Verhältnis von Kritik und Kunst* (Berlin, 2007).

Marcel Duchamp (1887–1968) was an independent French-born artist associated with Dada and Surrealism who became an American citizen in 1955. His readymades of 1913 onwards and other later concepts influenced the development of Fluxus, Pop, performance and conceptual art. Retrospectives include Pasadena Museum of Art (1963) and Philadelphia Museum of Art (1987).

Bill Fontana is an American composer and artist who since the early 1970s has used sound as a sculptural medium to interact with and transform our perceptions of visual and architectural spaces. He has realized sound sculptures and radio projects for museums and broadcast organizations around the world. His website is www.resoundings.org

William Furlong is a British artist and professor at Wimbledon College of Art, London, who has exhibited internationally both solo and as Audio Arts – the art practice and audio magazine he co-founded in 1973 and the archive of which was acquired by the Tate archives, London, in 2005. Audio excerpts from the archive are at www.tate.org.uk/britain/exhibitions/audioarts/

Liam Gillick is a British artist whose projects include the series What If Scenarios and Discussion Islands. He was included in Utopia Station, Venice Biennale (2003). Solo exhibitions include The Museum of Modern Art, New York (2003) and the German Pavilion, Venice Biennale (2009).

Kim Gordon is an American musician, artist, filmmaker and curator. She was a co-founder of the band Sonic Youth in 1981 and since the early 1980s has worked on numerous creative projects across different media, including collaborative performance installations with Jutta Koether.

Dan Graham is a New York-based American artist and writer on art and culture who began working in the early 1960s. His writings are collected in *Rock My Religion* (1993) and *Two-Way Mirror Power* (1999). Retrospectives include The Museum of Contemporary Art, Los Angeles (2009).

Paul Hegarty teaches philosophy and visual culture as Head of the French department at University College, Cork. He jointly runs the experimental record label dotdotdotmusic, and has made noise performances since 1999. He is the author of *Noise/Music: A History* (2007).

Martin Herbert is a British writer and art critic based in Tunbridge Wells, Kent. He is a regular contributor to *Artforum* and his writing has appeared in numerous other international art journals including *TATE Etc.* and *Parkett*.

Chrissie Iles is the Anne and Joel Ehrankranz Curator at the Whitney Museum of American Art. She has curated and written extensively on film, video, performance and mixed media artists of the 1960s and 1970s and has co-curated the Whitney Biennial since 2004. Her notable survey exhibitions include 'Into the Light: The Projected Image in American Art 1964–1977' (2001).

Tom Johnson is an American minimalist composer, based in Paris since 1983. His works include *The Four Note Opera*, *An Hour for Piano*, *Rational Melodies* and the *Bonhoeffer Oratorio*. His book *The Voice of New Music* (1991) anthologizes his new music reviews for the *Village Voice*, New York, between 1972 and 1982.

Branden W. Joseph is Frank Gallipoli Professor of Modern and Contemporary Art at Columbia University. His books include *Random Order: Robert Rauschenberg and the Neo-Avant-garde* (2003) and *Beyond the Dream Syndicate: Tony Conrad and the Arts after Cage* (2008).

Douglas Kahn is Professor of Innovation and Media at the National Institute of Experimental Arts, University of New South Wales, Australia. His work explores the intersections of history, theory, politics and artistic practice in experimental artforms across media since early modernism. His most influential book is *Noise, Water, Meat: A History of Sound in the Arts* (1999).

Allan Kaprow (1927–2006) was an American artist who established Happenings in 1959, a term he abandoned in 1967, after which he explored other participatory models. His writings are collected in *Essays on the Blurring of Art and Life* (1993). Retrospectives include Haus der Kunst, Munich (2006) and The Geffen Contemporary at MOCA, Los Angeles (2008).

Mike Kelley is an American artist whose work since the late 1970s has encompassed installation, performance, sculpture, video, writing and curating. In 1973 he co-formed with other West Coast artists the band Destroy All Monsters. Solo exhibitions include the Whitney Museum of American Art (retrospective, 1993) and Gagosian Gallery, New York (2005).

Seth Kim-Cohen is Director and Assistant Professor of Art and Theory at the Institute for Doctoral Studies in the Visual Arts (IDSVA), Portland, Maine. The author of *One Reason To Live:Conversations About Music* (2006) and *In the Blink of an Ear: Toward a Non-Cochlear Sonic Art* (2009), he has released eight albums of experimental music.

Yves Klein (1928–62) was a French artist whose influential work from the late 1940s onwards explored among other themes the monochrome, notions of the void and of the contemporary sublime. Retrospectives include Centre Georges Pompidou, Paris (2007).

Christina Kubisch is a German artist in acoustic and visual media who has exhibited and released recordings internationally since the 1970s. She is Professor of Sculpture and Media Art at the Academy of Fine Arts, Saarbrücken.

Brandon LaBelle is an American artist and writer based in Berlin whose work explores aspects of acoustic space. He has exhibited and curated internationally since the mid 1990s and is the author of *Background Noise: Perspectives on Sound Art* (2006) and *Acoustic Territories: Sound Culture and Everyday Life* (2010).

Dan Lander is a Canadian artist whose works for radio and loudspeaker have been exhibited internationally since the early 1990s. Producer of the radio programme *The Problem with Language* (CKLN, Toronto) from 1987 to 1991, he co-edited *Sound by Artists* (1990) and *Radio Rethink: Art, Sound and Transmission* (1994).

Bernhard Leitner is an Austrian sound and media designer and artist based in Vienna, who has worked and taught internationally since the late 1960s and exhibited since the late 1970s. Surveys of his work include *P.U.L.S.E. Spaces in Time* (with DVD) (2008).

Alvin Lucier is an American composer of experimental music and sound installations that explore acoustic phenomena and auditory perception. His key works include *I am sitting in a room*, *North American Time Capsule*, *Music on a Long Thin Wire* and *Crossings*.

Len Lye (1901–80) was a New Zealand-born kinetic artist and experimental filmmaker who worked in England from 1926, in association with the surrealists, and became an American citizen in 1950. Retrospectives include Centre Georges Pompidou, Paris (2000).

Christian Marclay is an American artist and musician based in New York who has been exhibiting and performing since the late 1980s. Solo exhibitions include the Hammer Museum, UCLA (2003), Seattle Art Museum (2005) and Foundation for Contemporary Art, Montreal (2009).

W.J.T. Mitchell is Professor of English and Art History at the University of Chicago and editor of *Critical Inquiry*. His books include *What Do Pictures Want?* (2005), *Picture Theory* (1994), *Art and the Public Sphere* (1993), *Iconology* (1987) and *The Politics of Interpretation* (1984).

Robert Morris is an American artist based in New York whose interrogations of established aesthetic positions from 1960 to the late 1970s were central to the emergence of conceptual art and Minimalism. Retrospectives include Centre Georges Pompidou, Paris (1995). His writings are collected in *Continuous Project Altered Daily: The Writings of Robert Morris* (1993).

Alexandra Munroe has since 2006 been Senior Curator of Asian Art at the Solomon R. Guggenheim Museum and was formerly Director at the Japan Society, New York, where her exhibitions included *Japanese Art after 1945: Scream against the Sky* (1994) and *Yes Yoko Ono* (2000).

Bruce Nauman is an American artist based in New Mexico whose works have been influential since the late 1960s. Touring retrospectives include Los Angeles County Museum of Art (1972), Walker Art Center, Minneapolis (1994) and Centre Georges Pompidou, Paris (1998).

Hermann Nitsch is an Austrian artist who first emerged as a member of the Vienna Actionists in the late 1950s. In 1962 he established the Orgien Mysterien Theater and in the early 1970s began to issue recordings of the music of the O.M. Theater, later performing and exhibiting internationally.

Michael Nyman is a British composer, musician and musicologist who has been composing since the mid 1960s. From the early 1970s he was an exponent of and writer on minimalist and experimental composition.

Jacques Rancière is a French philosopher who first came to prominence as a co-author, with Louis Althusser and others, of *Reading Capital* (1965). His books include *The Ignorant Schoolmaster* (1982), *Disagreement* (1998) and *The Politics of Aesthetics* (2004).

Steve Roden is an American artist based in Los Angeles who has been exhibiting, making sound performances and recordings in the USA and internationally since the mid 1980s.

Luigi Russolo (1885–1947) was an Italian artist and composer and a member of the Futurist group. In 1913 he issued the manifesto 'the Art of Noises' and devised the noise-generating devices *Intonarumori*, pioneering noise performance before and after the First World War.

R. Murray Schafer is a Canadian composer, writer and environmentalist who has been composing and writing since the early 1960s. His major book, *The Tuning of the World* (1977), documents the findings of his World Soundscape Project, which introduced the concept of acoustic ecology.

Michel Serres is among France's most original thinkers and has taught in French universities since the 1960s. He has held a professorship at Stanford University since 1984. His books include *Le Parasite* (1980), *Genèse* (1982), *Hominescence* (2001), *Récits d'humanisme* (2006) and *Biogée* (2010).

Steven Shaviro is DeRoy Professor of English at Wayne State University, Detroit. His books include *The Cinematic Body* (1993), *Doom Patrols: A Theoretical Fiction About Postmodernism* (1997) and *Connected: Or What It Means to Live in a Networked Society* (2009).

Mieko Shiomi is a Japanese artist and composer based in Osaka, who co-founded the experimental music group Ongaku, with Takehisa Kosugi, Yasunao Tone and Shuko Misuno in 1960. In 1964 she moved to New York, making work in the context of the Fluxus group, returning to Japan in 1965, where after a period she began again to compose independently.

Michael Snow is a Canadian artist, filmmaker, composer and musician who has been influential internationally since the mid 1960s. Surveys of his work include the book *1948–1993: Music/ Sound, The Michael Snow Project* (1993) and the DVD *Anarchive2: Digital Snow* (2002).

Antonio Somaini is an Italian critic and curator and a Professor at the University of Genoa. He has written extensively on art and sound, cinema and technology and has worked curatorially with Christian Marclay among other contemporary artists.

Emily Thompson is a Professor of the History of Technology at Princeton University. A former sound engineer and technological designer, she researches the cultural history of sound, music, noise and listening. She is the author of *The Soundscape of Modernity: Architectural Acoustics and the Culture of Listening in America, 1900–1933* (2004).

Yasunao Tone is a Japanese artist based in New York who is best known as a composer and performer of experimental sound works with 'wounded' CDs. In the 1960s in Japan he was involved with Fluxus and avant-garde movements such as Group Ongaku and Team Random, before moving to New York in 1970.

David Toop is a British musician, writer and sound curator. His books include *Ocean of Sound: Aether Talk, Ambient Sound and Imaginary Worlds* (2001) and *Haunted Weather: Music, Silence and Memory* (2004). He has released seven solo albums and curated five CD compilations.

Bill Viola is an American artist based in California who has worked with sound and been a pioneer of video art since the early 1970s. Retrospectives include Whitney Museum of American Art (1997, touring internationally to 1999).

Paul Virilio is a French philosopher and cultural theorist of urban space, architecture and technology. His books include *The Aesthetics of Disappearance* (1991), *Bunker Archaeology* (1994), *Virilio Live: Selected Interviews* (2001) and, with Sylvère Lotringer, *The Accident of Art* (2005).

Bibliography

This section comprises selected further reading and does not repeat the bibliographic references for writings included in the anthology. For these please see the citations at the end of each text.

Adorno, Theodor W., *Essays on Music*, ed. Richard Leppert (Berkeley and Los Angeles: University of California Press, 2002)

Ashley, Robert, *Music with Roots in the Aether: Interviews with and Essays About Seven American Composers* (Cologne: MusikTexte, 2000)

Augaitis, Daina, and Dan Lander, *Radio Rethink: Art, Sound and Transmission* (Banff: Walter Phillips Gallery, 1994)

Back, Les, and Michael Bull, eds, *The Auditory Culture Reader* (Oxford: Berg, 2003)

Bernstein, David W., ed., *The San Francisco Tape Music Center: 1960s Counterculture and the Avant-Garde* (Berkeley and Los Angeles: University of California Press, 2008)

Birnbaum, Daniel, et al., *Doug Aitken* (London and New York: Phaidon, 2001)

Block, Ursula, and Michael Glasmeier, eds., *Broken Music: Artists' Recordworks* (Berlin: Berliner Künstlerprogramm des DAAD: gelbe Musik, 1989)

Cann, Tyler, and Wystan Curnow, *Len Lye* (Melbourne: ACMI, 2009)

Cascone, Kim, 'The Aesthetics of Failure: "Post-Digital" Tendencies in Contemporary Computer Music', *Computer Music Journal*, vol. 24, no. 4 (2000)

Celant, Germano, *The Record as Artwork: From Futurism to Conceptual Art* (Chicago: Museum of Contemporary Art, 1977)

Chanan, Michael, *Repeated Takes: A Short History of Recording and Its Effects on Music* (London and New York: Verso, 1995)

Chion, Michel, *Audio-Vision: Sound on Screen* (New York: Columbia University Press, 1994)

Collins, Nicolas, *Handmade Electronic Music: The Art of Hardware Hacking* (London and New York: Routledge, 2009)

Conrad, Tony, 'Inside the Dream Syndicate', *Film Culture*, no. 41 (1966)

Cooke, Lynne, ed., *Max Neuhaus: Times Square, Time Piece Beacon* (New York: Dia Art Foundation 2009)

Cox, Christoph, 'Lost in Translation', *Artforum*, vol. 44, no. 2 (2005)

– 'Sound Art and the Sonic Unconscious', *Organized Sound*, vol. 14, no. 1 (2009)

– and Daniel Warner, eds, *Audio Culture : Readings in Modern Music* (New York: Continuum, 2004)

Drobnick, Jim, ed. *Aural Cultures* (Toronto: YYZ Books, 2004)

Duckworth, William, and Richard Fleming, *Sound and Light: La Monte Young, Marian Zazeela* (Lewisburg, Pennsylvania: Bucknell University Press, 1996)

Dyson, Frances, *Sounding New Media : Immersion and Embodiment in the Arts and Culture* (Berkeley and Los Angeles: University of California Press, 2009)

Eno, Brian, *A Year with Swollen Appendices* (London: Faber & Faber, 1996)

Erlmann, Veit, ed., *Hearing Cultures: Essays on Sound, Listening and Modernity* (Oxford: Berg, 2004)

Ferguson, Russell, et al., *Christian Marclay* (Los Angeles: UCLA Hammer Museum, 2003)

Gillick, Liam, *Proxemics: Selected Writings 1988–2004* (Zurich: JRP/Ringier, 2006)

Goldberg, RoseLee, *Laurie Anderson* (New York: Harry N. Abrams, 2000)

Green, Malcolm, ed., *Brus, Muehl, Nitsch, Schwarzkogler: Writings of the Vienna Actionists* (London: Atlas Press, 1999)

Grönenboom, Roland, ed., *Sonic Youth: Sensational Fix* (Cologne: Verlag der Buchhandlung Walther König, 2008)

Gronert, Stefan, and Christina Végh, eds, *Music: John Baldessari* (Cologne: Verlag der Buchhandlung Walther König, 2007)

Hanhardt, John G., ed., *Nam June Paik* (New York: Whitney Museum of American Art, 1982)

Higgins, Hannah, *Fluxus Experience* (Berkeley and Los Angeles: University of California Press, 2002)

González, Jennifer, et al., *Christian Marclay* (London and New York: Phaidon, 2005)

Hudak, John, and Takehisa Kosugi, 'Fishing for Sound', in *Takehisa Kosugi: Interspersions* (Berlin: Daadgalerie, 1992)

Ihde, Don, *Listening and Voice: Phenomenologies of Sound* (Albany: State University of New York Press, 2007)

Armstrong, Elizabeth, and Joan Rothfuss, eds, *In the Spirit of Fluxus* (Minneapolis: Walker Art Center, 1993)

Joseph, Branden W., *Random Order: Robert Rauschenberg and the Neo-Avant-Garde* (Cambridge, Massachusetts: The MIT Press, 2003)

Kahn, Douglas, *Noise, Water, Meat: A History of Sound in the Arts* (Cambridge, Massachusetts: The MIT Press, 1999)

– and Gregory Whitehead, eds, *Wireless Imagination: Sound, Radio and the Avant-Garde* (Cambridge, Massachusetts: The MIT Press, 1992)

Kelley, Mike, *Minor Histories: Statements, Conversations, Proposals*, ed. John C. Welchman (Cambridge, Massachusetts: The MIT Press, 2004)

Kelly, Caleb, *Cracked Media: The Sound of Malfunction* (Cambridge, Massachusetts: The MIT Press, 2009)

– 'Can Someone Please Turn the Music Up? The Exhibition of Sound in Contemporary Australian Art', *Art Monthly* (Australia), no. 225 (2009)

Kim-Cohen, Seth, *In the Blink of an Ear: Towards a Non-cochlear Sonic Art* (New York: Continuum, 2009)

Kittler, Friedrich A., *Gramophone, Film, Typewriter* (Stanford: Stanford University Press, 1999)

Kotz, Liz, *Words to Be Looked At: Language in 1960s Art* (Cambridge, Massachusetts: The MIT Press, 2007)

LaBelle, Brandon, and Steve Roden, eds, *Site of Sound: Of Architecture and the Ear* (Los Angeles: Errant Bodies Press, 1999)

Leitner, Bernard, 'Sound Architecture', *Artforum*, vol. 9 (1971)

Levin, Thomas, 'The Aesthetics and Politics of Christian Marclay's Gramophonia', *Parkett*, no. 56 (1999)

Licht, Alan, *Sound Art: Beyond Music, Between Categories* (New York: Rizzoli International Publications, 2007)

– 'Sound Art: Origin, Development and Ambiguities', *Organized Sound*, vol. 14, no. 1 (2009)

Lockwood, Annea, and Frank J. Oteri, 'Annea Lockwood Beside the Hudson River' (2004) http://newmusicbox.org/article.nmbx?id=2364

López, Francisco, 'Blind Listening', in *The Book of Music and Nature: An Anthology of Sounds, Words, Thoughts*, ed. David Rothenberg and Marta Ulvaeus (Middletown, Connecticut: Wesleyan University Press, 2001)

Mari, Bartomeu, and Ralf Beil, eds, *Janet Cardiff and George Bures Miller: The Killing Machine and Other Stories 1995–2007* (Ostfildern Ruit: Hatje Cantz, 2007)

Miller, Paul D., *Sound Unbound: Sampling Digital Music and Culture* (Cambridge, Massachusetts: The MIT Press, 2008)

Munroe, Alexandra, ed., *Japanese Art after 1945: Scream against the Sky* (New York: Japan Society/Harry N. Abrams, 1994)

Nancy, Jean-Luc, *Listening* (New York: Fordham University Press, 2007)

Nauman, Bruce, *Please Pay Attention Please: Bruce Nauman's Words*, ed. Janet Kraynak (Cambridge, Massachusetts: The MIT Press, 2003)

Parsons, Michael, 'The Scratch Orchestra and the Visual Arts', *Leonardo Music Journal*, vol. 11 (2001)

Peltomäki, Kirsi, *Situation Aesthetics: The Work of Michael Asher* (Cambridge, Massachusetts: The MIT Press, 2010)

Priest, Gail, ed., *Experimental Music: Audio Explorations in Australia* (Sydney: University of New South Wales Press, 2009)

Rainer, Cosima, et al., *See This Sound: Promises in Sound and Vision* (Linz: Lentos Kunstmuseum/Cologne: Verlag der Buchhandlung Walther König, 2009)

Serres, Michel, *The Parasite* (Baltimore: Johns Hopkins University Press, 1982)

Smith, Nick, 'The Splinter in Your Ear: Noise as the Semblance of Critique', *Culture, Theory and Critique*, vol. 46, no. 1 (2005)

Sterne, Jonathan, *The Audible Past: Cultural Origins of Sound Reproduction* (Durham: Duke University Press, 2003)

Strickland, Edward, *Minimalism – Origins* (Bloomington: Indiana University Press, 2000)

Tone, Yasunao, 'John Cage and Recording', *Leonardo Music Journal*, vol. 13 (2003)

Yasunao Tone: Noise Media Language (Los Angeles: Errant Bodies Press, 2007)

Toop, David, *Ocean of Sound: Aether Talk, Ambient Sound and Imaginary Worlds* (London: Serpent's Tail, 2001)

Van Assche, Christine, ed., *Sonic Process: A New Geography of Sounds* (Paris: Éditions du Centre Pompidou/Barcelona: Actar, 2002)

Viola, Bill, 'David Tudor: The Delicate Art of Falling', *Leonardo Music Journal*, vol. 14 (2004)

Vitiello, Stephen, and Marina Rosenfeld, 'Stephen Vitiello and Marina Rosenfeld' (2004) http://newmusicbox.org/59/interview_vitiello.pdf

Voegelin, Salomé, *Listening to Noise and Silence: Towards a Philosophy of Sound Art* (New York: Continuum, 2010)

Weiss, Allen S., *Experimental Sound and Radio* (Cambridge, Massachusetts: The MIT Press, 2001)

Young, La Monte, and Marian Zazeela, *Selected Writings* (Munich: Heiner Friedrich, 1969)

Index

Acknowledgements

Editor's acknowledgements

I am grateful for the support of Peter Blamey, Roger Conover, Ian Farr, Ann Finegan, Douglas Kahn, Jai McKenzie and Kusum Normoyle. I would also like to thank the Sydney College of the Arts library staff for their assistance throughout the research for this book.

Publisher's acknowledgements

Whitechapel Gallery is grateful to all those who gave their generous permission to reproduce the listed material. Every effort has been made to secure all permissions and we apologies for any inadvertent errors or omissions. If notified, we will endeavour to correct these at the earliest opportunity. We would like to express our thanks to all those who contributed to the making of this volume, especially: Marina Abramovic, Vito Acconci, Svetlana Alpers, Laurie Anderson, Jacques Attali, Harry Bertoia, Carly Berwick, Eric de Bruyn, Kim Cascone, Germano Celant, Michel Chion, Steven Connor, Christoph Cox, Martin Creed, Phil Dadson, Suzanne Delehanty, Paul DeMarinis, Helmut Draxler, Millie Findlay, Bill Fontana, William Furlong, Liam Gillick, Kim Gordon, Dan Graham, Paul Hegarty, Martin Herbert, Ryoji Ikeda, Chrissie Iles, Tom Johnson, Daniel Jordan, Branden W. Joseph, Douglas Kahn, Mike Kelley, Seth Kim-Cohen, Takehisa Kosugi, Christina Kubisch, Brandon LaBelle, Dan Lander, Bernhard Leitner, Alvin Lucier, Christian Marclay, W.J.T. Mitchell, Robert Morris, Alexandra Munroe, Bruce Nauman, Hermann Nitsch, Michael Nyman, Jacques Rancière, Steve Roden, Jérôme Sans, R. Murray Schafer, Michel Serres, Steven Shaviro, Mieko Shiomi, Michael Snow, Antonio Somaini, Akio Suzuki, Emily Thompson, Yasunao Tone, David Toop, Bill Viola, Paul Virilio, Susannah Worth. We also gratefully acknowledge the cooperation of: Academy Editions, Acconci archive, *Art & Artists*, *Art in America*, Art Metropole, ARS, *Artforum*, *ARTnews*, Auckland University Pres, The Collation Center, Columbia University Press, Continuum, Daidalos, Destiny Books, Edition Hansjorg Mayer, Éditions Cercle d'Art, Editions du Centre Pompidou, Éditions Gallilée, *Esquire Magazine Japan*, Estate of Max Neuhaus, Flood, *FO(A)RM*, Forma Arts & Media, Grey Room, Harry N. Abrams, Hatje Cantz Verlag, High Risk Books, Japan Society, John Cage Archive, *Journal of Visual Culture*, JRP/Ringier, Katalog Lentos, Kehrer Verlag, Lannis Gallery, Len Lye Estate, The MIT Press, Montreal Museum of Fine Arts, Museum of Contemporary Art Tokyo, Museum of Modern Art Stuttgart, *MusikTexte*, Neuberger Museum, *October*, Oxford University Press,

Palais de Tokyo, Phaidon Press, P.S.1 Contemporary Art Center, Ritornell, Robert McDougall Contemporary Art Annex, Schiffer Pubishing, Serpent's Tail, S.M.A.K., Something Else Press, Stanford University Press, State University of New York, Tate Publishing, University of Alabama Press, University of California Press, University of Michigan Press, University of Minnesota Press, *Village Voice*, Walker Art Center, Wesleyan University Press and The Whitney Museum of American Art.

Whitechapel Gallery

whitechapelgallery.com

Whitechapel Gallery is supported by
Arts Council England